1993

Yale Publications in the History of Art

Walter Cahn, Editor

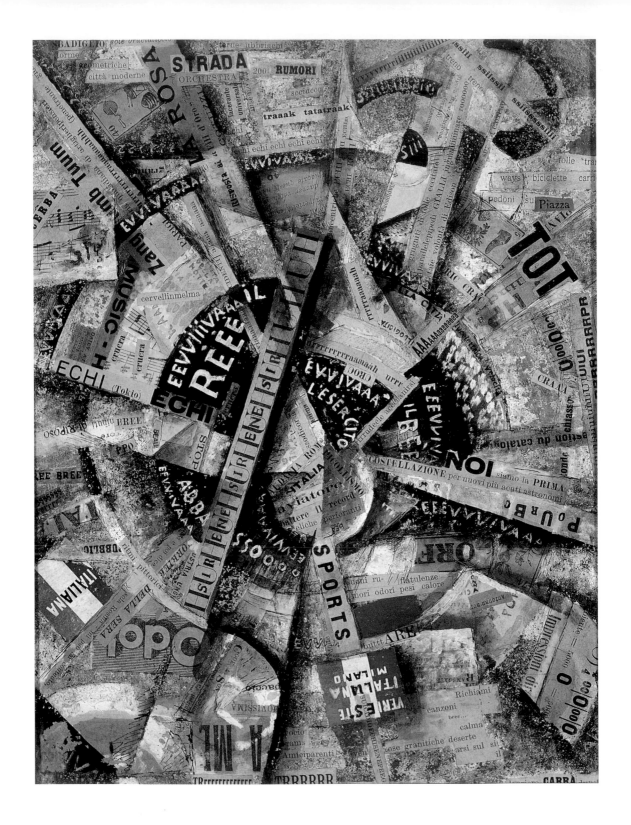

Yale University Press

New Haven and London

In

Defiance of

Painting:

Christine Poggi

Cubism,

Futurism,

and the

Invention

of

Collage

Set in Cheltenham type by Compset, Inc.
Printed in Hong Kong by Everbest Printing Co., Ltd.

Library of Congress Cataloging-in-Publication Data

Poggi, Christine, 1953–
In defiance of painting : cubism, futurism, and the invention
of collage / Christine Poggi.
p. cm.
Includes bibliographical references and index.
ISBN 0-300-05109-3
1. Collage. 2. Art, Modern—20th century. I. Title.
N6494.C6P6 1992
709′.04—dc20 91-37317 CIP

A catalogue record for this book is available from the
British Library.

The paper in this book meets the guidelines for perma-
nence and durability of the Committee on Production
Guidelines for Book Longevity of the Council on Library
Resources.

10 9 8 7 6 5 4 3 2 1

Frontispiece: Carlo Carrà, *Free-Word Painting—Patriotic
Festival,* July 1914, pasted papers, charcoal, ink, and
gouache on board. Mattioli Collection, Milan.

For Bernard

Contents

Preface

In 1930 Louis Aragon wrote a remarkable essay for an exhibition of collages at the Galerie Goemans in which he noted the critical silence surrounding the invention of collage by the Cubists and the continued use of collage techniques among contemporary artists:

> It is curious that almost no one has apparently taken note of a singular occupation, whose consequences are still not entirely understandable, and to which certain men have devoted themselves in these times in a systematic fashion that recalls more the operations of magic than those of painting. Moreover it called into question personality, talent, artistic propriety, and all sorts of other ideas that comforted the tranquil sensibilities of cretinized brains. I wish to speak of that which one calls *collage* for purposes of simplicity, even though the use of glue is only one of the characteristics of this operation, and not an essential characteristic. Without doubt this subject contains within it something that frightens the spirits, for, in all the voluminous criticism devoted to Cubism since its birth, for example, one only finds a few superficial words to note the existence of *papier collé,* as one called it at first, to designate this first apparition of collage through which the uneasiness of Braque and Picasso from 1911 was revealed. . . . To understand more clearly that which has occurred during nearly twenty years, it is necessary therefore, to study this development historically, by beginnning to speak of *papier collé* as it appeared at its birth.[1]

Since Aragon wrote this passage, numerous critics and art historians have written interpretive histories of Cubism and of collage, especially during the past twenty years. In spite of the wealth of this literature and the important contribution it has made to our knowledge, there is still no book-length study of the invention of collage that seeks

to understand it in relation both to modernism and to the historical issues of the period. This book, itself something of a collage, explores the interrelationships of a number of pictorial and poetic practices—collage, *papier collé,* constructed sculpture,[2] and *parole in libertà* (free-word poetry). It represents an attempt to engage a field whose very complexity and experimental character preclude a reassuring sense of closure.

I take my title from Aragon's essay of 1930, "La peinture au défi," translated as "In defiance of painting," to capture the sense of *inquiétude* toward the norms of painting that inspired the many inventions of the Cubists and Futurists. For the most part this study concentrates on the relatively brief but highly productive period of 1912 to 1919. The year 1912 marks the invention of collage, papier collé, Picasso's constructed sculpture, and Futurist parole in libertà, a new poetic style closely related to collage. I chose 1919 as an appropriate terminus because this was the year Marinetti published his most famous collection of parole in libertà composed before and during the war, *Les mots en liberté futuristes.* Conditions after the war were significantly different and therefore seem to require a separate study.

Throughout this book, my intent has been to view the artistic practice of the Cubists and Futurists as structured, in part, by the historical dialogue that existed between these two very different groups of artists. This dialogue has often been characterized as disdain for Futurist rhetoric and concern with subject matter on the part of the Cubists, and by intense rivalry fueled by patriotism on the part of the Futurists, especially Umberto Boccioni and Carlo Carrà. Yet the historical record reveals more complex and developing forms of exchange and a constant redefinition of attitudes.

Ardengo Soffici, an artist and prominent Italian critic, frequented the Bateau Lavoir between 1903

and 1907 as well as the Lapin Agile, the Cirque Medrano, and the Closerie des Lilas. He met Picasso in 1902 or 1903 and subsequently witnessed the painting of the *Saltimbanques* and *Les Demoiselles d'Avignon.* During this time he also knew Georges Braque, Guillaume Apollinaire, Max Jacob, Juan Gris, and other members of *la bande à Picasso.* After returning to Italy in late 1907, he began to correspond with Picasso and visited him on many subsequent sojourns in Paris. On 24 August 1911 Soffici published a highly laudatory article on Picasso and Braque in *La Voce,* which Picasso wrote to say he had "read with emotion" and to ask for more copies.[3] The surviving correspondence between Picasso and Soffici, which dates from 1909, suggests that a real friendship and exchange of ideas developed between these two artists. This relationship complicated Soffici's later adherence to Futurism, rendering it somewhat ambivalent.

Gino Severini, who lived in Paris during most of the prewar period, was also a close friend of Picasso, Braque, and Apollinaire, seeing them almost daily during the crucial periods of the spring and fall of 1912. His collage practice was a direct response to Picasso's work as well as to Marinetti's innovations in poetry, filtered through his adherence to Divisionism. Like Soffici, he was equally at home in artistic and literary circles and frequently played the role of mediator between Cubists and Futurists.

Umberto Boccioni, as his letters indicate, was obsessed by feelings of competition with Picasso and Braque, whom he admired privately and frequently criticized publicly. Moreover, his interest in sculpture was aroused by work (possibly Braque's early paper sculptures,) that he saw in Paris during his visits to the French capital in February and March 1912. This led to his elaboration of a new theory of multimedia sculpture during the summer of 1912 and eventually to the execution of con-

structed works that reveal an effort to challenge and supersede Cubist practices. A similar awareness of Cubist innovations informs the works Soffici and Carrà executed early in 1914 while on a visit to Paris and just afterward. Guillaume Apollinaire's growing interest in Futurist ideas and his friendship with Soffici, Severini, Marinetti, and to a lesser extent the other Futurists led to mutual influence and an exchange of ideas beginning in the fall of 1912 and culminating in his *poèmes-conversation* and *calligrammes* of 1913 and 1914, which suggest many parallels with Marinetti's parole in libertà.

If the Cubists were not as influenced by the Futurists, there is still evidence of dialogue and in some cases of parodic response. Curiously, one of Picasso's very earliest collages, *The Letter* (fig. 3), executed in the spring of 1912, includes a real Italian stamp postmarked in Florence and probably mailed to Picasso by Soffici. Two later collages by Picasso, *Still Life "Almanacco Purgativo"* (fig. 113) and *Pipe, Glass, Newspaper, Guitar, Bottle of Vieux Marc ("Lacerba")* (D / R 701), and one by Braque, *The Violin* (fig. 114), executed in early 1914, include excerpts from the Futurist journal *Lacerba* and comment on Futurist style. It is also possible that Picasso's ironic play with pointillist dots, which emerged as a major pictorial device early in 1914, functioned in part as an answer to the presence of Carrà and Soffici in Paris at this time and to the continuing importance of Divisionism in Italian aesthetics. Interestingly, one of the earliest of Picasso's works to exhibit this use of pointillism, *Bottle, Newspaper and Instruments of Music* (D / R 622), was reproduced in *Lacerba* on 1 May 1914 and may therefore have been a subject of discussion between Picasso and Soffici.

Clearly, the work of the Futurists cannot be understood without an awareness of the French art they sought to challenge; but the Futurists also illuminate the work of the Cubists, both historically and theoretically. What they rejected and what they imitated tells us much about the issues of the period, especially about the controversy over the kind of unity a work of art should have, the extent to which materials should be transformed, the role of mechanical reproduction, whether pictorial or poetic language should be "motivated" or viewed as arbitrary and conventional, the role of politics in art, and the definition of originality. By considering the constructed and multimedia works of the Cubists and Futurists as alternative and often opposed ways of addressing these issues, their meaning emerges more clearly. Common purposes also existed—primarily in the challenge to the existing hierarchy of genres, in the use of a variety of new and modern materials, and in the exploration of the parallels between pictorial and verbal modes of expression. No other groups of artists can be said to have engaged these issues in the medium of collage in as direct and sustained a way before the war. Kasimir Malevich, Vladimir Tatlin, and other members of the Russian avant-garde responded to both Cubist and Futurist collage innovations before the war, but their further development is marked by the relative isolation of Russia from France, especially once the war began. Dada artists George Grosz and John Heartfield made collage postcards during the war, but they have not survived. Moreover, these works take on meaning less in relation to Cubism or Futurism than to the immediate experience of the war. Tristan Tzara's "collage" poetry is plainly indebted to that of Marinetti and the Futurists but is a bit late for purposes of establishing a dialogue. Similarly, the collages and poetic experiments of Kurt Schwitters and Max Ernst were made after the war and, though influenced by both Cubism and Futurism, respond to the conditions of a greatly altered world. This book therefore focuses first on the Cubists and second on the Futurists, who were the only other artists to begin making

collages and to theorize a mixed-media art as early as 1912. This is not to argue that the dialogue between Cubists and Futurists provides a sufficient context for interpreting the idea or works of either group, but that it is an illuminating means of analyzing many issues of importance.

My thinking on the subject of collage draws on recent semiological analyses derived from both structuralist and poststructuralist sources as well as historically informed methods of interpretation and close visual and textual analysis of individual works. Although these methods cannot be entirely separated in practice, they each provided a framework within which to pose significant and, at times, new questions. The study of collage and of contemporary developments in poetry seems to invite a semiological approach since Cubist and Futurist artists and poets were so obviously engaged in an analysis and subversion of established means of representation. The value of such an approach is primarily heuristic; it encourages us to question traditional interpretations and to *see* more of the formal innovations of art that by now seem familiar. Despite the emphasis given to formal and semiological problems, historical issues cannot be bracketed without considerable distortion. Attitudes toward craft, decoration, the public, the market, popular culture, nationalism, and the threat (or promise) of war cannot be understood apart from the social conditions in which they were articulated. This book, therefore, participates in what has emerged as a broad reconsideration of modernism from both a theoretical and historical point of view. For Cubism, and especially the invention of collage, has traditionally been defined as exemplary of modernism's aspiration toward anti-illusionism, purity of means, unity, and autonomy. The interpretation offered here will challenge this view, focusing instead on the ways Cubist collage undermined traditional notions of material and stylistic unity, sub-

verted (rather than affirmed) the role of the frame and of the pictorial ground, and brought the languages of high and low culture into a new relationship of exchange. Inquiétude toward the norms of oil painting and a new awareness, especially by Picasso, of the arbitrariness of pictorial conventions inspired the unparalleled freedom of invention to be seen in prewar Cubist collages and constructions. The Futurists shared the Cubists' project of questioning and subverting traditional genres and forms of expression, although paradoxically their work is in the end more determined by the Symbolist legacy they sought to negate than the work of the Cubists.

This book is divided into nine chapters. Chapter 1 provides an overview of the history of the invention of collage, papier collé, constructed sculpture, and Futurist parole in libertà. Many of the themes central to this book can be discerned in the earliest examples of work done in the new media: the Cubists' challenge to prevailing definitions of originality, their interest in the use of mechanically produced and anti-aesthetic materials, and in particular Picasso's exploration of the arbitrariness of pictorial conventions; and in contrast, the Futurists' desire to motivate their pictorial and verbal signs, their use of new and varied materials to create expressive contrasts and a sense of dynamic movement, and their use of art as a vehicle of political propaganda.

Chapter 2 focuses on Picasso's invention of the first constructed rather than modeled or carved sculpture in the fall of 1912, the famous *Guitar* (figs. 5, 42), and on the relation of this invention to his subsequent collages and papiers collés. Special attention is devoted to the intervention of African masks during this decisive moment of rupture with the classical Western tradition. African masks provided Picasso with a powerful model for an art based not on resemblance, but on an arbitrary,

structural relation between signifying elements: solid and void, straight and curved lines, transparency and opacity. In his work with collage, these oppositions would be expanded to include figure and ground, the machine-made and the hand-drawn, the visual and the tactile, and the literal and the figured (or the real and the illusory).

Picasso's contemporaries understood the constructed *Guitar*—and his subsequent collages—as a challenge to the traditional distinction between painting and sculpture. They therefore called these new works *tableau-objets,* noting that a similar "objecthood" characterized African masks and sculptures, which seemed to be autonomous entities and to exist in real space independently of the picture frame or the pedestal. Picasso's witty and subversive play with the two possible grounds for his collages and constructions, the "tableau" of classical illusion, and the "table" of the three-dimensional world, is the subject of chapter 3. This play was founded on a willingness to view representational conventions as arbitrary and unstable and to subvert any attempt on the part of the viewer to grasp the work's meaning in an unequivocal manner. An analysis of Picasso's work from this period, therefore, reveals it to be directly opposed to the contemporary interpretive framework, which sought to explain the fragmented views and curious geometrical distortions of Cubism as a mode of conceptual realism.

In chapter 4 I turn again to an examination of the contemporary critical opposition between conception and vision, but this time as it informs the collage practice of Georges Braque and Juan Gris. Both artists wished to signify a rejection of mere copying or imitating the data of vision in their works, but this rejection was manifested in different ways by each artist: Braque through the paradoxical introduction of trompe l'oeil collage

elements and Gris by pasting flat images like labels or pages from books to his paintings. Implicit in this rejection of copying was a desire to define their artistic practice as the antithesis of the manual work of the artisan or painter of signs, in favor of a more elevated view of artistic creation as a product of the imagination.

Despite this rejection of craft and of the kind of skill valued by most viewers, the Cubists did not aspire to the same kind of aesthetic purity and autonomy in their works of art as many of the Symbolists and Fauves. On the contrary, their collages reveal an attempt to undermine that autonomy by allowing elements of mass-produced culture to infiltrate the previously privileged domain of oil painting. This engagement with modernity in the form of an embrace of popular culture and its artifacts suggests an alliance with artists such as Edouard Manet and Georges Seurat. The complex and often paradoxical relation of Cubist collages to popular culture, to the market, to the museum status of their works, and to their public is analyzed in chapter 5.

Chapter 6 opens the second part of this study with an analysis of how the Futurists conceived the use of collage as an attack on tradition and the museum status of works of art. According to this view, by bringing a variety of nonaesthetic materials into their compositions the Futurists avoided the stasis of previous modes of representation and at times introduced the possibility of real movement. Paradoxically, in carrying out this attack on tradition, the Futurists relied on the aesthetic theory of their predecessors in the French and Italian avant garde, the Symbolists and Divisionists, respectively. Thus they tended to regard collage as a means of generating expressive contrasts between real and abstract elements or between the various kinds of

collage materials, much as the Divisionists had once sought heightened luminosity from the contrast between juxtaposed complementary colors or between particular lines and forms.

In chapter 7, I turn to related developments in Futurist poetry and particularly to Marinetti's invention of parole in libertà. Here too we find a strong link with the aims of nineteenth-century innovators in poetic form, especially Stéphane Mallarmé and Gustave Kahn, for whom the young Marinetti had great admiration. But Marinetti surpassed his Symbolist predecessors in the boldness of his program, which destroyed the final vestiges of traditional unity and meaning in poetry in favor of expressive speed and dynamism. Inspired by Marinetti's invention, nearly all the Futurists began to experiment with the new, "telegraphic" style of writing. By the summer of 1914, this explosion of parole in libertà, much of which appeared in the pages of *Lacerba,* had led to the creation of a new synthetic form, at once visual and poetic: the free-word picture.

Chapter 8 is an analysis of the Futurists' response to the war. Encouraged by Marinetti to "live the war pictorially,"[4] Severini, Boccioni, Carrà, and Soffici all made collages that celebrated the military victories of the French and advocated Italian intervention in the war. For a time, the conviction that all personal interests must be set aside for the cause of the patria led to a brief and final renewal of Futurist energies, one that faded again during the course of 1915. Only Giacomo Balla remained relatively unaffected by the *rappel à l'ordre* that swept through the ranks of the avant-garde during this period, claiming the allegiance (in differing ways) of Cubists and Futurists alike. Balla remained true to his vision of a "Futurist Reconstruction of the Universe,"[5] populated with colorful decorative objects, toys, and abstract constructions made of

mechanical and noise-making elements. These works reveal both a proto-Dada sense of playful destruction and a constructive sensibility that provides a glimpse of the direction in which collage techniques would be taken by the postwar generation.

The conclusion argues that the invention of collage be understood as instituting an alternative to the modernist tradition in twentieth-century art. This alternative tradition emphasizes heterogeneity rather than material or stylistic unity, and a willingness to subvert (rather than affirm) the distinctions between pictorial, sculptural, verbal, and other forms of expression. A rejection of modernism can also be seen in the Cubists' recognition of the conventionality, and therefore iterability, of pictorial signs, which seems to have led to the further recognition of a link between the signs of "high" art and those of mass culture. The many machine-made materials and artifacts that turn up in Cubist collages establish a parallel between these previously distinct cultural codes. The resulting works do not celebrate the machine or the popular commodity so much as redefine originality: no longer is it the immediate expression of a unique self, but rather the manipulation of preexisting conventions and schemas. In contrast, the goal of the Futurists was to overcome the arbitrariness of pictorial and verbal signs through onomatopoeia, the expressive deformation of typography, and heightened contrasts of materials, colors, and forms. Their collages and free-word poems do celebrate the power and speed of the machine, even while retaining a Romantic definition of originality. Despite this and other notable differences, both groups contributed to the remarkable spirit of invention that prevailed before the war and paved the way for subsequent explorations of collage and other mixed-media works.

Acknowledgments

Many institutions and individuals contributed in significant ways to the completion of this book, which began as a dissertation. A Walter Read Hovey Memorial Fund Grant, a Fulbright/Hays Fellowship for study in France, a Kress Foundation travel grant, and a Georges Lurcy Fellowship at the Whitney Humanities Center, Yale University, provided financial support during the initial phases of research and writing. The Research Foundation and the Lenkin Fund of the University of Pennsylvania contributed additional funding for the final phase of work.

I would like to thank Anne Coffin Hanson for her enthusiasm for this project and for the excellent advice and criticism she provided along the way. Robert L. Herbert also read several early drafts, and the present version owes a great deal to his astute suggestions and criticisms in both content and organization. I am also grateful to Peter Brooks and Richard Shiff for reading the text in its form as a dissertation; their insightful comments encouraged me to clarify many ideas and formulations. My colleagues at the University of Pennsylvania John McCoubrey and Leo Steinberg have also contributed to this book through many conversations about Cubism and the art of Picasso in particular.

Many other individuals discussed the ideas presented in this book with me or provided me with information and access to collections or archives, and I offer them my warmest thanks: Marie-Laure Bernadac, Laurence Berthon, Yve-Alain Bois, Benjamin H. D. Buchloh, Celeste Brusati, Angelo Calmarini, Pepe Karmel, Massimo Carrà, Ester Coen, Paolo Colombo, Pierre Daix, Edward F. Fry, Jürgen Glaesemer, Ron Johnson, Lewis Kachur, Quentin

Laurens, Brigitte Leal, Patricia Leighten, Giovanni Lista, Lydia Malbin, Luce Marinetti Barbi, Marianne Martin, Isabelle Monod-Fontaine, Michelle Richet, Mark Rosenthal, William Rubin, Angelica Rudenstine, Luigi Sansoni, Hélène Seckel, Kim Sichel, Andreas Speiser, and Richard Zeisler. I am grateful to Marisa Poggi for her assistance with the Italian translations and to Aline M. Elliot and Jean-Baptiste Mounier for their assistance with the French translations. Without their help, some nuance and clarity would no doubt have been lost. Special thanks are due Stacy Garfinkel, my research assistant, and Stephanie Poggi, who helped gather and organize the illustrations. I am also indebted to my graduate students at the University of Pennsylvania, especially those who took my seminars on Cubism and on Collage, Montage, and Assemblage in Twentieth-Century Art.

At Yale University Press I would like to thank Judy Metro, my editor, for her interest in this book and many contributions to its publication.

Finally, I am especially grateful to Bernard M. Elliot for participating in every stage of this project, from the moment of its inception to its present realization.

"We must have been crazy,

or cowards, to abandon this!

We had such magnificent means.

Look how beautiful this is—

not because I did it, naturally—

and we had these means yet

I turned back to oil paint

and you to marble.

It's insane!"

Picasso to Henri Laurens,

8 July 1948, on seeing one

of his collages of 1914

(cited in Kahnweiler,

"Entretiens avec Picasso,"

1956)

Chapter 1

The Invention of Collage,

Papier Collé,

Constructed Sculpture,

and

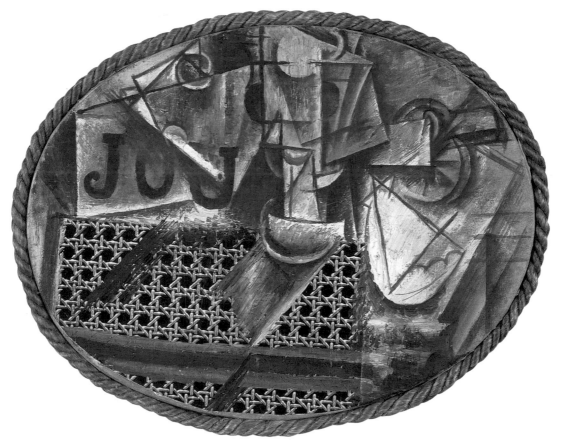

1. Pablo Picasso, *Still Life with Chair-Caning,* spring 1912, oil and oilcloth on canvas, with rope frame. Musée Picasso, Paris. Photo: Giraudon/Art Resource, New York.

Free-Word Poetry

In the spring of 1912, Picasso pasted a piece of oil-cloth printed with a trompe l'oeil chair-caning pattern to the surface of a small, oval canvas representing a café still life (fig. 1).[1] This work, which he framed with a coarse rope, has acquired legendary status in the history of art as the first deliberately executed collage—the first work of fine art, that is, in which materials appropriated from everyday life, relatively untransformed by the artist, intrude upon the traditionally privileged domain of painting. The use of these materials, which retain their former identity within the new pictorial context, challenged some of the most fundamental assumptions about the nature of painting inherited by Western artists from the time of the Renaissance. The invention of collage put into question prevailing notions of how and what works of art represent, of what unifies a work of art, of what materials artists may use; it also opened to debate the more recent Romantic definition of what constitutes originality and authenticity in the work of art. If the *Still Life with Chair-Caning* remains an enigmatic and powerful work even now, more than seventy-five years after it was executed, it is because of the audacity with which it raised these questions, which continue to be of importance to artists and theorists today.

Picasso, however, did not immediately pursue the possibilities suggested by the *Still Life with Chair-Caning*. He spent most of the summer of 1912 working in the south of France in the company of Georges Braque, who at that time was developing a number of new techniques designed to emphasize the literalness of the pictorial ground. Among these were the addition of sand to give real sculptural depth and texture to the surface and the use of a house decorator's comb to simulate the appearance of wood grain. In addition, Braque was making paper sculptures, which unfortunately have not survived. There is some evidence that Braque had been experimenting with paper sculpture as early as the summer of 1911.[2] In a letter to Daniel-Henry Kahnweiler, the publisher, theoretician, and art dealer of Picasso, Braque, and Gris, from Céret in

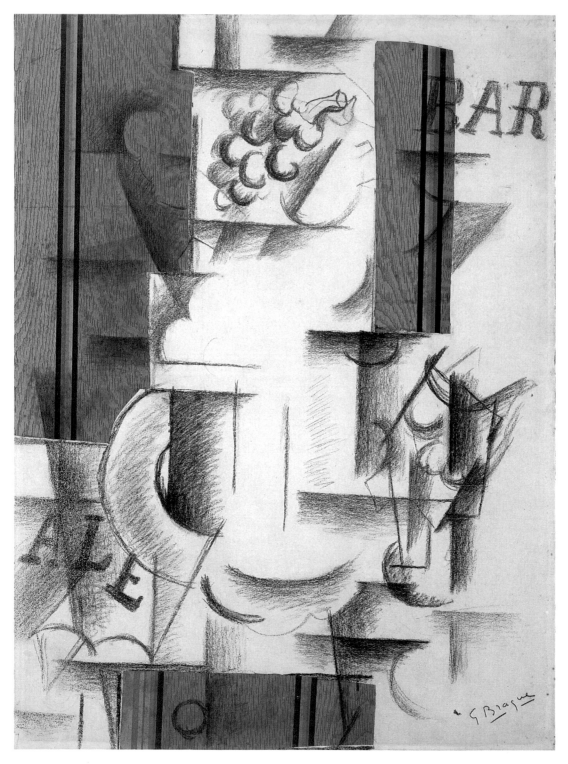

2. Georges Braque, *Fruitdish and Glass,* September 1912, pasted papers and charcoal on paper. Private collection.

September 1911, Braque wrote, "I miss the collaboration of Boischaud [Kahnweiler's assistant] in making my painted papers [*papiers peints*]."[3] Since Braque did not design wallpaper and had not yet invented papier collé, the term *papiers peints* may refer to painted paper reliefs, as William Rubin has suggested. According to Zervos, these paper sculptures were "soon abandoned, for he saw in them only an experience for enriching and organizing his painting."[4]

If Braque did not view his paper sculptures as ends in themselves, they nevertheless contributed to the invention of papier collé. The story of this discovery, as Braque related it late in life to Douglas Cooper and André Verdet, reveals much about the collaborative efforts and rivalries of Braque and Picasso during this period.[5] In early September, Braque happened to see a roll of imitation wood grain wallpaper in a shop window in Avignon. Although he immediately perceived a number of pictorial uses for this paper, which resembled the wood grain he and Picasso had been manufacturing with a house decorator's comb, Braque waited until Picasso departed for Paris on September 3 before purchasing the paper. He wanted to surprise his friend with his discovery, much as he must once have been surprised by Picasso's inventive use of the piece of oilcloth printed with imitation chair-caning. When Picasso returned from Paris to Sorgues on September 12, Braque presented him with his first papier collé, the *Fruitdish and Glass* (fig. 2). Just as Picasso had used a real stamp as a substitute for a painted stamp in *The Letter,* one of his earliest collages of spring 1912[6] (fig. 3), Braque used the wood grain wallpaper in a literal manner, to represent the texture and color of wood. In *Fruitdish and Glass,* two strips of wallpaper placed in the upper part of the papier collé denote the wood paneling (or perhaps *faux bois* wallpaper?) on the wall of the café, while a third strip placed horizontally at the lower edge signifies the café table or, more specifically, the drawer of the table. Thus Braque used the wallpaper as a substitute for the areas of wood grain patterning he had executed with a housepainter's

3. Pablo Picasso, *The Letter,* early 1912, oil and postage stamp on canvas. Location unknown. Photo: Galerie Louise Leiris, Paris.

4. Georges Braque, *The Fruitdish,* 1912, oil and sand on canvas. Private collection. Photo: Courtesy Thomas Ammann Fine Art Zurich.

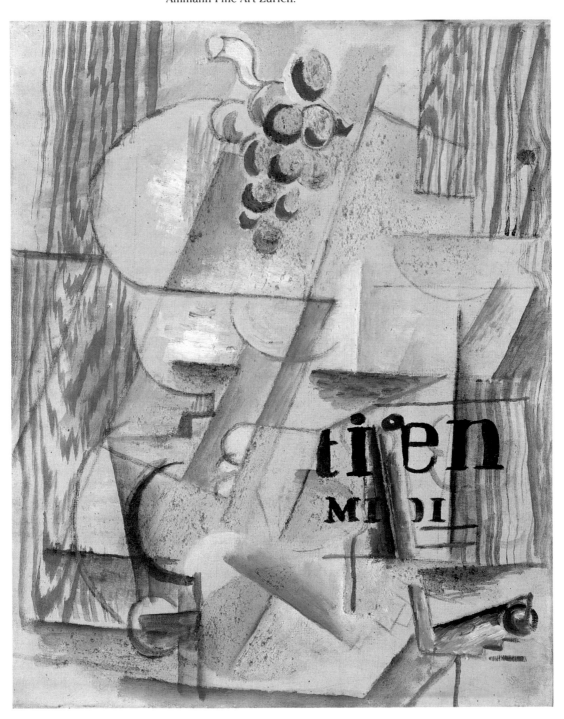

comb in an earlier painting, titled *The Fruitdish*
(fig. 4).[7] The literal use to which Picasso and
Braque put these ready-made materials in their
very earliest collages testifies to their interest in
questioning the value of trompe l'oeil, illusionistic
copying in painting.[8] Braque would continue to use
wood grain wallpaper almost exclusively in his first
series of papiers collés while Picasso and Gris be-
gan to experiment with other materials.

Shortly after seeing Braque's *Fruitdish and Glass*
and perhaps several other early papiers collés,
Picasso created his first constructed cardboard
Guitar (fig. 5) and inaugurated his first series of
collages. On 9 October, he wrote to Braque from
Paris, "My dear friend Braque, I am using your lat-
est paperistic and powdery procedures. I am in the
process of conceiving a guitar and I use a little dust
against our horrible canvas."[9] This letter, which
most likely refers to the cardboard *Guitar* and
works with sand such as *Table with Guitar* (D / R
509), is noteworthy in several respects. It reveals
that Picasso's use of paper, sand, and other sub-
stances had been stimulated by Braque's experi-
ments, but also that he viewed these unorthodox
techniques as a gesture against "our horrible can-
vas." What can Picasso have meant by this phrase?
It suggests a rejection of the canvas as a given pic-
torial ground, which by its very presence evoked
the tradition of easel painting and of illusionism.[10]
Given what we know of the context, it also suggests
that Picasso's subsequent collage practice—the use
of "paperistic and powdery procedures"—was
intended as a challenge to "our horrible canvas"
and the tradition associated with it.

By the late fall of 1912, Picasso had embarked on
the series of collages and cardboard constructions
that was to be one of his most remarkable achieve-
ments, both in terms of the creative freedom and
invention it exemplifies and in terms of the critique
of representation it posed. Inspired by a Grebo
mask (fig. 6) Picasso had purchased during one of
his *chasse aux nègres* in Avignon during the sum-
mer, Picasso's works of the fall and winter reflect
his recognition that plastic signifiers, like those of
writing, bear an arbitrary rather than substantive

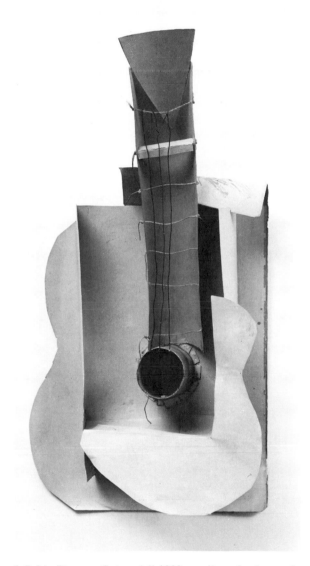

5. Pablo Picasso, *Guitar,* fall 1912, cardboard, wire, and
string. Collection, The Museum of Modern Art, New
York. Gift of the artist.

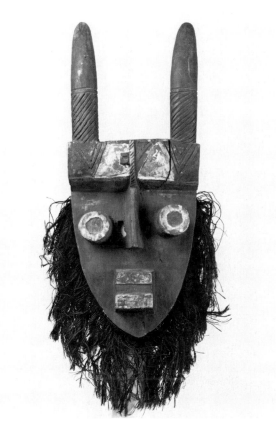

6. Grebo mask, painted wood and fiber. Musée Picasso, former Collection Pablo Picasso.

link to their signifieds. This led him to explore the traditional codes of representation in order to undermine their seeming transparency through a systematic play of formal and material oppositions.

Significantly, a whole range of new materials appears at once in these collages, including wallpaper, a variety of colored papers (sometimes hand-colored, sometimes machine printed), musical scores, newspapers, magazine illustrations, liquor labels. In these new works, however, the materials pasted or pinned to the surface no longer function in a literal or semantically stable way. Wallpaper may represent wallpaper, as in *Guitar and Wineglass* (fig. 7), but it will also be converted into a means of signifying the virtual body of a violin, as in *Violin and Musical Score* (fig. 8). Newspaper undergoes a number of transformations, giving shape to musical instruments and the wall they hang on, in *Violin* (fig. 9), for example, or to bottles and glasses, as in *Siphon, Glass, Newspaper, Violin* (fig. 10). Picasso also employed newspaper to mark the chair rail of a wall or table edge (or both) (fig. 7) and to denote the lighter plane of a figure's head in *Head of a Man* (fig. 11.) Newspaper was the most frequently used material in Picasso's early collages, just as faux bois wallpaper was Braque's most characteristic collage material.

Other differences in the early collage practice of the two artists are equally significant. Despite the unorthodox use of materials, Braque's papiers collés demonstrate that he retained a traditional respect for craft. The wallpaper, usually limited to very few pieces and at times to a single piece, was carefully cut and glued to the paper support. Pinholes in the wallpaper and visible pencil markings reveal the precision with which Braque placed these elements within his compositions. From the beginning what comes to the fore in Braque's papiers collés is the complex relationship between the faux bois paper and the elegantly drawn scaffolding in charcoal. Picasso's earliest collages, on the other hand, tended to be more crudely executed. It would be difficult to imagine the ripped paper ground of *Violin and Musical Score* (fig. 8), for example, appearing in a papier collé by Braque.

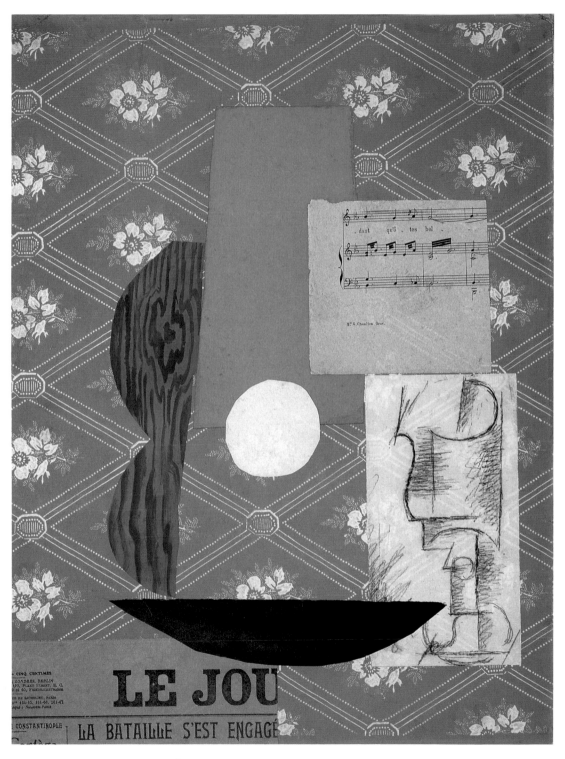

7. Pablo Picasso, *Guitar and Wineglass,* fall 1912, pasted papers, gouache, and charcoal on paper. Marion Koogler McNay Art Museum, San Antonio, Texas. Bequest of Marion Koogler McNay.

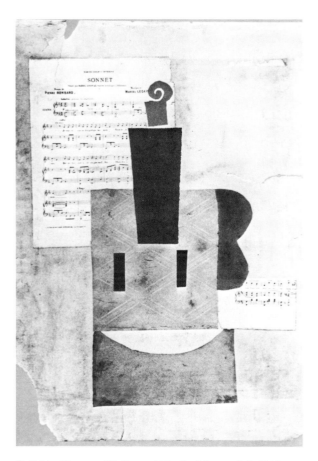

8. Pablo Picasso, *Violin and Musical Score,* fall 1912, pasted papers on the cover of a cardboard box. Private collection.

9. Pablo Picasso, *Violin,* fall 1912, pasted papers and charcoal on paper. Musée National d'Art Moderne, Paris.

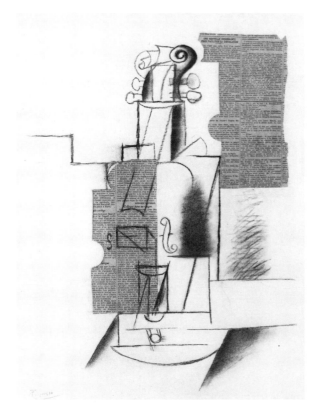

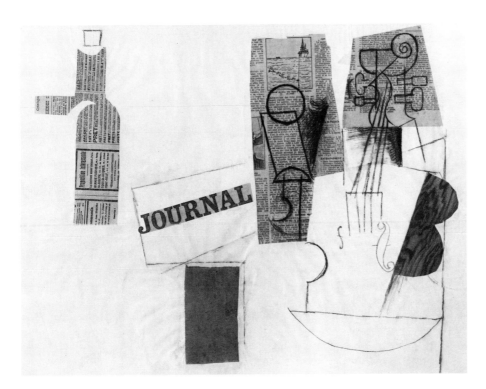

10. Pablo Picasso, *Siphon, Glass, Newspaper, Violin,* fall 1912, pasted papers and charcoal on paper. Moderna Museet, Stockholm.

11. Pablo Picasso, *Head of a Man,* fall-winter, 1912, pasted papers, ink, and charcoal on paper. Collection, The Museum of Modern Art, New York.

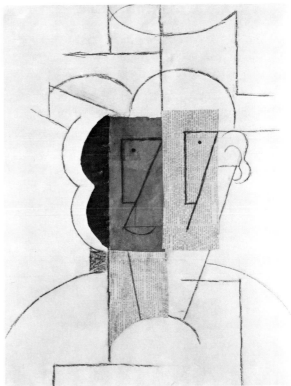

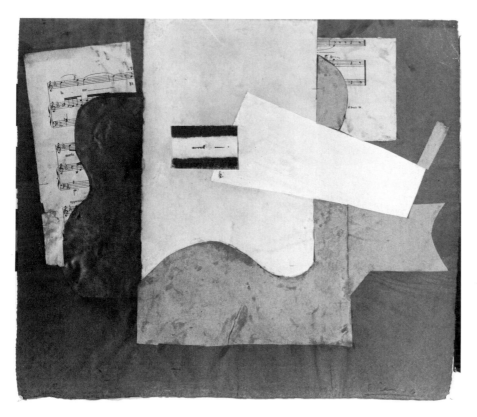

12. Pablo Picasso, *Musical Score and Guitar,* fall 1912, papers glued and pinned to cardboard. Musée National d'Art Moderne, Paris.

In some collages, such as *Musical Score and Guitar* (fig. 12), Picasso simply left the pin or pins he had used to work out his composition in place. These pins contribute to the fragility of these already highly ephemeral works and emphasize their constructed character. Picasso began to use pins on a regular basis in his collages and constructions in 1913, and in these works they often function as compositional elements in their own right. These pins may be interpreted as Picasso's humorous response to the illusionistic nails Braque painted in two works of winter 1909–10, *Violin and Palette* (fig. 31) and *Violin and Pitcher* (R 59). Rather than paint or draw an illusionistic nail as a means of emphasizing the flatness and materiality of the canvas, Picasso introduced actual pins. This renders the pictorial situation even more complex, since the pins not only assert the flatness of the paper they are stuck into, but also demonstrate that the collage elements do not literally adhere to the ground and form a unity with it. On the contrary, in works such as *Landscape of Céret* (fig. 13), the

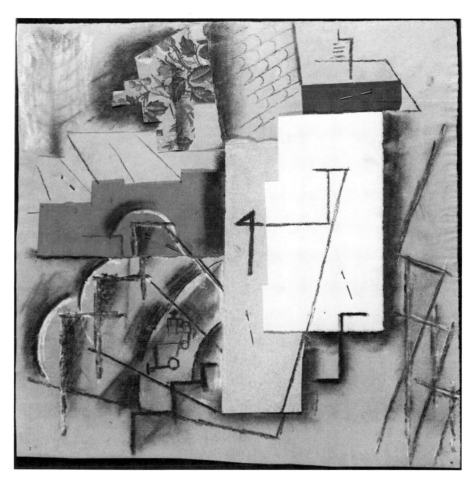

13. Pablo Picasso, *Landscape of Céret,* spring 1913,
papers glued and pinned, and charcoal on paper. Musée
Picasso, Paris. Photo R.M.N.

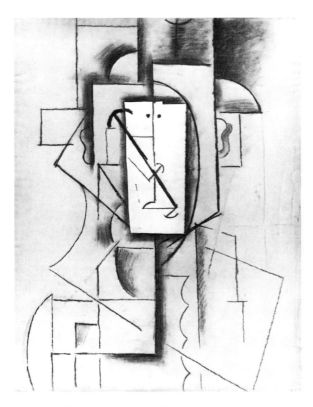

14. Pablo Picasso, *Head of a Harlequin,* spring-summer 1913, pinned paper and charcoal on paper. Musée Picasso, Paris. Photo R.M.N.

pinned elements float away slightly from the ground and thus both mask and counter its supposed flatness by establishing literal rather than illusionistic depth upon it.[11] And in at least one case, the pins take on a figurative function as well, allowing Picasso to create a literally detachable mask for a harlequin (fig. 14).

Most significant, however, is the fact that many of the collages in this first series contain very few, and at times, no hand-drawn elements.[12] Works such as *Violin and Musical Score* (fig. 8), *Musical Score and Guitar* (fig. 12), and *Violin* (fig. 15) exemplify Picasso's new compositional procedures. These collages resolutely refuse to reveal the artist's temperament through the (by-then) conventionally unique mark of the hand. For the immediacy of drawing or painting, Picasso substituted a process of selecting, cutting, and pasting preformed materials. The collages composed in this manner seem to issue from a series of decisions demonstrating formal intelligence and wit rather than the mastery of technique in the traditional sense. One might argue that a precedent for Duchamp's critique of the Romantic concept of originality, as it was conceived in the "ready-mades," lies in these collages.

For both Picasso and Braque, the invention of collage was also a means of introducing color into their works without allowing it to take on the emotional and representational function it had had in late nineteenth- and early twentieth-century avantgarde painting. Both artists rejected the use of brilliant, sensuous color in the early period of their collaboration. This has often been explained as a means of concentrating on form and structure, color being too uncontrollable, too much of a wild card. But the restriction of color in early Cubism to what Gino Severini would describe as "Corotesque"[13] grays, ochres, beiges, browns, and greens must also be seen as a self-conscious rejection of bright color with its associations of strong emotional or subjective expression. Before it could be reintroduced, color would have to be divested of these connotations as well as of the distorting effects of chiaroscuro.

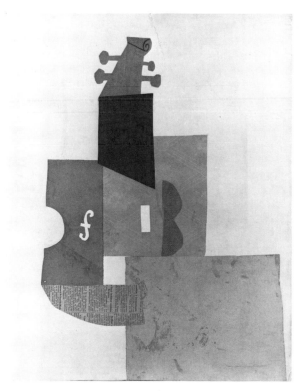

15. Pablo Picasso, *Violin,* fall 1912, pasted papers on paper. Musée Picasso, Paris. Photo R.M.N.

When bright color did make its reappearance in Picasso's works in the spring of 1912, it functioned almost as a collage element in its challenge to the stylistic and material unity of the work.[14] Picasso first attempted to treat color as a borrowed or appropriated element in the series of oval still lifes he executed in the spring of 1912. In several of these works, which immediately preceded the *Still Life with Chair-Caning,* he introduced the colors of the French flag and the slogan "Notre avenir est dans l'air" into otherwise austere, monochromatic canvases (fig. 16). The effect is highly disjunctive, not only because of the contrast in hue, but because these bright colors are applied in commercial Ripolin enamel. Flat, opaque, and somewhat glossy in appearance, the Ripolin conflicts with the sensuous texture and luminosity of oil paint. A similar effect obtains in *Landscape with Posters* of July 1912 (fig. 17), in which Ripolin provides a vivid ground for billboard advertisements, each with its own distinctive typography.[15] Color invades the field of Picasso's painting at this time much as posters and billboards had already invaded the urban environment. (One should not see in this a return to reality, since the areas of local color are already constituted precisely as preexisting signs.) Given his interest in challenging the hegemony of oil painting, it seems no accident that Picasso's *Still Life with Chair-Caning* contains a commercial artifact or that the newspaper text in one of his earliest papiers collés, *Violin* of December 1912 (fig. 18), is a dry discussion of the manufacture of artists' colors, including statistics on the international production of raw materials, trade laws, annual profits, and so forth.

Whereas Picasso's approach to color seems to have been highly ironic and subversive of the very medium of oil painting, for Braque the issue appears to have been primarily one of demonstrating the compositional independence of form and color. Divorcing color from form was a way of preserving it from the distortions of chiaroscuro and of returning to an ideal of pure, local color. In order to accomplish this, Braque believed, color should be

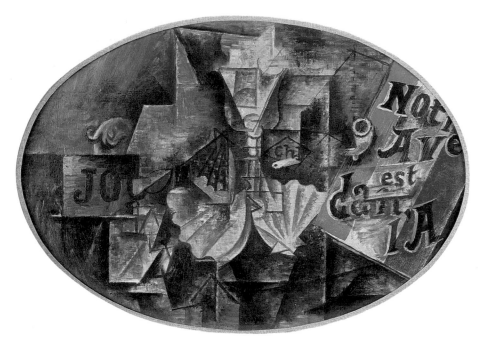

16. Pablo Picasso, *Still Life: "Notre Avenir est dans l'Air"*, spring 1912, oil and ripolin on canvas. Private Collection.

17. Pablo Picasso, *Landscape with Posters,* summer 1912, oil and ripolin on canvas. The National Museum of Art, Osaka.

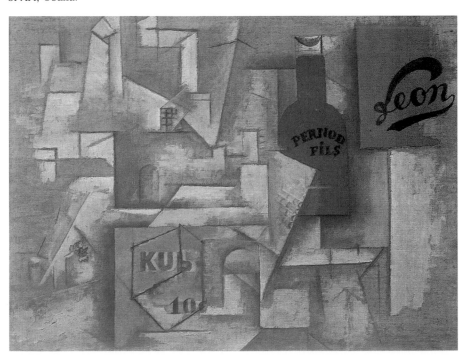

regarded as an attribute of material substance, rather than as a changeable effect of light. As such, the information it yielded about objects became associated with tactile rather than optical sensations. In an interview with Dora Vallier, Braque explained, "I saw how much color depends on material. Take an example: dip two white pieces of cloth, but of different material in the same pigment; their color will be different."[16] Given that until the spring of 1912, Cubist painting had retained the use of chiaroscuro (even while undermining its efficacy as a device of illusion), it had evidently been difficult for Braque to conceive of the use of unmodeled color without destroying compositional unity. Perhaps because Picasso was *not* concerned with local color (and its association with truth) and was willing to break the stylistic unity of analytic Cubism, it was he who first introduced color into his works. Braque, startled on seeing the colors in Picasso's *Still Life: "Notre Avenir Est Dans l'Air"* (fig. 16), is reported to have said with some ambivalence, "So we're changing our tune."[17] Shortly thereafter, however, he turned his attention to the problem of finding a means of introducing color as an independently signifying element into Cubist works. The solution was found with the invention of papier collé: "The problem of color was brought into focus with the *papiers collés*. This is a fact that criticism has never really understood. With that we arrived at cleanly dissociating color from form and at seeing its independence in relation to form, because that was the main concern: color acts simultaneously with form, but has nothing to do with it."[18]

In contrast, Picasso exploited collage materials so that color became independent not only of form, but also of any true relationship to the depicted object. There is neither a perceptual nor a conceptual use of color in collages such as *Violin and Sheet Music* (fig. 19); yellow, black, white, and blue are the colors of the pasted papers, not of the violin. These colors serve to clarify the oppositional structure of Picasso's composition, but they bear a purely arbitrary relationship to the objects depicted within that composition. This is consistent

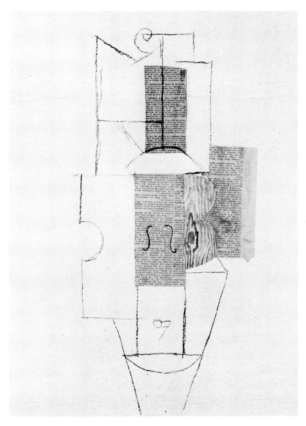

18. Pablo Picasso, *Violin,* winter 1912, pasted papers, watercolor, and charcoal. Alsdorf Foundation, Chicago.

19. Pablo Picasso, *Violin and Sheet Music,* fall 1912,
pasted papers on cardboard. Musée Picasso, Paris.
Photo R.M.N.

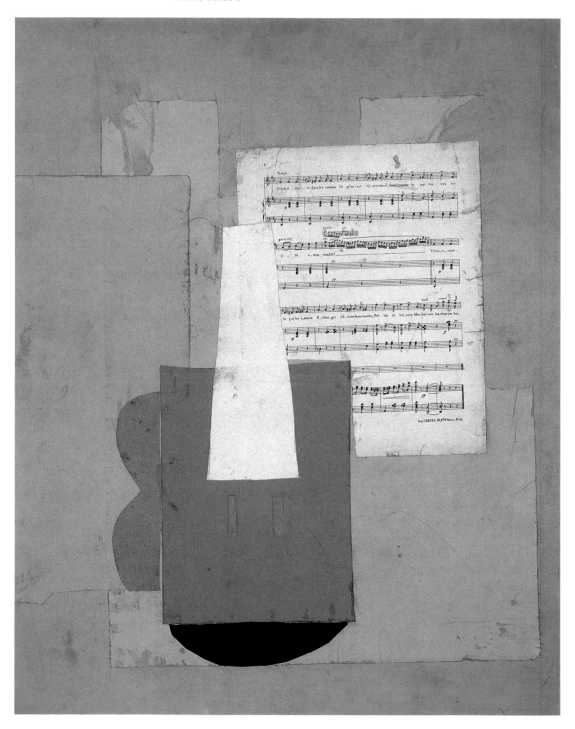

with Picasso's arbitrary and highly imaginative use of materials and with his recognition of the arbitrary and therefore mutable character of representational signs.

Juan Gris also executed his first collages in the fall of 1912. In fact, Gris's *Le Lavabo* (fig. 20) was the first collage to be exhibited publicly and to receive critical attention. The occasion was the celebrated Section d'Or exhibition, organized by Jacques Villon, his brothers, and the Puteaux circle of Cubists, and held in October 1912 at the Galerie la Boétie. Maurice Raynal, writing in the single number of a journal also titled *La Section d'Or* that accompanied the exhibition, called attention to "the curious originality of Juan Gris' imagination," which had led him to glue a piece of a mirror and part of a bottle label to his canvas.[19] Raynal explained these odd inclusions as devices intended to demonstrate the principle of anti-illusionism guiding Gris's art. Raynal's commentary on *Le Lavabo* bears citing in full, because it reads as if Raynal were quoting a statement given to him by the artist:[20]

> To show clearly that in his conception of pure painting there exist objects that are absolutely antipictorial, he has not hesitated to stick several real objects on to the canvas. Plane surfaces cannot, in fact, be painted, since they are not bodies; if one does so, one falls back into imitation or into the preoccupation with skill which is the preserve of the painters of shop signs. If I think of a bottle and wish to render it as it is, the label on it appears to me simply as an unimportant accessory which I might leave out, for it is only an image. If I feel I must show it, I could copy it exactly, but that is a useless labor; so I place the actual label on the picture—but not until I have cut it out to fit the form I have given to the bottle; this is the nicety which will determine the charm of the idea. Juan Gris has applied the same principle to the mirror he has placed on his canvas. This matter has led to much discussion, but one can say that it has in no way harmed the work, and that it denotes the curious originality of Juan Gris' imagination.[21]

According to this analysis, Gris's understanding of pictorial illusion presents, in some ways, an alternative to that of Braque. Unlike Braque, who felt that the depiction of depth on a flat surface necessarily involved undesirable optical distortion from the true form of an object and who therefore had introduced flat letters and numbers into his painting, Gris apparently believed that there was no point to copying already flat images. In his view, such copying reduced the artist to a merely skillful artisan, a maker of trompe l'oeil effects. Rather than engage in such commercially contaminated practice, Gris simply appropriated the already existing image, which in the case of *Le Lavabo* was a bottle label. By carefully cutting and fitting this label into his composition, Gris felt that his inventive artistry, not the image itself, would draw the attention of the spectator. This notion seems to have guided much of Gris's later collage practice, which can be distinguished from that of Picasso and Braque in that the collages of Gris are characterized by complex patterns of precisely cut and carefully positioned papers. Often these patterns are so intricate and involve so many overlapping layers of paper that the canvas support is completely covered.

The anti-illusionism of the mirror fragment in *Le Lavabo* presents a somewhat different case from that of the fragment of a bottle label. Whereas flat images are too easily copied, a mirror cannot be copied at all. Kahnweiler reports the following conversation between Gris and Michel Leiris in which the artist explained his inclusion of the real mirror: "'You want to know why I had to stick on a piece of mirror?' he said to Leiris. 'Well, surfaces can be re-created and volumes interpreted in a picture, but what is one to do about a mirror whose surface is always changing and which should reflect even the spectator? There is nothing else to do but stick on a real piece.'"[22] This statement, taken with the explanation provided by Raynal, points to the leading concerns of Gris's art in 1912. The artist was inspired by an intellectual desire to demonstrate the limits of pictorial illusion, the precise place where the metaphor that painting is like a mirror fails.

20. Juan Gris, *Le Lavabo,* late summer-fall 1912, oil, pasted paper, and mirror on canvas. Private collection.

And like Picasso and Braque, Gris rejected the definition that painting is above all an art of imitation in order to give primacy to the creative act of the artist.

Despite notable differences, Gris's collage practice is closer to that of Braque than to that of Picasso. Both Braque and Gris were attentive to the inherently expressive and iconic properties of the materials they used, whereas Picasso tended to use materials in ways that ran counter to their natural properties or everyday significations. Unlike Picasso, for example, Gris most often used newspaper to represent newspaper itself. His collages, like those of Braque, engage the question of the true and the false in pictorial representation in the hope of finding the true. Picasso's collages, on the other hand, establish nonhierarchical oppositions, so that no single form or means of representation emerges as superior to or truer than any other. Gris's collages tend to emphasize the creative process of restructuring or reassembling objects, either from their constituent parts or on the basis of an abstract geometrical pattern. For the most part, however, this restructuring occurs without entirely negating a sense of the prior integrity of the depicted objects. In many cases, the spectator may imaginatively reconstitute the familiar, everyday appearance of these objects by realigning the vertically displaced strips that give a fragmented appearance to Gris's early collages. This possibility is denied to the viewer of a Picasso collage, who typically confronts works in which the restructuring of an object issues from a system of pictorial oppositions rather than from a system of displacements.

A similar diversity characterizes the collage practice of the Futurists, the first group of artists to take up the challenge to traditional forms of compositional and material unity posed by the Cubists. Our knowledge of the dating and sequence of the Futurists' collage works, however, is much less secure. Because their collages and constructions so frequently responded to Cubist innovations or posited a critique of contemporary Cubist practice,

some attention will be devoted to clarifying the historical relationship between the two groups. Only Giacomo Balla, who worked in Rome throughout the period examined in this study, remained relatively unaffected by Cubist style or compositional principles.

The first Futurists to include a variety of materials in their sculptures and paintings were Umberto Boccioni and Gino Severini in the summer and fall of 1912. Boccioni had visited the studios of Picasso and Braque[23] on the occasion of the first Futurist exhibition of painting held at the Galerie Bernheim-Jeune in February and March of 1912 and soon thereafter conceived a passion for sculpture. It is possible that he saw Braque's painted paper sculptures during one of these visits, for on March 15 he wrote from Paris to a friend, "These days I am obsessed with sculpture! I believe I have seen a complete renovation of this mummified art."[24] During the spring and summer he elaborated a theory of Futurist sculpture that called for the use of a variety of modern materials in order to challenge the traditional nobility and homogeneity of marble and bronze. He eventually published his ideas in the "Technical Manifesto of Futurist Sculpture,"[25] dated 11 April 1912, although it did not appear until 30 September. Although evidently inspired by what he had seen in Paris, many of the ideas in the manifesto are new, including the suggestion that sculptures should include moving elements analogous to mechanical devices such as pistons or cogwheels. While working on the manifesto, Boccioni attempted to put his ideas into practice by executing several new sculptures.[26] His efforts culminated in an exhibition of Futurist sculpture held at the Galerie la Boétie in June of 1913. Of the exhibited works, *Fusion of a Head and a Window* (fig. 21) best exemplifies the Futurist principle that a diversity of materials could signify the fusion of an object with elements of the surrounding environment. According to Boccioni's theory, the use of various materials would not only provide a means of evoking a sense of this fusion, but would also necessarily generate a kind of inner or absolute dynamism

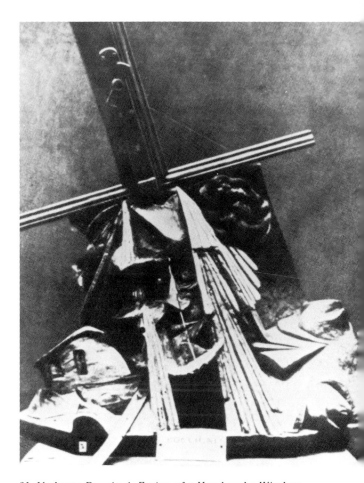

21. Umberto Boccioni, *Fusion of a Head and a Window,* summer 1912, painted plaster, glass, hair, and wood. No longer extant.

based on a collision of the different physical properties—weight, density, and mass—of the constructive elements. Boccioni's desire—one shared by the other Futurists—to develop empirical laws regarding the innate expressive properties of materials and forms was fundamental to the Futurist approach to collage. It also reveals the underlying continuity between the Futurists and their Symbolist and Divisionist predecessors, despite their claims to have abolished all connection with history and tradition. In this respect, the Futurist view of representation differed essentially from that of the Cubists. Picasso, in particular, emphasized neither the natural meanings of forms and materials nor the intuitive, spontaneous act of the artist, but a sense that representation is a matter of manipulating conventional signs. This led to an inevitable conflict in aims and attitudes, for the Futurists wished to reproduce their immediate sensations in works of art that claimed to speak in a natural, empathetically charged language.

The early collage practice of Severini bears witness to this antinomy in aesthetic outlook. Severini recorded in his autobiography that the idea of including real objects in his paintings was first suggested to him in the fall of 1912 by Apollinaire, who had observed a similar usage among the Italian Primitives.[27] Severini immediately understood this departure from the norms of easel painting as a means of heightening the expressive contrasts in his works, much as his earlier Divisionist experience had led him to base his paintings on the contrasts of complementary colors and of particular lines and forms. Even in canvases of 1910–12, realistically painted details had appeared as formal contrasts to other, highly abstracted shapes. Severini was now able to enhance this contrast by including real elements from the everyday world into his increasingly hermetic compositions. Given his Divisionist frame of reference, it is not surprising that he frequently introduced sequins into early collages such as *The Blue Dancer* (fig. 22). Here the sequins serve to capture real, flickering light,

surely an advance over the Divisionist use of separate touches of pure, complementary colors as a means of recreating the natural brilliance of light. In his later collages, Severini explored the more abstract properties of his collage elements and eventually, with the inspiration of F. T. Marinetti's invention of parole in libertà (free-word poetry) in the spring of 1912, of words and numbers as well.

In early 1914 the issue of whether an artist could interject elements of reality into works of art in lieu of painting them became a matter of debate for the Futurists, as it had been in 1912 for the Cubists. The terms of this debate were articulated, quite acrimoniously, in the pages of *Lacerba* by Giovanni Papini and Umberto Boccioni.[28] Both Papini and Boccioni used Picasso's recent constructions as a point of reference, Papini asserting that the Spaniard never used elements of reality without altering their function, and Boccioni claiming that Picasso's latest works, in fact, did contain such unaltered elements. All the Futurists, however, agreed that materials *should* be transformed by the creative act of the artist and ultimately be subsumed in the formal unity of the work. For this reason, and partly to fend off attacks by critics like Papini, collage materials tend to be much more manipulated and disguised in Futurist works than they do in the collages of Picasso or Braque. Only the highly decorative collages Gris produced in 1914 can compare to those of Boccioni, such as *Charge of the Lancers* (fig. 23), or those of Ardengo Soffici, such as *Still Life with Lacerba* (fig. 24).

The latter two examples also point to another important difference in the attitudes of the Cubists and Futurists toward political subject matter and toward the public. The Futurists frequently introduced collage elements of an unambiguously political nature into their works, often reusing their own manifestos or excerpts from the Futurist journal *Lacerba* as a means of addressing the public. By late 1914, this interest in advocating a Futurist political program led to a series of strident and visually effective collages intended to promote the cause of Italian nationalism and intervention in the

22. Gino Severini, *The Blue Dancer,* late 1912, oil and sequins on canvas. Mattioli Collection, Milan.

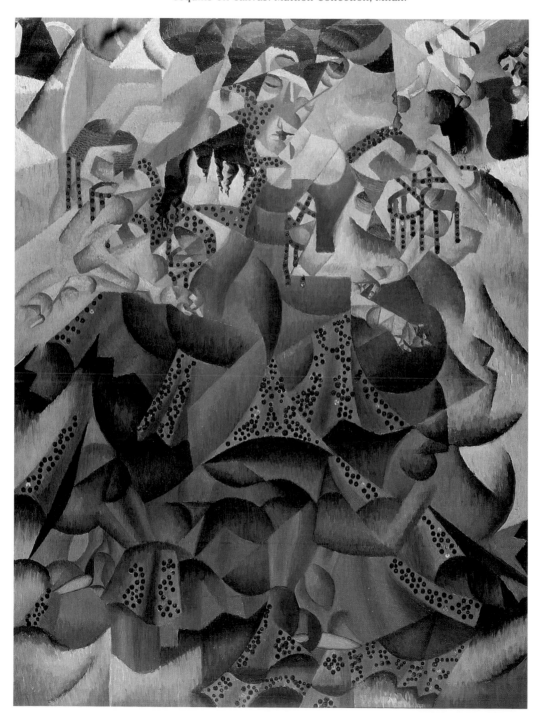

23. Umberto Boccioni, *Charge of the Lancers,* January 1915, pasted papers and tempera on pasteboard. Jucker Collection, Milan.

24. Ardengo Soffici, *Still Life with Lacerba,* late 1913 or 1914, pasted papers and gouache on paper. Private collection.

25. Carlo Carrà, *Free-Word Painting—Patriotic Festival*, July 1914, pasted papers, charcoal, ink, and gouache on board. Mattioli Collection, Milan.

war. Carlo Carrà's *Free-Word Painting—Patriotic Festival* (fig. 25) aspires to affect the viewer empathetically through the direct power of colors, forms, and dynamically distributed words. Although the Cubists also made use of newspaper clippings in their collages, they did not allude to the threat of war or to the political controversies of their day in so direct and instrumental a fashion. The great majority of Picasso's collages with newspaper clippings date from his first campaign with pasted papers in late 1912 and early 1913. As Patricia Leighten has observed, many of these clippings concern the war in the Balkans.[29] Certainly the war and its threat to world peace would have been a subject of discussion among Picasso and his friends, yet the incorporation of these texts never reached the level of overt propaganda found in Futurist collage. By the summer and fall of 1914, when the Futurists increasingly pasted into their collages news clippings on the war and on the question of the role Italy was to play in it, Picasso was immersed in an exploration of other, less inflammatory materials: wallpaper, playing cards, sand, and, of course, an ironic play with pointillist dots. No allusion to the war can be found in his collages or constructions of 1914, except perhaps by its conspicuous absence. By this time the German invasion had caused many anarchists and socialists in France to reject their pacifist views in favor of defending their country. Picasso, who was sympathetic to the anarchist cause, wrote to Soffici on 21 January 1915 to express his desire that the war end, but also that France be preserved:

My dear friend. Send us news. How are you? We are at war in France since the month of August are you at war also in Italy? I wish all this were over when I think of my friends and of myself too.

I wish you the best my dear friend my dear friend and long live France. Picasso.[30]

Despite the extreme divergence in their political views (Soffici was utterly opposed to socialism and despised the working class), the Spaniard and the Italian found themselves allied in the hope that

France would be victorious in the war. Yet Picasso never glorified war for its own sake and chose not to participate in it, while the Futurists, including Soffici, Marinetti, Carrà, and Boccioni, were among the first to enlist when Italy broke with the Triple Alliance and entered the war on the side of France. Moreover, by the fall of 1914, Picasso had all but ceased to make collages, while the Futurists experienced a renewed impetus to explore its possibilities.[31] This impetus originated in their desire to generate public enthusiasm for the interventionist cause. For Severini, Boccioni, and Carrà, this meant a retreat from the growing tendency toward abstraction in their work in favor of a concern with contemporary events and documentary facticity. Carrà's *French Officer Observing Enemy Movements* (fig. 26), published in his volume *Guerrapittura* of 1915, demonstrates this use of collage in a fairly straightforward way; here the artist simply pasted a newspaper photo of General Joffre onto an otherwise highly abstracted drawing of a marching soldier.[32] The contrast between these two modes of representation is startling, and ironically its meaning probably would have remained obscure to most contemporary viewers. Other collages in *Guerrapittura,* however, such as the well-known *The Night of January 20, 1915 I Dreamed This Picture (Joffre's Angle of Penetration on the Marne against Two German Cubes* (fig. 27), made more innovative use of documentary elements, involving an integration of the formal and representational levels of meaning. Collages such as this were intended to affect the viewer empathetically, by conflating the "natural" meaning of dynamic angles and static cubes with the historical victory of Joffre at the Marne.

Another characteristic feature of Futurist collages in 1914 and 1915 was the inclusion of letters and words, whether drawn, stenciled, or in the form of collage elements glued to the surface of the work. The inspiration for this is to be found in Marinetti's invention of a new poetic form: parole in libertà. Departing from the French tradition of free verse, Marinetti proclaimed in the "Technical Manifesto of Futurist Literature" the abolition of

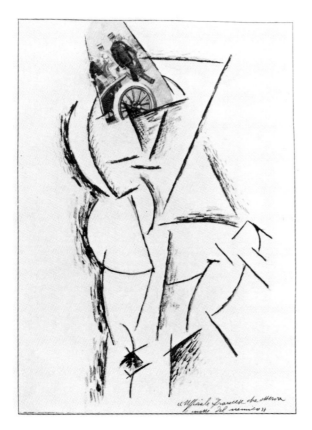

26. Carlo Carrà, *French Officer Observing Enemy Movements,* from *Guerrapittura,* 1915, pasted paper and charcoal on paper. Private collection.

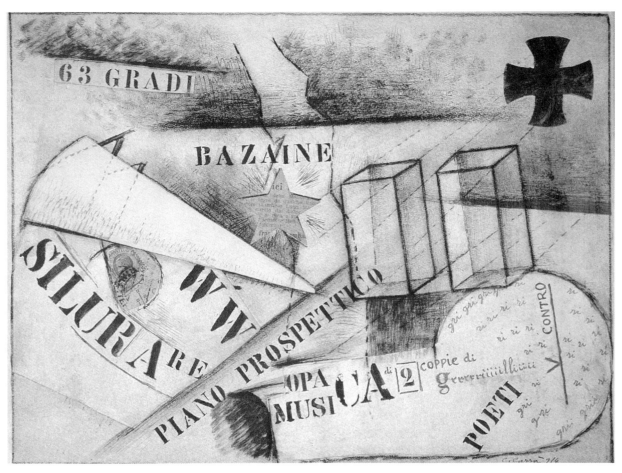

27. Carlo Carrà, *The Night of January 20, 1915 I
Dreamed this Picture* (*Joffre's Angle of Penetration on
the Marne Against Two German Cubes*), early 1915,
pasted papers, charcoal, ink, and pencil on paper.
Private collection.

syntax, the exclusive use of infinitive verbs, the suppression of superfluous conjunctions and other modifiers that slow the pace of language, and finally, the discovery of unpredictable analogies between highly disparate objects. These were to be signaled by the adoption of mathematical symbols, so that Marinetti's early parole in libertà often resembled complex, lengthy equations or scientific charts.

Only in 1914 and 1915, however, did Marinetti and the other Futurists begin to explore more fully the possibilities implied by the freedom to scatter words dynamically about the page, to stretch and deform verbal elements through the use of innovative typography and free orthography, and to appropriate and redistribute existing texts to create visually expressive patterns. In many ways the invention of parole in libertà is the equivalent in poetry to the invention of collage in the visual arts. Both techniques called for a willingness to dispense with preconceived unities based on logical transitions or relations between elements. And in both collage and parole in libertà, abrupt juxtapositions of images and words torn from their familiar contexts were intended to give rise to unexpected, new meanings. In composing parole in libertà such as *Zang Tumb Tumb* of 1914, Marinetti actually cut up and pasted together the mockups of individual sections, so that his creative practice literally came to resemble that of collage. Later works such as "A Tumultuous Assembly: Numerical Sensibility" (fig. 28), published in *Les mots en liberté futuristes* in 1919, expanded the principle of collage that lay behind the earlier parole in libertà. Many of these works, including "A Tumultuous Assembly," are best described as *tavole parolibere* (free-word pictures), in that a simultaneous viewing of the whole takes precedence over reading. By mid-1914 nearly all of the Futurists had begun to experiment with parole in libertà or tavole parolibere, and they often included words or verbal collage elements in their pictorial compositions as well, so that the distinction between poetry and the visual arts became more and more difficult to maintain.

In this attack on the seemingly arbitrary separation of genres, the collage practice of the Futurists resembles that of the Cubists. By 1912, both groups had found that working *between* existing genres, or synthesizing the possibilities of various media, could be a means of creating exciting new works that defied traditional categorization. The brief period of experimentation and invention that ensued remains unparalleled in the history of twentieth-century art. The privileged medium of oil painting was challenged by collage and papier collé, while pictorial and sculptural techniques and modes of presentation converged in the creation of constructed sculpture. Writing entered the field of Cubist painting, in part as a means of calling attention to the conventional and arbitrary character of pictorial codes. Splintered and loosened from a verbal context, the words and letters in Cubist paintings and collages exemplify the same multivalence as the fragmentary pictorial forms, and in the variety of their typography take on a visual character in their own right. In Futurist parole in libertà and tavole parolibere a related but inverse development occurs. The semantic function of words is charged with a new visual presence so that words vie with images to become vehicles of iconic or seemingly motivated expression. In both Cubist and Futurist works, then, poetry and painting establish new alliances, although these are governed by opposing principles.

The advent of the war eventually brought an end to the exhilarating spirit of invention that prevailed

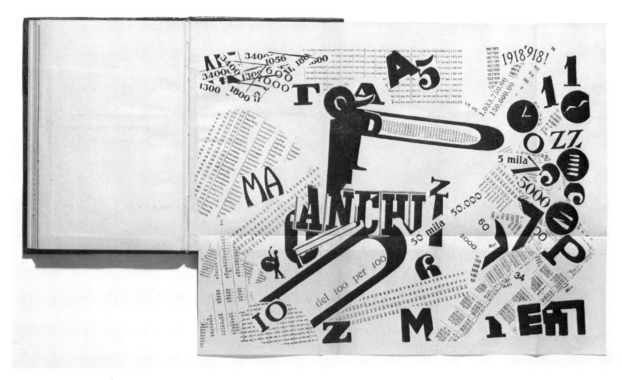

28. F. T. Marinetti, "A Tumultuous Assembly (Numerical Sensibility)," from *Les mots en liberté futuristes,* 1919.

in Cubist and Futurist circles. In part this was due to the dispersion of artists and poets, many of whom were mobilized and suffered injuries or death. In the absence of the collaboration and rivalry of fellow artists, poets, and supporters innovation became difficult. As Picasso once remarked to Kahnweiler in recalling the achievement of Cubism, "But one cannot do it alone, one must be with others. . . . It requires teamwork."[33] Moreover, in the face of a climate of intense patriotism expressed as respect for tradition, clarity, and order, the challenging of conventions seemed almost treasonous. Nonetheless, the changes wrought by the invention of collage, papier collé, constructed sculpture, and free-word poetry had already profoundly altered the artistic landscape and would soon resurface in Dada, Russian Constructivism, and Surrealism. Ultimately, the *rappel à l'ordre* could not efface the prewar legacy.

Picasso's

Earliest

Constructions

and Collages:

The Arbitrariness

of

Representational

Signs

According to Picasso's recollections, his first constructed *Guitar* (fig. 5) preceded his first collages and papiers collés by several months.[1] A more precise date may be established on the basis of the letter, cited in chapter 1, which Picasso wrote to Braque on 9 October 1912: "My dear friend Braque, I am using your latest paperistic and powdery procedures. I am in the process of conceiving a guitar and I use a little dust against our horrible canvas."[2] From datable newspaper clippings we know that Picasso's first papiers collés were executed no earlier than November, with the possible exception of *Guitar and Sheet Music* (D / R 506). Since Picasso remembered executing the *Guitar* well before the papiers collés, it seems likely that the "paperistic procedures" mentioned in his letter do indeed refer to this work.[3] Previously, the *Guitar* had been situated early in 1912, so that it preceded the *Still Life with Chair-Caning* and was isolated from the structurally similar works of the fall of 1912. As both Yve-Alain Bois and William Rubin observed, however, the new chronology means that the constructions did not develop from collage techniques, as Clement Greenberg argued in his influential article of 1958 "The Pasted-Paper Revolution":[4] "It was as though, in that instant, he [Picasso] had felt the flatness of collage as too constricting and had suddenly tried to escape all the way back—or forward—to literal three-dimensionality. This he did by using utterly literal means to carry the forward push of the collage (and of Cubism in general) literally into the literal space in front of the picture plane."[5] Greenberg viewed the invention of constructed, open-work sculptures as an extension and literalization of the anti-illusionistic, though still pictorial, conventions of collage, whereas the opposite had occurred; the collages and papiers

collés of Picasso and Braque grew out of insights acquired in making constructed sculpture. Moreover, as Bois has asserted, Greenberg's interpretation denies the "inaugural character of the 1912 *Guitar,* its role as the point of departure for synthetic cubism."[6] For Bois, the revolutionary role played by the *Guitar* lies in its full exploration of the arbitrariness of signs—an exploration that issued directly from Picasso's recognition of this principle in the Grebo mask he had acquired that August in Avignon.

The following interpretation, although it agrees with Bois on the date of the *Guitar* and on its "inaugural character" with respect to synthetic Cubism, will give somewhat greater emphasis to the continuity in Picasso's developing formal logic. Whereas Bois describes Picasso's encounter with the Grebo mask as an "epiphany" that led him to understand the arbitrary, relational, and therefore nonsubstantial nature of plastic signs, I will argue that to a large extent this principle can be discerned in Picasso's work from the summer of 1910 on.[7] Certainly it is at the basis of the *Still Life with Chair-Caning,* with its play on the relational value of horizontal and vertical fields as well as of literal and figured elements.[8] What is more, Picasso's interest in the use of heterogeneous and specifically mass-cultural materials, also evident in the *Still Life with Chair-Caning* (fig. 1), should be integrated more fully into an account of the artist's investigation into the nature of the sign.

Thus, in spite of their radical character, the innovations of the fall of 1912 were not unprecedented; rather they represent the culmination of earlier formal and thematic explorations by Picasso and Braque.[9] The revelation of the Grebo mask was prepared by Picasso's prior allegorical approach to style, which implied that style is a kind of language

rather than the necessary or transparent expression of a temperament. The facility with which Picasso was able to master and indeed consume styles no doubt contributed to his realization that style can be a kind of mask, to be worn at will. Once style was dissociated from an original author, there was no reason to observe the law of unity. Picasso's early work exhibits a remarkable freedom in this regard, allowing heterogeneous styles to coexist within the same canvas. Leo Steinberg has pointed out that *At the Lapin Agile* of 1904–05 comprises three distinct styles: Manet for the guitarist, Toulouse-Lautrec for the woman in the center, and Picasso's own Blue Period for the self-portrait as harlequin.[10] Within this context, even his own manner becomes a convention from which the artist may quote. Picasso deployed this heterogeneity of style as a means of conferring meaning through citation and formal contrast. (*At the Lapin Agile* suggests that Picasso's own work takes its place within the historical tradition of Manet and Toulouse-Lautrec.) In his *Portrait of Gertrude Stein,* the imposition of an Iberian-inspired mask functions to sever the relationship of resemblance and psychological expression, giving Stein's visage remarkable intensity but negating a sense of inwardness. Other prominent examples of stylistic multiplicity include *Les Demoiselles d'Avignon* of 1907[11] and *Bread and Fruit Dish on a Table* of winter 1908–09, in which the manners of Henri Rousseau and Cézanne oppose each other.[12] Style, in these works and others, is treated as a set of conventions to be learned and quoted, even deliberately misquoted or satirized. By the time of the first collage, *Still Life with Chair-Caning,* heterogeneity and the formal oppositions it engenders were already a well-established device in Picasso's oeuvre.

Picasso's technique of appropriation and recontextualization can be described as a form of allegory, a mode of speaking as if with two or more voices. In the place of a perfect, transparent unity of form and content, we find the evident manipulation of codes and a preference for multiple meanings and fragments. As Walter Benjamin has observed, fragments and ruins are archetypal emblems of allegory, because in them the loss or decay of prior meanings is rendered visible as both a natural and historical process.[13] This process of depletion allows fragments and other borrowed materials to sustain the superposition of new second-order meanings within a new context. Yet the confiscated elements—styles, objects, or materials—retain something of their earlier signification, so that the unity of the sign is fractured from within. The distance that opens between old and new meanings is also to be seen in the distance between the artist and his manipulation of codes, none of which belong to him alone. Picasso's irony and humor are aspects of his recognition of this distance and of the freedom it granted him.

If style could be viewed as a set of conventions to be borrowed, fragmented, and displaced, so too could the traditional techniques of illusion: perspective and chiaroscuro. Paintings such as *The Factory at Horta de Ebro* (D / R 279) and *The Reservoir, Horta de Ebro* (D / R 280), both from the summer of 1909, retain the language of illusion but render it enigmatic and largely inoperative. In these works, perspective orthogonals converge in a number of contradictory directions, so that the mechanism of linear recession is rendered visible. Similarly, chiaroscuro is divorced from its traditional function of modeling; fragmented bits of light and dark are dispersed throughout these canvases without regard for a consistent source of illumination. These apparently arbitrary reversals, fragmentations, and displacements create a striking effect of *ostranenie,* or estrangement,[14] which allows the devices of illusion to be freshly perceived and analyzed as conventions rather than accepted as transparent signifiers of the external world.

A similar effect was achieved when Picasso translated the pictorial codes of analytic Cubism to the medium of sculpture during late 1909. In *Woman with Pears (Fernande)* (fig. 29), of summer 1909, Picasso attempted to integrate the flatness of the picture surface with the depiction of volumes by articulating three-dimensional organic form into

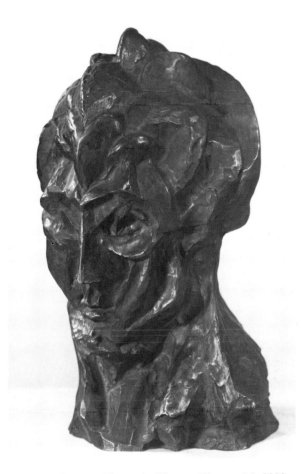

29. Pablo Picasso, *Woman with Pears (Fernande)*, summer 1909, oil on canvas. The Florene May Schoenborn and Samuel A. Marx Collection, New York.

30. Pablo Picasso, *Head of a Woman (Fernande)*, 1909, bronze. The Alfred Stieglitz Collection. Photo © The Art Institute of Chicago.

a series of angled planes defined by arrises and by alternating light and dark zones. As a result of this procedure, the forehead became analogous to the pleated folds of an open accordion. This solution to a peculiarly pictorial problem was then transferred to the three-dimensional bronze *Head of a Woman* (fig. 30) of 1909–10, where it lost its original meaning and became even more "strange" and obviously a product of convention.[15]

Although potentially disruptive, the radical discontinuities created by Picasso's manipulation of chiaroscuro and perspective were contained by the imposition of new forms of unity: emphasis on the integration of figure and ground, the use of a limited vocabulary of forms, a rhythmic distribution of light and dark across the surface, and the restriction of color to a narrow range of gray, brown, beige, and green. But the impulse to challenge this unity and redefine it was never far from his mind— or from Braque's. Thus Braque's illusionistically painted nail in *Violin and Palette* (fig. 31) and in *Violin and Pitcher* (R 59), both of winter 1909–10, the stenciled lettering and tassels in *Le Portugais* of 1911 (fig. 32), and the faux bois patterning in *Homage à J. S. Bach* of spring 1912 (R 122) serve to break the stylistic unity of the paintings: for as iconic signs, these elements provided a contrast to the more abstract, fragmented style of analytic Cubism. These references to other pictorial vocabularies—trompe l'oeil painting and the techniques of house decorators—also functioned to direct attention to the artifices of illusion, the ways in which it must be staged and framed. Picasso's use of a rope frame and a piece of oilcloth printed with trompe l'oeil chair-caning in his first collage emerged directly from this play with different and often conflicting modes of pictorial representation.

In the *Still Life with Chair-Caning* we see for the first time the principle of stylistic heterogeneity extended to materials.[16] It seems likely that the idea of combining different materials in making a work of art was due in large measure to the example of African objects. The African masks in the Trocadéro, including a Grebo mask which Picasso must have known (fig. 33), contain various fibers—

31. Georges Braque, *Violin and Palette,* winter 1909, oil on canvas. Solomon R. Guggenheim Museum, New York. Photo: Robert E. Mates © 1991.

32. Georges Braque, *The Portuguese,* 1911, oil on
canvas. Öffentliche Kunstammlung, Kunstmuseum
Basel.

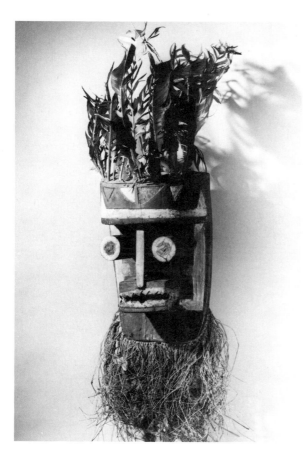

33. Grebo mask, painted wood, feathers, and fiber. Collection, Musée de l'Homme, Paris.

straw and raffia—used to create ornamental head-dresses and beards. A similar use of natural fiber appears in a Fang mask owned by Braque. Yet unlike the rafia or straw in these masks, the rope in Picasso's first collage is a machine-made product, and its appearance there speaks of the displacement of traditional crafts by modern methods of mass production. Interestingly, the chair-caning pattern printed on the oilcloth also reflects the widespread substitution of mechanically produced synthetic materials for handcrafted artifacts at the turn of the century. And in this collage a new twist in the critique of illusion can also be noted: the most illusionistic part of this work is the one which the artist did not make but merely appropriated from the existing culture, much as a primitive *bricoleur* might have done in seeking an expedient solution to a tedious task.[17] This refusal to do the work of imitation is revealing: it demonstrates the devaluation of manual skill, in the popular sense, in the face of the rising tide of mechanical methods of reproduction, and it ironically calls attention to the fact that the most illusionistically real images may be those which are the products of this facile reproduction.

The summer following the invention of collage was a period of exceptional creativity, about which at present not enough is known. Picasso spent most of the spring and summer first at Céret in the company of his new mistress, Eva (Marcelle Humbert), and then in Sorgues, near Avignon, where he and Eva were joined by Braque and his wife in late July or early August. One of the most interesting experiments of this summer was the attempt to incorporate true relief and, in at least one case, an actual object onto the canvas surface, in the only collage Picasso seems to have executed during the summer of 1912, the canvas titled *Guitar: "J'aime Eva"* (fig. 34). This unusual work may have been partly inspired by a portrait by Henri Rousseau, which Picasso surely knew since it belonged to his friend Serge Ferat. The painting, titled *Myself, Portrait Landscape* of 1890 (fig. 35), portrays Rousseau in the traditional costume of an *artiste-peintre*, as he liked to call himself, complete

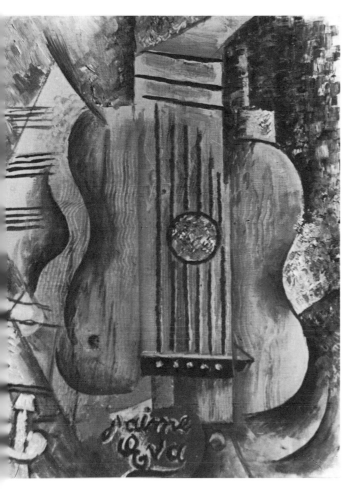

34. Pablo Picasso, *Guitar: "J'aime Eva,"* summer 1912, oil and gingerbread on canvas, photograph of original state. Photo: Galerie Louise Leiris, Paris.

with artist's beret, palette, and brush. Rousseau wrote the names of his two (then-deceased) wives, "Clèmence et Joséphine," upside-down on the palette in a naive but moving tribute to his beloved muses. Picasso may have had this portrait in mind when he wrote to Kahnweiler on 12 June 1912, "Marcelle is very sweet and I love her very much and I will write it on my pictures."[18] The work which seems to correspond to this statement is *Guitar: "J'aime Eva"*. In its original form, which has been preserved only in a photograph (fig. 34), Picasso wrote the words "J'aime Eva" in *faux naif,* childlike handwriting on a heart-shaped piece of gingerbread and glued it to the canvas.[19] Yet where Rousseau inscribed the names of his wives on his palette, the symbol of his art, Picasso made his declaration in a manner that mimicked a popular format and graffitilike style.[20] Within its new pictorial context, the gingerbread was transformed into a sign, referring to the language of popular culture as well as to the work of Rousseau. The results of this experiment, however, seem to have been deliberately ephemeral, and Picasso did not again incorporate three-dimensional objects into Cubist works of art until early 1913.

According to Kahnweiler, in 1909 Picasso had attempted to replace chiaroscuro with actual plaster relief in a lost work called *The Piano*.[21] His objective, Kahnweiler remembered, was to give this work literal rather than illusionistic shadows.[22] During the summer in Sorgues, he and Braque experimented with other means of creating literally projecting surfaces. Here Braque seems to have taken the initiative; by August he was mixing sand and other rough substances with his paint, and Picasso soon adopted these techniques as well. Braque's first papiers collés of early September, to which he affixed strips of faux bois paper along with sand, emerged from this effort to give his works a greater sense of literal physicality.

During this period of searching for alternatives to the Western illusionistic tradition, African art proved to be of singular interest to both artists. They visited Marseilles in early August and, according to Braque, "bought up all the African objects."[23]

35. Henri Rousseau, *Myself, Portrait-Landscape,* 1890,
oil on canvas. National Gallery, Prague.

Picasso, in a letter to Kahnweiler dated 11 August, stated that he had bought a "very fine" mask (probably one of the two Grebo masks he owned) and two sculptures.[24] A sketch from the Sorgues sketchbook titled *Souvenir de Marseille* (fig. 36), dated 9 August 1912, records this visit. The sketch itself exemplifies Picasso's current understanding of the compositional structure of African art: each object was drawn from a particular conceptual point of view without respect for relative scale and was distributed across the pictorial field in a nonhierarchical manner. Picasso rendered figures and objects alike in a schematic, pictographic style that translated volume and depth into a series of ambiguously related planes and profiles. Yet a full realization of the structural implications of the Grebo mask is not yet apparent.

The first evidence of Picasso's response to the Grebo mask appears in several drawings in the Sorgues sketchbook that follow (with only one intervening page) *Souvenir de Marseille*.[25] Not surprisingly, this response initially took the form of drawings for three-dimensional constructions (figs. 37–40). Although no works that might correspond to these drawings survive, the clarity with which the forms were mapped out suggests that Picasso regarded them as working plans.[26] Braque, at this time, was already engaged in making paper constructions, as we know from a letter he wrote to Kahnweiler on 24 August: "I am working well and am profiting from my stay in the country to do things that one can't do in Paris, among other things, sculpture in paper. This has given me a great deal of satisfaction."[27] Picasso, as his sketchbook suggests, was also thinking of things less easily done in Paris. Unlike *Souvenir de Marseille*, these highly schematic drawings convey a new sense of three-dimensionality, at times using already discredited methods such as perspective and chiaroscuro. What is most remarkable, however, is the exploration of the possible formal equivalence of a mask or head and a musical instrument, in this case a violin. Here the analogy that would inspire the constructed *Guitar* first comes into view. For not only was the projecting sound hole of the *Gui-*

36. Pablo Picasso, *Souvenir de Marseille*, August 1912, page from the first Sorgues sketchbook. Musée Picasso, Paris. Photo R.M.N.

37. Pablo Picasso, *Man with a Violin,* August 1912, page from the first Sorgues sketchbook. Musée Picasso, Paris. Photo R.M.N.

38. Pablo Picasso, *Man with a Violin,* August 1912, page from the first Sorgues sketchbook. Musée Picasso, Paris. Photo R.M.N.

39. Pablo Picasso, *Head of a Man,* August 1912, page from the first Sorgues sketchbook. Musée Picasso, Paris. Photo R.M.N.

40. Pablo Picasso, *Head of a Man,* August 1912, page from the first Sorgues sketchbook. Musée Picasso, Paris. Photo R.M.N.

tar a translation of the projecting eyes of Picasso's Grebo mask, but the slight curvature of the ground plane was retained in the ground plane of the *Guitar*. Picasso even converted the decorative triangular shapes at the top of the mask (fig. 6) into a corresponding triangular scroll in the *Guitar*. In the Sorgues drawings this analogy between a head and a musical instrument becomes the subject of formal wit. In the first two sketches of the series, both head and violin were reduced to boxlike structures, upon which Picasso placed a few schematic markings indicating the placement of projecting forms and possibly of incisions to signify the identifiable characteristics of the head and violin (figs. 37, 38). In the following two drawings, Picasso studied the features of the head more closely. Once again, he constructed these features from symmetrically configured cylinders or planes, which project from a basic boxlike structure, just as the eyes of Picasso's Grebo mask project from the plane of the head.[28] In the first of these drawings (fig. 39), the eyes and eyebrows thrust forward, while the nose is an inverted wedgelike form that collapses inward, thereby reversing natural spatial relations. Reversals such as this, which point to the relational character of signs, would eventually be realized in three dimensions in the *Guitar*. The second of these drawings (fig. 40) displays the recurring double arc, which would serve to designate both ears and the profile of a guitar (or violin) in so many of Picasso's subsequent works. The semantic loosening of this simple ideogram can already be discerned in its displacement from a natural position at the level of the eyes to a new position near the top of the head.

What of Braque during this fertile moment in Picasso's production? As we know from his letter to Kahnweiler of mid-August, he was making paper sculptures at this time. Because none of these early constructions survive, it is impossible to know what they looked like and, in particular, whether they too were inspired by African masks. Given Braque's predilection for conceiving recession in terms of overlapping planes and his interest in creating tactile surfaces, it is likely that his works in paper were designed to explore these ideas in three dimensions. Although it is evident from his letter to Kahnweiler that he enjoyed making them, he seems to have thought of his paper sculptures primarily as aids to his paintings and unfortunately took no measures to preserve them. His later assertion that his papiers collés developed from his earlier constructions may be literally true, but the sculptures themselves seem to have been conceived in relation to his paintings. Because Braque's constructions are lost, this important aspect of the collaborative enterprise of the summer remains difficult to assess.

We do know, however, that Braque made his first papiers collés in early September (figs. 2, 41) and that, according to Picasso, these works inspired him to experiment with "paperistic and powdery procedures" as well. Braque's technique of pasting strips of faux bois wallpaper to his pictorial ground allowed him to dissociate signs for the color and texture of objects from the drawn contours of those objects—a technique that has been compared to the dissociation of volume and mass in the Grebo mask and in Picasso's *Guitar*.[29] Yet Braque's disjunctive treatment of color and drawing did not derive from the example of African masks (where it is not an issue); nor is it the formal or conceptual equivalent of Picasso's severing of volume and mass. While it is true that both Braque's papiers collés and Picasso's constructions and collages depend on the principle of dissociation, so that the organic unity of the depicted ob-

41. Georges Braque, *Still Life BACH,* 1912, pasted paper
and charcoal on paper. Öffentliche Kunstsammlung,
Kunstmuseum Basel.

jects is broken into distinct and contradictory elements, they do so with different goals in mind. Braque used faux bois paper to convey the local color and texture of wood in an effort to *defeat* the distortions of chiaroscuro and perspective. It is precisely because the latter produce distortions in their rendering of three-dimensional form that they must be given separately. Picasso, in contrast, delighted in confirming the essentially *arbitrary* nature of signs, since it is this principle which allowed him to reinvent the language of representation and its syntax. This freedom of invention would be most dramatically realized in the *Guitar,* a work that would transform the history of sculpture in this century.

The African Model

To this day, Picasso's *Guitar* (fig. 5) startles with the boldness of its new conception of sculptural form. Whether carved or modeled, traditional sculpture had always been conceived as an art of three-dimensional forms in space, and these forms had been presented in terms of solid masses. Even relief sculpture, which the *Guitar* approximates more closely than free-standing sculpture, provided the viewer with a continuous surface or skin. Indeed, this surface could be considered the most crucial signifier of traditional sculpture, since it revealed the inner structural logic of the figure's weight-bearing position in space.[30] Students of sculpture in the classical tradition were required to have a clear understanding of the skeletal and muscular structure of the human body, so that the outer surface of the sculptural figure could be read as the index of its inner core, that is, as an effect causally related to this core. By the late nineteenth century, however, the coherence of surface and inner structure began to erode, and the sculptural surface came to be regarded as an expressive element in its own right. In the work of Auguste Rodin

and Medardo Rosso, for example, this surface became the indexical sign of the sculptor's unique creative act, preserving all the marks of his encounter with wax, clay, or plaster as well as the marks of the secondary process of bronze casting. Thus, although the signifying function of the surface had undergone a radical transformation, it continued to be the primary vehicle of sculptural meaning.

Conceived as an open construction of planes positioned in space rather than as an art of solid masses, Picasso's *Guitar* swept away all of the traditional significations of surface. The duality of surface and inner structure disappeared with the refusal to treat form in terms of mass. In addition, the acts of cutting, bending, and assembling planes of flat cardboard and, later, sharp-edged sheet metal (fig. 42),[31] displaced the more sensual processes of modeling, carving, and polishing. Although Picasso's *Guitar* bears all the signs of a spontaneous creative process, in comparison with the modeled sculpture of Rodin, the rough-hewn wooden sculpture of Paul Gauguin, or even Picasso's own previous sculpture in wood and bronze, here it is the work of the imagination that predominates. Unlike marble or bronze, the privileged materials of traditional sculpture, cardboard and sheet metal are not noble or durable; but neither are they "primitive" mediums like clay or wood, which can be associated with creative (godlike) fashioning from the earth itself. Sheet metal, a modern, industrial material, is resistant both to fine finish and to the marks of the sculptor's hand, and in many ways it must have seemed the very antithesis of a material suitable for sculpture. But it was precisely the inappropriateness of materials like cardboard and sheet metal and the difficulties they presented the artist that interested Picasso. In a statement recorded by Jaime Sabartés, Picasso

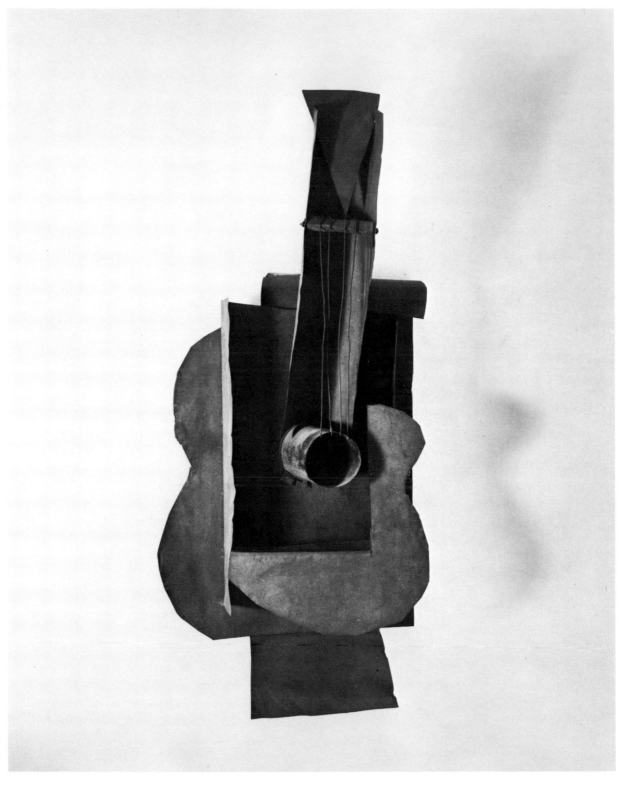

42. Pablo Picasso, *Guitar,* fall 1912–14, sheet metal and
wire. Collection, The Museum of Modern Art, New York.

recalled, "We sought to express reality with materials that we did not know how to handle and which we prized precisely because we knew that their help was not indispensable to us, and that they were neither the best nor the most adequate."[32]

As many scholars and critics have observed, the *Guitar* can be interpreted as a three-dimensional transposition of the semitransparent, interpenetrating planes that characterized Picasso's painting of 1910–11. Kahnweiler provides the most illuminating testimony on this transitional phase and its meaning for Picasso's subsequent work. In his view, the real turning point in Cubism occurred in the series of paintings Picasso executed in Cadaqués in the summer of 1910. Here, for the first time, Picasso "pierced the closed form."[33] This "decisive advance" allowed planes to flow into the ground and hence into each other, thereby denying any sense of unified, coherent mass to objects. According to Kahnweiler, the depiction of objects in space in terms of "closed" forms necessarily implied the depiction of their depth and solidity by means of chiaroscuro and perspective.[34] Picasso, who wished to avoid both of these traditional illusionistic devices, was therefore led to break through the closed "skin" of objects and to depict them in terms of fragmented, overlapping planes.[35] For Kahnweiler this meant that "Picasso's new method made it possible to 'represent' the form of objects and their position in space instead of attempting to imitate them through illusionistic means. With the representation of solid objects this could be effected by a process or representation that has a certain resemblance to geometrical drawing. This is a matter of course since the aim of both is to render the three dimensional object on a two dimensional plane."[36] By "pierc[ing] the closed form" of objects, Picasso was able to dismantle the tradi-tional boundaries between objects and their surrounding space. This, in turn, allowed him partly to fuse these objects with the ground, thereby establishing a new coherence of depth and surface. Mass itself seemed to dissolve in the flickering play of semitransparent planes that assert a position in space along one clearly modeled edge only to bleed into the ground elsewhere. In addition, as Kahnweiler implied, an organic view of form was rejected in favor of an articulated, geometrical form of representation. Unlike traditional drawing, which attempts to simulate natural appearances, geometrical drawing distinguishes itself from nature as a purely intellectual form of abstraction. It is a form of rendering in which the existence of a prior set of conventions remains evident.

The essential point, then, is that Picasso's new method allowed him to represent objects in space without recurring to traditional means of illusion. For Kahnweiler, *representation* and *imitation* were no longer synonymous in the Cubism of 1910–11. One might argue that an understanding of the conventional rather than the imitative nature of representation had informed Picasso's Cubist painting before 1910. But it was the specific nature of the critique of illusion posed by the paintings of 1910 and 1911 that allowed Picasso to conceive representational conventions as being inherently relational; for once the organic integrity of objects had been dissolved, it became possible to compose or construct objects out of discrete formal elements. These elements would then take on meaning as a result of the oppositional structure governing the whole. Thus, for example, each assertion of volume is countered by its negation, figure and ground undermine each other, bits of chiaroscuro contradict each other. Each formal element functions only in relation to its opposing term within the given pictorial context. It is not, as Kahnweiler supposed,

that "the painter no longer has to limit himself to depicting the object as it would appear from one given viewpoint, but wherever necessary for fuller comprehension, can show it from several sides, and from above and below."[37] Indeed, Picasso conceived the *Portrait of Daniel-Henry Kahnweiler,* executed during the autumn of 1910, in a strictly frontal manner (fig. 43). Form is rendered in terms of rhythmically alternating light and dark planes, which do not correspond to a consistent source of light. If one of Kahnweiler's eyes is depicted as a light plane and the other as a dark plane it is not because light falls on the sitter from a particular direction; rather, the eyes oppose each other as contrasting formal elements.[38] Picasso's aim was not to give the viewer more information about the objects or people he represented but to undermine the traditional conventions of illusion by isolating them and setting them into opposition. The New Caledonian figure and (unidentified) mask that Picasso represented to either side of Kahnweiler's head are emblematic of the important relation between Picasso's work of this period and the conventionalized forms of "primitive" art.[39]

In the late summer and fall of 1912, a similarly conventionalized treatment of form once again attracted Picasso to African masks. In *The Rise of Cubism,* Kahnweiler asserted that the use of intersecting and superimposed planes in Picasso's constructions was directly inspired by African masks from the Ivory Coast, in which the eye, nose, and mouth were rendered as distinct forms—cylinders and wedges—projecting from a planar ground.[40] In a later article titled "Negro Art and Cubism" Kahnweiler more specifically related the projecting sound hole of the *Guitar* to the similarly projecting, cylindrical eyes of a "Wobé" mask (fig. 6) in the artist's possession (now known to be a Grebo mask).[41] The artist himself, when questioned later by William Rubin, confirmed that a Grebo mask had been the source of inspiration for the constructed *Guitar*:

> Picasso noted that while noses and lips are obviously projecting facial features, he had always thought of the eye as a receding, "hollow" feature

in sculpture, especially as he treated more the "orbite"—the socket of the eye—than the eye itself; he recalled that as a young sculptor modeling in clay, he would form it by pressing in his thumb. Now the Grebo sculptor, as he pointed out, had systematically indicated both the projecting and the receding features of the face by salient forms; this he could do because he was not illustrating a face but "re-presenting" it in ideographic language—a perfect example of what Picasso found "raisonnable" in tribal art.[42]

It is not surprising that Picasso, who had always been fascinated by "primitive" or conceptual means of representing eyes, should initially have been struck by the projecting eyes of a Grebo mask. Influenced early on by Gauguin, who had in turn been influenced by Egyptian bas-reliefs, Picasso had already placed eyes seen frontally on figures depicted in profile. (A notable example occurs in the left-hand figure in *Les Demoiselles d'Avignon,* but others might be cited.) And, as discussed above, Picasso had depicted the eyes in his portrait of Kahnweiler as opposing light and dark forms. The treatment of eyes as projecting cylinders, however, must have seemed to denote the primacy of conception over sensation even more strongly. By rendering the eyes as salient objects, rather than as depressions in relation to the abstracted plane of the face,[43] the Grebo artisan had reversed the natural relationship of depth to surface. This reversal, however, retained the notion of the difference between these two planes, and within a figurative context this proved sufficient for the cylinders to be interpreted as eyes. The Grebo mask, then, demonstrated that what was essential to the legibility of the cylinders as eyes was their relational value within a given representational context, rather than any absolute value they might have as geometrical forms. Picasso based his *Guitar,* in which a projecting cylinder represents a sound hole, on this very principle of the structural equivalence of opposites within a closed formal system.

A number of art historians, including Leo Steinberg, Rosalind Krauss, and most recently Yve-Alain Bois, have compared the relational structure

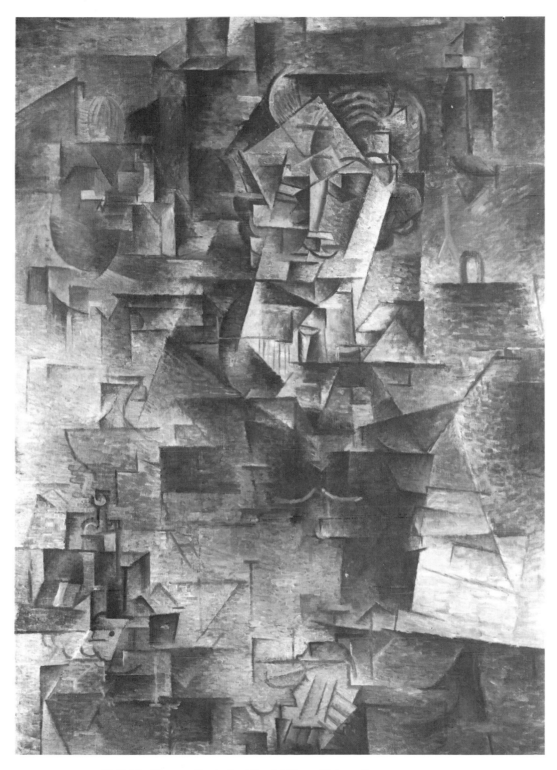

43. Pablo Picasso, *Portrait of Daniel-Henry Kahnweiler,*
fall 1910, oil on canvas. The Art Institute of Chicago.
Gift of Mrs. Gilbert W. Chapman in memory of Charles
B. Goodspeed.

of forms in Picasso's *Guitar,* as well as in his collages, to the contemporary linguistic theories of Ferdinand de Saussure.[44] Without positing that Picasso had any knowledge of Saussure's revolutionary theories, these art historians have argued that a parallel understanding of the arbitrary nature of signs informs Picasso's synthetic Cubist works, especially those executed in constructive collage techniques.[45] In this light, the critique of prior theories of representation that lies at the base of both the *Guitar* and the subsequent collages is viewed as inaugurating a revolution in the visual arts comparable to that inaugurated by Saussure in linguistics.

A brief review of Saussure's structural analysis of language will clarify what is at stake in this interpretation of Picasso's collages and constructions. Saussure's great innovation was to conceive language as a synchronic, relational system, complete and coherent at each moment of its temporal existence. In opposition to his immediate linguistic predecessors, Saussure proposed a model in which the temporality of language consisted of a series of static systems succeeding each other in time. Without denying the importance of historical change, Saussure insisted that as a total system language existed in a kind of perpetual present and that meaning emerged only as a result of this synchronicity.

By distinguishing the synchronic from the diachronic dimension of language, Saussure was able to direct attention to the universal, structural organization of language. This structure proved to be based on a self-governing system of relational values or differences, which established the possibility of meaning at every level of linguistic articulation, from the smallest phoneme to larger syntactical units. The differential nature of this system might be compared to that which governs the exchange of bills in the modern economy, in which it is the *difference* between a five- and ten-dollar bill, rather than the intrinsic value of the paper, which carries meaning. Similarly, according to Saussure, the linguistic signifier does not bear a positive, or substantive, relation to a given signified; its primary relation is to the other terms in the language system that might have been chosen in its stead. Another way of saying this is that terms have value [*valeur*] before they have meaning, and that value is established as the negation of the other possibilities of the system: "Instead of pre-existing ideas then, we find in all the foregoing examples values emanating from the system. When they are said to correspond to concepts, it is understood that the concepts are purely differential and defined not by their positive content but negatively by their relations with the other terms of the system. Their most precise characteristic is in being what the others are not."[46]

Saussure further argued that because of this differential structure, the relation of individual signifiers to their respective signifieds is purely arbitrary. This relation depends on social conventions and usage, rather than on a substantive link between words and mental concepts or images: "Everything that has been said up to this point boils down to this: in language there are only differences. Even more important: a difference generally implies positive terms between which the difference is set up: but in language there are only differences without positive terms. Whether we take the signified or the signifier, language has neither ideas nor sounds that existed before the linguistic system, but only conceptual and phonic differences that have issued from the system."[47]

Yve-Alain Bois, among others, has brought Saussure's theory of the sign to bear on Picasso's

Guitar in order to call attention to the artist's awareness of the relational value of plastic signs and of their "virtual" rather than substantive character.[48] Saussure's theories provide fruitful comparison because they enable us to articulate more clearly what Picasso understood on the level of formal possibility. Indeed, as Bois argues, a full recognition of the nonsubstantial nature of the sign is strikingly evident in the *Guitar*.

Picasso's self-consciously structural approach to representation led him to emphasize the conceptual status of the work of art. To say that these works are conceptual, however, does not imply that they are true to the essential nature of what they represent. By deploying sets of binary opposites—recessed versus projecting forms, transparent versus opaque planes, straight versus curved edges—Picasso called attention to the relational value of the formal signifiers in the *Guitar*. This pairing allowed him to treat his formal elements as empty signifiers that would be granted meaning by the context. Thus a projecting cylinder can signify the recession of a guitar's sound hole, and a delimited open space can be made to read as the equivalent of a solid, sculptural form. Whereas the value of a linguistic signifier is predicated on the absence or negation of other possible alternatives, the spatial simultaneity of the plastic arts allowed Picasso to construct his *Guitar* out of copresent opposites. This allowed the oppositional or relational value of his formal elements to become especially evident. Our ability to interpret these formal elements as meaningful antinomies depends on their prior existence as opposing artistic conventions, just as our interpretation of the projecting sound hole as a reversal depends on its difference from our prior definition of a sound hole as a recession.

If we are to accept in full the structuralist interpretation of Picasso's *Guitar,* however, some ac-count must be made of the lingering presence of resemblance (or iconicity) as a signifying principle in this and other, related works.[49] For resemblance is there to be seen: the double curve, which defines the left edge of the ground plane, for example, resembles the curved profile of a guitar. The survival of resemblance in a structurally defined work is problematic because resemblance has been seen as the means by which the signs of the visual arts are motivated. Whereas the linguistic signifier *tree* bears no natural or necessary relationship to its referent, a picture of a tree is said to be motivated by virtue of resembling that tree. Since a picture of a tree appears to carry meaning in a direct or transparent manner, it will not be subject to the system of arbitrary, differential values that characterizes linguistic signs. And indeed, Saussure limited his discussion of the arbitrariness of signs to those of language, suggesting that further study in the new field of semiology would be needed to analyze the principles at work in other representational systems. The role of resemblance in Picasso's *Guitar* can be taken as a kind of testing ground, then, for the theory that the signs of the visual arts can be produced by a differential, arbitrary structure like that of language.

In isolating the double curve at the left edge of the *Guitar,* one immediately notes that it differs markedly from the double curve at the right edge of the foreground plane. Yet both curves are sufficiently different from the projecting straight edges, which they also oppose, to read as what might be called sculptural phonemes, that is, as carriers of meaning. In order for these curves to signify the shape of a guitar's profile, absolute or intrinsic resemblance is not required, but only a relative likeness which can be deciphered as the negation of other possible forms. Moreover, these double

curves function as signifiers of a guitar's profile only because of their placement within the whole. In many of Picasso's subsequent works, the same double curve appears at the side of the head and therefore comes to represent an ear (figs. 11, 14). Thus resemblance seems to be contingent on factors similar to those that govern linguistic relations: sufficient difference from other possible forms to take on a specific significance and placement within a meaningful "syntactical" context.

Each of the discrete formal elements in the *Guitar* can be assigned a representational function. If the left-hand double curve refers to a guitar's profile, for example, the depth of the musical instrument is signified independently by the straight-edged planes that lie perpendicularly to the ground plane. Additively, these forms signify the various physical properties of a guitar, but they do not cohere in an organic whole. As a result, each element takes on a distinct, emblematic character, like the individual motifs in complex allegorical compositions. Resemblance as a means of motivating the signs of the visual arts is thereby at least partially defeated; it appears as a conventional effect of the differential system out of which the *Guitar* is visibly constructed, rather than as a principle determining the appearance and composition of the whole.

Some insight into Picasso's understanding of the conventional nature of resemblance at this time (1910–12) can be gleaned from a story recounted in the memoirs of both Fernande Olivier and Francis Carco. Olivier's eyewitness account is the more detailed and informative version:

One day Deniker[50] brought a naval officer and explorer to see Picasso. He came to the studio and he told us how once, when he'd found himself amongst a tribe who produced sculpture, he was curious to watch their reactions to a photograph, which was something they'd never seen.

He showed them a photograph of himself in uniform. One member of the tribe took it, looked at it, turned it upside-down and sideways and returned it without having made out or understood what it was. The explorer took it upon himself to teach him and explained that it was a picture of himself. The man laughed incredulously, and taking a paper and pencil began making a portrait of the officer. He drew the head, the body, the legs and the arms, as he saw them, in the traditional style of tribal figures, and he held out the picture to the officer. Having looked at it again, though, and more attentively this time, he took the drawing back in order to add the shiny buttons of the uniform, which he had forgotten to draw. The amusing part of the story is that he saw no reason to put the buttons in their proper place. Instead, he surrounded the face with buttons! He did the same thing with the stripes, putting them at the side of the arms and over the head. It is scarcely necessary to go into the conclusions which were drawn from this story. After that a lot of curious things turned up in cubist paintings.[51]

Carco's version is substantially the same, although he identifies the explorer as Max Jacob's brother and reveals something of Picasso's response. Speaking of the portrait made by the African he writes,

Resemblance, greatly neglected on this canvas in favor of volumes, immediately struck the painters, and they made the remark that the gold buttons on the tunic of Max's brother were not represented at their ordinary place, but were arranged in an aureole around his face. Astonishing discovery! The dissociation of objects was discovered, admitted, acquired, and this must have inspired Picasso in his very first researches,

because he decreed a short while later: "If you paint a portrait, you put the legs on the canvas separately."[52]

At stake in this story is a new interpretation of how resemblance functions as a vehicle of signification in the visual arts. If pictorial signs are indeed motivated by virtue of resembling their referents, these signs should be immediately and universally legible. As the story told by the explorer reveals, however, even photography, which most Westerners regard as the form of pictorial representation most able to achieve an exact likeness of its model, is not readily understood by those unfamiliar with its conventions. In an example closer to Picasso's own experience, Gertrude Stein tells us that "Picasso at this period often used to say that Spaniards cannot recognise people from their photographs."[53] Resemblance, then, turns out to lie in the eyes of the beholder rather than in certain configurations of line, color, and form. As Carco suggests, Picasso was able to explore this notion in a number of ways, all of which work to undermine the transparency or naturalness of resemblance wherever it occurs: by articulating form into an aggregate of discrete pictorial or plastic signs; by treating trompe l'oeil details in particular as emblematic motifs, which can be redistributed within a composition; by making it possible to read a given shape (or an entire configuration) as referring to more than one object at once; by placing different kinds of conventional illusion in a single work and setting them into opposition; and finally, by challenging the traditional Renaissance paradigm that a picture surface is like a window or mirror.

In general, Picasso's encounters with African art and artifacts seem to have encouraged him to question many of the dominant assumptions that had governed Western art since the Renaissance. By offering an alternative model, African art allowed the relativity of Western values to come into view and confirmed Picasso in his search for an anti-idealist, anti-organic, conceptual form of art. In addition, Picasso certainly noted that African objects created for ritual purposes could not easily be assimilated to the Western conception of genres. Kahnweiler recalled that, in general, African works seemed to confirm the Cubist notion that a work of art is an object with a physical existence in the world of physical things.[54] African masks, in particular, are neither sculptures nor paintings, although they are usually both carved and painted. Picasso and Braque solved the problem of the presentation of these masks, which were meant to be worn, by hanging them on their walls next to paintings and drawings, musical instruments, and other objects they collected.

This new means of conceiving works of art allowed Picasso to challenge prevailing distinctions between painting and sculpture and to create what at the time were often defined as *tableau-objets*.[55] Indeed, André Salmon has described the uncertainty and "shock" of contemporary visitors to Picasso's studio when faced with his collages and constructions:

Viewers, already shocked by the things they saw on the covered walls, and that they refused to call paintings because they were made with oil-cloth, packing paper and newspaper, said with a raised finger pointing to the object of Picasso's intelligent attentions:

—What's that? Do you put that on a pedestal? Do you hang that on a wall? What is it, painting or sculpture?

Picasso, dressed in the blue of Parisian artisans, responded in his most beautiful Andalusian voice:

—It's nothing, it's the guitar![56]

Interestingly, for these viewers and Salmon alike, the uncertainty over how to display Picasso's collages and constructions was experienced as one of their most subversive features. No longer paintings, no longer sculptures, these works signaled the end of the "imbecile tyranny of genres": "And that's it, the airtight partitions are demolished. We are delivered from painting and sculpture, already liberated from the imbecile tyranny of the genres. It's no longer this and no longer that. It's nothing. It's the guitar!"[57]

Picasso must also have been struck by the fact that African artists were not constrained by any prejudicial notions regarding the purity or unity of their media. African masks and figures are frequently constructed from a number of different materials, many of them ephemeral: wood, paint, feathers, fibers, beads, shells, and so on. Vladimir Markov, in one of the earliest structural analyses of African sculpture, *L'art de nègres* (1914), emphasized this very heterogeneity in materials and artistic processes. Writing of the "technique of treating materials," Markov observed,

> One cannot say that this technique is "pure" . . . It is quite rare that one has the discipline of a single material or a single tool, wood and an axe for example.
>
> There are fetishes that are constituted by an assemblage of numerous materials: metal plates, rings, cowry shells, shoe-laces, hair, and so forth, in which the choice and organization, moreover, reveals a sophisticated taste and sensibility for material, because iron, bronze or shell, each of these materials pleased the eye of primitive man and was appreciated.[58]

Markov further noted that the use of these diverse materials was highly imaginative and "arbitrary" in

the sense that imitation of reality was not a goal. A cowry shell could signify an eye, nails could signify hair. For Markov, this form of symbolism "can be intuitive or speculative, but it is always creative, and we Europeans can only envy a way of thinking that engenders such a richness of forms."[59] Picasso was attracted to African objects because of their conceptual treatment of form, which he described as "raisonnable,"[60] but he must also have found the way these objects defied aesthetic categorization and the inventive use of materials they displayed liberating. It is in this double lesson of African art—which embraces both a formal and a material dimension—that we may observe the convergence of pictorial and sculptural practices in the fall of 1912.

The First Series of Collages and Constructions

When in the fall of 1912 Picasso initiated what would be the first of three series of Cubist collages, the themes and issues of the preceding months continued to dominate his new work. Several of the earliest collages are clearly two-dimensional translations of the cardboard *Guitar* and its play of positive (opaque) and negative (transparent) forms. In *Guitar and Wineglass* (fig. 7), for example, Picasso assembled his collage from seven pieces of paper, cut and pasted to a wallpaper ground. Each of these pieces of paper remains a discrete representational element within the composition, which as a whole represents a guitar hanging on a wall. Just as in the *Guitar*, the central portion of the guitar's body appears as a negative shape, defined only by the paper elements that surround it. This shape is the pictorial equivalent of what Kahnweiler described as the open or "transparent" form of the constructed *Guitar*, transparency being an effect created by an absence or break in the continuous

surface or skin of a work. The effect of transparency is all the more remarkable in the collage for having been achieved with opaque and clearly flat shapes.[61] Against the seemingly transparent surface of the hollow and partly overlapping the blue bridge of the guitar, Picasso pasted a white circle representing a sound hole, thereby reenacting the reversal of recessed and projecting forms that had animated the constructed *Guitar*. This reversal is, however, just one example of the many figure / ground reversals that traverse the whole of Picasso's collage production. In *Guitar and Wineglass,* each element is at once a figure to be read against the wallpaper ground and a miniature field of representation in its own right and therefore functions as a synecdoche of the picture as a whole.[62] The most obvious example of this may be the white rectangle bearing the depiction of a Cubist glass, but each of the other pieces of paper have also been treated as representational surfaces. Moreover, just as in the *Guitar,* pictorial signifiers in this collage seem to take on value only because of the relational system within which they are imbedded. The guitar is given conflicting profiles, curved on the left, straight-edged on the right. These formal antinomies are repeated in the small drawing of the glass, again with the curved profile appearing at the left and the straight-edged at the right.

Similar oppositions and reversals can be noted in the collage titled *Violin* (fig. 15), also of the fall of 1912. Here the wallpaper, at once figure and ground, is allowed to bleed freely across a small gap left in the upper corner of the violin's body. And in this collage, *three* alternate sound holes make their appearance, so that once again an analogy to the mask is established. This format is repeated in another *Violin* (fig. 44), in which Picasso enclosed a single sheet of cut paper within an en-

velope of laid paper, so that the forms of the musical instrument become visible only when the work is held up to the light. Here the opposition of opaque (or positive) and transparent (or negative) shapes is given a literal reality it did not have in earlier works.[63] Seeing through this work is the equivalent, therefore, of seeing it at all.[64] In another collage from this period, also titled *Violin* (fig. 9), Picasso established a figure / ground reversal of a different sort by cutting a single piece of newspaper so as to represent, through the placement of the resulting halves, both the right and left profiles of a violin. Picasso glued one of the pieces of newspaper near the center of the collage so that it defined the left edge of the violin. He then used the other piece of paper, flipped over, to mark the violin's right edge.[65] The two sides, mirror images of each other, thus produce the opposing profiles of the violin, but only because one is treated as a positive and the other as a negative shape. In addition, as Rosalind Krauss has argued, the disparity in the size and thickness of the two f-shaped sound holes of the violin must be read as a sign of foreshortening due to rotation into depth. Yet this sign for depth is inscribed in the very place where it is most noticeably absent, on the rigidly frontal plane of the collage surface.[66] Significantly, this inscription of rotation in space had already appeared in the cardboard *Guitar,* in which the depth of the right projecting profile is nearly twice that of the left profile. As a result of this discrepancy, the horizontal plane which joins these two projecting edges recedes diagonally toward the left, implying a recession that is countered by the frontal geometry of overall work. As Krauss has observed, in works such as these there is "no positive sign without the eclipse or negation of its material referent."[67] One might add, there is also no positive sign that is not itself negated by another sign.

With characteristic wit, Picasso's play on the possible formal analogies of mask and violin (or guitar) continued to pervade this series of works. In *Violin* (fig. 44), the familiar forms of the musical instrument are anthropomorphized, the scroll transformed into a curl of hair, the profile at left into an ear, the sound holes into eyes and mouth. Even the two sets of violin strings, positioned at an angle to each other to suggest the break in the line at the bridge, seem to resemble a crooked nose. In *Violin and Musical Score* (fig. 8) Picasso adopted the cartoonist's convention for signifying the thoughts or words of a character, in order to make his whimsically human violin sing. And in another collage executed at this time, *Head of a Man* (fig. 11), an opposing transformation seems to be under way, the man's head threatening to turn into a guitar. This guitar, however, participates in the doubling of signifiers that governs the overall structure of this collage, so that the guitar may be read as upside-down (the man's neck becoming the neck of the guitar as well) or as right-side up (another neck recedes into the distance at the left).

It could be argued that in exploring these analogies between a head (or mask) and a musical instrument, Picasso sought to bring an essential metaphorical similarity to light.[68] This might seem convincing if one considers the analogy established through the pictograph of the double arc which signifies both the profile of a guitar (or violin) and an ear—these objects being linked through their common relation to sound. Yet one can also argue that these analogies are visual puns, created rather than discovered by the artist, who was able to establish fortuitous resemblances out of a limited vocabulary of forms or signifiers. For it is precisely the severe restriction of this repertory of formal elements that allows each of them to take on an astonishing range of value. Some of the less commonly observed visual puns in Picasso's collages of this period confirm this view. In *Still Life with Fruit* (fig. 45), for example, a glass drawn onto a fragment of newspaper at the right may also be interpreted as a small figure reading that very

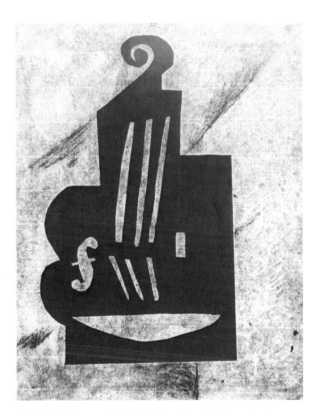

44. Pablo Picasso, *Violin,* fall-winter 1912, pasted paper between two sheets of laid paper, with chalk. Musée Picasso, Paris. Photo R.M.N.

45. Pablo Picasso, *Still Life with Fruit,* fall-winter 1912,
pasted papers, gouache, and charcoal on cardboard.
Philadelphia Museum of Art, A. E. Gallatin Collection.

newspaper.[69] It is Picasso's play with the Cubist for-
mal vocabulary—the tipped-up top of the glass, the
flattened curvature of the body of the glass, the
doubled profile at the left, the fragmentation of the
stem and base—that gives rise to the "[app]arition"
that a figure is there to be seen.[70] In *Bottle and
Glass on a Table* (fig. 46), a bottle and glass con-
tain the overlapping profiles of two open-eyed fig-
ures staring to the right, while in another work
from this series (fig. 47), the glass, now converted
to a monocyclist, speeds off the edge of the table.
Part of our pleasure in recognizing these visual
puns seems to lie in their ability to destabilize rep-
resentation, turning vision into a form of imagina-
tive hallucination. Once again the motivating force
of resemblance is undercut, for if a single image
can resemble two highly disparate objects at once,
how can it maintain the illusion of being a trans-
parent, univocal sign? And indeed, how can it be
said that Picasso's distortions arise from his analy-
sis of the essential structure of an object, when
more than one object is signified? Saussure, in a
statement that has been criticized for reasserting
the notion that the sign is a transparent vehicle of
communication (a notion his overall linguistic
model had sought to reject), compared the relation
of signifier to signified to the relation between the
recto and verso of a piece of paper: "Language can
also be compared with a sheet of paper: thought is
the front and the sound the back; one cannot cut
the front without cutting the back at the same time;
likewise in language, one can neither divide sound
from thought nor thought from sound; the division
could be accomplished only abstractedly, and the
result would be either pure psychology or pure
phonology."[71] Picasso, however, delighted in dem-
onstrating that a single recto may have two versos,
and that it is always possible to fold a piece of pa-
per so that the sides (which in any case is a rela-
tional concept) become confused and the meanings

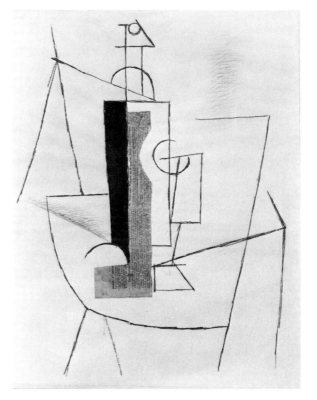

46. Pablo Picasso, *Bottle and Glass on a Table,* fall-
winter 1912, pasted paper, ink, and charcoal on paper.
The Alfred Stieglitz Collection, The Metropolitan
Museum of Art.

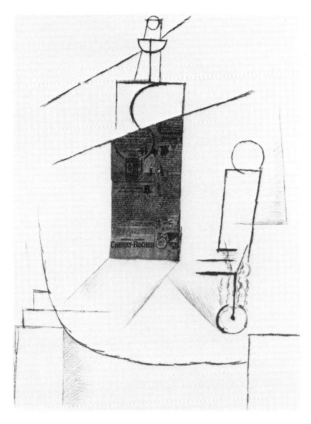

47. Pablo Picasso, *Bottle and Glass on a Table,* fall-winter 1912, pasted paper, charcoal, and crayon on paper. Private collection.

reversed or doubled. This, then, was the lesson of the African masks, those silent "witnesses"[72] to the inventive dislocation and transformation of cultural signs, the *bricollage,* carried out in Picasso's studio.

In the next chapter, the notion of the tableau-objet as it was defined by Picasso's collages and constructions will be the subject of analysis. As we have seen, both Salmon and Kahnweiler associated the use of constructive, multimedia techniques with a new concept of the work of art as an independently existing object, which for Salmon, abolished the "imbecile tyranny of genres."[73] Kahnweiler related the invention of the tableau-objet specifically to Picasso's interest in the objecthood of African masks and sculpture;[74] according to this view, then, the tableau-objet would seem to issue from insights similar to those which led to the construction of the cardboard *Guitar*. If this is so, however, we cannot accept the inference that the creation of tableau-objets exemplified Picasso's desire to affirm the substantive reality of the work of art as an object, for objecthood itself must be constructed in relation to its opposing term: the illusionistic tableau. Beginning with the *Still Life with Chair-Caning,* Picasso composed many of his collages and constructions by juxtaposing the vertical plane of illusion (the tableau) and the horizontal plane of reality (the table). Through this opposition, he demonstrated that the value of each term depends on the relational structure of the whole, and that within this structure, seemingly natural relations might be reversed. Thus the critique of Western conventions of representation posed by the *Guitar* finds a striking precedent in the development of the tableau-objet. The opposing terms of this critique—the table and the tableau—were already fully present in Picasso's first collage, the *Still Life with Chair-Caning.*

Frames of

Reference:

Table and

Tableau

in Picasso's

Collages

and

Constructions

One of the most frequent assertions made about the Cubist work of art is that it redefined the ontological status of the work of art. No longer modeled on the classical notion that a painting is like a transparent window onto the world, Cubist works are said to be conceived as autonomous, self-sufficient objects. Early critics—indeed some of the artists themselves—emphasized that in rejecting the norms of imitation, the artist was liberated from the constraints of both tradition and nature. The Cubist artist thereby appeared to achieve an unprecedented godlike power of creation, adding to the world of things new objects whose material presence affirmed what was described as a new kind of realism. Here, however, an essential, recurring paradox in the interpretation of Cubism arises. For insofar as the Cubist object is taken to exemplify concrete being or autonomous self-presence, it must refuse the function of representation.

This paradox has gone largely unnoticed by most critics and historians of Cubism. Typically, those who assert the objecthood of Cubist works also assert that Cubist formal innovations were intended to give the viewer more complete information about the essential nature of things in the everyday world, clearly a function of representation. These critics and art historians claim that by rejecting the Renaissance single-point perspective system and accidental effects of light, Cubist artists were able to combine different views of objects, thus presenting the spectator with what was known about those objects, rather than what might be immediately perceived. This argument, predicated on the binary opposition of conception and vision, was first put forth in 1908 by Georges Braque[1] and was amplified into a coherent theory in 1910 by Jean Metzinger,[2] who tried to codify and explain the formal innovations he observed in Picasso's studio. Metzinger's

notion that Cubism was an art of realism (what was later to be called conceptual realism) was seized with great enthusiasm by many early champions of Cubism, including critics such as Roger Allard, Jacques Rivière, Guillaume Apollinaire, Maurice Raynal, and Kahnweiler. Although objections and revisions have been proposed, notably by Leo Steinberg,[3] and more recently by Rosalind Krauss[4] and Yve-Alain Bois,[5] this interpretation has provided the canonical explanation for the principles and sequence of Cubist formal innovation. It is upheld, for example, in Christopher Gray's *Cubist Aesthetic Theories*,[6] in Douglas Cooper's *The Cubist Epoch*,[7] and in John Golding's major study *Cubism, A History and an Analysis 1907–1914*,[8] a book that has influenced many subsequent histories and surveys of modern art. In his discussion of Picasso's early Cubist works of 1909, Golding writes,

> Picasso's dismissal of traditional perspective had been the result of his interest in investigating the nature of solid form and of a desire to express it in a new, more thorough and comprehensive, pictorial way. . . . Picasso was anxious to present in each image as much essential information about the subject as he could. When he subdivides and facets form, it is in an attempt to break through to its inner structure. . . . One gets the impression that Picasso is striving for some ultimate pictorial truth, some absolute representation of reality.[9]

Elsewhere in his text, Golding asserts that "the Cubists saw their paintings as constructed objects having their own independent existence, as small, self-contained worlds, not reflecting the outside world but recreating it in a completely new form."[10] Collage is for Golding "the logical outcome" of this conception of Cubist works as "self-contained, constructed objects," for the inclusion of different ma-

terials in collages "emphasized in a very concrete way their weight and solidity as material objects."[11] Golding does not acknowledge any slippage or change in his definition of Cubist realism from 1909 to 1912, but emphasizes the continuity of the aesthetic intent of the movement before and after the invention of collage: "While *papier collé* involved new methods of work and initiated almost at once a new phase in the art of Picasso and Braque, it did not involve any fundamental change of aesthetic. . . . Cubism continued to be an art of realism; its subject matter remained the same, as did the interests and intentions of the painters."[12]

Similar discussions of the realist intent of Cubist artists dominate much of the literature on Cubism, without any reference to the contradictions inherent in this type of analysis. Yet a theory of realism based on the material presence of the object as a self-contained world does not coexist easily with a theory of realism based on the quantity of information conveyed about the world outside the frame.[13]

The invention and early practice of collage provide an excellent focal point for an analysis of Cubist realism because individual collage elements have been read as both real within the illusory context of painting or drawing and as signs for a reality not physically present. The double status of these elements recapitulates the essential paradox of the Cubist work itself, which appears to exist both as a material object (and to call attention to itself as such) and as a mode of representation.

In addition, Picasso's collage works dramatize the Cubist challenge to prevailing standards of pictorial unity, both academic and avant-garde. The notion of pictorial unity was a crucial factor in the critical attempt to define the ontological status of the Cubist work. For the Cubist work to assert its material and formal self-sufficiency, it had to appear to be internally coherent, governed by laws derived from the medium itself. Yet, for the Cubist work to be interpreted as conceptually realist, the stability and actuality of the referent had to be posited. Pictorial unity then took the form of a creative synthesis of objectively known (a priori) information. In either case, favorable early critics tended to see Cubist works, including the collages, as exemplifying the ideal of pictorial unity.[14] Kahnweiler, for example, described Cubism as taking on and solving problems that are "the basic tasks of painting: to represent three dimensions and color on a flat surface, and to comprehend them in the unity of that surface." And this was to be achieved with "no pleasant 'composition' but uncompromising, organically articulated structure."[15] Kahnweiler insisted, however, that this "return to the unity of the work of art, in the desire to create not sketches, but finished and autonomous organisms"[16] be reconciled with the representational function of painting.

In so doing, Kahnweiler turned to his recent reading of Kant, which provided him with a model for the interpretation of Picasso's "great advance made at Cadaqués" in 1910. This advance, the piercing of the closed form, could then be seen as a means of combining different views of objects into a synthetic, perceptually unified whole: "Instead of an analytical description, the painter can, if he prefers, also create in this way a synthesis of the object, or in the words of Kant, 'put together the various conceptions and comprehend their variety in one perception.'"[17] For Kahnweiler, the resolution of the conflict between representation and structure was one of the great achievements of Cubist painting, yet his explanations are riddled with internal contradictions and fall short of doing justice to the self-conscious complexity and ironic wit of Cubist works. Nonetheless, the attention he

gave to this problem in his writings reveals its importance for artists and their public in the Cubist period.

Picasso himself frequently called attention to the issue of pictorial unity through the motif of the frame, rendering problematic its place, form of appearance, and ultimately its meaning. His manipulations of the actual frames of his collages and of framing motifs, however, suggests a challenge to, rather than an exemplification of, the ideal of the unified work. In classical painting, the frame plays the important role of defining the boundary between the fictional, unified world of the painting or drawing and the real world outside. The frame thus plays a dual role: it establishes the difference of the fiction within the frame from the reality beyond it, but it does this in order to define this fictional world as a coherent, autonomous reality. Picasso's frames, however, commonly appear *within* his works, thereby disrupting their internal unity and the clear distinction between the worlds of reality and fiction. In this, Picasso's frames are curiously like his collage elements (newspaper clippings, playing cards, wallpaper fragments, parts of musical scores, and so forth); for both frames and collage elements are familiar, everyday objects and are normally excluded from the field of pictorial illusion. Their eruption within that field represents a subversion of prevailing notions of artistic unity, and this in turn puts into question the realist interpretation of Picasso's collages.

The "Inner Frame"

In 1913, in his influential early volume *Méditations esthétiques, les peintres cubistes,* Apollinaire presented his readers with a provocative yet undeveloped defense of collage techniques in the work of Cubist artists. In a paragraph following a discussion of the inclusion of real objects (such as oilcloth with imitation chair-caning printed on it, stamps, and popular songs) in the art of Picasso, Apollinaire wrote: "The object, real or represented in *trompe-l'oeil,* is clearly called upon to play a more and more important role. The object is the inner frame of the picture and marks the limits of its depth just as the outer frame marks its external limits."[18] These remarks, probably inspired by conversations with Picasso,[19] were written during the fall of 1912, just as Picasso and Braque were beginning to experiment with collage techniques.[20] Curiously, having established the "inner frame" as an important concept, Apollinaire goes on to apply it to nearly all the other artists in his book, until in the end it comes to signify merely "picturesque intensity."[21] Yet the suggestive concept of the inner frame has a specific meaning in relation to Picasso's first deliberate collage, *Still Life with Chair-Caning* (fig. 1) and continues to be relevant to Picasso's collages of 1913 and 1914.

In the text cited above, Apollinaire does not distinguish between real and represented objects. Either, he says, may become the "inner frame" of a picture in the sense that a piece of oilcloth or stenciled words are visibly flat and thus call the spectator's attention to the surface of the painting. For Apollinaire, this emphasis on the picture's surface acts to limit the illusion of depth and can be compared to the way a frame limits the picture's external boundaries. This is quite plausible, and the ramifications of this interpretation have been elaborated by many critics and art historians. Here I will argue for another interpretation, which turns on, rather than ignores, the slippery critical distinction between the real and the represented, or the literal and the figural.

Picasso's collage *Still Life with Chair-Caning* presents the viewer not only with the startling inclu-

sion of a piece of oilcloth printed with imitation chair-caning, but also with a frame in the unusual form of a mariner's rope. This device may have been inspired by the use of rope or hemp frames in popular chromo-lithographs, which Picasso is known to have collected,[22] or by the use of rope to frame souvenir mirrors in port towns.[23] The rope, then, like the oilcloth, is a ready-made, mass-produced material associated with popular rather than fine art and is employed by Picasso to simulate artisanal skill. The rope, a low or even non- art material, serves to parody the beveled wooden frames that traditionally signify high art, just as the inclusion of oilcloth parodies the value accorded the medium of oil painting. The prominent, gestural smears of oil paint across the smooth surface of the oilcloth further emphasize this ironic juxtaposition of means.

In calling attention to the frame, however, Picasso gave it a further paradoxical function. The rope, in marking the edge of the collage as a picture of a café table, also makes the oval canvas itself synonymous with that table, thus conflating the literal object with the table that it represents.[24] As early as the spring of 1911, a year before the *Still Life with Chair-Caning,* Picasso had occasionally defined the edges of the tables in his still lifes with twisted ropes, at times including the fringe of a table cloth, so that rope, sometimes with fringes or tassels, came to denote the presence of a table.[25] This use of the rope motif would probably have been easily understood by Picasso's contemporaries, for fringes, tassels, and swags were often used to decorate furniture, especially tables, chairs, and couches, in bourgeois homes of the late nineteenth and early twentieth centuries. The taste for such ornate furniture represented an attempt on the part of many bourgeois and middle-class families to imitate the decorative motifs of the late Empire style

found in the homes of the nobility. A photograph of Picasso at the age of seven further suggests that the fringe may have evoked memories of the familiar middle-class decors of his childhood (fig. 48). And a recently published photograph of Picasso's studio in 1909 shows Braque sitting next to a round table covered with a fringed tablecloth similar to those that could have been seen in wealthier homes (fig. 49).[26] The presence of a cheap version of such a decorative object in Picasso's studio is consistent with what we know of Picasso's "mania for collecting" objects that "would not have been out of place in the concierge's office." This, Fernande Olivier tells us, "was part of their charm for him."[27]

In two of the earliest canvases to represent the still life table with fragments of rope, *Mandolin and Glass of Pernod* (fig. 50) and *The Chess Pieces* (fig. 51), both of 1911, the rope serves as a framing device in two competing senses. The fragments of rope, drawn illusionistically in the midst of an otherwise hermetic system of fractured pictorial forms, signify both the framing edges of the depicted still life table and the curtain loop in the upper corner of the work. As curtain loop and tassel, the rope refers to the traditional Renaissance model of painting, in which the canvas is seemingly transformed into a transparent or open window. The curtain loop also suggests the traditional *repoussoir,* a framing element that creates the illusion of depth by appearing to lie in the forward plane of the canvas, so that other objects may appear pushed back behind it. Thus it is a motif associated with the idea of viewing as revelation, of seeing into depth as a mode of knowledge. Artists have frequently used curtains for this purpose, and Picasso's appropriation of this conventional device is particularly significant in the Cubist context.[28]

48. Photograph of Picasso at the age of seven with his sister Lola.

49. Photograph of Georges Braque in Picasso's studio, 1909. Photo: Beinecke Library, Yale University.

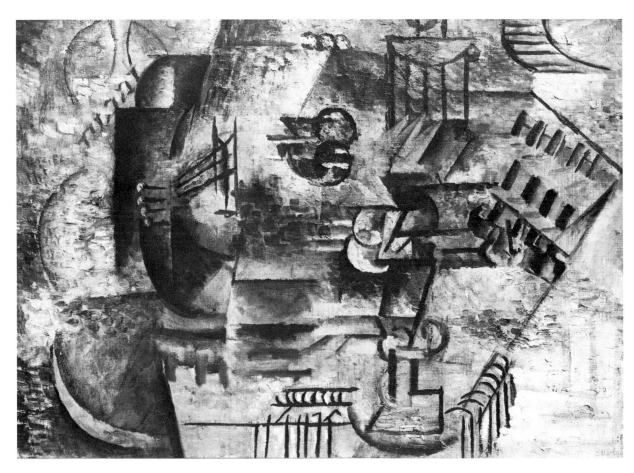

50. Pablo Picasso, *Mandolin and Glass of Pernod,*
spring 1911, oil on canvas. National Gallery, Prague.

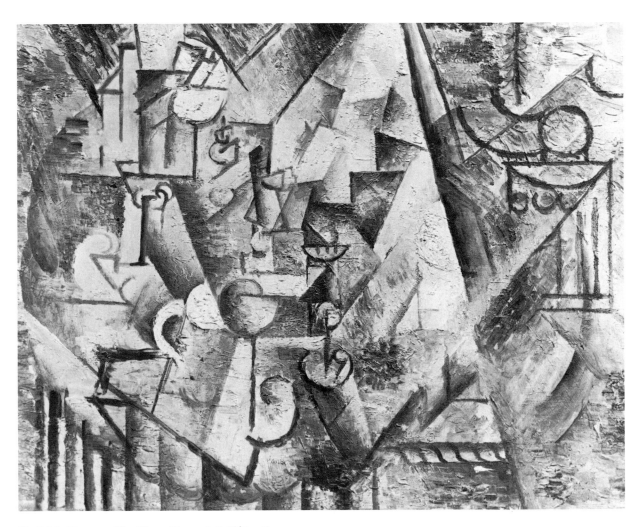

51. Pablo Picasso, *The Chess Pieces,* fall 1911, oil on
canvas. Private collection.

Seeing the rope as a reference to traditional no-
tions of transparency and illusion clarifies the irony
of Picasso's depiction of the fragment of rope in
what has been described as trompe l'oeil realism,
but which in its crudeness seems more like a delib-
erately naive caricature of trompe l'oeil. The natu-
ralism of the style of drawing used to depict the
rope is hardly eye-fooling and can be called trompe
l'oeil only in comparison to the geometric drawing
of the rest of the work. The curtain loop and tassel,
therefore, stand as *emblems* or representations of
trompe l'oeil illusion and do not perform its tradi-
tional functions; for the metaphorical curtain,
pulled back by the rope and tassel, fails to reveal a
coherent view into an illusory depth beyond. On
the contrary, the objects and forms depicted here
and in Picasso's other works of this period appear
to hover in a shallow, ambiguously defined space.

Picasso's irony is not confined, however, to refer-
ences to the illusionistic devices of the past. In the
present two examples, the rope motif serves also to
establish the framing edge of the table. While the
canvas is the literal support of Picasso's picture,
the table is the figurative support of the still life ob-
jects that rest upon it; by framing his table, Picasso
drew a parallel between these two, equally meta-
phorical supports or grounds of his art. The curtain
loop and tassel, referring to the traditional notion
of the canvas as transparent vertical plane, hovers
like a discarded talisman in the upper corners of
these opaque pictures. The table edge / frame, re-
ferring to the alternative, modernist concept of the
work of art as material object occupying a horizon-
tal plane, also appears in fragmentary form.

In neither sense does the use of the rope motif as
a framing device succeed in establishing a defini-
tive metaphorical paradigm for how the work is to
be received. The rope motif thus denotes, emblem-
atically, two conflicting models for the relation of

the viewer to the work of art without establishing
the primacy of one over the other. In these explora-
tions of 1911, however, the opposition of the verti-
cal plane of the tableau to the horizontal plane of
the table remains a matter of pictorial allusion.
Nonetheless, Picasso's isolation of this theme in
paintings such as *Mandolin and Glass of Pernod*
and *The Chess Pieces* demonstrates his early inter-
est in analyzing the relation of illusion and object-
hood in terms of the opposition of vertical and
horizontal planes.[29]

A clear distinction between the literal plane of
the table and the figurative plane of the tableau is,
however, difficult to maintain in paintings such as
Mandolin and Glass of Pernod or *The Chess Pieces*.
Once established, the opposition is deliberately ne-
gated by the fact that the rope of the curtain loop
has its pictorial rhyme, or alter ego, in the rope of
the table edge. It is also difficult to determine
whether the modernist notion of the work of art as
table / object is more literal than traditional no-
tions of the work of art as canvas / window / mirror.
The canvas in these paintings, after all, is literally
present, whereas the table is not.

It may have been partly in response to this latter
paradox that Picasso eventually decided to frame
his collage *Still Life with Chair-Caning* with an ac-
tual rope, thereby heightening the possibility for a
literal reading of the table as a concrete object.
The ambiguous oval shape of the canvas / table,
however, immediately undermines the possibility of
a univocal, literal reading, for the oval may repre-
sent a round table seen from an oblique angle,
seen, in fact, somewhat as a person seated at a café
table would see it. Moreover, Picasso has empha-
sized the divergence of his oval canvas as *object*
from what it *represents* by painting in the edges of
a rectangular table, thickly across the horizontal

lower edge and more thinly in a diagonal that im-
plies recession at the right. Insofar as the edge of
the table is construed as a frame, these alternate
borders of the depicted table may be read as a fur-
ther instance of Picasso's use of inner frames. The
edges of the table, in part synonymous with the
enclosing border of canvas, reappear within that
border, thus dismantling the traditional binary
oppositions of inside / outside, work of art /
exterior world. The intrusion of the cane-printed
oilcloth operates similarly: it subverts the conven-
tional role of the frame to define a coherent border
within which the work should be compositionally
and materially unified.[30]

Significantly, Picasso made it impossible for the
viewer to determine which representational para-
digm governs the appearance of the oilcloth. Is the
oilcloth to be taken as a literal or real object, that
is, does the oilcloth refer to the surface of the ta-
ble? or to a tablecloth resting upon it? Most early
critics, Apollinaire and Kahnweiler among them, in-
terpreted the fragment of chair-caning as just such
a bit of reality thrust into the fictive realm of paint-
ing, but this could be the case only if Picasso had
intended the fragment of oilcloth to refer, meto-
nymically, to an oilcloth tablecloth. The oilcloth
cannot refer to the real chair-caning surface of a ta-
ble without becoming a representation and point-
ing to something that is absent. The oilcloth,
however, is ambiguously placed at the lower edge
of this collage. Should it, then, be taken to repre-
sent the reflection of the back of a chair, which
would imply that we are to read the canvas surface
as a mirror, the paradigm often adopted by trompe
l'oeil painters? The use of imitation chair-caning,
indeed, seems to refer to the trompe l'oeil tradition
while reversing its priorities. Braque seems to have
argued for this view when he stated in 1917 that

"the simplicity of the facts" had led people to con-
fuse the papiers collés, that is, the use of imitation
wood grain materials in certain drawings, with
trompe l'ocil, "of which they are precisely the op-
posite." Braque regarded these materials as "simple
facts, but *created by the mind*."[31] Similarly Picasso,
in choosing to appropriate a ready-made imitation,
suggests that his art lies not in meticulous crafts-
manship, but in imaginative conception. Yet his
collage takes its place within the eye-fooling tradi-
tion. Picasso painted over the upper three edges of
the piece of oilcloth so that its boundaries would
be obscured. Given the context of his friendly ri-
valry with Braque, and the absence of any prior ap-
propriations of this type, one can imagine that
Picasso hoped to fool Braque into thinking he had
painted the imitation chair-caning. This would have
been quite a tour de force, even more impressive in
its display of skill than Braque's manipulations of
the housepainter's comb to create imitation wood
grain.[32] Picasso thus used the machine-made object
to refer to illusionistic painting, yet, like a tradi-
tional trompe l'oeil painter, he wanted the illusion
to fail in the end so that his artifice (or in this case
his conceit) might be appreciated. The lower edge
of the oilcloth, therefore, is unpainted and cut
away from the rope frame to reveal the edge where
oilcloth meets canvas ground. This rough edge
points to Picasso's future collage practice, in which
it is the distinction between the collage element
and the drawing rather than their integration that is
most often emphasized. It is also possible to read
the table as a glass surface, like a window, so that
we see through it to the seat of the chair beneath.
According to this paradigm, Picasso's collage ap-
proximates the ideal framed window of classical
painting, although the fictional realm within the
frame is anything but convincingly illusionistic or
coherent. The gray smears of paint on the surface

heighten the confusion of alternative paradigms, since they may be read as shadows on an opaque surface or as reflections of light on a glass or mirror surface.[33] By multiplying the alternatives, Picasso denies a direct, transparent relation between his pictorial signifiers and their referents in the external world. He thereby points to the arbitrariness of those signifiers in the absence of a single governing interpretive context or paradigm.

The *Still Life with Chair-Caning* of the spring of 1912 remained a relatively isolated experiment in Picasso's oeuvre until his collaboration with Georges Braque during the fall of that year led the two artists to explore a wide variety of collage techniques. At this time Picasso made an unusual collage, *Violin and Newspaper* (fig. 52), as part of a series of multimedia works on the theme of a musical instrument hanging on a wall. This work has attracted little notice, perhaps because like so many of his collages and sculptural constructions it remained in the artist's possession during his lifetime. Painted on glass, *Violin and Newspaper* again takes up the motif of the window and is interesting to compare to an earlier work by Braque, *The Portuguese* of 1911 (fig. 32). Braque's painting is usually described as representing a Portuguese guitarist. But as Jean Laude has argued, Braque represented this guitarist as if seen through a café window, in such a way that the depicted scene seems to coincide with the very pane of glass.[34] That we are looking at the guitarist through a café window is suggested by the curtain loop and tassels at right and by the letters and words—"D BAL" from *grand bal,* "OCO" from *chocolat,* and "10,40" (a price)—which appear to be advertisements stenciled on a pane of glass.[35] Yet these words, like the forms of the guitarist, are fragmented in arbitrary ways, and the illusion of the café window's transparency and of a clear, readable space beyond it is thereby denied. Rather, figure and ground seem to merge in the oscillating play of opaque and transparent forms.

Picasso's *Violin and Newspaper* demonstrates that once again he has literalized what in his pre-

52. Pablo Picasso, *Violin and Newspaper,* fall 1912, oil and sand on glass. Private collection.

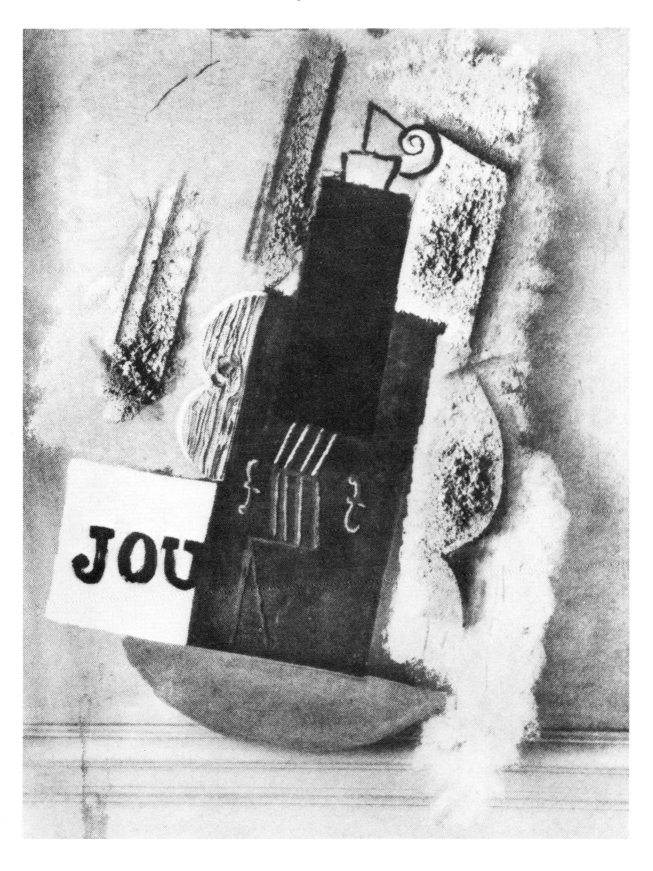

vious work, and in Braque's, had remained figurative. Here the canvas ground has given way to an actually transparent pane of glass, which in conventional terms barely functions as a ground at all.[36] One of the things this work reveals is that the canvas must be opaque in order to operate convincingly as a figure of transparency. For in looking through the "unfinished" parts of the glass, we see a section of the chair rail that is part of the wall behind the glass but that in this photograph, which was taken in Picasso's studio, enters the composition of the work as a foreign element, thereby disrupting its internal unity and self-sufficiency. Yet this reality from outside the picture fails to remain completely foreign to Picasso's composition since it resembles nothing so much as a frame and, moreover, resembles the painted fragment of a frame (also possibly displaced violin strings) above. And in the play of multiple substitutions— signaled by the word "JOU" (cropped from *journal*)—the chair rail which appears just beneath the painted violin also denotes the edge of a supporting table.[37] Despite its unusual mode of appearance, it is not surprising that Picasso would choose to introduce the motif of the chair rail or wainscoting as a kind of inner frame in this painting of a violin. A related work of autumn 1912, *A Violin Hanging on a Wall* (fig. 53), represents a violin with painted wood grain wainscoting to the right. Another section of painted wood grain, horizontal in format and placed just below the violin, suggests the presence of a supporting table. This thematic reference to both wall and table as alternate supports or grounds also occurs in a lost version of the constructed *Guitar* as it was reproduced in *Les Soirées de Paris* in November 1913 (fig. 54) and in many other works of this period.

It would be interesting to know whether Picasso intended *Violin and Newspaper* to be framed in a conventional way, which would, of course, greatly diminish the ambiguity this work establishes between reality and illusion. One indication that he did not lies in a photograph of Gertrude Stein's studio taken sometime in late 1912 or 1913 (fig. 55). In

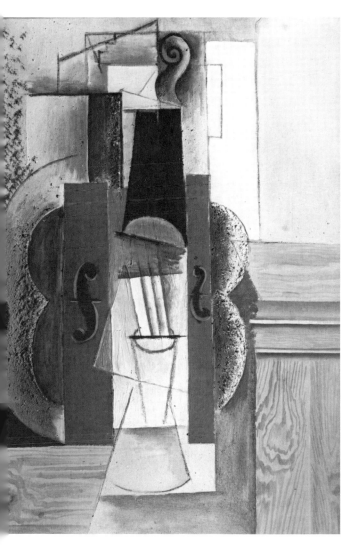

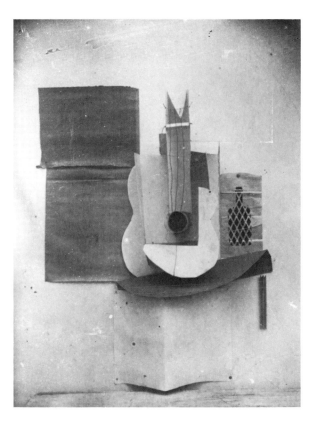

53. Pablo Picasso, *A Violin Hanging on a Wall,* fall 1912, oil and sand on canvas. Kunstmuseum Bern, Hermann and Margrit Rupf Stiftung.

54. Pablo Picasso, *Construction with Guitar,* 1913, photograph published in *Les Soirées de Paris,* November 1913. No longer extant as reproduced.

55. Photograph of Gertrude Stein's studio. Gertrude
Stein Archives, Beinecke Library, Yale University.

the photograph, several of Picasso's Cubist works hang unframed on quite crowded walls, including a work titled *Violin,*[38] which is very similar in composition to *Violin and Newspaper*. The unframed presentation of *Violin* suggests that Picasso probably also intended *Violin and Newspaper* to remain unframed, as part of his strategy to challenge the fictional coherence of the world contained within this picture. As Gertrude Stein declared in her essay on Picasso (1938), with the creation of Cubism "the framing of life, the need that a picture exist in its frame, remain in its frame was over."[39]

In a further effort to disrupt the pictorial unity of *Violin and Newspaper,* Picasso created actual relief in certain areas by adding sand to the glass surface and by simulating wood grain with thickly applied paint. These textured areas appeal to the viewer's tactile sense, and the information they yield remains independent of the information yielded by the more purely optical or pictorial forms. One can also note that in a witty reversal of the use of illusionistic shadows in earlier Cubist works, here the shadows are real, cast by the painted sections of the work onto the wall behind the glass.

It has sometimes been argued by modernist critics such as Clement Greenberg that the Cubists pasted pieces of paper to their canvas grounds in order to affirm the flatness of the picture plane. This emphasis on flatness is taken as a confirmation of the necessary, originary flatness of the medium of painting itself. Yet such works as *Violin and Newspaper* call attention to the ground in order to render it problematic rather than secure. The relief of certain areas and the visibility of objects and cast shadows behind the picture plane negate the homogeneity and flatness of the ground as ideal features of the representational field. Any interpretation of Picasso's collages that emphasizes the artist's interest in calling attention to the medium in order to dramatize its integrity and primacy remains blind to the radical disruptive force of Picasso's Cubist works. These are not self-contained, unified works that can be easily assimilated to the modernist aspiration for a timeless, pure,

and ideal realm through art.[40] Rather, collages such as *Violin and Newspaper* demonstrate the failure of the ground to hold, of the frame to enclose, and of the forms to signify a unified reality.

The Play of Identity and Difference

Fragments of twined rope, sometimes with fringe and molding patterns (both either drawn or cut out of wallpaper), continue to appear in Picasso's collages for the next two years. In the spring of 1913, Picasso created a series of still lifes in which the interchangeability of these framing motifs is a major theme. Rope is used to signify the supporting table in *Bottle of Vieux Marc, Newspaper and Glass* (fig. 56) and in *Guitar, Wineglass, Bottle of Vieux Marc* (fig. 57), whereas molding from the border of a wallpaper pattern signifies the table edge in *Bottle of Vieux Marc, Glass and Newspaper* (fig. 58) and in the greatly simplified collage *Guitar on a Table* (fig. 59). In these examples, the wallpaper engenders a double reading analogous to that found in Picasso's *Still Life with Chair-Caning*: a single pictorial element (here the wallpaper, in the earlier collage the rope) refers to the flat, vertical plane of the wall (and, by implication, of the picture plane) as well as to the horizontal plane of the table.

A related duality appears in *Guitar, Wineglass, Bottle of Vieux Marc,* and in *Guitar and Cup of Coffee* (fig. 60). In both collages the wallpaper reinforces a sense of verticality in relation to the horizontality of the table, but the table itself is depicted as both straight-edged and round. This latter duplication of pictorial signifiers also recalls the doubly represented table in the *Still Life with Chair-Caning,* in which a straight-edged table was figured within the literal border of the oval table. In none of these examples, however, does the juxtaposition of signifiers represent an attempt to synthesize different views of a table into a single, synthetic whole; rather, the signifiers remain in opposition. And in both collages the same constructive principle occurs in the treatment of the guitar, which is composed of disjointed curved and straight halves, and in the display of a circular and squared, modeled and flat neck of the bottle of Vieux Marc in

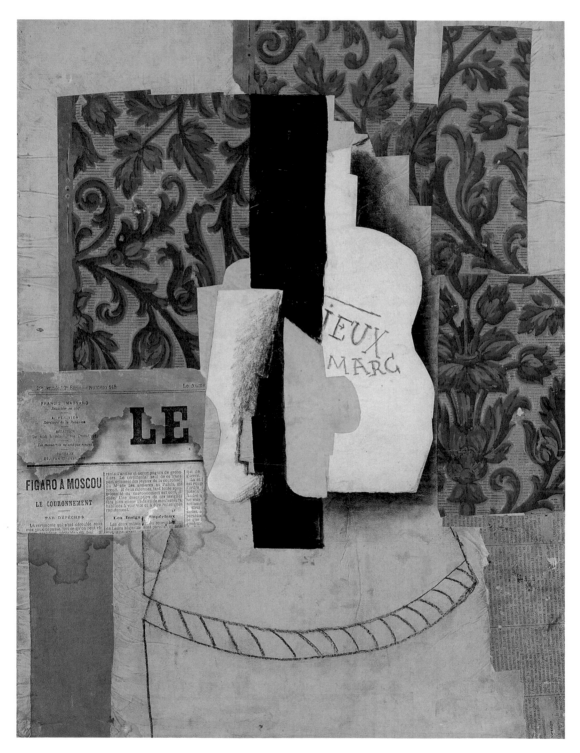

56. Pablo Picasso, *Bottle of Vieux Marc, Newspaper and Glass,* 1913, pasted papers, oil, and charcoal on paper on canvas. Kunstsammlung Nordrhein-Westfalen, Düsseldorf.

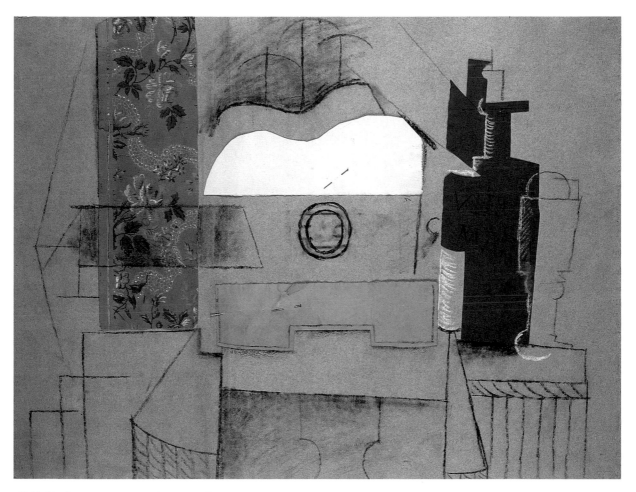

57. Pablo Picasso, *Guitar, Wineglass, Bottle of Vieux
Marc,* spring 1913, papers glued and pinned, crayon,
and charcoal on paper. Musée Picasso, Paris. Photo
R.M.N.

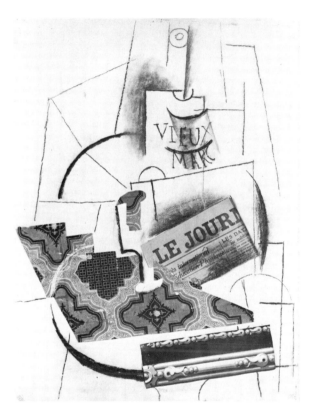

58. Pablo Picasso, *Bottle of Vieux Marc, Glass and Newspaper,* spring 1913, papers pasted and pinned, and charcoal on paper. Musée National d'Art Moderne, Paris. Photo Lauros-Giraudon.

59. Pablo Picasso, *Guitar on a Table,* spring 1913, papers pasted and pinned, and crayon. Private collection.

60. Pablo Picasso, *Guitar and Cup of Coffee,* spring 1913, pasted papers, gouache, and charcoal on paper. National Gallery of Art, Washington. Collection of Mr. and Mrs. Paul Mellon.

Guitar, Wineglass, Bottle of Vieux Marc. The viewer does not acquire a wealth of information about these represented objects but comes to realize that he or she knows very little about them. Is the table round or square? The image remains suspended between these two contradictory, yet simultaneously affirmed possibilities. Albert Gleizes and Jean Metzinger had warned their readers about the danger of equivalent formal oppositions in their treatise of 1912 called *Du Cubisme*. In this didactic text they had argued that "the science of design consists in instituting relations between straight lines and curves. A picture which contained only straight lines or curves would not express existence. It would be the same with a picture in which curves and straight lines exactly compensated one another, for equivalence is equal to zero."[41] According to Gleizes and Metzinger, then, the structural equivalence of straight and curved lines in a work would result in a self-canceling composition, severing rather than affirming the tie to existence. Ironically, this seems to be the path chosen by Picasso. His pictorial oppositions assert the artificiality of art and the arbitrary, diacritical nature of its signs. From a number of contemporary accounts, we know that Picasso could be extremely caustic to those who insisted on seeking to establish an essential or true link between art and nature. André Salmon, one of Picasso's poet friends, reported the following humorous but enlightening incident in *Paris-Journal* in 1911: "To a younger man, who asks him whether one should draw feet round or square, Picasso replies with much authority: 'There are no feet in nature!' The young man fled, and is still running, to the great joy of his mystifier."[42] According to Kahnweiler, the young man in question was Metzinger himself.[43]

Yet perhaps in answer to all those who have observed the systematic arbitrariness of Picasso's

forms during 1912–14, the artist's remark affirms the nonidentity of his art with what it represents. In an interview of 1923, Picasso reconfirmed this principle: "They speak of naturalism in opposition to modern painting. I would like to know if anyone has ever seen a natural work of art. Nature and art, being two different things, cannot be the same thing. Through art we express our conception of what nature is not."[44]

Clearly Picasso's pictorial signifiers refer to everyday objects in the world; yet they do so without resembling those objects in the traditional (coherent) sense, nor even, as has been claimed, by resorting to a higher conceptual realism. If realism is understood as a mode of representation that is in some sense true or adequate to the objects represented, Picasso's collages must fail. These works are constructed through the play of differential signifiers: the straight-edged versus the curved, the modeled versus the flat, the transparent versus the opaque, the handcrafted versus the machine-made, the literal versus the figurative, and so forth. The principle of difference, already operative in the distinction between nature and art, thus becomes a principle governing the internal organization of the work of art as well. The formal oppositions Picasso employs are drawn from the history of art[45] and from contemporary aesthetic theories such as those of Signac or Léger that are based on "laws of contrast," and in this sense they are motivated by convention; they belong to a shared pictorial tradition and are already imbued with meaning. Yet these oppositions point to their own arbitrariness in relation to the thing represented, even as they allow representation to occur.

The question that remains to be asked is whether the system of formal differences at play in Picasso's Cubist work describes a closed field—one

that is circumscribed or framed—or one that is open to change and rupture, perhaps through the interpretive role of the spectator. The answer to this question can be approached only by turning again to Picasso's collages and to the leitmotif of the frame as it is represented in those collages.

In Picasso's work after 1912 the tendency of collage elements to break through literal or figural frames became especially marked in his constructions. Most of these extremely fragile works, made of humble and unlikely materials, remained in Picasso's possession throughout his lifetime, and some are known only through photographs. Gertrude Stein recalls that she was "very much struck at this period, when cubism was a little more developed, with the way Picasso could put objects together and make a photograph of them. I have kept one of them, and by the force of his vision it was not necessary that he paint the picture. To have brought the objects together already changed them to other things, not to another picture but to something else, to things as Picasso saw them."[46]

An example of this is an assemblage from 1913 (fig. 61), an invention of great irony and wit, that in its original form seems to have dispensed with the enclosing borders of a frame altogether. The work comprised a drawing on sized paper, hung like a backdrop against Picasso's studio wall. The drawing represented a partially masked harlequin, with arms and hands cut out of newspaper and attached with pins and string to a real guitar, suspended from the ceiling. There is also a real table, much like the tables in Picasso's still lifes of this period, with the familiar bottle, cup, pipe, and newspaper, all in close proximity to the wall. The guitar, in particular, seems remarkably whole and physically present compared with the fragmentary, indeed, unfinished drawing or with the constructed *Violin*

also hanging from the wall. Yet Picasso inserted this familiar object in a representational system that forces us to recognize it, paradoxically, as both a real guitar and as a sign for a guitar. If the most fundamental definition of a sign is that it refer to something that is *absent,* or if, in other words, there must be a *difference* between the signifier and the referent, the status of the guitar is indeed problematic. For the guitar appears to be identical to itself[47] and therefore to exist, quite simply, as a real or literal object, much like the nearby table. The table itself might appear to be independent of this tableau were it not for the newspaper lying on it that is tipped up against the wall, drawing it into the realm of fictions, just as the harlequin's newspaper arms reach out and appropriate the guitar to itself. Once inserted into the stagelike context of Picasso's studio, the literalness of the guitar is put in question; it seems to resemble itself, to become a naturalistic mode of representation in opposition to the nearby Cubist geometric drawing, much like the naturalistic details that appeared in Picasso and Braque's most hermetic paintings during 1910 to early 1912. The guitar is also reversed, a position that renders it nonfunctional and suggests that it is a reflection or reproduction of itself, rather than a uniquely existing object. Picasso's manipulation of the guitar and other objects in this assemblage drives a wedge between the literal identity of these objects and our perception of them, thus making things into signs.[48] The guitar and table, then, can be read as representations of Picasso's own contemporary still lifes but also as an ironic comment on their aspiration to the status of the real.

The image of a guitarist holding a reversed guitar may also refer to earlier representations in the history of art, particularly Edouard Manet's *The Spanish Singer* of 1860 (fig. 62).[49] Manet's critics had

61. Pablo Picasso, *Assemblage with Guitar Player,* 1913,
photograph of an assemblage in Picasso's studio. No
longer extant as reproduced.

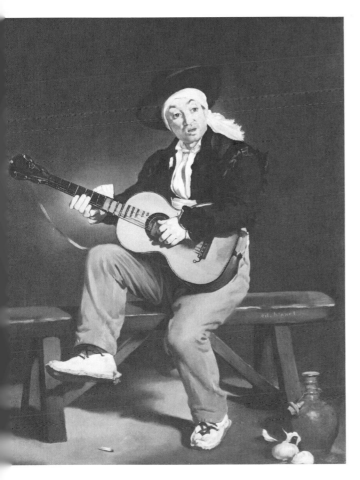

62. Edouard Manet, *The Spanish Singer*, 1860, oil on canvas. The Metropolitan Museum of Art. Gift of William Church Osborn, 1949.

observed that the guitar in *The Spanish Singer,* strung for a right-handed player, was reversed and, further, that the positions of the guitarist's hands indicated he did not know how to play this instrument. Picasso may have been initially attracted to Manet's painting because of its Spanish associations, but if it was a precedent for his assemblage, it seems to have been primarily for the "mistakes" noted by Manet's contemporaries.[50] Given Picasso's own effort to disrupt spatial coherence, it is not surprising that he would have been interested in Manet or that he might choose to refer to just those features of Manet's painting that critics had found most disturbing. What would those critics have said of the chords played by the three-fingered newspaper hands of Picasso's harlequin? And of the guitar and table, which are too small in relation to the larger-than-life-size drawing on the backdrop? Or of the musician, who appears to have legs incapable of supporting him: made of paper and tacked to the support, they have been allowed to slide limply under the table? Finally, Picasso's guitarist, like Manet's, is depicted in costume. In Manet's painting, the guitarist's costume, something of a pastiche, calls attention to the fact that Manet painted a model posed in his studio.[51] Picasso's assemblage makes the studio setting an even more obvious feature of the work's presentation.[52]

By transforming the objects in his assemblage into signs of prior representations, Picasso reversed the normal relation of representation to model, a relation he reversed once again by taking the photograph, thereby introducing a frame and subjecting these objects to "the force of his vision."[53] The spectator's uncertainty regarding the status of these objects arises only in the absence of this frame, with the merger of pictorial, stagelike, and real-life space that existed in the original studio setting. In that setting it might have been possible to regard the guitar and table as real, potentially functional objects. If, however, we introduce a kind of closure or frame, as the photograph does, these objects appear as elements of a predetermined system of formal oppositions, as *figures*

63. Pablo Picasso, *Glass, Die and Newspaper,* spring 1914, painted wood and tin. Musée Picasso, Paris. Photo R.M.N.

of the real, rendered temporarily nonfunctional through Picasso's manipulations and our own constitutive activity as spectators.

Most of Picasso's subsequent collages and constructions introduce the frame as a border to be parodied or transgressed. In *Glass, Die and Newspaper,* of spring 1914 (fig. 63), for example, cut and twisted sections of a milk tin, crudely painted to resemble a glass and fragment of newspaper, project from the bounded plane of the vertical tableau, as if to signal a desire to attain three-dimensional objecthood. Again the frame plays an integral role in establishing this play between illusory and real depth, which in turn threatens to elide the distinction between painting and sculpture.

In *Glass and Bottle of Bass*, also of spring 1914 (fig. 64), Picasso created a mock frame by pasting a wallpaper border to the four sides of his picture.

64. Pablo Picasso, *Glass and Bottle of Bass,* spring 1914,
pasted paper and charcoal on cardboard. Private
Collection.

But this frame fails to function convincingly because the paper has been very crudely cut and glued (scissor marks and overlapping are visible), the orientation of the pattern alternates around the four edges, and most crucially, a section is missing from the upper right corner. Picasso filled this gap with a frame drawn in pencil directly onto the cardboard ground, without, however, making any attempt to imitate the wallpaper pattern. Further emphasizing the difference of this hand-drawn section from the wallpaper frame, Picasso made it cast an illusionistic shadow to the right, as if only the drawn frame had volumetric presence. Yet, because of its isolated and fragmentary character, the shadow cannot be confused with a real shadow and thus calls attention to itself as an illusion. The function of the frame as an enclosing border is also negated by the extension of the cardboard ground beyond the perimeter marked by the (inner) frame, causing the literal and framed edges of the collage to diverge. The wallpaper border thus appears as a (badly rendered) picture of a frame. The small bit of paper bearing Picasso's name is similarly paradoxical. It functions in relation to this picture both as a literal nameplate of the type (if not the material) frequently found in museums and as an ironic imitation of such identifying labels.

Within the wallpaper frame of *Glass and Bottle of Bass,* Picasso created a picture of a still life table / tableau hanging on a wallpapered wall. A photograph of Kahnweiler's apartment, taken about this time, provides evidence that the Cubist dealer hung works by Picasso and other artists on walls covered with striped wallpaper that closely resembles the wallpaper background in this collage (fig. 65). Thus Picasso's picturing of the prevailing modes of presentation of works of art (including his collages) includes label, frame, and wall. Ironically, a later reference to how works of art are sold was added to *Glass and Bottle of Bass* in the form of the small blue sticker with the number 354 from one of the Kahnweiler sales of the early 1920s.

In *Still Life (The Snack)* (fig. 66), also from the spring of 1914, two alternate frames are intro-

65. Photograph of Daniel-Henry and Lucy Kahnweiler in
their apartment, 1913. Photo: Galerie Louise Leiris,
Paris.

66. Pablo Picasso, *Still Life* (*The Snack*), spring 1914,
painted wood and fringe. The Tate Gallery, London.

duced: the beveled fragment of wood suggesting both picture frame and chair rail and the decorative golden fringe denoting the table edge. Neither frame succeeds in establishing a definitive boundary for the work or even in claiming precedence as its governing paradigm. Yet the movement away from a framed, literally flat and figuratively transparent field is restricted, the context paradoxical but clearly defined. The literal is consistently signified as such within a representational system in which it opposes the figurative, and this opposition is enhanced by the simplicity and harmony of Picasso's composition. The naturalistic treatment of the bread and sausage, which rest on the table surface, for example, contrasts with the formal and partially fragmented construction of the Cubist glass. The glass, moreover, is nailed to the vertical picture plane and hovers, ironically, just above the table. Through this inventive device, Picasso established an opposition between the bread and sausage, which behave like literal objects subject to gravity and thus belonging to the real world of the café table, and the glass, which is suspended (hung like a picture) from the alternate ground of the tableau. These two apparently exclusive worlds collide to form a single, compelling scene that once again undermines as it establishes the opposition of table and tableau. For with a shift of focus, the glass appears as a literal projection from the flat plane of the tableau, while the bread and sausage are revealed as being made of rather sloppily painted wood. In addition, the table top is tilted upward, so that it too proves to be subject to the deformations of perspective.[54] And this means that the cheese and sausage (like the glass) must be nailed in place. In the end, what is affirmed is the interchangeability of the terms *literal* and *figurative*—that is, the way in which, in a system in which individual terms have no essential meaning but only differential values, the functional identity of opposed terms can be revealed.

No interpretation can be regarded as stable or fixed, and Picasso plays out the consequences of this notion in his collages and constructions with great wit. Binary oppositions are continually asserted, then negated, only to reappear in displaced form. Yet Picasso never displaces the system of oppositions itself. This play of oppositions eventually assumes the traditional role of the frame itself, to determine which elements belong to the work and which do not. In Picasso's Cubist collages, constructions, and assemblages, unity is no longer primarily a question of subject matter, material, or style—although these continue to be important factors in the game. Rather, unity has become a question of oppositional formal structures perceived by the artist / spectator and is therefore context-dependent and subject to change.

The Table and the Tableau

Throughout this analysis of Picasso's collages and constructions, the relation of the table, as a sign of the modernist aspiration for the literal object, to the tableau, as a sign of traditional illusion, remains fundamental. André Lhôte tells us that "on this new theme, Picasso and Braque embroidered the most delicate and the most clever arabesques. They strove to assimilate the table to the tableau."[55] And according to Kahnweiler, the painters themselves discussed the notion of the tableau-objet a great deal: "The Cubists, following in the footsteps of Cézanne, always insisted on the *independent existence* of the work of art. They talked about 'le tableau-objet,' an object which could be put anywhere. . . . The Cubist poets used also to talk of '*le poème-objet*'."[56]

Given the well-known enjoyment of puns and other paradoxes (both linguistic and pictorial) in the circle of painters and poets sometimes called "la bande à Picasso," their discussions may have led to an interest in the semantic possibilities contained in the word *tableau.* This word, which derives from the Latin *tabula,*[57] for wooden board or plank, refers by extension to *table* as well as to other smooth, flat surfaces available for inscription. By the thirteenth century in France, *tableau* signified a painting on a panel of wood, and eventually, with the rise of the aesthetic view of art in the eighteenth century, the self-sufficient, portable easel painting.[58] Thus *tabula* has historically denoted both tables and paintings. Perhaps the common origin of *table* and *tableau* in the *tabula* became an enabling insight for Picasso, one that inspired him to seek a reciprocity or hidden identity in objects that previously had seemed to be contradictory in nature. It is this view of the paradoxical identity of the work of art as potentially both table and tableau (whether derived from visual or verbal analysis or both) that allowed Picasso to play a game of infinite substitution and reversal within the opposition of these terms / objects, as it had been constructed by his contemporaries. This formal play reveals a critique of the call for the tableau-objet, insofar as it might be construed as making a new claim for the transparency of the signifier, or realism, as Picasso's contemporaries often called it.

In inventing Cubist collage, however, Picasso put in question many of the fundamental assumptions of his Symbolist predecessors and, indeed, contemporaries. His collage works undermined not only the conventional fictions of the classical tableau, but also those of the new, avant-garde tableau-objet. By inscribing both paradigms in a paradoxical play of identity and difference, Picasso demon-

strated that the material literalness of the object itself was constituted within a system of oppositions, just as the by-then discredited transparency of the picture plane had been constituted as a fiction in opposition to the world outside the frame. As if motivated by a Nietzschean project of radical doubt, Picasso seemed to test each new claim for artistic authenticity, or realism, in order to reveal its conventional basis.

Picasso's strategy for accomplishing this was to displace the prevailing opposition of the tableau and the tableau-objet by turning to a new paradigm, which may also be derived from the *tabula.* This was the notion of the work of art as a *table à jouer,* a gaming table. Thus conceived, the work of art became a conventionalized field of representation, open to the play of paradox, conflicting interpretations, and the collision of multiple (high and low, pictorial and verbal) cultural codes. The fragmentation and dispersal of forms in Picasso's Cubism issued from this view of artistic language as essentially constructed and arbitrary, like the rules of a game. Once a motivated relation of pictorial form to referent had been rejected, Picasso was able to abandon the related fictions of univocal, transparent meaning (realism) and an organic or perceptual form of pictorial unity. Nor do Picasso's collages and constructions affirm an experience of unified selfhood for the viewer who becomes engaged in the game of interpretation. The viewer (player) cannot hold the perceptually alternating planes of the table and tableau in mind at once, just as he or she cannot read the pictorial forms and the texts of the newspaper clippings at once.

Picasso's collages call for a continuously shifting interpretive strategy as well as for a shifting visual focus, and this must take place over time. This process leads to an accretion of meanings but rarely

to the sense that one has resolved the contradictions or paradoxes presented by the work. The question of pictorial unity itself is thus displaced from the collage to the experience of the viewer, where it is suspended and dispersed in the time of interpretive analysis, like a series of moves in a board game. Picasso himself assumes the role of the master player / dissembler who invites the viewer into the scene of play. Like Picasso's many Blue and Rose period self-portraits in the guise of a harlequin, the harlequin in the *Assemblage with Guitar Player*—which the artist preserved as an independent work after dismantling his assemblage—may be interpreted as a self-portrait (fig. 67). Ironically, the harlequin is partially unmasked; two planes bearing the schematic marking of the ear (a double curve) and the tangential lines of the eyebrows and nose fan out to the left. But the self thereby revealed is shown to consist only in another schematic representation (a vertical line for a nose and two dots for eyes), as if the self for Picasso were a layering of masks, of paperlike surfaces without interiority or depth.

The work of art considered as a table à jouer also contributes to our understanding of the role of Picasso's subject matter during this period. Picasso repeatedly turned to still lifes—and especially the café table—not because the subject could be regarded as a mere pretext for formal innovation but in part because of its traditional association with realism, including trompe l'oeil painting. Thus Picasso was able to subvert the notion of realism from within the very genre most frequently concerned with visual description and the actuality of the referent. Additionally, many of the objects familiar to Picasso's café tables—musical instruments, cards, dice, wine, cigarettes, pipes, wineglasses, even the fragmented word "JOU"—evoke popular scenes of play and lighthearted enjoyment.[59] As Picasso told his friend from the Bateau-Lavoir days, the poet and painter André Warnod in 1945, "The studio of a painter should be a laboratory. There, one does not make art in the manner of an ape, one invents. Painting is a play of the spirit."[60]

67. Pablo Picasso, *Head of a Man,* 1913, oil, charcoal, ink, and crayon on sized paper. Richard S. Zeisler Collection, New York.

Conception

and

Vision

in the

Collages of

Braque

and Gris

Conception and vision: by means of this apparently simple opposition early critics and theorists of Cubism sought to explain the unprecedented departures from naturalism that characterized the new style in painting. In so doing, these theorists drew on one of the most fundamental antinomies in the history of art. The opposition between an art based on conceptual interpretation and an art based on more purely visual data had been adopted as early as the sixteenth century to define the differences between northern and southern Renaissance styles in Italy as well as the more general differences between the Italian and Dutch traditions. More recently, the Symbolists had argued that theirs was an art of ideas, in contrast to Impressionism, which they believed had remained mired in the minute transcription of mere sensations. At stake in this recurring opposition was the claim that by seeking to represent abstract concepts, or the ideal, artists did more than record or copy what they could see. In the process of abstraction, essential structures were distilled from accidental details to reveal truths that lay beneath the surface. Ultimately, it was asserted, the imagination triumphed over the hand, and the artist became a creator rather than a craftsman.

Similar arguments were made in defense of the Cubists by artists and critics alike. Georges Braque himself made one of the earliest known statements on this subject in early 1908 to an American interviewer, Gelett Burgess. Referring to a painting he had exhibited at the Salon des Indépendants under the title *Woman,* Braque asserted, "To portray every physical aspect of such a subject required three figures, much as the representation of a house requires a plan, an elevation and a section. . . . I want to expose the Absolute, and not merely the factitious woman."[1] The drawing Braque

gave Burgess as a record of the painting (R 3) shows three aspects of a single woman, as if a single perceptual view provided inadequate knowledge or conceptual possession. Only in the *Large Nude* of spring 1908 (R 5) did Braque attempt to combine multiple views of a woman into a single figure, giving the viewer more of the buttocks and back than would normally be available to vision. This opposition between conceptual knowledge and perception suggested a further opposition between enduring truths and merely momentary and superficial sensations. That such explanations were already in circulation as early as 1910 can be seen from the sarcasm of a relatively hostile critic such as Léon Werth, who claimed that he too "could invent a few definitive phrases on the art that must give the structure of things and must not confine itself to catching in a vague tremor the appearance and emotion of the moment, the eye's whim."[2]

Not until early 1912, however, did Jacques Rivière fully articulate the conception / vision antinomy, in an important essay titled "Present Tendencies in Painting." Rivière had seen the as-yet-unpublished text of Gleizes and Metzinger's forthcoming book *Du Cubisme* and had felt the need to assist these artists in clarifying their aims. Most notable is his analysis (and critique) of Cubist style as a means of achieving a conceptual or essential representation of things "as they are." According to Rivière,

the true purpose of painting is to represent objects as they really are; that is to say, differently from the way we see them. It tends always to give us their sensible *essence,* their presence; this is why the image it forms does not resemble their *appearance.* . . .

Let us now try to determine more precisely what sorts of transformation the painter must

impose on objects as he sees them in order to express them as they are. These transformations are both negative and positive: he must eliminate lighting and perspective, and he must replace them with other and more truly plastic values.[3]

Rivière proceeded to explain that lighting and perspective must be eliminated because they had the pernicious effect of altering the true or absolute form of objects according to a merely accidental (momentary, particular) set of conditions. Rather than serve as a means of revelation, as was commonly believed, "lighting prevents things from appearing as they are."[4] The use of perspective was subjected to a similar critique, for here too, Rivière argued, an accidental position in space must not be allowed to dissimulate the true form of an object: "A book, seen in perspective, can appear like a slender rectangular ribbon when it is in reality a regular hexahedron. And this deformation, which is that of objects placed in the forward plane, is benign compared to the mutilations that other objects undergo: partially masked, arbitrarily cut by those that precede them in the order of depth, they appear deformed, ridiculous, unrecognizable."[5] The aim of the artist, according to Rivière, was to overcome the particular, partial, and indeed distorted views provided by traditional painting and to achieve a total, synthetic, true representation of objects. This could be accomplished by recourse to the most revealing view of an object or to a synthesis of views. The artists in whom Rivière placed most faith for the future realization of his project for a new conceptual art were Derain, Dufy, La Fresnaye, Dunoyer de Segonzac, and above all, André Lhôte. Unfortunately, "Picasso, who for a moment seemed near to possessing genius, strayed into occult researches where it is impossible to follow him," and the work of Braque and the Puteaux

Cubists was not much better.[6] Already a gap between the theory (and Rivière's was the most cogently formulated theory of its time) and the work of the artists was beginning to make itself felt.

The criticism of Maurice Raynal, who was at home both in Montmartre and in Puteaux, was also organized by the prevailing opposition of conception and vision. In August of 1912, shortly before the opening of the *Section d'Or* exhibition, in which for the first time a collage was exhibited to the public, Raynal declared,

> The quest for truth has to be undertaken not merely with the aid of what we see, but of what we conceive. But since the time of the primitives, painters have chosen to render what they see in preference to what they conceive, and they have done so forgetting that nothing was less legitimate than external perception, nothing was [more] in contradiction with the laws of reason than visual sensation. . . . In painting, if one wishes to approach truth, one must concentrate only on the conceptions of the objects, for these alone are created without the aid of those inexhaustible sources of error, the senses.[7]

Unlike Rivière and others, who argued that by painting concepts artists returned to the very origins of art, Raynal believed that the need to imitate what one sees was a primitive instinct "and, in consequence, the antithesis of the higher aspirations of the mind."[8] Only an art of conception could provide a means of augmenting objective knowledge. Yet Raynal also adhered to the Symbolist view that the process of conceptualization would reveal the personality of the artist: "Each artist, according to his temperament and his individual ideas of painting, will give the lines the directions that he, in his independent judgement, considers necessary. It is in this part of the work that the art-

ist's personality will be affirmed most clearly."[9]

Thus, by October 1912, when Gleizes and Metzinger's now-famous volume *Du Cubisme* appeared, followed in the spring of 1913 by Apollinaire's *Les peintres cubistes,* the opposition of conception and vision in the critical literature of the period was well established. Indeed, the explanatory force of this formulation seemed incontestable, although individuals argued about some basic assumptions.[10] While acknowledging the necessity of rejecting imitation, for example, Gleizes and Metzinger took issue with Rivière's postulate that a single true form of an object existed. For these artists, there could be no objective knowledge of reality independent of individual sensation and perception. They expressed their amazement that, "well-meaning critics try to explain the remarkable difference between the forms attributed to nature and those of modern painting by a desire to represent things not as they appear, but as they are. As they are! How are they, what are they? According to them, the object possesses an absolute form, an essential form, and we should suppress chiaroscuro and traditional perspective in order to present it. What simplicity! An object has not one absolute form; it has many. It has as many as there are planes in the domain of signification."[11] For Gleizes and Metzinger, the essential could be sought only within the subjectivity of the artist. Apollinaire was largely in agreement. He defined "authentic Cubism" as "the art of depicting new wholes with formal elements borrowed not from the reality of vision, but from that of conception."[12] The secret aim of the Cubist painters, he believed, was to create pure, plastic works of art, but like Gleizes, Metzinger, and Raynal, he insisted that the new "pure painting" would affirm the personality of the artist. Writing in defense of Picasso's use of collage materials, for example, Apollinaire asserted that "these strange,

uncouth and ill-matching materials become noble because the artist confers on them his own strong and sensitive personality."[13] The ideal, for these artists and critics, was an art in which objective reality and subjective conception coincided in a single, pure work of art. No one at this period seems to have questioned, however, that the goal of the artist should be the representation of a truth more noble than that provided by mere vision.

To a large extent, the critical opposition of conception and vision, as it was formulated by contemporary theorists and artists, has continued to dominate subsequent interpretations of Cubism. Yet, as we have seen, this framework does not provide an adequate means of understanding the collages of Picasso. In these works Picasso instituted a systematic play of the real and represented in which the notion of truth is always undermined. And although Picasso's forms seem to issue from the mind rather than from vision, this does not imply that an essential or true structure has been revealed. Indeed, the juxtaposition of opposing formal elements—figure and ground, transparent and opaque forms, machine-printed and hand-drawn elements—which characterizes Picasso's work from 1912 to 1914 precludes such a possibility. For these oppositions point to the relational, diacritical nature of pictorial signifiers within a given representational system, thereby negating a substantive or essential link to the signified (or to the referent in the world beyond the frame).

The collage practice of Braque and Gris, however, *can* be elucidated according to the terms of the conception / vision dichotomy. These artists, whose attitudes in many ways remained more traditional than those of Picasso, continued to be concerned with the possibility of finding a true means of representation. For both Braque and Gris, the

use of collage techniques was part of a broader attempt to overcome the limitations of an art based on the imitation of appearances. What had to be rejected was the notion that copying was a valid artistic enterprise, and for both artists this was most clearly exemplified by the trompe l'oeil tradition. Yet the solutions proposed by Braque differed in crucial ways from those of Gris. In Braque's work, trompe l'oeil wallpaper is turned against itself, in a sense, and made to stand not for visual appearances but for a verifiable tactile reality. This corresponds to Braque's belief that the sense of touch is more reliable than that of sight. For Gris, on the other hand, collage elements are at first given a more purely negative role: they represent the artist's refusal to copy images that are already flat and therefore serve to highlight the more creative aspects of Gris's conceptual schema. In Gris's later collages, wallpaper, labels, newspapers, and so forth are put to more varied uses. This new freedom eventually culminates in a series of highly decorative compositions in 1914.

The interesting fact is that, despite the avowed intention of both Braque and Gris to make conceptual works of art, in the course of their work the distinction between conception and vision became more and more difficult to maintain. Braque tried to represent the "simple facts of the mind" by eliminating the distorting effects of chiaroscuro and perspective. Yet the tactile sensations he wished to substitute for visual sensations remain accessible only to vision. Gris conceived the workings of conception as analogous to the operation of a prism, filtering and refracting forms according to a pre-established grid. Thus, for both artists, the purity of conception is represented as a form of purified vision. Under close scrutiny, then, the previously clear distinction between conception and vision

begins to collapse—conception becomes indistinguishable from a certain kind of seeing, and seeing is understood as an act of the mind. It is the collage practice of Braque and Gris that allows us to witness this paradoxical enactment and dissolution of the structural antithesis between conception and vision.

Indeed, Braque's earliest papiers collés, in which the artist used primarily faux bois wallpaper in conjunction with charcoal drawing in order to engage the opposition of vision and conception as well as that of vision and touch, represent a telling and highly coherent moment in his oeuvre. In his attempt to negate pictorial illusion, Braque drew on two possible antinomies to vision: the conceptual and the tactile. If faux bois wallpaper became his preferred material in the early papiers collés, it was because it seemed capable of signifying both the conceptual and the tactile at once. By late 1913, however, Braque had begun to use a wide variety of materials as collage elements, following Picasso's practice, and the issues central to his earlier work seem to have been, at least in part, abandoned.

The Certainties of Faux Bois: Braque's Early Papiers Collés

L'Art est fait pour troubler, la Science rassure.
—Georges Braque, *Le jour et la nuit*

In 1917, in his earliest recorded statement on the invention of papier collé, Braque made the surprising assertion that the pasting of faux bois paper to his picture surface had given him a feeling of certainty.[14] This paradoxical, yet apparently nonironical, conjunction of the term *certainty* and the term *faux,* which designates both that which is false and that which is an imitation, requires some interpretation. According to the traditional explanation,

first proposed by Kahnweiler,[15] Braque introduced objects from the real world into his painting in order to rescue the increasingly hermetic Cubism of 1910–12 from near abstraction. This interpretation relates the use of collage materials to the earlier use of trompe l'oeil details in Analytic Cubism as a device to assist the puzzled viewer in deciphering the subject matter of the work. It has also been argued that the technique of pasting paper to the pictorial support was a means of calling attention to the flat, material reality of the work of art.[16] Compelling as these readings have been, they fail to consider the specific nature of Braque's preferred collage material, faux bois wallpaper, and its relation to the overall Cubist project of subjecting conventional modes of illusionistic representation to scrutiny and subversion. Indeed, it would seem a curious paradox if faux bois wallpaper, so patently not the thing itself but a cheap, machine-made simulacrum of wood paneling, could signify certainty for Braque. And if Braque must introduce trompe l'oeil details and materials to restore a sense of realism to his works, what then is the overall status of representation based on resemblance in Cubism?

To begin to answer this question, one must turn to a wider context of art-critical discourse on the nature and means of representation, which had been in crisis since the mid-nineteenth century in France. This crisis was precipitated in large measure by Romanticism's challenge to academic norms and values in painting, which eventually caused the classical distinction between an imitation and a copy to collapse.[17] In early nineteenth-century classical theory, the copy had referred to the servile repetition of an original, whereas the imitation had called for masterful translation, copying with a difference.[18] By the mid-nineteenth century in France, however, the growing emphasis on

originality and individual expression made the principle of imitation based on the mastery of classical conventions anathema to avant-garde artists. When Charles Blanc tried to reestablish the authority of the old categories, he did so with a revised vocabulary, now opposing the "ideal" to the "real."[19] Whereas the ideal ran the risk of resulting in lifeless abstraction, the real, like the mere copy of earlier classical theory, seemed devoid of art itself.[20]

Gustave Flaubert parodied the mid-nineteenth-century anxiety of copying in his posthumously published work, *Bouvard and Pécuchet*. The antiheroes of his novel, two former copy clerks who have inherited a fortune, spend most of the narrative attempting to acquire objective and total knowledge of the universe through a systematic study of a great many scientific and philosophical disciplines. Admitting defeat in the end, they revert to what they know best, copying. No longer certain even of what to copy, they fix on those familiar objects that would later turn up in Cubist collages as well: "They copy papers haphazardly, everything they find, tobacco pouches, old newspapers, posters, torn books, etc. (real items and their imitations. Typical of each category). . . . Onward! Enough speculation! Keep on copying! The page must be filled. . . . There are nothing but facts—and phenomena. Final bliss."[21] The (inevitable) failure to construct a conceptual framework for the acquisition of knowledge, it would seem, produces obsessive, mindless copying.

Copying, however, insofar as it could take on the positive sense of artlessness, that is, of direct vision and a sincere unmediated response to nature, became part of the rhetorical stance of many late nineteenth-century artists. The Impressionists, for example, often described themselves as simply

copying what they saw, implying by this a rejection of academic conventions. Avant-garde artists during this period tended to distinguish idiosyncratic, highly subjective copying from trompe l'oeil painting, in which the personality of the artist was effaced. In this, they found themselves on common ground with academic theorists. Interestingly, trompe l'oeil painting, considered to be the last word in imitation, was rejected by artists and theoreticians in all camps during the late nineteenth and early twentieth centuries in France. Trompe l'oeil painting was criticized by academic theorists for failing to idealize nature and for negating the fundamental condition of art, that is, that it be perceived as a representation rather than as the object represented. According to Charles Blanc, for example, "Just as it is true that man is powerless to imitate materially inimitable nature, and that in the art of the painter natural objects are introduced, not for what they themselves represent, but in order to represent a conception of the artist; so is it true, in the end, that the sign is a conventional means of expression rather than an absolutely imitative process, for the final degree of imitation is precisely that where it no longer signifies anything."[22] Trompe l'oeil was also rejected by the Naturalists for suppressing the temperament of the artist, and by the Symbolists for adhering to mere concrete appearances and thereby denying the resources of allusion and suggestion. Albert Aurier, for example, in calling for an "ideistic" art of the symbol, specifically rejected the material realism of trompe l'oeil: "The artist, of necessity, will have the task of carefully avoiding this antinomy of all art: the concrete truth, the illusionism of trompe l'oeil, so that his picture will not give the false impression of nature which would act upon the spectator like nature herself, that is to say, without the possibility of

suggestion."[23] The vehemence with which all groups derided the public for its philistine pleasures in eye-fooling illusion reveals a perceived threat to the status of the artist in the realist expectations of the crowd.[24] The appeal of trompe l'oeil seemed to lie in admiration for a skill that might be learned and that could be measured according to criteria derived from everyday life. Late nineteenth- and early twentieth-century artists and theorists were unanimous in their belief that the artist should aspire to something more lofty and immaterial: a work of art should reflect the inspiration of genius rather than the artisan's display of craft, however magical. It is within this context, then, that Braque's appropriation of trompe l'oeil techniques and effects must be examined.

Braque's father and grandfather had been *peintre-décorateurs*, and the artist himself had been fully trained in the family *métier*. Braque's decision to become a fine artist, therefore, reveals a newfound ambition to create with the mind as well as with the hand. In an interview late in life, the artist cited Nietzsche's comment that "a goal is a servitude" and further remarked that his painting had always remained free of such servitude.[25] In taking this stance, Braque went so far as to deny even the intention to make paintings: "If I had an intention, it was to realize myself from day to day. In realizing myself, it turned out that what I make resembles a picture. Going along, I continued, voilà."[26] In spite of this rejection of the goal-oriented activity (and status) of the artisan, Braque retained a great respect for materials and techniques in his work, as many critics have noted.[27] According to Salmon, during one of the Cubists' frequent discussions on the subject of the inimitable in art, Braque amused his companions with tales of housepainters' tricks of the trade, especially their ability to "extract large

amounts of marble and precious wood from imaginary quarries and forests."[28] Although the craft of the house decorators was praised, Salmon emphasized the fact that "even so, nobody thought of imitating these skilful artisans."[29] It was considered preferable "to imitate the imitation," as Picasso had done when he used the housepainter's comb to translate fake wood grain into the wavy hair and mustache of a man in his portrait titled *The Poet* (D / R 499).[30]

Braque, too, in his early papiers collés strove to turn the technique of trompe l'oeil against itself, to make an art of illusion stand for an art of nonillusion, indeed, for an art of tactile presence. Like many of his contemporaries, Braque equated imitation with its most extreme manifestation, trompe l'oeil. "Verisimilitude," he asserted, "is nothing but trompe l'oeil."[31] Furthermore, for Braque truth and verisimilitude were incompatible. According to the artist, "One has to choose: something cannot be simultaneously true [*vrai*] and verisimilar [*vraisemblable*]."[32] Thus, for trompe l'oeil to signify a kind of truth, resemblance had to be emptied of the illusory and merely accidental properties of vision. For verisimilitude to be an instrument of certainty, it had to become a sign for an empirically verifiable, tactile experience of the world.

This ideal must also be seen as part of Braque's aim to reverse the values of Impressionism, which had privileged vision over touch. According to his own account, Braque spent his childhood in Le Havre "en pleine atmosphère impressionniste."[33] By the early twentieth century, Impressionism had become the dominant style in the salons and thus provided young, ambitious artists with a set of pictorial norms against which they might test their own ideas. Many of the innovations of early Cubism and indeed Braque's experiments with collage techniques can be interpreted as attempts to go beyond the perceived limitation of Impressionism to the transcription of mere visual sensation.

The Impressionists, in their search for a means of achieving a direct, unmediated response to nature, had defined pictorial truth in terms of the ideal of naive vision. This ideal corresponded to the traditional metaphor according to which the revelation of truth was analogous to the experience of seeing. Paradoxically, such seeing could be translated into painting only by the spontaneous, gestural mark of the artist. The immediacy of the artist's *touch,* conceived as an indexical marking of an individual's unique presence and response to nature, thus served as a sign for the immediacy of the artist's *vision*. By privileging vision over the other senses, the Impressionists also created a new form of pictorial unity. Color and line were welded into a single technique of sketchlike drawing, so that forms and contours emerged only as the result of color relationships. In the effort to render the effect of immediately perceived visual sensations, the depicted scene tended to flatten into a field of shimmering color, which denied the viewer a sense of the tactile presence of objects. Ideally, spectators of Impressionist art were invited to contemplate the spectacle before them in a moment of heightened stillness but not to imagine any form of physical interaction with the work. For Braque, however, to have a purely visual relationship to the world was to emulate the tourist; in contrast, he aspired to emulate the artilleryman: "Visual space separates objects from each other. Tactile space separates us from objects. The tourist looks at the site. The artilleryman hits the target (the trajectory is the prolongation of his arm.)"[34]

Reacting against Impressionist (and Neo-Impressionist) norms in his early Cubist paintings such as

Houses at L'Estaque of 1908 (R 14), Braque rejected a purely optical mode of representation and sought instead an art concerned with volume and the tangible space between objects. In an interview with Jacques Lassaigne, the artist recalled that "soon I even inverted perspective, the pyramid of forms, so that they might come towards me, so that they might reach the spectator."[35] Here the important point is that Braque sought to establish a new *physical* relation between the spectator and the work of art. After a series of nearly monochromatic landscapes, Braque turned his attention increasingly to still lifes, associating this genre with the depiction of objects that are within reach of the hand. According to the artist, "Then I began to make above all still lifes, because in nature there is a tactile space, I would say almost a manual space. Moreover, I have written: 'When a still life is no longer within reach of the hand, it ceases to be a still life.' . . . For me this corresponded to the desire that I have always had to touch the thing and not only to see it."[36] Braque's notion of the tactile, then, includes not only the material properties of objects, but the activity of the artist or spectator who must reach out to them through a materialized experience of space: "The trajectory is the prolongation of the arm." This activity of reaching out to the object, of touching it, is fully indexical, implying both physical contact and knowledge. In contrast, vision could only suggest the data of the third dimension inferentially.[37] Braque traced his interest in the still life and in the tactile qualities of space itself to his earlier practice of painting landscapes *en plein air:* "Moreover, I worked after nature. This is even what directed me towards the still life. There I found a more objective element than landscape. The discovery of the tactile space that put my arm in motion before the landscape in-

vited me to look for an even closer, palpable contact."[38]

Thus Braque attempted to reverse the late nineteenth-century hierarchy which privileged vision over touch as a mode of knowledge.[39] By the summer of 1912 he began to mix sand, metal shavings, and other substances with his paint as a device to call attention to the materiality of the canvas surface and, in some instances, as a means of creating literal rather than illusionistic depth upon it. In the painting *The Fruitdish* (fig. 4), which probably immediately preceded Braque's first papier collé, the artist used sand in a remarkably literal fashion to establish slight relief on the highlighted area of each grape, but he also scattered it in other areas. The imitation wood grain wallpaper Braque incorporated into his earliest papier collé, *Fruit Dish and Glass* (fig. 2), in September 1912 functioned similarly, as a sign for the tactile, material quality of wood, although now independently of any shape or position in space this wood might have. The oblong fragments of wallpaper are carefully positioned at the extremities of Braque's composition, where they signify the wood grain paneling of the wall behind the still life as well as the drawer of the table upon which the still life rests. Yet the pieces of paper that suggest the paneling of the back wall refuse to remain in the distance, since they are plainly visible as flat elements lying on top of the paper support and on the same forward plane as the drawer.[40] For Braque, the wood grain paper undermines spatial relations, can be both figure and ground at once, and is conceived as a sign for material substance independently of its location in space. Later Braque recalled, "It was this very strong taste for material itself that led me to consider the possibilities of material. I wanted to make of touch a form of material."[41]

In addition, the use of sand, metal shavings, saw-dust, and faux bois paper allowed Braque to make color appear as an effect of material substance, rather than as an accidental effect of light. Freed from a previously subordinate role within a unified system of representation, texture and color now functioned independently of other pictorial signifiers. In an interview with Dora Vallier, the artist explained, "I saw how much color depends on material. Take an example: dip two pieces of white cloth, but of different material, in the same pigment; their color will be different. It goes without saying that this dependence, which links color and material, is even more perceptible in painting. And what pleased me very much was precisely this 'materiality' that I got from the different materials that I introduced into my pictures."[42] Braque's aim in linking color and material was to discover the true local color of each material, independently of light and form. As the artist put it, "Color acts simultaneously with form, but has nothing to do with it."[43] The fanciful and often arbitrary use of color in Picasso's early collages reveals the difference of his approach from that of Braque. Because he was not interested in local color, Picasso's guitars and violins are as likely to be constructed of variously colored papers, musical scores, flowered wallpaper, or newspaper as of faux bois wallpaper. *Guitar and Wineglass* of late 1912 (fig. 7), which includes faux bois paper along with other colored and printed papers, and *Bar Table with Guitar* of spring 1913 (fig. 68) are exemplary in this regard.

Braque's early papiers collés also tend to be far simpler than those of Picasso, perhaps in order to allow the difference between the signs of vision and touch to be clearly established. In papiers collés such as *Still Life BACH* (fig. 41) and *Still Life with Violin* (fig. 69), both of 1912, the colored wood

grain wallpaper, limited to a few simple, oblong fragments, opposes the comparatively more ethereal, fading lines of charcoal drawing. One can still detect the remnants of traditional perspectival diminution and modeling in the scaffolding of charcoal drawing, but the Renaissance system of representation now appears in a state of disarray. Arbitrarily fragmented contours and contradictory areas of modeling no longer form a coherent or rationalized view of nature. Significantly, in *Still Life with Violin* Braque chose to varnish the wood grain paper, thereby heightening its sheen (as if it were a real piece of wood) and emphasizing its material presence in relation to the more fragile drawing.[44]

When in 1913 Braque began to explore the spatial relations between collage elements, he insisted on establishing these relations in an empirical fashion. In *Still Life with Tenora* (fig. 70), for example, he created literal relations in depth through simple overlapping, as if other, more visual means could provide only unreliable data.[45] The charcoal drawing, weaving its way in and out of the framework of overlapping papers, once again counters the simplicity of these relations with an elusive rendering of forms that seem to hover in space and to pass through and across the firmly anchored paper rectangles. Here, however, we encounter one of the paradoxes of Braque's early papier collé practice, for in fragmenting his drawing into bits of chiaroscuro and perspective, Braque has transformed these classical devices for representing the data of vision into conceptual emblems. In *Black and White Collage* (fig. 71), overlapping itself becomes a matter of illusion, the drawing once again threatening to subvert a sure sense of figure and ground.

By deploying form, color, and line as independent elements, Braque negated the Impressionist mode of perceiving form and line as the effects of

68. Pablo Picasso, *Bar Table with Guitar,* spring
1913, chalk and pasted and pinned papers. Private
collection.

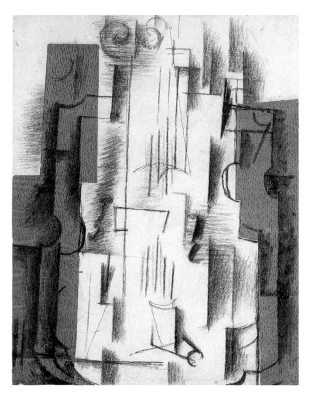

69. Georges Braque, *Still Life with Violin,* 1912, pasted paper and charcoal on paper. Yale University Art Gallery. The Leonard C. Hanna, Jr., Susan Vanderpoel Clark, and Edith M. K. Wetmore Funds.

70. Georges Braque, *Still Life with Tenora,* 1913, pasted paper and charcoal on paper. Collection, The Museum of Modern Art, New York. Nelson A. Rockefeller Bequest.

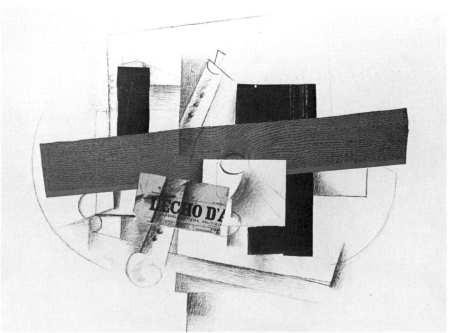

juxtaposed colors. In so doing, he also severed the essential unity of color and form posited by Matisse, who believed these pictorial elements necessarily modified and influenced each other in the viewer's perception of the whole. Matisse explained this notion, which had been of principal importance in the development of Fauvism, to Tériade in the following terms: "Here are the ideas of that time: Construction by colored surfaces. Search for intensity of color, subject matter being unimportant. Reaction against the diffusion of local tone in light. Light is not suppressed, but is expressed by a harmony of intensely colored surfaces. . . . To be noted: the color was proportioned to the form. Form was modified, according to the reaction of the adjacent areas of color. For expression comes from the colored surface which the spectator perceives as a whole."[46] Braque, however, chose not to emphasize the subjective nature of the encounter between self and world, central to late nineteenth-century aesthetics and still the motivating force of Fauvism. Rather than strive to establish a single effect and thereby affirm the unity of the perceiving subject, Braque conceived his pictorial elements as disjunctive signs which constitute an object through accretion. And, as we have seen, these signs were then set into opposition. Most typically, the literal flatness and uninflected color of the faux bois paper contradict the fragmentary indications of shape and volume provided by the monochromatic drawing. At times, as exemplified by *Still Life with Guitar* (fig. 72), the drawing proceeds as if on a unified, transparent ground, ignoring the boundaries of the faux bois paper. At other times, it engages in a play of mutual interference with the fragments of wallpaper, as when the flat, pasted paper appears to cast a shadow at its lower edge.

Braque's reversal, in his early papiers collés, of the prevailing Impressionist hierarchy of the senses corresponds to a related shift in the definition and valuation of pictorial deformation. Late nineteenth-century artists and critics had placed a positive value on what they called *déformation,* seeing in the very awkwardness of an artist's drawing or facture the sign of a strong subjective response

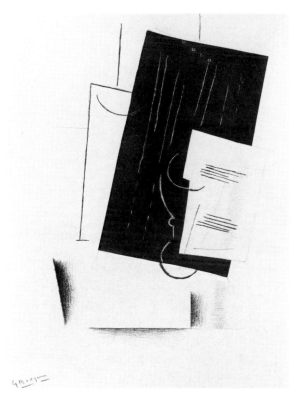

71. Georges Braque, *Black and White Collage,* 1913, pasted paper, charcoal and white chalk on paper. Yale University Art Gallery, Gift of Collection Société Anonyme.

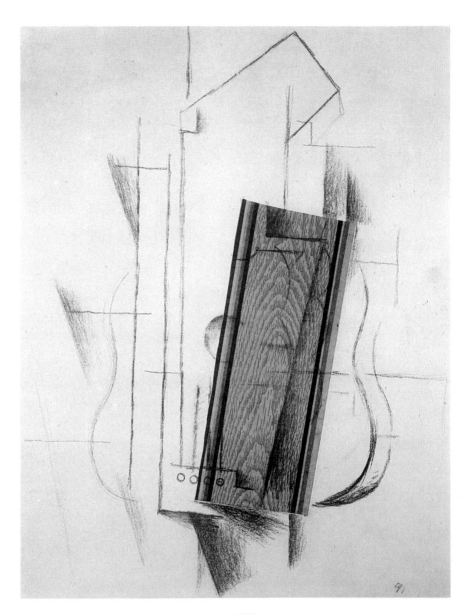

72. Georges Braque, *Still Life with Guitar,* 1912, pasted paper and charcoal on paper. Jucker Collection, Milan.

to nature. It was in the artist's deformations or departures from academic norms of drawing, spatial construction, and chiaroscuro that his or her originality was most easily detected. By the early twentieth century, however, the meaning of deformation had undergone a marked shift, which entailed a concomitant negative valuation. For early Cubist theorists, deformation was understood as the inevitable by-product of the depiction of depth on a flat surface. Thus perspective, a representational system devised to reproduce the effects of vision, came to be considered a distortion from the known, absolute shape of an object. As Braque put it, "The senses deform, the mind forms."[47] Where vision no longer seemed to give access to truth, tactile sensations assumed the privileged role of providing reliable information about things in the world. Braque's goal seems to have been to discover a means of representation that would avoid the deformations of perspectival illusion, while conveying a strong sense of the material presence of objects. The fragments of trompe l'oeil wallpaper he glued to his paper supports eventually came to serve this purpose in two ways. First, as flat, representational elements they were not subject to perspectival deformation and in fact established a firm counterpoint to the depiction of depth in other areas of the work. In this they resembled the letters Braque had introduced into his painting in 1911, of which he said, "They were forms that could not be deformed because, being flat, the letters were outside of space and their presence in the painting, by contrast, permitted one to distinguish the objects that were situated in space from those that were outside of space."[48] Second, the faux bois paper represented the color and texture of wood as objectively given statements, unmodified by accidental effects of light. Thus, although still a form of

trompe l'oeil, the faux bois paper seemed immune to the distorting power of vision. It made its effect through the "simplicity of the facts" and for Braque seemed to be a creation of the mind.[49]

In this context, the principle of resemblance, of iconic representation exemplified in the bits of trompe l'oeil wallpaper, takes on a new meaning. These fragments of wallpaper are no longer parts of an organic whole, and therefore resist the viewer's impulse to read them as naturally motivated signs. Resemblance, now a product of cheap, technical processes, seems to become a conventional sign by its very origin in mechanical reproduction. Here, where one might expect a display of skill, the artist's hand is nearly absent, given only the fairly perfunctory task of cutting and positioning the paper. The faux bois paper, moreover, is merely one kind of sign among others, and the possibility or impossibility of synthesizing all the information provided devolves onto the viewer. As resemblance is rendered problematic, the spectator is invited to test the data of vision by recourse to the sense of touch. As Braque once stated, "It is not enough to make someone see what one has painted, one must also make him touch it."[50] Ironically, this was the traditional means of testing trompe l'oeil painting as well. But where a conventionally unified trompe l'oeil painting might fool a spectator into reacting to the depicted scene as if it were real, the viewer of a Braque papier collé will test it to verify which of two contradictory systems of illusion corresponds to the facts. Unlike the legendary grapes painted by Zeuxis, which so easily tricked a bird into pecking at them, the hand-drawn, crudely modeled grapes in Braque's first papier collé, the *Fruitdish and Glass* (fig. 2), must compete with the trompe l'oeil effects of mass-produced wallpaper. Ultimately, divergent modes of imitation cast imitation itself into doubt, and the spectator who

reaches out to this work will discover that the paradox with which we began has been not resolved, but only heightened. The status of the faux bois paper remains uncertain: is it true because it evades the distortions of perspective and the accidental effects of chiaroscuro? or false because it is, after all, only faux bois and not wood? What is compelling in the end is this very resistance to interpretation, this uncertainty.

Juan Gris: Conceptual Prisms

Here is the man who has meditated on everything modern, here is the painter who wants to conceive only new structures, whose aim is to draw or paint nothing but materially pure forms.
—Guillaume Apollinaire, *Méditations esthétiques, les peintres cubistes*

Juan Gris made only two collages during the fall of 1912, *Le Lavabo* (fig. 20) and *The Watch* (fig. 73), yet in these two works a great deal of what would be the artist's distinctive and highly thoughtful approach to collage can be seen. Gris had these two complex works ready for the Section d'Or exhibition sometime before 1 October 1912, so it is likely that he had begun work on them during the summer of 1912.[51] The inspiration for *Le Lavabo* and *The Watch,* then, must be sought in the collages Picasso had executed during the previous spring rather than in the papiers collés of Braque.[52] And indeed, the literal use to which Gris put his collage materials in these early works is more closely related to Picasso's experiments with chair-caning and a stamp than to the contemporaneous but independent work of either Picasso or Braque.

Gris's first two collages can also be distinguished from the collages Picasso and Braque were making during the fall of 1912 in that they are large, imposing works, executed for the most part in oil on canvas. Thus they retain the look of painting and, what is more, address the viewer in the guise of traditional still life allegories; a crudely illusionistic curtain representing the artifices of realism is drawn to the side, as if to make available to the viewer the knowledge that comes of vision. Yet the world revealed through this classical gesture is ambiguous and contradictory, composed of fragmentary forms and shapes that have been compressed into a shallow space. Two apparently incompatible worlds, one referring to a natural, everyday mode of vision, the other to the Cubist mode of reordering the elements of vision according to conceptual schemas, are thus brought into paradoxical proximity and are forced to share the same pictorial arena. If they seem to coexist harmoniously, it is because of the extraordinary sense of balance and symmetry Gris achieved in organizing each composition. Nonetheless, a hierarchy exists in the relationship between the order of visual facts and the order of the artist's imagination; it is the latter which takes center stage and is presented as that which has been revealed. As we have seen, the motif of the pulled-back curtain and tassel rendered in mock trompe l'oeil had already been put to similar use in several works by Picasso and Braque in 1911 and early 1912. In adapting this motif to a new pictorial context, however, Gris amplified its role as an emblem of traditional illusion.[53] In *Le Lavabo* and *The Watch,* the curvilinear, crudely modeled, quasi-organic forms of the allegorical curtain stand in stark opposition to the flattened, geometrical forms of the view thus presented. This opposition calls the viewer's attention to the duality of vision and conception, which emerges as the governing paradigm of Gris's art.[54]

Of these first two collages by Gris, *Le Lavabo* received the most attention by reviewers of the Section d'Or exhibition.[55] The fragments of mirror and

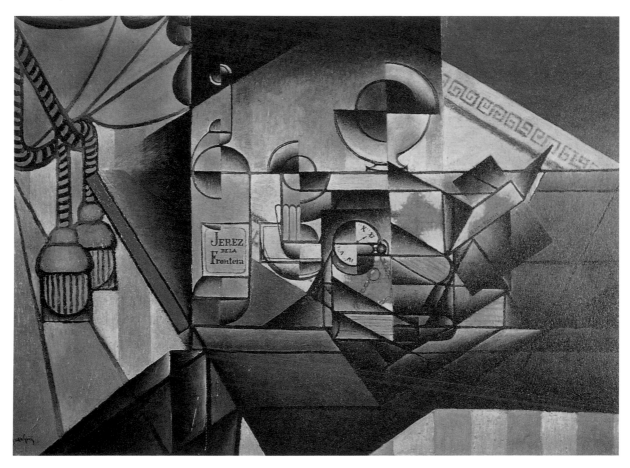

73. Juan Gris, *The Watch,* September 1912, oil and
pasted paper on canvas. Private collection.

the bits of printed paper affixed to this canvas caused something of a sensation, as they must have been calculated to do. But their appearance within this work was carefully considered, and consequently the collage has the clarity and precision of a logical proof. The bits of paper are labels carefully cut out and glued to the canvas in lieu of painted representations. As Raynal explained, it would have been a useless labor to reproduce these labels since they were already flat images, and the artist therefore would only too easily have been able to copy them.[56] The most expedient solution was simply to appropriate the existing image, but not without altering it in some way in order to demonstrate the transformative will of the artist. This reasoning accords well with the allegorical presentation of the work as a whole, which seems to juxtapose the notion of trompe l'oeil, which might be defined as a similar kind of useless copying, with a clearly superior, conceptual mode of representation. The critics, however, did not dispute this point, possibly because the inclusion of mirror fragments seemed more disturbing. The meaning of this strange intrusion from the real world was explained to the public in an anonymous notice that appeared in *Gil Blas* on 1 October 1912 to announce the forthcoming Section d'Or exhibition:

> It appears that it is impossible, for a conscientious artist, to reproduce a mirror on a canvas. If one wants to make a perfect imitation of it, this seems, in effect, actually impossible. One cannot render the brilliance of a mirror, and as it reflects the thousands of objects that pass in front of it, one cannot, unless one is a Futurist, reproduce them all. As a result of this quite curious line of reasoning, the Cubist Juan Gris has decided not to proceed with the use of tricks. In order to paint a well-equipped dressing table, he has quite simply glued a real mirror to his picture.[57]

Despite this rationale, many critics remained hostile to Gris's innovation. Louis Vauxcelles denounced it as a facile, mechanical solution,[58] and

Gustave Kahn, writing in the *Mercure de France,* saw both the mirror and the bits of text as antipictorial intrusions which could only be the products of a "baroque" (strange, deformed) fantasy: "Yet if, before the Cubist effort, one remains inclined to the most favorable sympathy, it is not yet the time to admire; it would be necessary, moreover, that one renounced certain baroque fantasies, the insertion of the glitter of glass in pictures, that one did not seek to make others believe that a number or a printed character has a pictorial value."[59]

The emphasis in all of the criticism of Gris's collages, favorable or not, seems to have been on the strangeness of the artist's thought process and of his departure from the prevailing norm of the materially and visually unified work of art. The critics seemed to sense that in executing these works Gris was rejecting several of the most fundamental assumptions that formed the basis of the Renaissance tradition. Gris had spent the months preceding the Section d'Or exhibition joining in the theoretical discussions held in Puteaux at the home of Jacques Villon. Many of the artists who would later exhibit together at the Galerie la Boétie participated in these discussions, whose subjects ranged from the fourth dimension and the golden section to the theories of Leonardo and Alberti.[60] In taking up the motifs of the drawn-back curtain and the mirror in *Le Lavabo,* Gris probably intended to refute the theories of both Leonardo and Alberti. For Alberti, in arguing that painters should concern themselves with rendering the visual aspect of things in the world, had likened the picture plane both to an open window and to the mirrorlike surface of a pool of water.[61] Similarly, in *A Treatise on Painting* Leonardo compared the pictorial surface to a window and to a mirror.[62] In Gris's collage both metaphors are shown to fail: the pulled-back curtain does not reveal a plausible simulacrum of the visual world, and the fragments of a real mirror point to the impossibility of treating a static pictorial field as if it were a medium of passive reflection. On the other hand, Gris would have found a curious confirmation of his ideas regarding the value of copying ready-made images in the third section of

Alberti's *Della pittura*. Here the author advised artists who would copy the work of others (rather than study nature directly) to copy sculpture instead of painting. According to Alberti, "nothing more can be acquired from paintings but the knowledge of how to imitate them; from sculpture you learn to imitate it and how to recognize and draw the lights."[63] Alberti suggested in this passage that only in the translation of a three-dimensional scene or object to the two-dimensional picture plane would the artist find scope for a demonstration of his artistry. To "imitate" a painting was merely to reproduce an existing two-dimensional image, a matter of no great difficulty. Gris would certainly have concurred, even though he rejected other aspects of Alberti's theory.

Gris made this point even more explicitly in two collages executed during the spring of 1913, *Violin and Engraving* (fig. 74) and *The Guitar* (fig. 75). In both of these works Gris introduced an actual work of art, in the form of a print, which he carefully cut to fit into the fragmentary shape of a painted frame. In *Violin and Engraving,* the picture thus constructed seems to hang from an illusionistically rendered nail in the upper right corner of the canvas. Here again Gris adapted a motif found in certain late 1909–10 paintings of Braque to his own particular ends and in the process modified its meaning. The nail in Gris's collage enhances the illusionism of this section of the canvas in opposition to the fragmentary forms that compose the rest of the composition. Yet that very illusionism is founded, paradoxically, on the appropriation of a previously existing image rather than on the work of copying. When Kahnweiler wrote to tell Gris that he had sold this collage, the artist responded by asserting that the new owner could substitute a picture of his own choosing for this engraving with

out affecting the true value of the work: "You are right, as a matter of fact; in principle the picture should be left as it is. But, once M. Brenner has acquired the picture, if he wants to substitute something else for this engraving—his portrait, for example—he is free to do so. It may look better or it may look worse, like changing the frame on a picture, but it won't upset the merits of the picture."[64] Kahnweiler, of course, demurred but only because he had not fully grasped (or did not agree with) the radical significance of Gris's statement. For Kahnweiler, as for most subsequent commentators,[65] no aspect of a Gris collage could be altered without destroying the integrity of the work's original appearance, and, it is implied, the integrity of the artist's conception. But Gris's letter to Kahnweiler asserts an opposing view. If the engraving could be replaced with another picture, it was because this engraving was the only part of the collage Gris *had not made*. The image was meaningful not in its own right, but as an emblem of the artist's refusal to copy. The original intervention of the artist, however, remained determining: if a new image were to be substituted for the engraving, it would have to conform to the engraving's shape and placement in order to preserve Gris's composition.[66] Ultimately, for Gris the "merits of the picture" lay in those elements that revealed the artist's imagination or invention: his choice of subject, composition, and facture. The merits of the picture, that is, lay everywhere *except* in the collage element. For this reason, the fragments of paper and mirror in Gris's early collages often have the character of descriptive additions or supplements to already complete compositional structures. The role played by these supplementary materials, however, is crucial to Gris's project, for they exemplify the principle of negation that allows the other, positive

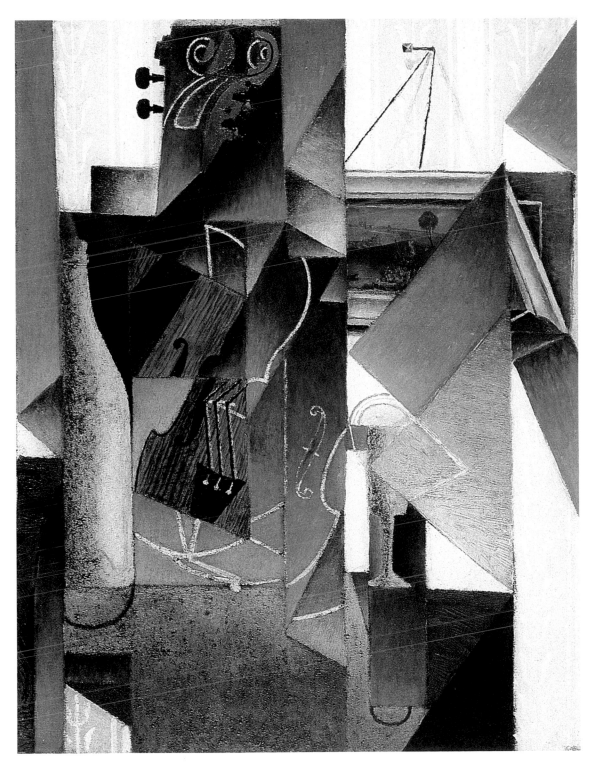

74. Juan Gris, *Violin and Engraving,* April 1913, oil,
sand, and pasted engraving on canvas. Private
collection.

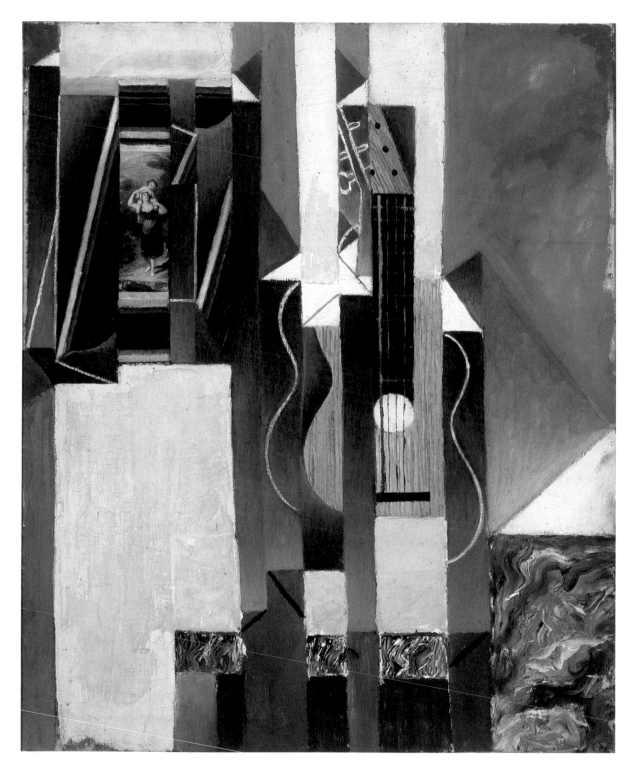

75. Juan Gris, *The Guitar,* 1913, oil and pasted paper on canvas. Musée National d'Art Moderne, Paris, Donation Louise et Michel Leiris.

aspects of Gris's painting to become visible.[67] But if the collage elements negate the value of copying in making paintings, they do not disturb the prevailing definition of oil painting itself.

It is evident, then, how different this practice of collage was from the contemporary collage practice of Picasso. Whereas Picasso allowed collage materials to displace the immediate, indexical marking of the artist's hand, Gris used the collage element as a means of emphasizing the originality and purity of his drawing and handling of paint surfaces. And whereas Picasso constructed his fragile collages out of the debris of popular culture, as if he could produce a work of art only from the elements of existing pictorial and verbal languages, Gris's forms appeared to issue directly from his mind. Both artists defined artistic invention as an imaginative process in which fragments of traditional illusion could play only a problematic and paradoxical role. But for Picasso, invention lay in regarding the work of art as a site for the intertextual play of appropriated elements, and these elements were allowed to retain all the marks of their prior existence in the world of commodities. Gris, on the other hand, seems to have regarded the picture plane as a field in which to reflect not the visual appearances of things as Alberti had advocated, but the purity of his conceptions. Of all the Cubists, Gris came closest to creating works of art structured by the prevailing critical antinomy of vision and conception. And in moving toward an art of conceptual purity, Gris transformed the pictorial surface from mirror into prism.

A measure of the difference that obtained between the work of Picasso, Braque, and Gris at this time can be taken by analyzing Gris's use of trompe l'oeil wood grain and marble. Like Picasso and Braque, Gris chose not to adopt the spontaneous,

flickering brushstroke of the Impressionists or the deliberately crude drawing and heightened color of the Fauves. Nonetheless, he did give a great deal of attention to creating rich, varied surfaces of textures and colors, each contained within a carefully delimited area defined by an a priori geometrical pattern. The care that Gris gave to elaborating these surfaces reveals the strong appeal that working with paint held for him. *The Siphon* (fig. 76) of spring 1913, a painting with additions of sand, exemplifies Gris's approach to the material aspect of his canvas. Instead of resorting to ready-made wood grain wallpaper or using a painter's comb to simulate wood grain as Picasso or Braque might have done, Gris created this texture by using a paintbrush and palette knife.[68] After applying oil paint to a section of his canvas and allowing it to dry partially, Gris inscribed the individual lines of the wood grain pattern on this surface with the aid of a palette knife, thereby establishing a literally furrowed texture. The areas of *faux marbre* were simulated by a similar process, using brush and knife to make swirling patterns and textures in a thickly painted surface. The sand in this work, with the exception of some lightly scattered in the upper left corner, was glued to a coloristically defined inner section of the siphon and seems to denote its pressurized contents. Given the precision of this work, it is difficult to imagine Gris echoing Picasso's words in his letter of 9 October 1912 to Braque: "I use a little dust against our horrible canvas."[69] For Gris, unlike Picasso, the use of collage techniques had not arisen from a desire to challenge the fine art status of oil painting. Indeed, most of Gris's collages were executed in oil on canvas, which the artist continued to regard as a privileged medium. Gris accorded a similar sense of dignity to his subjects, however humble. He

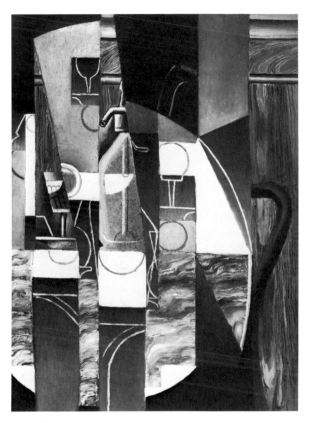

76. Juan Gris, The *Siphon,* 1913, oil and sand on canvas. Rose Art Museum, Brandeis University, Waltham, Mass. Gift of Edgar Kaufmann, Jr.

seemed to share Baudelaire's vision of the beauty of modern life and its quintessential objects.[70] The irony that permeates Picasso's inventions at this time is notably absent in the work of Gris, although it is not devoid of humor.

In striving to create a purely conceptual order on the blank space of the canvas, Gris generally proceeded by establishing an a priori gridlike structure within which fragments of objects take their places. The drawings and paintings that survive from 1910–11 exhibit a related impulse to generate broken contours and fragmentary views through the diagonal movement of what appear to be rays of light. In *Still Life* of 1911 (fig. 77), for example, a pattern of diagonal lines traverses the surface of the canvas from the upper left to the lower right corner. This pattern is counterbalanced by a series of tonal transitions that move in the opposite direction, so that a grid composed of intersecting diagonal sections interrupts and animates the simple shapes of Gris's vertically aligned still life objects. Through the operation of this grid, what would otherwise appear to be a series of arbitrarily broken outlines and strange elisions of figure and ground appears to be motivated or caused by the refractory power of light. The distortions that occur do not suggest an analysis of the constituent or essential aspects of the depicted objects, and they do not issue either from an attempt to splay out the sides of objects normally hidden from view or indeed from a combination of different views. The broken contours and repeated forms suggest, on the contrary, that the viewer must perceive these objects as if through the fracturing mechanism of a prism.

Gris continued to use this method of compositional organization in 1912, although for a time he preferred the greater stability of a grid of horizontal

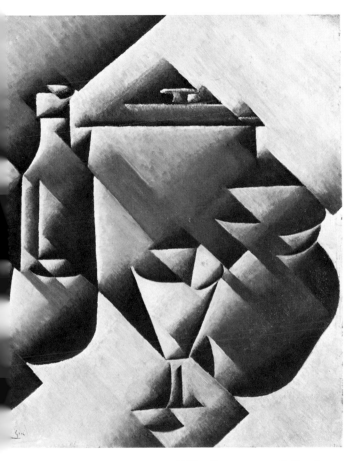

77. Juan Gris, *Still Life,* 1911, oil on canvas. Collection, The Museum of Modern Art, New York. Acquired through the Lillie P. Bliss Bequest.

and vertical lines. Both *Le Lavabo* and *The Watch* exhibit the black grillwork typical of this new style. Here, as in the earlier drawings, the pattern of lines determines a corresponding pattern of shifts and transformations in the depiction of objects. Unlike the earlier work, however, these lines at times cohere to or describe the edges of those objects. For the most part, the individual sections are treated as independent pictorial fields; in *The Watch,* for example, the splayed-out pages of the book contain discrete fragments of Apollinaire's poems. But these fragments are presided over by the unifying pattern of black lines. Moreover, a formal analogy seems to govern the progressively unfolded appearances of the book and a similar unfolding of the still life table. Thus the organic coherence of the mirror as surface, already fractured in *Le Lavabo,* gives way to the luminous repetitions of conceptual structures.

Gris's aspiration toward pictorial purity determined both his approach to collage and the final appearance of his works in this medium. He seems to have shared Braque's view that "nobility comes from contained emotion."[71] In a work by Gris, the sensuality of color is always controlled by the compositional grid, the spontaneity of brushwork denied by a desire for clarity and precision. As Gris told Kahnweiler in a letter of 1914, not without regret, "my spirit is too precise to sully a blue or to twist a straight line."[72] Collages such as *The Siphon* and *Glass of Beer and Playing Cards* (fig. 78), also of 1913, demonstrate this principle of restraint. Gris organized these works according to a dominating pattern of vertical strips. In *The Siphon,* the oval of the still life table, tilted upward to conform to the verticality of the picture plane, is superimposed upon a series of vertical strips, which in turn is traversed by a series of horizontal lines. One can

78. Juan Gris, *Glass of Beer and Playing Cards,* 1913, oil
and pasted paper on canvas. Columbus Museum of Art,
Ohio. Gift of Ferdinand Howald.

79. Pablo Picasso, *Glass and Bottle of Suze,* fall 1912,
pasted papers, charcoal, and gouache. Washington
University Gallery of Art, St. Louis.

compare the resulting structure with Picasso's col-
lage of autumn 1912, *Glass and Bottle of Suze* (fig.
79). Here, too, an oval tabletop has been superim-
posed upon—as well as imbedded within—a pat-
tern of vertical strips, this time in the form of
newspaper columns. The depicted scenes are also
similar: on each table rest a bottle and glass, part
of the wall of the room is represented, and a table
leg emerges from beneath each table as if seen in
cross-section (even though the tables have been
represented as if seen from above). Despite these
similarities, the two works are strikingly different,
having been constructed according to divergent
principles. Picasso assembled the bottle of Suze in
this collage from a variety of materials and, for-
mally, from an opposition of curvilinear and
straight contours. The viewer is not invited to re-
shuffle these elements in order to return them to a
prior state of naturalism or organic coherence. And
although something of a gridlike composition
emerges from the juxtaposition of newspaper col-
umns, this grid does not seem to govern the formal
play of Picasso's collage elements. In *The Siphon,*
on the other hand, it would be possible to shift
some of Gris's vertical strips and thereby to recon-
stitute a coherent view of certain objects or parts
of those objects. By moving the central panel up-
ward, for example, one could realign the white out-
line of the table leg with another portion of this
outline farther to the left. This realignment, how-
ever, would only create additional displacements
above, causing a rupture, for example, in the con-
tinuous line of the wainscoting. In *Glass of Beer
and Playing Cards,* a coherently silhouetted beer
mug might be established by shifting the vertical
band that constitutes the right side of the mug up-
ward so that the white outline becomes contiguous
with the outline of the fully modeled form of the

mug to its left. But this realignment would in turn
disalign the continuity between the blue curvature
on the orange wallpaper and the edge of the sand
to the right, both forms constituting a view from
above of the beer's foam. Changes or transforma-
tions in the appearance of an object seem to occur
in a number of directions: they follow the alternat-
ing rhythm of vertical bands but also the contra-
puntal system of horizontal bands. Occasionally
there is also a sense of transformations occurring
in depth, as if Gris had peeled away the surface of
certain vertical bands to reveal an alternate mode
of representation or point of view beneath.

Gris's structural grids operate in complex and
contradictory ways, at times fracturing objects
along predictable lines but elsewhere working
against this sense of preestablished order. Despite
the complexity and dominance of these surface
patterns, however, a sense of the prior integrity of
the depicted objects always seems to emerge. Gris
never allowed the objects depicted in his early
works to become submerged in a play of figure /
ground reversals or be subjected to the play of
purely arbitrary formal oppositions. Paradoxically,
although the order of the grids and the order of the
objects remain theoretically independent of each
other, the grid, by providing the viewer with a
sense of motivation for the fragmentation and re-
construction of objects, simultaneously preserves a
sense of their integrity. To the extent that the dis-
parate views can be explained and the broken con-
tours potentially returned to an organically whole
representation, the object remains inviolate.

The grid was only one of the devices Gris
adopted as a means of unifying his compositions.
The use of repeated formal elements, including cir-
cles, contours, textures, and eventually entire ob-
jects, distributed in a rhythmic fashion across the

surface of the canvas also contributed to an effect of unity. This repetition of forms is a structural aspect of *The Watch* and becomes more complex in a work like *The Siphon,* in which even the textures of wood grain and marble are made to rhyme with each other. Maurice Raynal, writing in 1923, was the first to draw attention to this characteristic feature of Gris's art, which he called "la métaphore plastique."[73] Raynal's analysis, however, proceeds according to contradictory impulses. He asserts that Gris's "metaphors" should not be confused with "puns," which "do not derive from any constructive necessity."[74] Gris's metaphors, on the contrary, "contain a truth of judgment" about the objects they compare and in this sense are "legitimate."[75] At the same time, however, Raynal points out that Gris's "isomorphisms" are purely formal; if they appear within his art, it is because the artist has found them "necessary to the general harmony of his tableau."[76] Here, as in many critical texts of this period, a desire for a truthful representation of objects comes into conflict with an equally strong desire that the canvas preserve its formal autonomy, that it contain nothing but purely plastic elements. This contradiction, however, is a determining one for Gris as well, and thus Raynal's text helps to illuminate the tensions in Gris's art. Significantly, the growing emancipation of the decorative impulse in Gris's work, which culminated in his series of collages from 1914, was accompanied by a related tendency to pose the question of *le vrai et le faux* in art.

The series of collages Gris embarked on in the spring of 1914 is remarkable both for its material richness and for its compositional complexity. The new role played by the collage element in this series is symptomatic of the change in Gris's approach to pictorial construction. The collage element, which had previously been given only a supplementary status, now invades the entire field. The surfaces of collages such as *The Table* (fig. 80) and *Fruitdish and Carafe* (fig. 81) are nearly entirely covered with a wide variety of overlapping papers. These fragments, moreover, are now deployed in increasingly complex ways: the shape of a piece of paper may correspond to the shape of the depicted object or it may itself provide a ground for figuration, whether drawn, painted, or in the form of additional, superimposed collage elements. And Gris continued to appropriate materials for their literal representational function as mere images, as he had in his earliest collages. In *The Table,* for example, Gris glued a page of a *Fantômas* detective novel to his drawing of an open book and part of a real newspaper headline to his canvas in lieu of imitating these images with pencil or paintbrush. But these collage elements also take on a metaphoric value: the spectator's attempt to distinguish the true and the false (alluded to in the newspaper clipping) from the myriad paradoxical and contradictory clues contained in the collage may be compared (not without some humor) to the investigative work of the detective in the novel.

Gris also began to introduce fragments of paper for their descriptive or purely material value in the collages of 1914. In *Fruitdish and Carafe,* for example, Gris constructed a composite depiction of a carafe from a variety of partially superimposed materials. Sections of faux marbre and faux bois wallpaper, corresponding perhaps to the material substance of the table and wall, provide an already divided ground for the elaboration of further interpenetrating forms and material substances. Over this ground, Gris then glued several fragments of beige paper, which seem to denote various aspects of the inner circular structure of the carafe. And

80. Juan Gris, *The Table,* spring 1914, pasted paper and
gouache on canvas. Philadelphia Museum of Art. A. E.
Gallatin Collection.

81. Juan Gris, *Fruitdish and Carafe,* spring 1914, pasted
papers, charcoal, and gouache on canvas. Rijksmuseum
Kröller-Müller, Otterlo, The Netherlands.

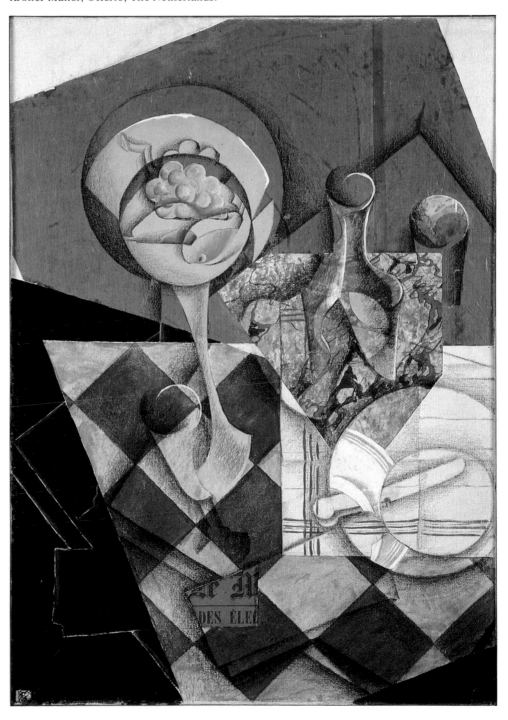

overlapping these fragments, Gris affixed a nearly transparent piece of paper (which he gave its own particular descriptive shape) to signify the carafe's transparency. Through this glazing, the viewer distinguishes the various layers of Gris's complex surface, which in places reveals even small portions of the canvas. A similar use of nearly transparent paper in numerous other collages of this period points to Gris's continuing concern with effects of light as well as to his growing interest in the expressive or inherent properties of materials.

Here a striking difference to the approach of Picasso toward materials must be noted. Whereas Picasso had demonstrated the multiplicity of ways in which the material aspect of a signifier is *not* transparent to its signified, Gris sought to show the coincidence of substance and meaning. For Gris, the transparency of glass was embodied (rather than arbitrarily signified) in the transparency of a paper whose two faces had merged and become one. Transparency, however, is always contingent on the presence of light. Gris made this clear in *The Table* by dividing his composition into two, antithetical zones; a dark blue and black peripheral zone is spotlighted by an oval field in the center. The projecting edges of the rectangular table in all four corners of the canvas have been constructed by pasting thin paper to the canvas ground and then painting both the paper and remaining canvas with the same dark blue paint. Shading, executed in charcoal over the paint, brings these nearly obliterated differences in texture to the threshold of visibility. In dramatic contrast, the golden tonality that pervades the central oval allows for a wide range of differences in material textures, patterns, weight, and color as well as subtleties of drawing to be perceived. As in Gris's earlier work, then, composi-

tional order in this and many other collages of 1914 continues to appear as an effect of illumination. The power of light provides the condition of possibility within which all other visible differences will be articulated.

Throughout the work of 1914 one can note a loosening of the a priori grid. This grid, nearly submerged in the weave of accumulated layers, now plays with a lighter, more nuanced touch across and through the structure of Gris's collages. Its effects can still be perceived, however, in the repetition of diagonal, horizontal, and vertical edges. These edges now owe a double allegiance, to the objects whose outlines they describe and to the decorative order of the surface. The doubling of objects, depicted as if they had been seen in divergent mirrors, causing one image to seem a paler reflection of the first and sometimes to intersect it at a forty-five-degree angle, is an aspect of the dual function of these edges. In *The Table* we find a virtual catalogue of these doubled depictions: two books, two bottles, two cigarettes, two glasses, two tables, two newspapers. In each case, a more fully modeled form of the object (ostensibly the more materially present version) is set at an angle to a more ghostly, disembodied image. The mysterious *dispar*[ition] of a man, alluded to (as well as enacted) in the partial effacement of both the word and image in a small fragment of newspaper, enhances the suggestion that an opposition prevails here between things which are materially present and things which are in the process of disappearing from sight. But is it possible to speak of a hierarchy of images, which would correspond to a prior hierarchy in the reliability of the senses? Should we understand these doubled images as instances of the true and the false, greater certainty to be accorded

(perhaps) to the more concretely defined, upright images?[77] This would be to assimilate Gris's dualisms to those of Braque, specifically, to his valorization of touch over vision. In Gris's collages, however, the situation is more ambiguous. Notions of truth seem to be resolved in terms of the inherent properties of materials, which are available to both vision and touch, rather than to touch alone. The headline "LE VRAI ET LE FAUX" terminates in the word "CHIC" and refers, appropriately, given this context, to matters of style in Paris.[78] The doubling of appearances, always governed by the intersecting axes of vertical and horizontal lines, is also a matter of style, of decoration. Gris's repeated forms, which do not constitute true oppositions, might best be described as visual complements. The two images do not essentially contradict each other, except in terms of placement, but this is a function of the grid, not of the formal elements as such.

There are some partial exceptions to this rule. In *The Table,* Gris represents the still life table as both an upright oval, which coheres to the vertical plane of the canvas, and as a rectangular table receding in depth. Although the disparity in point of view might be explained as an attempt to give the spectator more information about the table than a single view could provide, the contradiction between an oval and a rectangular table can only work to undermine the spectator's confidence that any information at all about the table has been provided. This opposition, long central to Picasso's still lifes, Gris adapted to good effect in *The Table,* although in doing so he gave it a new burden of meaning: the metaphorical opposition between a realm of shadows and a realm filled with light. In another collage of this series, *The Bottle of Banyuls*

(fig. 82), Gris established an opposition à la Picasso in the construction of the bottle by juxtaposing partly overlapping, contradictory formal elements: an opaque, straight-edged shape lies beneath and slightly to the left of a transparent, curvilinear shape. Gris enhanced this difference by giving the straight-edged, speckled bottle a flipped-up, round top, in contrast to its striped alternate, which displays a flat top. Yet this opposition, which negates the possibility of a transparent or unambiguous relation between the pictorial signifier and its referent, is in turn undermined by Gris's use of materials. For Gris, characteristically, has used the transparency of a certain kind of paper to signify the transparency of glass. There is, therefore, in this and many other Gris collages, an ambiguity in the way pictorial forms and materials are understood to signify; at times they seem to operate according to arbitrary formal oppositions (which deny the possibility of a substantive relation between signifier and referent), while at other times they seem to be motivated by the inherent properties of material substances.

Increasingly in these works, the enumeration of the physical aspects of objects, the multiplication of materials, and the attention to two-dimensional patterns works toward the creation of a unified, decorative effect. In March of 1915, Gris wrote to Kahnweiler to express his view about the progress he had made in his work of the previous months. Kahnweiler, having been out of the country at the outbreak of World War I, had taken refuge in Switzerland and therefore had not seen any of the works Gris had executed since the summer of 1914. Gris wrote, "I believe that I have been making, for some time, quite some progress, and that my canvases begin to have a unity that they lacked. They

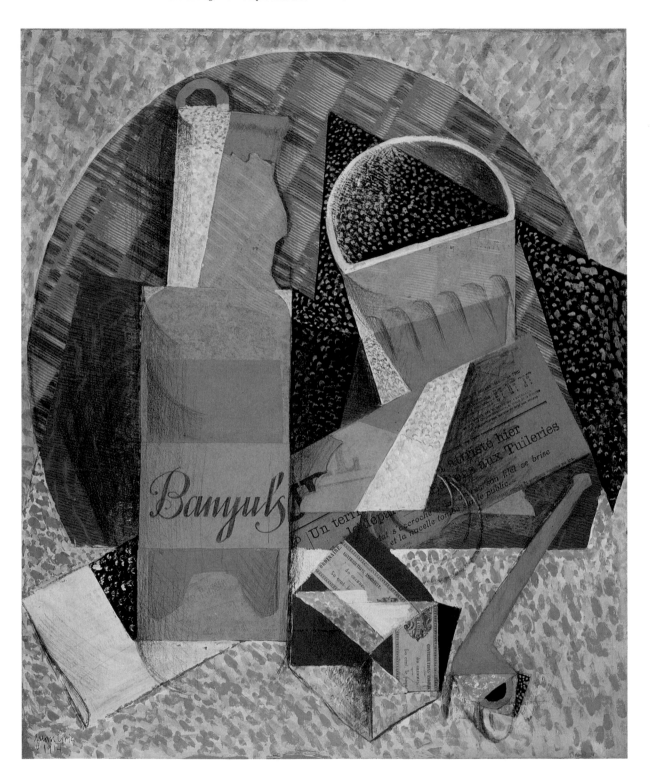

82. Juan Gris, *The Bottle of Banyuls,* 1914, pasted papers, oil, charcoal, gouache, and pencil on canvas. Kunstmuseum Bern. Hermann and Margrit Rupf Stiftung.

are no longer those inventories of objects that so discouraged me previously."[79] Later, in 1921, Gris would write to Kahnweiler that his work, despite the dealer's disavowal, was indeed decorative: "Clearly it is decoration. One need not be afraid of words when one knows what they signify, but all painting has always been decoration."[80]

As Gris's collages evolved toward an ever-greater decorative richness, the a priori integrity of the object, a characteristic of his earlier work, began to dissolve in the complexity of elaborated surfaces (fig. 82). The order of the grid, the conceptual prism that had been manifest in Gris's earliest works, now permeates the structure of representation so that the order of the grid and the order of the object can no longer be distinguished. This new unity, however, works to undermine the vision / conception polarity that had previously been a governing principle of Gris's art. The structural metaphor of the prism understands conceptual purity in terms of a purified vision. The repetitions, displacements, broken contours, and fragmentation generated by the operation of the prism, which stands for the reflective creativity of the mind, are nevertheless presented as being analogous to the visible play of light through a faceted form. In this, Gris's aesthetic of purity resembles that of the Symbolist poet Mallarmé, for whom "the prismatic subdivisions of the Idea"[81] also served as a metaphor of creation: "Poetry consisting in *creating,* one must capture in the human spirit the states of mind, the gleaming flashes of a purity so absolute that, well sung and brought into the light, they constitute in effect the jewels of man: here, there is symbol, there is creation, and the word poetry has its meaning: this is, in sum, the only possible human creation."[82]

Chapter 5

Cubist Collage,

the Public,

and the

Culture of

Commodities

History is inherent in aesthetic theory.
Its categories are radically historical.
—**Theodor Adorno,** *Aesthetic Theories*

When Apollinaire published four of Picasso's constructions in *Les Soirées de Paris* in November 1913, thirty-four of the journal's forty subscribers registered their outrage by canceling their subscriptions.[1] If this reaction seems surprising given the undoubtedly avant-garde character of the journal's readership, it provides us with a rare indication of the exceptional difficulty contemporary viewers had in accepting Cubist multimedia works. The absence of an enlightened public beyond the small circle of Picasso's fellow artists and friends is further confirmed in the fact that Picasso chose to keep many of his important collages and nearly all of his constructions throughout his life. As late as 1938, Gertrude Stein believed the small paper construction Picasso had given her to be the only surviving example of the artist's work of this type.[2]

If the negativity of public reaction to Picasso's constructions was extreme, it nevertheless followed the pattern of reception given to Cubism in general. The rejection of Braque's L'Estaque landscapes in 1908 by the Salon d'Automne's jury led him to join Picasso in refusing to exhibit his works in any of the Parisian salons.[3] Picasso, as is well known, had made it a consistent practice to avoid exhibiting in these salons from the time of his arrival in Paris in 1900, thereby consciously choosing to forego the most common method for achieving recognition open to a young, ambitious artist.[4] Both artists preferred to sell their works through the small number of dealers who would represent them. Not all of the dealers who had been willing to take Picasso's works before his Cubist period, however, would continue to do so. For example, Vollard, the dealer who had given Picasso his first one-man exhibition in Paris in 1901 and who later bought many of his Blue and Rose period works, did not find Cubism to his liking.[5] By 1912, there-

fore, shortly after the invention of papier collé, Kahnweiler succeeded in acquiring exclusive rights to the entire production of Picasso and Braque, in part because there was not much competition from other dealers. Gris, after exhibiting for the first time at the Salon des Indépendants in 1912 and later that year at La Section d'Or with the Puteaux Cubists, signed an exclusive contract with Kahnweiler in February 1913. Thereafter, he too refused to participate in any public exhibitions in Paris. This meant that, with the exception of Kahnweiler's one-man exhibition of Braque's rejected Salon d'Automne landscapes in 1908 and the few paintings Gris exhibited before signing his contract with Kahnweiler, the entire production of Cubist works by the three major Cubist artists remained out of view to all but a small number of friends, critics, and collectors.

Although this absence may have increased the public's misunderstanding of the aims and achievements of these artists, it also seems to have been a shrewd manoeuver in terms of contemporary exhibition conditions and the workings of the market. The Salon des Indépendants, for example, was completely open, and any artist who paid the small entrance fee could exhibit at least two paintings. This soon led to a problem of increasing numbers of exhibitors, many of them presenting mediocre works. An astonishing 1,182 artists participated in 1910, while by 1914 the number had risen to 1320.[6] Young painters who hoped to make a reputation and attract buyers faced the risk of being lost in the large number of works exhibited. Occasionally artists could overcome these conditions by controlling the hanging arrangements, as the Puteaux Cubists did in 1911 when they succeeded in exhibiting as a group in the famous *Salle 41*. Successful efforts of this sort to attract critical attention were

rare, however, and Picasso, Braque, and Gris, who were assured an income by Kahnweiler, may have been wise to abstain from such public demonstrations. Critics never failed to notice their absence from the salons and frequently cited Picasso as the inventor of Cubism despite his unwillingness to associate himself with his "followers," the Puteaux Cubists. The result was that the Puteaux Cubists were more available to the public, and the theories they promoted as well as the criticism they received tended to stand for Cubism as a whole in the eyes of the public. A mystique developed about those Cubist artists who refused to exhibit and whose work was constantly referred to in the writings of the many poets and critics in their circle of friends. As early as 1909, Picasso's works began to command relatively high prices, and he was able to move from his studio in the Bateau-Lavoir to the boulevard de Clichy, where, according to Fernande Olivier, he established a bourgeois way of life.[7] Braque's circumstances also improved, although more slowly than Picasso's, in part because his production was much lower. Gris, on the other hand, remained impoverished during most of his brief life.

Kahnweiler explained the Cubists' decision not to exhibit in the Parisian salons (a decision he had encouraged) as being motivated by the artists' need for the time and tranquility to work. The exhibition he gave Braque's early Cubist landscapes in 1908, which had given rise to the first use of the word *cube*, was his last. The small but devoted number of collectors interested in the Cubists' works sufficed to keep the gallery and painters alive.[8] Kahnweiler recalled with pride in his memoirs the complete absence of advertising, including newspaper announcements, gallery exhibitions, or even window displays as means of promoting the

careers of his artists (although he did frequently send their works to foreign exhibitions).[9] The withdrawal from the public sphere, then, was not only commercially advantageous, after a certain point, but reflected the disdain of the artists and their dealer for the predictably hostile reaction of the critics and the "crowd." According to Kahnweiler,

> We never again exhibited publicly, which will well prove to you the absolute contempt in which we held not only criticism, but also the great crowd. . . .
>
> For at that time, people went to the Independents to get mad or to laugh. In front of certain pictures there would be groups of people writhing with laughter or howling with rage. We had no desire to expose ourselves either to their furor or to their laughter; so we didn't show the pictures.[10]

Picasso, Braque, and Gris took the hostility of the public for granted and met it with defiance.[11] The *je m'en foutisme* of Picasso in particular was already well established by the Cubist period. In response to a letter from Kahnweiler in which the dealer told Picasso that one of his most loyal *amateurs,* Wilhelm Uhde, did not like his most recent pictures with Ripolin enamel and flags, the artist wrote, "That's fine. Let him not like it! At this rate we'll disgust the whole world."[12] Picasso's letter, dated 17 June 1912, refers to the paintings he had executed that spring just after his return from Le Havre at the end of April. For the first time in these works, after several years of sober color schemes, Picasso had introduced the bright colors of the French flag and the slogan "Notre Avenir est dans l'Air," taking these elements from the title page of a French propaganda brochure put out by the military.[13] These paintings were the direct forerunners of the *Still Life with Chair-Caning* and the develop-

ment of collage, which would test the limits of many other friends and critics as well.

Certainly there was a measure of what both Kahnweiler and Olivier have called heroism in the persistence of these artists, especially during their period of severe financial difficulty. Before gaining his contract with Kahnweiler, Gris had occasionally earned money by providing illustrations for popular satirical magazines in Spain and France, including *L'Assiette au Beurre, Le Charivari, Le Témoin, Le Cri de Paris, Blanco y Negro,* and *Madrid Cómico*. As soon as he was able to, however, he gave up this practice and turned his attention increasingly to pure painting.[14] According to Fernande Olivier, Picasso refused the offers he received to do such illustrations, even when he was most destitute. "During a period of great distress [1904–05], it was proposed that he do an *Assiette au Beurre,* a humorous journal popular at the time and which would have paid between seven and eight hundred francs. He refused energetically, even heroically."[15] Picasso's refusal to work for the satirical magazines, despite the fact that he had been greatly influenced just a few years earlier by the illustrations of Steinlen and the posters of Toulouse-Lautrec, suggests that he believed artistic integrity to be incompatible with making art for commercial purposes or mass consumption. This attitude, common at the time, was based on the notion that a work of art should find its raison d'être exclusively within itself and that ideally it should not be subject to external constraints. Braque, in choosing to abandon his planned career as a peintre-décorateur, affirmed his aspiration to create autonomous works of art rather than *décorations* whose ends were predetermined.

Such positions would appear to be typical of turn-of-the-century attitudes toward the hierarchical distinctions between fine and applied art, between pure painting and illustration, and between fine art and popular art. Yet if this is true, how can we explain the invention of collage, which challenged these hierarchical distinctions by introducing the techniques and materials of popular culture and the mass media into the previously pure domain of painting?[16] How are we to understand the Cubists' apparent embrace of popular culture with its clichéd sentiments and commercial forms and their simultaneous refusal to be influenced by popular taste or the exigencies of the market? Any interpretation of the collage revolution must account for this paradoxical attitude toward early twentieth-century cultural hierarchies and market conditions.

The relation of Cubist works to the changing market and exhibition conditions of the early twentieth century is a subject that has recently attracted the interest of a growing number of critics and art historians. An exhibition at the Tate Gallery in 1983 titled *The Essential Cubism: Braque, Picasso and Their Friends, 1907–1920,* for example, featured a catalogue essay by Douglas Cooper outlining the early history of the market for Cubist works.[17] The following year the Centre Georges Pompidou celebrated the important role of Kahnweiler in promoting the understanding and sale of Cubist works through his efforts as exhibition organizer, publisher, and writer of theoretical texts.[18] And an interesting analysis by Michael Baxandall of ways of constructing historical explanations of pictures contains a chapter that deals with the "structural cues and choices" available to Picasso between 1906 and 1910 because of contemporary market conditions.[19] All of these studies contain valuable information and raise important issues, but they tend to remain schematic and do not come to terms with the specific ways in which the formal appearance, technique, or subject matter of Cubist

works reflects or comments on the prevailing market characteristics of the period.

A recent, ambitious interpretation by David Cottington does deal with these issues in greater detail but comes to conclusions that I find problematic in that they effectively obliterate the avant-garde or oppositional character of Picasso's Cubist production.[20] Cottington argues that Picasso's post-1909 works, executed when his financial situation had become secure, reveal a conservative bias in their delight in formal invention and in their appeal to a self-selected group of cognoscenti. For Cottington this group was "ideologically homogeneous" and sought work that preserved the values of the French pictorial tradition—"the tradition of the Louvre" as Uhde put it.[21] But can one really ignore the differences between a relatively conservative collector / dealer like Uhde, who disliked Picasso's use of Ripolin enamel and flags, and a collector / writer like Gertrude Stein, for whom Picasso's ephemeral assemblages of everyday objects already constituted art? Picasso, as we know from his letter to Kahnweiler, was defiant in his response to Uhde's displeasure.[22] Nor does his comment to Braque as he began his exploration of sand and pasted paper techniques, that he was employing dust in defiance of the canvas,[23] suggest a conservative respect for the tradition of oil painting.

Picasso's collages and constructions were intended to subvert the conventions of oil painting as well as the hierarchical distinctions between high art and mass culture. The disgruntled readers of the November 1913 issue of *Les Soirées de Paris* certainly thought Picasso had gone too far in the creation of mixed-media constructions. And in early 1914 the Futurists found it necessary to argue over whether it was permissible for an artist simply to incorporate "untransformed" elements of every-day life into his art, as Boccioni maintained Picasso had done in his latest works.[24] Picasso, for his part, seems to have been self-confident enough to enjoy these controversies without altering his course. He continued to produce constructed works between 1912 and 1915, although none were sold.

Central to any analysis of Picasso's attitude toward the public and toward the tradition of fine art is the relation of his complex formal innovations to his use of mass-cultural artifacts. While the former would have been appreciated only by an elite circle of amateurs, the latter suggests an engagement with popular entertainments and discourses. For Cottington, formal invention always remains primary in Picasso's collages, mediating and distancing references to the social world beyond the frame. Although this is true (it is true of all art with varying degrees of emphasis), it leads Cottington finally to see in Cubist collage only a "colonization" of alternative cultural practices.[25] Here too, I would argue, the works themselves suggest a more complex and paradoxical relation to mass culture, one that illuminates the contradictions of the historical moment in which Picasso, Braque, and Gris found themselves.

In the light of contemporary social conditions and expectations about the production and place of art in society, many of the innovations of Cubist collage can be interpreted as a series of ironic refusals or negations. The practice of collage techniques indicates a denial of the precious, fine art status of traditional works of art as well as an attempt to subvert the seemingly inevitable process by which art becomes a commodity in the modern world. Cubist artists, therefore, share certain attitudes with their Symbolist predecessors, while rejecting others. Unlike the Symbolist generation of artists and poets, who had made it a matter of

moral and artistic integrity to withdraw from the proliferation of commercial mass culture and its instrumentalization of language and pictorial form, the Cubists called attention to these very developments. Their response to the marginalization of the artist and to the erosion of a genuine public (and private) sphere was to incorporate into their collages just those aspects of mass culture and communication that had seemed most debased to the fin de siècle sensibility: journalism as a form of rationalized writing for mass consumption, advertising and other techniques of market display, clichés and popular slogans as evidence of routinized cognition, and machine-made, cheap simulacra of fine or handcrafted materials. Collage works, by bringing these and other elements of commercial culture within the domain of painting and drawing, function as a critique, not only of prevailing market conditions, but also of the futility of the Symbolist response to these conditions. Nevertheless, the biting irony of the Cubist *inc*lusions reveals the enduring power of the Symbolist heritage and its *ex*clusions, its purist values and hierarchies, which (however paradoxically) the Cubists sought to negate.

The Work of Art and Its Destinations: The Museum and the Bourgeois Home

Although a subversive attitude toward the traditional requirements of museum quality art informs Picasso's collage practice from the very beginning, the most overt reference to the museum status of his own works occurs in a series of collages he executed in the spring of 1914. At this time he made three related collages on the theme of the picture of a picture: *Pipe and Musical Score* (fig. 83), *Glass and Bottle of Bass* (fig. 64), and *Bottle of Bass, Ace of Clubs, Pipe* (fig. 84). A fourth collage, *Glass* (figs.

85a, b), executed during the summer of 1914, also takes up this theme. The first three works were all created on a ground of wallpaper, have wallpaper frames, and exhibit small labels bearing the hand-printed inscription "PiCASSO." And in all four collages we find a centrally placed oval or rectangular piece of paper that represents both a picture hanging on a wallpapered wall and a still life table.

As I observed in chapter 3 in relation to *Glass and Bottle of Bass,* Picasso greatly enjoyed playing on the ambiguous status of the central oval or rectangular form, which functions both as the ground of the depicted still life and as a figure on the wallpaper ground. By shading the lower edge of the pasted paper in *Glass and Bottle of Bass,* Picasso enhanced the illusion that it projects slightly from the wallpaper ground, like a picture hanging on a wall. This illusion, however, is contradicted by the undisturbed, flowing contour of the bottle's shadow across the same lower right edge. Thus two different means of representing shadows, one as shading, the other as contour, work in opposition to each other.

A similar contradiction occurs in the other two collages of this series. In *Bottle of Bass, Ace of Clubs, Pipe,* the pipe extends onto the wallpaper ground at an angle like that of the bottle's shadow in *Glass and Bottle of Bass,* although here it seems to project outward toward the spectator as well. In *Pipe and Musical Score* the central collage element, this time rectangular in shape, seems to hover in front of the speckled wallpaper ground, an effect created by the shading along the left and lower edges. Another shadow, apparently cast by the pipe (although inverted in shape and position), is cut out of the same wallpaper as the ground. This shadow lies flatly across both grounds at the right edge, as if the patterned wallpaper ground had in-

83. Pablo Picasso, *Pipe and Musical Score,* spring 1914,
pasted papers, oil, and charcoal. Museum of Fine Arts,
Houston. Gift of Mr. and Mrs. Maurice McAshan.

84. Pablo Picasso, *Bottle of Bass, Ace of Clubs, Pipe,*
spring 1914, pasted papers and drawing. Photo:
Staatsgalerie Moderner Kunst Munich. Loan from
private collection.

85 a. Pablo Picasso, *Glass,* summer 1914, pasted papers
and gouache on paper, original state. Photo: Galerie
Louise Leiris, Paris.

85 b. Pablo Picasso, *Glass,* summer 1914, present state.
Jucker Collection, Milan.

vaded the picture hanging on it through a small gap along that edge. Two streaks of pointillist light, one composed of yellow and red dots, the other of blue and red dots, pass diagonally across the represented picture. They seem to stand for a rational, scientific understanding of light, which has been everywhere undermined in this collage. Partly confounded with the dotted pattern of the wallpaper, these rays of light seem to be a mere decorative embellishment, bearing no causal relationship to the depiction of light and shadow in the work. But if they do nothing to clarify the pictorial structure, they do direct the spectator's eyes, like a spotlight, to the small piece of paper at the lower edge on which Picasso inscribed his name.

This name, half-label, half-signature, reiterates the ambiguous status of the work itself. As a nameplate, the paper mockingly proclaims this collage, composed of cheap, counterfeit materials, to be a masterpiece worthy of a museum label (or of the labels dealers often put on paintings in imitation of museum practices). As signature, it asserts that this masterpiece is the creative expression of a unique individual, an assertion made problematic by the presence of so many machine-produced materials. By printing his name and conflating it with a picture label, Picasso further undermines its authority as an indexical sign for the revelation of the self. Instead, the signature appears as a conventional, already-written sign, like the printed letters "Ma Jolie" in the musical score above or the stenciled word "BASS" in the other two collages of this series. In analyzing the role of the "signature" in works such as these, one should remember that, at the suggestion of Braque, he and Picasso had not signed their works during 1910 and 1911. Such a practice certainly ran counter to prevailing notions of the value of originality, understood by avant-garde artists at this time as the most important—

and most saleable—quality of their art. According to contemporary theories, especially those inspired by Romantic aesthetics, it was precisely that which was most inimitable that was most valuable in a work of art. In 1910–11, however, Braque observed that it had become increasingly difficult to distinguish his work from that of Picasso, which seemed to render signatures obsolete. In an interview with Dora Vallier, Braque recalled, "I felt that the person of the painter shouldn't intervene and that consequently, the paintings should be anonymous. It was I who decided not to sign the canvases, and for a certain time, Picasso did the same. From the moment that someone could do the same thing as I, I thought that there was no difference between the paintings and that they should not be signed."[26] For Braque and Picasso in 1910–11, not signing canvases was a way of asserting the conceptual rather than the spontaneous or instinctual basis of Cubist art. During the collage period, it was also a way of pointing to the relation of works of art to other works of art, to previously existing representational codes, rather than to the individual, creative self. Thus when Picasso introduced his signature in the form of a nameplate, he did so with self-conscious irony about contemporary aesthetic theories of originality as well as contemporary market values. For the nameplate mocks not only the notion that a work of art reveals the unique temperament of an individual in an unmediated manner (like a signature), but also the bourgeois aspiration to possess the work of the master.

As pictures of framed pictures depicting still life paintings hanging on wallpapered walls, the collages in this series also present the viewer with some uncertainty about where these works depict themselves as hanging. The mock gilt frame and label may refer to a museum context, but the wallpaper suggests the wall of a bourgeois home. The two

settings seem to be conflated; in either case the work is depicted as being on exhibition by virtue of having been framed, labeled, and hung on a wall. Yet the prominent appearance of the wallpaper within the frame—and the importance given to the depiction of the wall by this means—raises the question of the status of these pictures as decorations.

Decorative wall paintings or the use of tapestries, of course, had always been beyond the means of all but the aristocracy and financial elite. With the invention of wallpaper, however, the ability to have decorated walls gradually came within the reach of the middle classes. Charles Blanc, in his influential *Grammaire des arts décoratifs* of 1867, expressed the contemporary view that wallpaper was above all a democratic art, designed to bring the pleasures of the beautiful to the masses. Among the decorative arts, Blanc cited wallpaper as one of

> the beautiful inventions of our times, . . . inspired by the thought of diminishing the privileges of fortune, allowing the greatest number of people to participate in the benefits of human industry and in the pleasures that the beautiful brings. It was natural moreover that the advent of democracy coincided with the almost universal desire to augment the well-being of the most numerous class and to invent for it, if not the equivalent of luxury, at least that which could give it the mirage of luxury.[27]

Praising the wallpaper industry for this accomplishment, Blanc went on to associate the coincidence of the democratizing force of the French Revolution with the new impulse given to the art of *papier peint* by the factories of Reveillon and Züber.[28] In reality, however, the manufacture of wallpaper in late eighteenth- and early nineteenth-century

France remained a time-consuming process, involving multiple block printing techniques and, at times, hand-coloring with stencils. French wallpaper during this period, considered by many to be its golden age, specialized in creating charming illusionistic *scènes* after the paintings of well-known artists. These scenes were composed of individually printed sheets which were then assembled, fixed to fabric, and pasted or tacked to the wall. Typically these scenes were hung on the portion of the wall above the chair rail and were framed by additional sheets printed with motifs derived from architectural ornament handbooks, including carved borders, friezes, and dados. In addition to the imitation of illusionistic views and architectural elements, French wallpaper during this period perfected techniques for imitating fabrics, marble, and wood grain.

During the 1840s, the invention of steam-powered, raised-surface revolving cylinders, which permitted printing on continuous paper, led to the development of cheaper, mass-produced wallpaper. By the 1880s these printing techniques had been augmented by photographic and lithographic processes, and wallpaper really did become the democratic art envisaged by Charles Blanc. The new technical means used to produce the wallpaper also had a number of aesthetic consequences. They encouraged the use of relatively small, repetitive patterns, and eventually the width of the rolls was also standardized. By the late nineteenth century, the French tradition of creating elaborate scenic wallpapers had been replaced by a new aesthetic that called for abstract, two-dimensional patterns. Because deep perspectives were, for the most part, not admissible, Blanc believed wallpaper should avoid imitating painting. Designers could, however, indulge their fancy in the exact replication of materials: "As long as the sensation obtained by these

beautiful industrial productions is not troubled at any point, is not marred by any misgivings, by any scruples of vision, it matters little that the substance be true, since the counterfeiting was not conceived, this time, with the intention of fleecing the purchaser, but, on the contrary, in order to multiply his pleasures by making the most of his resources."[29]

Blanc further advised that in the choice of wallpaper for a particular room, care should be taken to consider the overall atmosphere and whether the wallpaper was to be the primary decoration of the walls or a ground for other decorative objects. Here Blanc implicitly recognized the fact that whereas wallpaper had originally been invented as a substitute for mural painting or tapestry, by the late nineteenth century it was increasingly employed as a ground for additional decoration. If the wallpaper was intended to serve as a ground for other works of art, Blanc recommended papers that would not compete for the viewer's attention. In further distinguishing the wallpaper from the work of art, he emphasized the importance of the frame: "It is above all the frame that must detach paintings, engravings or drawings from the wallpaper, because once isolated by their framing, framed objects will have their full value if the background paper has nothing to attract the eye."[30] Nonetheless the entire wall, even where wallpaper served merely as a ground for other pictures, could be considered an aesthetic whole and could be framed with borders, just as the earlier illusionistic scenic views had been. Blanc credited some of the finest wallpaper manufacturers with creating sumptuous borders, imitating fabrics, tapestries, and even patterns from Chinese albums. These borders, according to Blanc, did nothing to destroy the unity and neutrality of the wallpaper ground.[31] They remained in vogue throughout the nineteenth century as a

cheap means of simulating more expensive, hand-carved dado rails and wainscoting, which were deemed essential to the pictorial definition of the wall. Picasso, in appropriating these borders for use as ersatz picture frames (both *for* and *in* his collages), was merely extending their traditional function as substitutes for costly, hand-carved borders.

As mechanical methods of production became the norm during the late nineteenth and early twentieth centuries, many critics and wallpaper designers decried what they felt was an inevitable debasement of the once-beautiful craftsman's art of making wallpaper. André Mare, a wallpaper designer who advocated a return to primitive wood-block printing methods, blamed contemporary mechanical techniques for the decline in the quality of wallpaper. Writing in the avant-garde journal *Montjoie!* in 1914, he asserted that "with the most rudimentary means of engraving, printing and materials, wallpaper has left us decors that one would wish to equal today.

For the last half-century, the use and perfection of machines have contributed to the suppression of all artistic interest. These researches are limited to the imitation of different materials (cretonnes, silks, velvets, leathers, etc.) and run counter to the designated goal."[32]

Just as the rolling press had displaced the mark of the craftsman's hand, a development that resulted in cheaper, standardized products, the character of the new middle-class clientele for wallpaper had also had its effect. Unlike the aristocracy, whose great salons had provided ample wall space for scenic views, the middle and lower class apartment dweller demanded more modest, repetitive patterns for smaller, private interiors. Even the poorest tenements often boasted some

sort of wallpaper decoration. Kahnweiler, in describing the condition of Picasso's studio at the Bateau-Lavoir on the occasion of his first visit there in 1907, recalled that "the wallpaper hung in tatters from the plank walls."[33]

Perhaps in memory of the Bateau-Lavoir days, the wallpaper in Picasso's collages is usually of the most ordinary type: stripes, floral patterns, borders. Frequently it is in very poor condition and gives the impression that the artist had only remnants at his disposal. Picasso emphasized this quality by cutting the paper crudely, mismatching the patterns when patching together several pieces, and spattering the glue so that it discolored the support. Braque and Gris, by comparison, were far more concerned with careful craftsmanship, even when manipulating these humble materials. No one would mistake this wallpaper for the luxury wallpapers that were occasionally granted the status of art in the *Salles décoratives* of the Salon d'Automne, where wallpaper by André Mare and Louis Süe could be seen, for example, or in the newly created Musée des arts décoratifs in the Pavillon de Marsan.[34] At most one could say (echoing Charles Blanc) that it gestured toward an appearance of luxury but fell short of achieving it. But it is precisely this contrast between the paper's obviously everyday, commercial, and indeed dilapidated appearance and the work of fine art to which it refers that reveals Picasso's critique of contemporary distinctions between handcrafted works of art and the products of mass culture. His use of this wallpaper as a cheap substitute for finer wallpaper, and indeed for the gilded frames that hung on the walls of bourgeois homes, is analogous to his use of a rope to frame *Still Life with Chair-Caning* or of oilcloth to represent chair-caning. There is both an element of wit in the artist's ability to see enough similarity to make the substitution and an element of irony in

the suggestion that a cheap, mass-produced material could become the formal equivalent of the finer material. But the ultimate irony may be that, like Duchamp's snowshovel, which now assumes its logical place within the museum, Picasso's counterfeit works of art have now been reframed in real, hand-carved frames and hung on pristine museum walls or in the homes of prominent collectors.[35] This is an outcome that Picasso undoubtedly foresaw.

Collage and Decoration

Picasso's series of collages on the theme of a picture representing a picture hanging on a wall occurs in the spring of 1914 when he was also beginning to introduce a variety of colorful, decorative patterns into his work. These collages, then, must also be considered within this context. They comment not only on the status of the work of art as decoration in the bourgeois home, but also on the play of decorative surfaces in the paintings of artists such as Van Gogh, Gauguin and the Nabis, Seurat, Matisse, and the Futurists.

For many Symbolist artists and theorists during the late nineteenth and early twentieth centuries, the term *décoration* had assumed a nearly mystical significance. It evoked the original, ideal status of painting and sculpture before the decline begun in the sixteenth century, when the plastic arts, still allied to the dominant forms of architecture, had played a central role in the cultural life of society. In an influential early essay of 1890, Maurice Denis expressed the Symbolist view that painting, at its origin, had been decoration; further, he held that the process of emancipation from the architectural support and the related development of trompe l'oeil were the causes of painting's current state of decadence:

In the beginning, the pure arabesque, as little trompe l'oeil as possible; a wall is empty: it is filled with marks, symmetrical in form, harmonious in color (stained glass, Egyptian paintings, Byzantine mosaics, Japanese hanging scrolls).

Then came the painted bas-relief (the metopes of Greek temples, the Medieval church).

Then antiquity's attempt at ornamental trompe l'oeil is taken up by the XVth century, replacing the painted bas relief with painting modeled in bas relief, which still, however, conserves the original idea of decoration. . . .

The perfection of this modeling: modeling in the round; this leads from the first Academies of the Carraccis to our decadence. Art is the illusion of relief.[36]

Albert Aurier, writing in 1891, echoed this view, equating "true" painting with decoration: "Decorative painting is, properly speaking, true painting. Painting can only have been created to *decorate* the banal walls of human edifices with thoughts, dreams and ideas. Easel painting is nothing but an illogical refinement invented to satisfy the fantasy or the commercial spirit of decadent civilizations."[37]

In the Symbolist historical schema, artists working during prescientific, preacademic periods had aspired to express emotions and spiritual truths, rather than merely to record natural appearances. As a result, when measured against academic standards, their art now appeared primitive, awkward, or marred by excessive *déformations*. Yet Symbolist artists and critics saw in these very departures and excesses signs of the naive or primitive artist's sincerity and of the work's expressive power. In order to restore to painting its former spiritual meaning, Symbolists such as Paul Gauguin, Paul Serusier, Maurice Denis, Albert Aurier, Charles Morice, and others advocated a return to a conception of art as decoration. Maurice Denis described and justified the art of the Symbolists in these very terms: "They wanted to lead art back to the simplicity of its beginning, when its decorative destination was still uncontested."[38]

The association of decoration with a view of art as expression became one of the guiding principles of Symbolism and other, allied movements. Artists who conceived their work as decoration tended to seek inspiration in medieval mural painting and stained glass, in primitive wood-cutting techniques, and in a number of non-Western artistic traditions, including Japanese prints and Egyptian wall painting. Their work emphasized subjective emotions and ideas expressed through simplified contours, the juxtaposition of unmodeled, bright colors, a flattened pictorial space, and a "synthetic" treatment of the whole. Frequently, in order to enhance the expressive quality of colors and forms, which were thought to be pictorial equivalents for feelings and ideas, the frame was incorporated into the overall composition of the work. Georges Seurat, in paintings such as *Sunday Afternoon on the Island of La Grande Jatte* and *Le Chahut*, painted a framing strip of pointillist dots around his pictures, so that even along the edges of his canvases the colors would be juxtaposed to their complementaries. And in some paintings, including *Le Chahut,* he extended this principle to include the actual frame, which thereby functions as an integral part of the work. Other artists, impressed by the logic of Seurat's framing devices, soon developed similar practices. In paintings by Van Gogh, Gauguin and the Nabis, colorful wallpaper patterns become integral compositional elements. These artists shared the belief that a decorative surface, achieved through simplified drawing, an avoidance of modeling, and reliance on the immediate effects of color would allow their paintings to become vehicles for the subjective expression of emotions or states of mind.

Similar attitudes could be found among a great many early twentieth-century artists, including, most notably, Henri Matisse. In a biographical note written in 1930, Matisse judged that his oeuvre before 1914 had been "above all decorative in character."[39] Like the Symbolists who had preceded him, Matisse equated a decorative style with the sincere expression of emotion. In 1912 he told Clara T. MacChesney that "a picture should, for me, always be decorative. While working I never try to think,

86. Henri Matisse, *Interior with Eggplants,* 1911, tempera on paper, original state with painted frame. Musée de Peinture et de Sculpture, Grenoble.

only to feel."[40] Some of the artist's most important paintings, including *La musique* and *La danse* of 1909–10, were originally commissioned as decorative works, and Matisse did not hesitate to exhibit them under the title "Decorative Panels."[41]

Matisse's aspiration to make decorative works of art culminated in 1911 in a series of four large interiors. These paintings, executed in the period following the artist's visit to an exhibition of Islamic art in Munich in the late summer of 1910, reveal a renewed interest in a flattened, symbolic space created through rich, luxurious effects of color and decorative patterning. *Interior with Eggplants* (fig. 86), one of Matisse's masterpieces of this period, exemplifies this decorative impulse taken to an extreme. The five-petal flower motif, which seems to originate in the small ochre wallpaper repair to the Japanese screen at the center, proliferates across all available surfaces, including the walls, carpet, and surrounding frame. The nearly dizzying array of patterns is organized, however, in terms of a play of complementary color, just as the composition is stabilized by an intricate system of interlocking rectangles. Among these rectangles are the frames of the window, mirror, and picture on the wall at the upper left, which provide the spectator with additional pictorial spaces, although not surprisingly the mirror fails to reflect the interior accurately, and the view out of the window, cut off at the right, has been transformed into another decorative pattern. The proliferation of patterns across the walls, carpet, and even onto the frame negates the illusion of a three-dimensional space unified within an enclosing border, in favor of creating a nonhierarchical *decorative* unity. Painting and decoration are conflated, as they are within the empty gold frame hanging on the wall, which encloses a section of wallpaper as if it were the equivalent of an easel painting. But this gold frame does not contain the work of art; the wallpaper flows centrifugally beyond its borders to invade the "faux cadre," suggesting the ideal of infinite extension.[42]

Picasso's collages of early 1914 may be compared to Matisse's decorative painting for the differences one can observe in the attitudes of the

two artists toward decoration. Matisse's Symbolist-inspired aspiration to make decorative works of art sprang from a retrospective ideal and revealed a sense of nostalgia for a lost golden age. Matisse conceived decorative painting as a means of creating a privileged, spiritual realm purified of all references to the preoccupations of everyday life. His paintings were intended to provide an occasion for a restorative contemplation of beauty within an intimate, perfectly unified environment: "What I dream of is an art of balance, of purity and serenity, devoid of troubling or depressing subject matter, an art which could be for every mental worker, for the businessman as well as the man of letters, for example, a soothing, calming influence on the mind, something which provides relaxation from fatigues and toil."[43]

In order to achieve a sense of purity and serenity in his decorative paintings, Matisse found it necessary to avoid allusions to contemporary commercial techniques. His own mode of production resembled that of the "primitive" artists whose inspiration he sought; like the works of these artists, his decorative paintings were meant to seem impervious to the industrial present. One of the dangers Matisse faced, however, was that the flat, simplified patterns and unmodeled colors he favored as purified means of symbolic expression were easily appropriated by mechanical techniques of reproduction. Despite the desire to affirm the uniqueness and purity of the individual's production, the decorative aesthetic found itself in undesired complicity with the design requirements of commercial, mass-produced imagery. This discovery became an occasion of disillusionment for Matisse, who had never conceived his decorative works as having a commercial afterlife:

Finally, after the rediscovery of the emotional and decorative properties of line and color by modern artists, we have seen our department stores invaded by materials, decorated in medleys of color, without moderation, without meaning. . . . These odd medleys of color and these lines were very irritating to those who knew what was going on and to the artists who had to employ these different means for the development of their form.

Finally all the eccentricities of commercial art were accepted (an extraordinary thing); the public was very flexible and the salesman would take them in by saying, when showing the goods: "This is modern."[44]

In this facile, market-driven form of imitation, Matisse saw only a meaningless profusion of color and line. Picasso, on the other hand, seemed to select collage materials precisely *for* their everyday, commercial associations. His works bring the viewer abruptly into the present and seem to mock the requirement that decorative techniques serve as an expression of the self or of the perceived essence of an object. Moreover, Picasso exploited the uncanny resemblance between the decorative motifs of fine artists and the debased products of commercial culture. The speckled wallpaper ground in *Pipe and Musical Score* (fig. 83), for example, imitates the surface structure of a Neo-Impressionist painting but has none of its expressive meaning. These wallpaper dots do not record carefully analyzed visual sensations, and they are not the pictorial equivalents of emotions or ideas. They are simply an abstract pattern suitable for machine reproduction. Similarly, the two hand-painted rays of pointillist light appear in Picasso's collage like citations from the art of the past. This self-conscious appropriation robs these decorative motifs of their

original significance; even as hand-drawn elements they remain second-hand, divorced from immediate experience. The manipulation of decorative motifs, understood in these terms, is essentially anti-Symbolist and antidecorative

Kahnweiler attributed the derisory attitude of the public toward Cubism to its failure to understand the antidecorative character of Cubist works of art: "People missed the real meaning of Cubism, which was a form of *writing* that was intended to be severe, consistent, and precise; they thought that it was merely a form of *decoration*."[45] The implication is that the public wanted works of art with immediate sensuous appeal to decorate its walls, works that, in Kahnweiler's terms, "remain on the wall."[46] Instead, in Cubism it found an art that aimed to engage the consciousness of the viewer on a deeper level. Indeed, for Kahnweiler, Cubism was above all a form of writing—that is, a conventional system of representation that, like any other, had to be learned: "If, as I maintain, painting is a form of writing, it is quite evident that all writing is a convention. One must therefore accept this convention, learn this writing. This is what generally occurs through simple familiarity."[47] Thus, unlike Symbolist artists, who asserted that ideally forms and colors should be pictorial equivalents of the artist's emotions and ideas and that communication should therefore occur naturally and universally, Kahnweiler stressed the process of familiarization required to decipher a Cubist work. According to this view, the spectator did not experience the work of art in the immediate, nondiscursive mode advocated by artists such as Van Gogh and Gauguin or by Matisse. On the contrary, the spectator was expected to engage in the difficult act of *reading*.

With the introduction of words and collage elements into the Cubist formal vocabulary, the analogy between Cubist pictorial signs and writing

became even more evident. The forms of writing that entered the Cubist pictorial field, moreover, tended to be those most obviously arbitrary or conventional in character: the writing of the newspapers, posters, labels, theater programs, menus, popular songs, advertisements. Most of these forms of writing were by nature anonymous and had originally operated within a popular, commercial context. Only Juan Gris, who aspired to a more purist, perhaps at times even Matissean art, occasionally incorporated the pages of a work of poetry into his collages. Picasso, who was well known for his love of poetry, and Braque, however, consistently sought out those forms of writing that were generally considered to be the obverse of poetry.

Mallarmé, Picasso, and the Newspaper as Commodity

The history of the newspaper in France closely parallels the history of wallpaper; both forms of cultural expression became increasingly democratized during the course of the nineteenth century under the pressure of industrialization and the development of mass-marketing techniques. Before the 1830s, newspapers, owing to their expensive subscription system, slow distribution outside of urban areas, and the lack of even minimal literacy among the majority of the French, had attracted a limited readership. In 1836, however, Emile de Girardin founded *La Presse,* the first successful low-cost, daily newspaper in France. The success of Girardin's innovation lay in his strategy of doubling circulation by cutting subscription costs in half.[48] This was achieved by supplementing subscription income with advertising and by attracting new readers through the invention of a new literary form, the *roman-feuilleton,* or serial novel. Here was a new form of literature, meant to be sold in

the streets.[49] The daily installments of these novels were an immediate success, encouraging many who had never before felt the need of a newspaper to subscribe. Once it was discovered that novels sold newspapers, the rest of the press hastened to imitate Girardin's formula.[50] A new form of commercial novel writing soon emerged in which the exigencies of serialization displaced older narrative structures.[51] Authors were careful to fit their installments to the allotted space, to end episodes on a note of suspense, and to fill their stories with intrigue, dramatic coincidence, violence, and bathos. A number of favored themes characterized the new form: the horror and fascination of the underworld, crime and social deviance, especially prostitution, the downfall and salvation of the poor and innocent. These novels engaged the popular imagination in a way that traditional literature, especially poetry, found extremely difficult to compete with. Alexandre Dumas's novel *Le Capitaine Paul* gained *Le Siècle* five thousand new subscribers in less than three weeks.[52] Eugène Sue's *Les Mystères de Paris,* published by *Le Journal des Débats* between 1842 and 1843, became the most widely read novel of the nineteenth century in France, far surpassing the novels of Balzac and Stendhal.[53]

During the course of the Second Empire, despite stringent government censorship, the publishing industry witnessed further expansion. Transported by railroads, newspapers now reached even remote rural areas, making urban culture more accessible and advancing the process of cultural homogenization. With the appearance of *Le Petit Journal* in 1863, the first paper to be printed on a rolling press and to be sold for a mere five centimes, it became possible for anyone to possess his or her own copy of a newspaper.[54] The circulation of local papers also rose dramatically, tripling after the Prussian

War and continuing to rise into the first decade of the twentieth century.[55] By the 1880s there were seventy daily newspapers in Paris alone, attesting to the emergence of a new mass audience for printed matter.[56] The phenomenal growth of the newspapers was accompanied by the growth of literacy among all classes, although the cities still outpaced the countryside. These developments had many profound effects, among them a blurring of the formerly precise boundaries between the literate and the illiterate and between the role of the journalist and that of the novelist, poet, or critic.

Prior to these transformations, it had been possible to distinguish between the gentility and lower classes in France at least partly on the basis of the ability to read. With the advent of nearly universal literacy by the end of the nineteenth century, however, mere reading could no longer provide a stable ground for class differences or cultural hierarchies. A new hierarchical opposition, however, gradually displaced the older one, now marking the differences between those who read newspapers and those who read books, especially books of poetry. This opposition became a determining one for the Symbolist generation of writers and poets, who conceived their writing as a form of protest against the penetration of the values and logic of the marketplace into the very structure and reception of literature.

Stéphane Mallarmé, who had experienced the growing marginalization of the poet in contemporary society and the erosion of a genuine public sphere for noncommercial writing, defined his own poetry as the "other" of the writing in the newspapers. "Poetry," he wrote in "The Evolution of Literature," "is everywhere in language where there is rhythm, everywhere except on posters and the back page of newspapers."[57] The vehemence of Mallarmé's denunciation of the newspaper and the

poster, a theme that appears throughout his critical essays, issued from his aversion to their commercial use of language. If he singled out the "back page" of the newspaper for special derision, it was because this was the page containing the greatest number of advertisements and *petites annonces*. For Mallarmé, then, the newspaper and the poster exemplified the prevailing tendency to transform language into a mere commodity, thereby rendering its qualitative value as symbol into mere exchange value. In "Crisis of Poetry," Mallarmé characterized all contemporary writing, with the exception of (pure) literature, as a form of journalism, which he further described as equivalent to the silent exchange of money:

One of the undeniable desires of my time is to separate, in view of their different purposes, the dual state of the word, crude or immediate here, there essential.

To narrate, to teach, even to describe, this is what is current, even though for each one, it would suffice perhaps to exchange human thought by taking or placing in the hand of others, silently, a coin; the elementary use of discourse caters to that universal *reporting,* in which, literature excepted,[58] all the genres of contemporary writing participate.[59]

What is more, journalistic writing had for some time encroached on the territory of literature proper. Owing to the popularity of the serial novel, true fiction ("fiction proprement dite") and imaginative narrative ("le récit imaginatif") could be found frolicking in the "well-frequented" pages of the dailies.[60] Mallarmé noted that the feuilleton, traditionally printed on the *rez-de-chaussée,* or "first floor," of the newspaper (that is, on the bottom quarter of the front page), now "supported the mass of the entire format," even displacing the

news, while "no one made allusion to verse."[61] It was in vivid contrast to the debased forms of journalistic writing, then, that Mallarmé conceived the purity and ideality of his unrealized project for a great "spiritual book." This contrast was most explicitly evoked by the metaphors Mallarmé used to describe the difference in the physical appearance of newspaper and book and the consequences this difference must have for the experience of reading. In his essay of 1895 "The Book: A Spiritual Instrument" Mallarmé wrote,

I . . . propose to examine, technically, how this rag [the newspaper] differs from the book, which is supreme. The newspaper provides an opening: literature[62] discharges itself there at will.

Now—

The foldings of a book have, with respect to the page printed large, an almost religious significance, which is less striking, however, than their thickness when they are piled together, offering a minuscule tomb, certainly, for the soul.[63]

Vis-à-vis the book, the newspaper is thin: its open pages, a mere parody of the pages of the book, contain no depth or hidden meanings. The religious significance of depth and foldings also implies a sexual metaphor, and Mallarmé compares the book to a virgin, whose folded leaves hide mysterious depths. The reader who cuts the pages is like the book's first lover, and reading, transfigured, becomes an act of consummation:

The virginal folding back of the book, once more, willing / lends for a sacrifice from which the red edges of ancient tomes once bled; the introduction of a weapon, or paper knife, to establish the taking of possession. . . . The folds will perpetuate a mark, intact, inviting one to open or close the page, according to the master. So blind and

negligible a process, the crime that is consummated, in the destruction of a frail inviolability.[64]

Thus, although marking the site of possession, for Mallarmé the cut folds of the book remain forever intact, pure, virginal.[65] By comparison, the newspaper is already defiled. To read a newspaper is to encounter the flat, open pages of the commodity, which, like the prostitute, disports itself with all comers. Nothing remains hidden, unknown, privileged: "The newspaper, its full sheet on display, acquires in the printing process an improper result, of plain, sloppy marking: no doubt, the striking and vulgar advantage of it, in everyone's view, lies in [*gise dans = gisant* = a recumbent effigy on a tomb] its mass production and circulation."[66]

For Mallarmé, the language of the newspaper also revealed its commercial servitude in the arbitrariness of the column format. He writes of the annoying and dangerous influence the newspaper has upon the book, citing "the monotonousness of its always unbearable columns, which are merely strung down the page by hundreds."[67] Marinetti, who sought in so many ways to reject his Symbolist heritage, would later praise the newspaper for compressing within its columns all the disparate events occurring simultaneously throughout the world in a single day.[68]

Mallarmé, of course, admitted ironically that the format of the book, too, was useless but dreamed of a new poetry that would overcome the arbitrariness of the vertical column as well as the arbitrariness of standard typography. This new poetry would also strive to guarantee a legitimate relation of sound to meaning. The poet deplored the perverse effects of "chance," [*le hasard*] which had put the sounds of the word *nuit,* so bright, and of the word *jour,* so sombre, in opposition to their meaning.[69] As Mallarmé conceived it, the task of poetry was to prevail over *le hasard,* to vanquish chance word by word,[70] but like so many poets and theorists in the Romantic and Symbolist tradition, he aspired to accomplish this goal in contradictory ways: by seeking to motivate the relation of signifier and signified through a conscious manipulation

of the aural and visual aspect of language and by negating the representational function of words.

As aspects of a dialectical process, these apparently incompatible aims were intimately linked. The effort toward motivation led Mallarmé to conceive poetry both as music and as a form of mimesis; yet the more poetry strove to become one with the thing signified, the more it seemed to become a thing in its own right. As a result of arranging words on a page so that they became images, with a calculated pictorial effect, the material presence of the page itself was emphasized, in negation of the absent referent. This attempt to breathe life into the signifier was paradoxically self-canceling, a mirroring of the second approach in which Mallarmé sought to deinstrumentalize language by obliterating reference to the exterior world altogether. Thus envisioned, the poem became a rarefied realm of pure, formal relationships. In practice, the tension between these two approaches was resolved only mythically, in the search for the pure and essential symbol. Mallarmé defined the symbol as infinitely disseminatory; not because the meanings that attach to it are arbitrary, like those of allegory, but because in the symbol, as in divine revelation, meaning must be both pointed to yet endlessly deferred.[71] The religious dimension of Mallarmé's ideal is illuminated by his dream of a "spiritual book," an architecturally structured and fully premeditated work in which the reader would discover the "orphic explanation of the earth."[72]

The poem in which Mallarmé most conspicuously attempted to achieve something of his ideal was *Un Coup de dés jamais n'abolira le hasard* (A throw of the dice will never abolish chance), published in 1897 (figs. 87, 88). He conceived this poem as approximating the horizontal flow of a musical score, in direct contrast to the tyranny of the newspaper's vertical columns. Words appear scattered across the page, but their place and typographical character have been carefully considered for expressive effect. As Mallarmé explained in a letter to André Gide, certain of the words were intended to form images of a constellation and a listing ship:

C'ÉTAIT
issu stellaire

LE NOMBRE

EXISTÂT-T'IL
autrement qu'hallucination éparse d'agonie

COMMENÇÂT-IL ET CESSÂT-IL
sourdant que nié et clos quand apparu
enfin
par quelque profusion répandue en rareté
SE CHIFFRÂT-IL

évidence de la somme pour peu qu'une
ILLUMINÂT-IL

CE SERAIT

pire
non
davantage ni moins
indifféremment mais autant

LE HASARD

Choit
la plume
rythmique suspens du sinistre
s'ensevelir
aux écumes originelles
naguères d'où sursauta son délire jusqu'à une cime
flétrie
par la neutralité identique du gouffre

87. Stéphane Mallarmé, double page from *Un Coup de dés jamais n'abolira le hasard* [1897], as published in 1914.

88. Stéphane Mallarmé, final pages from *Un Coup de dés jamais n'abolira le hasard* [1897], as published in 1914.

EXCEPTÉ
à l'altitude
PEUT-ÊTRE
aussi loin qu'un endroit

fusionne avec au delà

hors l'intérêt
quant à lui signalé
en général
selon telle obliquité par telle déclivité
de feux

vers
ce doit être
le Septentrion aussi Nord

UNE CONSTELLATION

froide d'oubli et de désuétude
pas tant
qu'elle n'énumère
sur quelque surface vacante et supérieure
le heurt successif
sidéralement
d'un compte total en formation

veillant
doutant
roulant
brillant et méditant

avant de s'arrêter
à quelque point dernier qui le sacre

Toute Pensée émet un Coup de Dés

The constellation will necessarily assume, in obedience to the strictest laws, and as much as a printed text permits, the aspect of a constellation. The ship lists, from the top of one page to the bottom of another, etc.; . . . the rhythm of a phrase on the subject of an act, or even of an object, has no meaning unless it imitates them, and figured on the paper, returned by the letter to the original print, despite everything, knows how to render something.[73]

Indeed, in *Un Coup de dés* every effort has been made to return individual letters to their primordial splendor, to slow the movement of the eye and the flow of narrative, to let the silence of the white spaces speak. Here unity lies in the simultaneous mise-en-scène of the double page, rather than in the perfected single line, while at the same time the flowing words suggest the mobility of music, with its hesitations, embellishments, and continuations. Mallarmé, writing once again of his "spiritual book," suggests the meaning these innovations had for him:

> The book, which is a total expansion of the letter, must draw from it, directly, a mobility and spacious, through correspondences, must institute a play, unknown, which confirms the fiction.
>
> There is nothing fortuitous there, where chance seems to capture the idea, the formal disposition is the equal [*l'égal* = equal to the task, legal, legitimate]. Do not judge, therefore, these words—industrial or having to do with materiality.[74]

In another passage of this essay, Mallarmé further emphasizes the difference of his new poetic system from that of the commercialized forms of the newspaper. For if the newspaper, with its "industrial" format brings us into contact with everyday reality,

a new "musical" poetry will provide a means of transcending that reality:

> I, in turn, misunderstand the true meaning of this book and the marvel implied by its structure, if I cannot, knowingly, imagine a given motif in view of a special place and height on the page, according to the fall of light on it or on the work. No more of those successive, incessant, back and forth motions of our eyes, a line finishes, to the next, to recommence: such a practice does not do justice to our delight, having immortally broken, for an hour, with everything, in realizing our fantasies. Otherwise or without this execution, as of music on the keyboard, actively measured by the pages of a score, who would not rather shut their eyes and dream?[75]

Ideas such as these of Mallarmé were prevalent among Symbolist poets, artists, and critics, many of whom shared his aspiration to create an autonomous art free of all reality.[76] Not surprisingly, they frequently associated an excessive concern with the imitation of reality with journalism, casting upon that symbol of modern life all the despised connotations of materialism. Maurice Denis, for example, in an essay of 1896, described the current followers of the Impressionists in these derogatory terms: "Work after nature was the last safeguard of the craft of the painter. In these last years one has succeeded in bypassing it completely. One does nothing more than note sensations, art is nothing more than the newspaper of life. It is journalism in painting it is the eye that devours the head."[77]

Given the prevalence of such attitudes at the turn of the century, Picasso's frequent choice of newspaper as a collage material suggests a self-conscious, ironic negation of Symbolist values.[78] In this Picasso's collages can be seen as part of the larger *crise des valeurs symbolistes* that awakened

so many poets—among them Jules Romains, Blaise
Cendrars, Apollinaire, and Marinetti—to the vitality
of urban life and commercial forms of expression.
The poem "Zone," written by Apollinaire in the fall
of 1912 just before Picasso began to affix newspa-
per clippings to his collages, includes the following
lines:

> Tu lis les prospectus les catalogues les affiches
> qui chantent tout haut
> Voilà la poésie ce matin et pour la prose il y a
> les journaux . . .
> Les inscriptions des enseignes et des murailles
> Les plaques les avis à la façon des perroquets
> criaillent
> J'aime la grâce de cette rue industrielle
> [You read prospectuses catalogues and posters
> which shout aloud
> Here is poetry this morning and for prose there
> are the newspapers . . .
> Lettering on signs and walls
> Announcements and billboards shriek like
> parrots
> I love the charm of this industrial street][79]

We know that Picasso was familiar with Mal-
larmé's poetry,[80] and in fact, the newspaper head-
line in one of his earliest collages from late 1912
(fig. 89) is cropped to produce "UN COUP DE THÉ"
from "Un Coup de Théatre," so that a pun on Mal-
larmé's famous poem emerges from the very news-
paper format the poet detested. Mallarmé had
found the strident boldness of newspaper headlines
especially offensive, and in *Un Coup de dés* he had
dispersed the title on successive pages to integrate
it with the overall form of the poem.[81] Picasso, on
the other hand, takes special delight in newspaper
titles, often choosing to engage in a play of all the
possible puns contained in the word *journal,* which
is also the generic name of all newspapers. One of

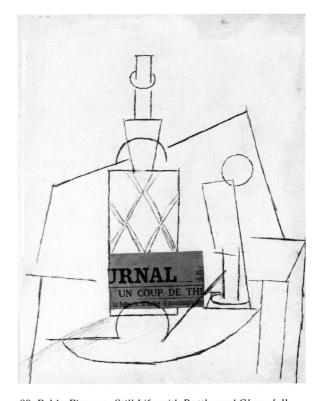

89. Pablo Picasso, *Still Life with Bottle and Glass,* fall-
winter 1912, pasted paper and charcoal on paper.
Musée National d'Art Moderne, Paris.

the better-known examples is *Guitar and Wineglass,* from the fall of 1912 (fig. 7), in which "LE JOU" (The game) appears just above the title of an article, "LA BATAILLE S'EST ENGAGÉ[E]" (The battle has begun). This phrase has been interpreted as alluding both to the Balkan Wars and to the beginning of the challenge of collage itself as a new pictorial form. A collage from the winter of 1912 (fig. 45) bearing the fragment "URNAL" has been variously interpreted as a reference to Maurice Raynal, one of the first critics to champion a collage work (although he later denounced the practice) and as a mocking reference to *urinal.* Attention has been drawn to these puns and jokes as well as to the numerous clippings about the Balkan Wars by art historians such as Robert Rosenblum[82] and Patricia Leighten.[83] They have demonstrated that Picasso's newspaper clippings are meant to be read for the black humor, double entendres, and political associations they reveal. Indeed, the clippings respect the verticality of the columns and are placed upright within the pictorial field so that they can be read with relative ease. What has not been sufficiently emphasized, however, is the connoted meaning of *newspaper* in an artistic milieu still largely dominated by Symbolist values.[84]

Certainly Picasso, as an early twentieth-century artist, faced many of the same material conditions that had prompted the ivory-tower, purist attitudes of some of the Symbolists. His early and consistent refusal, even at his most destitute, to exhibit his works in any of the Parisian salons and to contribute illustrations to satirical magazines indicates the strength of his desire to remain free of the pressures of public taste and of the marketplace. Nevertheless, the eruption of newspaper fragments within the previously homogeneous and pure domain of painting functions as a critique of Symbol-

ist ideals and, indeed, of Symbolist theories of representation.

In Picasso's collages, everything once banished or suppressed from the autonomous, pure realm of art now reappears within the text of the newspapers: contemporary political and social events, the roman-feuilleton, scientific discoveries, advertisements of all kinds, want ads. *Bottle and Glass on a Table* of late 1912 (fig. 90) prominently displays a newspaper clipping of liqueur advertisements, used to signify both the label and contents of the depicted bottle. Serialized romances also turn up, in *Violin* of autumn 1912 (fig. 9), in *Head of a Man,* also of 1912 (fig. 91), and in *Glass and Bottle of Bass* of spring 1914 (fig. 64), to name only a few examples. In a collage from 1912 in which an entire newspaper sheet serves as the ground for a still life of a bottle on a table (fig. 92) the title "LA SEMAINE ÉCONOMIQUE & FINANCIÈRE" (The economic and financial week) can scarcely be missed despite its inverted position. Picasso also glued two drawings executed on newspaper into his sketchbook during the spring of 1913, carefully preserving them. One of these (fig. 93), a drawing of a guitarist, appears on a fragment of newspaper bearing the clearly visible title "LE COMMERCE" followed by listings of current stock prices. The other is a drawing of a table rendered on an ad for women's apparel and lingerie.[85] Rather than fetishize the virginal white space of the page, in works such as these Picasso chose a ground that was already traversed by the market.

One of the most interesting uses of newspaper, and particularly of advertising, occurs in a small collage of early 1913, the *Still Life: "Au Bon Marché"* (fig. 94). Here, Picasso created a collage with materials taken from the commercial world, including newspaper clippings and cheap wallpaper. The subject of this work of art, in turn, alludes to its material origins by taking as its theme the promiscuity

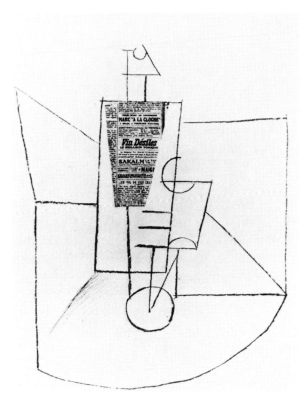

90. Pablo Picasso, *Bottle and Glass on a Table,* fall-winter 1912, pasted paper and charcoal on paper. Private collection.

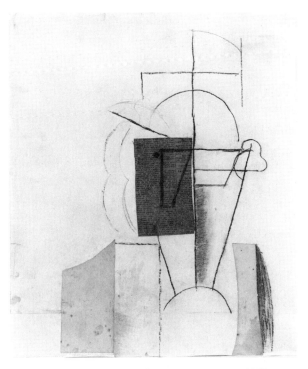

91. Pablo Picasso, *Head of a Man,* fall-winter 1912, pasted papers and charcoal on paper. The Fogg Art Museum, Harvard University. Anonymous Gift in memory of Frederick B. Deknatel.

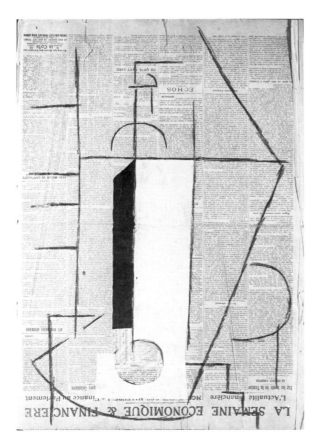

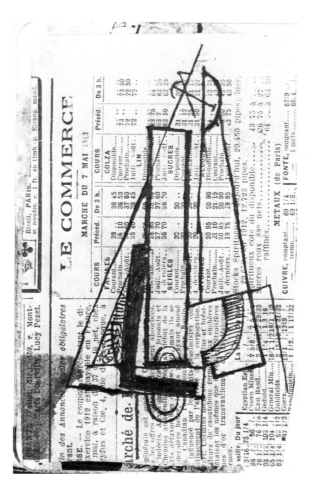

93. Pablo Picasso, *Study for a Figure,* May 1913, ink on newspaper, glued into the second Sorgues sketchbook. Musée Picasso, Paris. Photo R.M.N.

92. Pablo Picasso, *Still Life with Bottle,* fall-winter 1912, pasted paper and charcoal on paper. Musée Picasso, Paris. Photo R.M.N.

94. Pablo Picasso, *Still Life: "Au Bon Marché,"* early 1913, oil and pasted papers on cardboard. Ludwig Collection, Aachen.

of the commodity. Through the placement of two department store advertisements, one from La Samaritaine at top and another from the Bon Marché at center, Picasso reconstructed an image of the bourgeois female which ironically conforms to that of the mass media. She appears in her exemplary dual role as consumer of goods and as object of desire, that is, as intimately involved in the world of commodities. As Robert Rosenblum has observed, the placement of the fragments suggests a rather clandestine joke: at the top we see the torso of a woman, then an advertisement for lingerie, and just below, inserted into a gap in the wallpaper background and jutting into the lingerie advertisement, are the words "UN TROU ICI" (a hole here).[86] Picasso's pun may be a private joke referring to Apollinaire's first pornographic novel, written in 1901, *Mirely, ou le petit trou pas cher*.[87] On a more overt level, the humorous erotic allusions of this collage play on a popular late nineteenth- and early twentieth-century theme, the dubious morality of the department store salesgirl.

Part of the irony of this collage, however, is that while alluding to such themes the "TROU" cropped from the newspaper also refers to the pictorial gaps or holes created by perspectival illusion in the flat surface of the picture plane. Such pictorial holes were themselves of ill repute during the late nineteenth and early twentieth centuries, implying deception about the nature of the medium. As we have seen, one of the rallying cries of the Symbolists had been a return to the pre-Renaissance aesthetics of decoration, especially mural decoration. Symbolist artists sought to reflect the structure of the pictorial support in the work itself by avoiding deep perspectival holes that made walls appear to vanish. In Picasso's collage, the newspaper text asserts the presence of a *Trou* without, however, cre-

ating the illusion of one. The hole remains an effect of writing pasted, with Picasso's characteristic wit, to a slight projection in the wall-like ground. For in a sense, it *is* a wall that is depicted here, although one must still ask, What sort of wall? The striped, golden wallpaper ground and the allusion to a woman in lingerie suggest that this is an intimate interior, perhaps a boudoir. Yet the wineglass at right and the bottle at left convert the scene to a café setting, while the overall effect of the collaged advertisements evokes a poster-covered urban wall. Thus advertising, one of the subsidiary industries that developed in response to early capitalist mass-marketing techniques, presides over the collapse of the boundaries between the private and public realms, assimilating the interior to the street. Walter Benjamin captured the essence of this phenomenon in his essay on Baudelaire and nineteenth-century Paris: "The arcades were a cross between a street and an *intérieur*. . . . The street becomes a dwelling for the *flâneur;* he is as much at home among the façades of houses as a citizen is in his four walls. To him the shiny, enamelled signs of businesses are at least as good a wall ornament as an oil painting is to a bourgeois in his salon. The walls are the desk against which he presses his notebooks; news-stands are his libraries and the terraces of cafés are the balconies from which he looks down on his household after his work is done."[88]

As more and more areas of private experience seemed to become subject to the laws of the market, nineteenth-century theories of originality as self-expression were gradually undermined. One of the earliest signs of a new conception of the creative process—and particularly of originality—appears in Picasso's first series of collages executed during the autumn of 1912. In the place of the unique, indexical marking of the artist's hand, still

of primary significance in Symbolist and Fauvist works, we find only fragments of previously established codes of representation: newspaper clippings, bits of wallpaper, musical scores (figs. 8, 12, 15, 19). In *Guitar and Wineglass* (fig. 7) even the drawn glass appears to be ready-made, for it reads like a familiar quotation from Picasso's previous Cubist reconstructions of simple objects. In these early collages originality derives from the imaginative manipulation of conventional signs rather than from a spontaneous encounter between self and nature. This attitude toward representation suggests, in part, a return to the classical theory of invention, which relied on the recombination of previously known compositional elements or schemas. But whereas an academic artist was taught to base his art on the conventions of the finest art of the past, Picasso appropriated elements from the contemporary world of popular culture and mass communication.

Here again, the preponderance of newspaper in Picasso's collages is significant. Newspaper, perhaps more than any other cultural artifact, embodies the principle of reproducibility in utter negation of the unique or privileged object, for any copy of a newspaper is as good as any other. Moreover, having a lifespan of only a day or perhaps a week, it quickly reverts to the status of refuse, thereby exemplifying the principle of obsolescence inscribed in the very nature of the commodity. Picasso's introduction of newspaper within the realm of painting suggests a critique of its fine art status on several fronts. It challenges the durability of the work of art, traditionally defined in opposition to the ephemeral products of mass culture. It redefines the creative act as a manipulation of iterable, arbitrary signs, like those of writing. And it also thereby implicitly points to the conventionality of seemingly original, spontaneous signs for the reve-lation of the self, such as sketchlike brushstrokes or heightened color.

By 1912, it was no longer possible for Picasso to use such techniques without irony. When he wrote "J'aime Eva" in overtly childlike handwriting on a heart-shaped piece of gingerbread and glued it to his canvas (fig. 34) or stenciled "MA JOLIE," the easily recognized fragment of a popular song,[89] to his canvases (fig. 95), it was to underscore the paradox of expressing a private or personal emotion with a public language. Picasso's collages imply that this highly clichéd language is the only one available. The impossibility of inventing a purely expressive, uncontaminated, personal language that would still *be* a language is what Picasso revealed in these works.

Here the aesthetics of Mallarmé and Picasso converge once again. For although Mallarmé believed that a true work of art was unique, or should be,[90] his conception of the poem as a pure, independent object precluded causal references to the self, or what he called "the audible breathing" of the poet. In "Crisis of Poetry" Mallarmé spoke of the impersonality of his poetic ideal: "The pure work implies the elocutionary disappearance of the poet, who cedes the initiative to words, brought into collision by their mobilized inequality. They illuminate themselves through reciprocal reflections like a virtual swath of fire sweeping over precious stones, replacing the audible breathing in ancient lyric poetry or the personal and passionate control of the phrase."[91] For Picasso, however, the effacement of the self did not gesture toward the pure, expressive radiance of words. Rather, the artist's use of newspaper and other mass-produced materials signaled the obsolescence of contemporary cultural hierarchies and theories of representation in an age in which cultural artifacts had become commodities.

95. Pablo Picasso, *Pipe, Glass, Musical Score, Ace of Clubs, Guitar, "Ma Jolie,"* 1914, oil on canvas. Collection Heinz Berggruen, Geneva. Photo: The National Gallery of Art, London.

Fragments

In a letter to Paul Verlaine now titled "Autobiography," Mallarmé characterized his poetry as a collection of fragments, which necessarily fell far short of his ideal for a collectively written "Great Work":

What work? It is difficult to explain: a book, simply, in many volumes, a book which is a book,

architectural and premeditated, and not a miscellany of chance inspirations, however marvelous they may be. . . .

There, my friend, is the confession of my vice, laid bare, which I have rejected a thousand times, my spirit wounded or weary, but it possesses me and I will succeed perhaps; not that I will accomplish this work in its entirety (one would have to be I don't know whom for that!) but to realize a fragment of it, to let its glorious authenticity shine forth in some way, and so suggest the rest in its totality, for which a single life does not suffice. To prove through the completed portions that this book exists, and that I have known that which I was not able to accomplish.[92]

For Mallarmé, the disparity between his Great Work (or spiritual book) and the fragments he was able to realize only confirmed the beauty and perfection of his ideal. He viewed these fragments as radiant jewels, giving the reader a glimpse of a unity and brilliance that must remain unattainable. Although described here in typically Romantic terms as the inevitable discrepancy between a poet's vision and his achievement, there was also a social explanation for the fragmentary nature of Mallarmé's oeuvre. This was to be found in the absence of a stable, unified social order, which according to Mallarmé also gave rise to the "unexplained need" for individualism in poetry: "Above all the undeniable point is this: that in a society without stability, without unity, one cannot create a stable and definitive art. From this incomplete social organization, which also explains the restlessness of certain minds, the unexplained need for individuality was born."[93] The poet, no longer fulfilling a recognized and meaningful function within society, hovers on its margins, uncertain of an audience and without a reliable means of suste-

nance. As a defensive stratagem, he adopts a position of disdain for those masses who seem capable of reading only the newspapers. As Mallarmé put it, "In reality, I am a recluse. I believe that poetry should be for the supreme pomp and circumstance of a constituted society, in which glory would have its place. People seem to have forgotten glory. The attitude of a poet in an epoch like this one, where he is on strike against society, must be to turn his back on all the contaminated means that are offered to him. For anything that can be offered to him is inferior to his conception and to his secret labor."[94] One might conclude, then, that Mallarmé's fragments, however self-referential and hermetic, contained an element of protest against the materialism and "incomplete" social structure of his time. He intended his verses to resist contamination by the market and to offer some spiritual solace to those few confrères who preferred to live without succumbing to its allure.

Needless to say, however, this protest proved largely ineffectual and by the early twentieth century had become the object of parody. Like the hero of J.-K Huysmans's novel *A Rebours,* who emerged into the light of day after a prolonged attempt to live in an enclosed, artificial world, many turn-of-the-century poets (and artists) found it necessary to seek new sources of inspiration in collective urban experience and lowbrow entertainment.

The collage practice of Picasso, Braque, and Gris participates in this moment of renewed contact with popular culture. Here, as in the oeuvre of Mallarmé, we find an art of fragments, but these fragments no longer allude to an unattainable, spiritual ideal. If Mallarmé's fragments were conceived as individual jewels that might one day take their rightful place in a fully accomplished Great Work, the fragments in Cubist collages are best characterized

96. Pablo Picasso, detail of *Bottle of Vieux Marc, Newspaper and Glass,* 1913. For full view, see fig. 56.

as the debris of urban mass culture. What glitter they retain is of the cheapest, gaudiest kind. One of Picasso's collages of spring 1913, titled *Bottle of Vieux Marc, Newspaper and Glass* (fig. 96), suggests the artist was highly self-conscious about the withering away of the old, aristocratic world and the glory it represented. This collage contains two fragments from *Le Figaro* of May 1883[95] describing the coronation of Tsar Alexander III in Moscow, which according to the author "surpasses anything that one could dream [. . .] veritable picturesque grandeur."[96] Indeed, the reporter gave special attention to the sumptuousness of the procession and ceremony, the crown (made of twenty-four hundred diamonds surmounted by a diamond cross), the cathedral, and the dress of the participants. The newspaper, which by 1913 would have yellowed and become brittle, must have seemed to signal the obsolescence of such ceremonies in the modern age. Picasso enhanced this effect by laying a wash of pale yellow onto the paper ground, to which he

pasted some remnants of an especially gaudy gold and brown flowered wallpaper. But in this collage, the golden splendor of a bygone era, recoverable only in torn and faded fragments, confronts the modern scene of pleasure: the café table, a principal site of everyday, popular diversion. Thus one form of cultural spectacle comments on the decay of another, parodying its effects and emptying them of meaningful content. As Ludwig Wittgenstein once observed, "A coronation is the picture of pomp and dignity. Cut one minute of this proceeding out of its surroundings: the crown is being placed on the head of the king in his coronation robes.—But in different surroundings gold is the cheapest of metals, its gleam is thought vulgar. There the fabric of the robe is cheap to produce. A crown is a parody of a respectable hat. And so on."[97]

Indeed, the parody of a work such as *Bottle of Vieux Marc, Newspaper and Glass* must also be seen as social commentary, a *prise de position* toward the old aristocratic order and the patronage of the arts it once provided. Picasso's collage seems to point to the fact that a market economy has superseded older, traditional forms of patronage and that works of art now inevitably take their place within the world of commodities. Mallarmé, of course, in decrying the absence of a stable society, was also decrying the passing away of aristocratic patronage of poetry. Addressing the poets of his time, Mallarmé wrote in 1862, "Let man be democratic, the artist must separate and remain an aristocrat. . . . The present hour is a grave one: the people are being educated, the great doctrines are going to be spread. If there is a popularization [*vulgarisation*], let it be one of the good, not of art, so that your efforts do not tend—as they have not tended, I hope—to make you a *worker's poet,* which would

be grotesque if it were not sad for the true artist."[98] Given this aristocratic stance, it must have been with considerable bitterness and self-conscious mockery that Mallarmé proclaimed to the (female) readers of his journal of culture and fashion, *La Dernière Mode,* that today (1874), only women read poetry: "One must repeat, not without truth, that *lecteurs* no longer exist; I do believe there are only *lectrices.* Only a lady, in her isolation from Politics and morose troubles, has the necessary leisure to give rise, once her toilette has been completed, to a need also to adorn the soul."[99] Contemporary poetry, according to this cynical appraisal, retains only the prestige of luxury. And reading, associated with leisure and the contemplation of beauty for its own sake, becomes analogous to other (female) forms of vanity.

In rejecting this purist attitude, the Cubists continued to view themselves as practicing their art on the margins of a society that failed to understand them. As Thomas Crow has pointed out, the oppositional public, which artists like David or Courbet had once been able to address, no longer existed as a significant force in the early twentieth century.[100] The Cubists found their public in the extremely restricted circle of other avant-garde artists, poets, critics, dealers, and a few bourgeois amateurs.[101] But within these narrowed margins, there was a positive identification with the degraded pleasures of popular mass culture (as there had been earlier in the work of many nineteenth-century avant-garde artists, including Manet and Seurat). The Cubists seem to have conceived their collages, in particular, as sites where fragments of the cultural codes that circulate through our lives might continue to do so, albeit according to an altered imperative. Certainly these fragments—bits of newspaper, playing cards, cheap wallpaper, calling cards, cinema programs, popular musical scores,

cigarette and liquor labels, packing paper—retain their identity as cultural commodities.

Even Gris, the most purist of the Cubists, took pleasure in the quintessential commercial artifacts of his time. A collage such as *The Table* (fig. 80), for example, contains an easily recognizable page from one of the Fantômas novels, one of the most successful detective series of this period. Another example can be found in Gris's evident delight in the Gothic typeface and logo of the daily paper *Le Matin,* which advertises the fact that this paper was the first to employ the telegraph in gathering its news (figs. 97, 98). (*Le Matin* was one of the fastest growing modern newspapers and was read primarily by *les hommes d'affaires.*)[102]

Braque, on the other hand, frequently cropped newspaper texts to produce lowbrow sexual jokes, especially in his collages of 1913 and 1914. An example can be seen in a work such as *Violin and Pipe* of 1913–14 (fig. 99), in which a fragment of *Le Quotidien* producing "Le Qu" is juxtaposed to the silhouette of a violin, a displaced sound hole becoming a tail. The nearby pipe, one of Braque's "attributes," would also have been read as a humorous phallic symbol by his contemporaries. In another collage of 1913–14, *Still Life with Le Courrier* (fig. 100), a fragment of the newspaper's title suggesting the words "Le Coeur" is partially obscured by another newspaper fragment from which a heart has been cut. Braque reinforced his play of words and forms by juxtaposing this hole with the subtitle of the newspaper that seems to spell "Organ de Madam." In addition, the fanlike disposition of the collage elements evokes a cardplayer's hand, in which the Queen of Hearts is trump and perhaps prize.

This was a low form of humor in keeping with the café setting of so many Cubist collages. It is notable that in Cubist works, the plein air scenes of the Impressionists, Neo-Impressionists, and Fauves as well as the decorative interiors so typical of the Intimists and of Matisse give way to a nearly exclusive concentration on the urban café. For the café represents a public form of social interaction and enjoyment, rather than a private or natural world to which one might withdraw for subjective contemplation. In the Cubist café, individual subjectivity recedes, and the emphasis turns instead to shared diversions, produced according to the laws of mass consumption. Indeed, Picasso's *Still Life: "Au Bon Marché"* (fig. 94), as we have seen, exemplifies the collapse of the distinction between public and private realms of experience.

Yet the Cubists have not, in Mallarmé's terms, become "worker's artists." They have merely directed their critique to those Symbolist and Symbolist-inspired practices which had come to seem suspect: the creation of an ideal, unified, spiritual world, a realm, that is, where the enlightened individual might forget for a time the power of the market to cause all intrinsic values to wither. Through their collages, the Cubists revealed that such purified worlds have already been contaminated. How could it be otherwise—when sincerity was being manufactured by the hundreds of artists who crowded the salons? when spontaneous brushwork and pointillist dots had become standard fare? when an artist like Matisse could produce a naively rendered portrait of his young daughter, even signing it "Marguerite" in awkward, childlike strokes, as if this picture were executed by its subject (fig. 101)?[103] That such techniques were too easily copied and imitated by so many minor artists surely had begun to undermine the mythology they were based on: that a work of art should express the

97. Juan Gris, *A Man in a Café*, 1914, oil and pasted papers on canvas. Mr. and Mrs. William R. Acquavella. Photo Acquavella Galleries, Inc.

98. Juan Gris, *Le Paquet de Café*, 1914, oil and pasted papers on canvas. Ulmer Museum. Dauerleihgabe des Landes Baden-Württemberg.

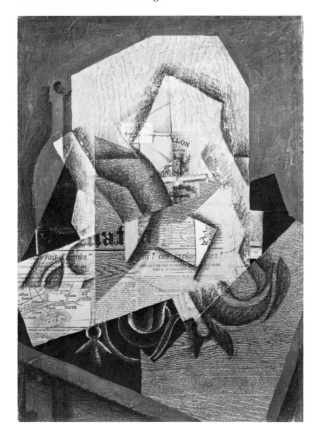

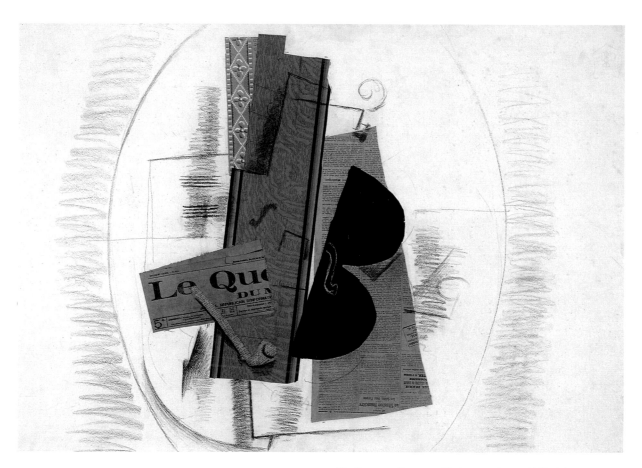

99. Georges Braque, *Violin and Pipe,* 1913–14, pasted
papers and charcoal on paper (adhered to cardboard).
Musée National d'Art Moderne, Paris.

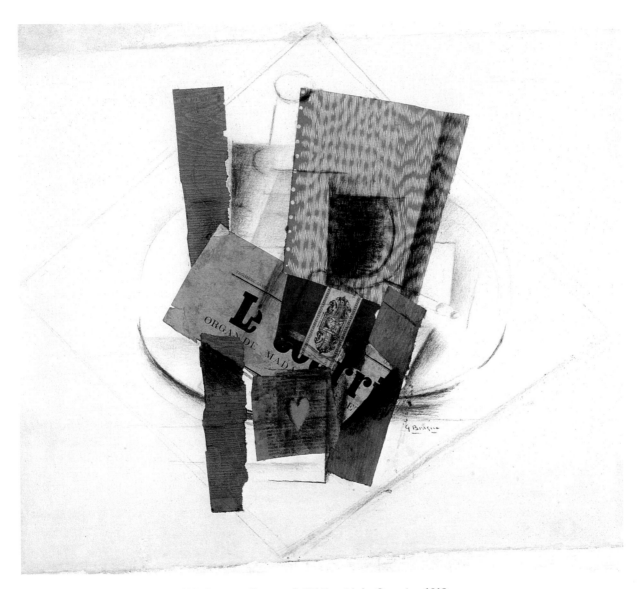

100. Georges Braque, *Still Life with Le Courrier,* 1913–
14, pasted papers, charcoal, and chalk on paper.
Philadelphia Museum of Art.

101. Henri Matisse, *Portrait of a Young Girl*
(*Marguerite*), 1907, oil on canvas. Musée Picasso, Paris.
Photo R.M.N.

emotions or ideas of the artist in a unique, unme-
diated manner, in a style that manifests itself as *dif-
ference* from the infinitely reproducible products of
mass culture.

All of this is not to say, however, that Picasso,
Braque, and Gris (unlike the Symbolists or Fauves)
accepted contemporary market conditions whole-
heartedly. On the contrary, they rejected them
even while providing an ironic critique of the purist
attitudes of their predecessors and contemporaries
in the avant-garde. Indeed many of the formal and
material properties of Cubist collages and con-
structions seemed designed specifically to elude
the apparently inevitable process of commodifica-
tion. Many collages and constructions, for example,
were structurally fragile, made of bits of paper
pasted or pinned to a paper support, the drawing
executed in friable, unvarnished charcoal. Conse-
quently, many have been lost or damaged. To the
potential buyer, they must have appeared less pre-
cious, less like a work of art. The absence of a
frame—or the presence of frames that parodied
fine art frames—contributed to the unfinished,
nonart look of these objects.[104] Some works, to be
sure, were not for sale. These were primarily the
constructions and were often kept by the artist, de-
stroyed, or given only a photographic existence.
Such was the case with Picasso's *Assemblage with
Guitar Player* (fig. 61). Only one of Braque's card-
board and paper constructions survives, and that
in photographic form (fig. 102). Yet even in the
photograph the word "ART" is legible, ironically ap-
pearing just where one might expect the label on
the cardboard bottle to identify its contents. Works
such as these were made for the pleasure of the
artist and a few friends, rather than for the market.

Picasso, Braque, and Gris took pride in remain-
ing aloof from the salon-going public, which would
not have understood, admired, or bought Cubist
works. They preferred to allow Kahnweiler to sell
these works for them, and he did so in the new, de-
veloping international art market. This meant that
apart from a few friends like the Steins, they did

102. Georges Braque, *Construction,* 1914. No longer extant. Photo: Galerie Louise Leiris, Paris.

not even have to concern themselves with the immediate Parisian public.

Ultimately, then, Cubist works, especially the collages and constructions, bear all the signs of an uneasy, paradoxical relation to the public and to the market. Constructed from the fragments of contemporary mass culture, these works seem to elide the distinction between fine and popular art. Yet the Cubist artist, in mounting his critique of the modernist notion that a work of art present the viewer with an ideal, pure realm, did so symbolically, from within the ranks of the avant-garde. The works of Picasso, Braque, and Gris, so closely identified with the processes and materials of popular culture, do not therefore address a popular or mass audience. Most important, these artists retained their privileged position within the existing division of labor. The refusal to copy, even the refusal to make identifiable products, confirmed their position as members of the intellectual, creative elite, as did the irony, wit, and humor that pervades Cubist works. As Terry Eagleton has so succinctly put it, "Wit is intellect without labour."[105] In Cubist collages and constructions, wit and imagination displaced sincerity and the unique, expressive brushstroke, but this did nothing to change the relations of production.

To find such a transformation, which would entail an insertion of art and its attendant practices into the realm of the social and political, we must turn to Futurism. Here the political manifests itself as the overt content of the artists' endeavors. In Futurist collages, fragments of popular culture or of Futurist manifestos enter the work of art primarily as a means of contributing to the sensationalism and immediacy of the work, and consequently to its political effectiveness. Moreover, whereas the Cubists had refused to explain their works of art, the Futurists addressed their public in an incessant outpouring of raucous, inflammatory proclamations, exhibitions, theater productions, and political manifestations. The artist and the public at last met face to face—but not without giving rise to a new set of paradoxical relations and posturings.

Destroying

the Cult

of the Museum:

The Futurist

Collage

Aesthetic

Anche per noi futuristi "la pittura non risiede
nei tubetti Lefranc."

—Carlo Carrà, "Vita moderna e arte populare,"
Lacerba, 1914

In "The Founding and Manifesto of Futurism," Marinetti made an unprecedented demand designed to shock his readers out of their complacency. He called for the destruction of Italy's libraries, museums, and academies, those repositories of tradition and learning so deadly in their influence on the vital forces of the present. Museums, in particular, drew his wrath: "Museums: cemeteries! . . . Identical, surely, in the sinister promiscuity of so many bodies unknown to one another. Museums: public dormitories where one lies forever beside hated or unknown beings. Museums: absurd abattoirs of painters and sculptors ferociously slaughtering each other with color-blows and line-blows, the length of the fought-over walls!"[1] Having described a scene of absurd conflict, Marinetti then asked the inevitable question: "Why poison ourselves? Why rot?"[2] Rather than devote oneself to a debilitating admiration for the past, the Futurist would burn the libraries, flood the museums. Like the anarchist who must destroy before he can build, Marinetti advocated the total annihilation of tradition and of the authority it continued to hold: "So let them come, the gay incendiaries with charred fingers! Here they are! Here they are! . . . Come on! set fire to the library shelves! Turn the canals to flood the museums! . . . Oh, the joy of seeing the glorious old canvases bobbing adrift on those waters, discolored and shredded!"[3]

This rallying cry was quickly taken up, in spirit if not in letter, by the artists who joined Marinetti's movement after the publication of his first manifesto. Within a few years, this call for total renewal led to a wide variety of pictorial and sculptural innovations. These included, most notably, a synthesis of verbal and visual modes of expression, and the use of heterogeneous materials in works of art.

In the spring of 1912, Marinetti's attack on the *passatista* (old-fashioned, anti-Futurist) form of the book inspired the invention of parole in libertà, a new, visually expressive poetry designed to liberate words from the shackles of syntax so they might take on the explosive force of projectiles. Shortly thereafter, Futurist artists sought to replace traditional "static" forms of painting and sculpture with a variety of collages and constructed works intended to insert the work of art more effectively into the dynamic stream of life. In both poetry and the visual arts, then, a desire to obliterate the distinction between genres or media emerged. In many ways it was parallel to the impulse that led the Cubists to include words in their pictures and to challenge the distinction between painting and sculpture. For the Futurists, as for the Cubists, painting and sculpture were associated with the museum and the conditions of display it provided. Carrà expressed the opposition between an art made for the museum and the synthetic creations of Futurism when he wrote, "While our predecessors, without exception (including Cézanne and Renoir) had as their dream and ultimate destination the MUSEUM, we Futurist painters will have created a type of concrete plastic synthesis, the fruit of our Futurist sensibility already tired and nauseated by the presence before us of embalmed cadavers to contemplate."[4] In the passage immediately preceding this one, Carrà asserted the right of the artist to employ any materials he might choose, as long as his selection was guided by his "creative spirit":

We Futurists also believe that "painting does not lie in Lefranc tubes." If an individual possesses a pictorial sense, whatever he creates guided by this sense will always lie within the domain of painting. Wood, paper, cloth, leather, glass,

string, oil-cloth, majolica, tin and all metals, colors, glue, etc. etc., will enter as most legitimate materials in our present artistic constructions.

The quantity and selection of this material will be regulated case by case by our creative spirit, which in matters of art, is the only authoritative arbiter that we admit.

Thus, if all categories become modified and destroyed, categories which were completely arbitrary in any case, and which made of art an *artificial game perpetrated with colors and canvas,* for art this will be an advantage, for it will be liberated from every prejudice and will manifest itself in its greatest sincerity and purity.[5]

Indeed, with the first experiments of Severini and Boccioni, executed during the summer and fall of 1912, the ideal of a new art, untainted by the stultifying atmosphere of the museum, seemed to demand the use of diverse and specifically modern, nonaesthetic materials. Moreover, the idea of construction implicit in the manipulation of these elements accorded well with the Futurists' desire to build a new universe upon the ruins of the old.

The stimulus for the inclusion of words and a variety of materials in the creation of new constructive works originally came from Cubist circles. Yet the Futurists had their own reasons for wishing to challenge the homogeneity and nobility of the traditional painting or sculpture. Unlike the Cubists, whose initial use of pasted materials had issued from an aversion to copying, the Futurists were interested in finding ways of suggesting the interpenetration of an object or figure with its environment. If to Picasso the "horrible canvas" had also come to signify the domain of an obsolete purity and autonomy, to the Futurists it signified all that was static and burdened with tradition. And if the Cubists

took pleasure in playing with the multiple significations of the materials they selected, the Futurists gave primacy to the inherent expressive qualities of their collage materials, regarding them as real physical objects with specific weight, density, mass, and the ability to reflect light.

Indeed, much of the Futurist collage aesthetic must be interpreted not only as a means of advancing the Futurist desire to achieve an art of sensory fullness and immediacy, but also as a self-conscious critique of Cubist style and of the values it implied. Above all, the Futurists objected to the coolness and intellectual quality of Cubist works and to the evident arbitrariness of the distortions and fragmentations they visited upon their subjects. Of all the early critics of Cubism, it was the Futurists who most consistently singled out this arbitrariness and the sense of artistic distance or mediation it created for reproach. In retrospect, the Futurists turn out to have been among the most perspicuous contemporary interpreters of Cubism, although they often could find little or no positive value in what they saw. Their own understanding of the act of representing remained rooted in nineteenth-century attitudes toward artistic expression, which emphasized immediacy and sincerity rather than self-conscious irony and wit. Thus, despite the many friendships and exchanges of ideas that at times brought the Cubists and Futurists together, the divergence in their aesthetic aims and practice was fundamental. In 1913 Carlo Carrà, expressing the views of most of the Futurists, set forth the terms of his rejection of Cubism:

If we accuse the Cubists, . . . of not creating works but only fragments, it is because in their pictures one feels the necessity of further and greater development. Moreover, it is because in their canvases an essential center in the organ-

ism of the whole work is lacking, as are those surrounding forces that flow towards such a center and gravitate around it.

Finally, it is because one notes that the arabesque of their pictures is purely accidental, lacking the character of totality and vitality that is indispensable to the life of the work.[6]

Lacking a vital, organizing, and organic center, Cubist works could only present the viewer with arbitrarily arranged fragments. "On the other hand," Carrà explained, "we Futurists seek, with the force of intuition, to immerse ourselves in the center of things, so that our 'I' forms a single complex with their uniqueness."[7] This intuitive force, which according to Carrà the Futurists also directed toward the study of materials, forms, and colors, would provide the basis for creating an art of necessity, rather than an art of contingency. Carrà believed that if one day a "plasticometer" could be invented capable of measuring the expressive force of lines, colors, and volumes in Futurist works, "every accusation of arbitrariness would be defeated."[8] Thus, in words that recall the late nineteenth-century enthusiasm for reconciling the laws of science with those of intuition, Carrà elucidated the principles of Futurist art. These principles establish an unbroken link between Futurist aesthetic theory and that of their Symbolist and Divisionist predecessors. If the Cubists and Futurists so often failed to understand each other, it was because by 1912 this link had already been severed in the work of the Cubists.

Futurist Collage and the Divisionist Heritage

In many fundamental respects, the use of words and modern materials in Futurist works is consistent with the continuing reliance of these artists on Divisionism (the Italian version of Neo-Impression-

ism) as the basis of their artistic practice. Before becoming Futurists in 1910, Balla, Boccioni, Severini, and Carrà had all considered the works of Giovanni Segantini, Giuseppe Pellizza da Volpedo, and Gaetano Previati to be among the strongest that Italy had produced and consequently developed their own individual interpretations of Divisionist technique. No doubt the work of the Italian Divisionists contributed to the predisposition of the Futurists for French Neo-Impressionism as well. Balla, for example, had returned from his visit to Paris in 1901 full of admiration for the plein air paintings of the Impressionists and Neo-Impressionists. Works such as *The Worker's Day* of 1904–06 and *The Madwoman* of 1905 reveal a personal interpretation of both French and Italian sources. Like the artists he admired, Balla based his work on direct observation and concentrated on capturing flickering effects of light through the use of complementary colors and a stippled brushstroke. If these works must ultimately be classified as Divisionist, however, it is because, like his Italian predecessors in the use of divided color, Balla never found the regular brushstroke of the Neo-Impressionists congenial to his aims and tended to vary it according to the effect to be produced. His use of complementary colors was also more intuitive than scientific.

As an established artist and early teacher of both Boccioni and Severini, Balla exerted a powerful influence on their thinking during this formative period. Severini recalled in his memoirs that "Balla painted with separate and contrasting colors, like the French painters; his 'pictorial talent' was of the highest order, genuine, with some resemblance to the subjects and the talent of a Pissarro. It was a great fortune for us to meet such a man, whose direction perhaps decided the course of our careers."[9]

Severini, who went to Paris in 1906 to see the work of the Impressionists and Seurat,[10] began shortly thereafter to develop a style derived from Neo-Impressionism; he viewed this movement as the necessary foundation for all contemporary work. Because he chose to live in Paris and because of his friendship with his neighbor Félix Fénéon, the foremost apologist of Neo-Impressionism, Severini's early work is more clearly indebted to French sources than that of the other Futurists. For Severini, the appeal of Neo-Impressionism lay in its ability to suggest a means of grounding painting in a scientific analysis of color and form, while maintaining a nearly mystical belief in the creative power of the individual artist. The works of Seurat also provided a model for the portrayal of modern urban subjects, deemed essential to the creation of a modern style. Nonetheless, Severini's technique differed from the minute pointillism of Seurat in that he relied on larger areas of complementary color and on a corresponding geometric "divisionism" of form. In this way he hoped to avoid the unfortunate grayness that he felt resulted from Seurat's practice of juxtaposing small touches of color of equal tonal value. Indeed, Severini understood the difference between his work and that of Picasso and Braque primarily as a matter of color: "While Picasso and Braque, perhaps in order to accentuate more clearly their reaction against Impressionism, had adopted the color range of Corot, I conserved as a base the formula of the Neo-Impressionists, adding however pure black, white and grey, convinced that such a formula of the division of colors, better than any other, could be adapted to a division of form."[11] As this passage indicates, Severini regarded the geometric distortions and dislocations of Cubism as a kind of divisionism of form. In his own work of this period, he sought to synthe-size divisionist color with this parallel divisionism of form in order to advance beyond Seurat's work without rejecting its basic premises. The muted color schemes adopted by Picasso and Braque during these years prevented Severini from fully appreciating their works.[12] Like the Puteaux Cubists, he viewed color as one of the essential resources of the painter and could see no reason to give it up. Thus when Boccioni wrote to Severini in early 1910 to ask whether he would sign the "Technical Manifesto" of the Futurist Painters, which declared that "painting cannot exist without *divisionism*,"[13] Severini agreed despite his dislike for publicity.[14] Divisionism, regarded by the signatories as the most advanced avant-garde style available, was adopted as the official style of Futurist painting, although not without qualification. Anxious to preserve the role of intuition in the creation of art, the manifesto stated, "This is no process that can be learned and applied at will. Divisionism, for the modern painter, must be an *innate complementariness* which we declare to be essential and necessary."[15] The application of complementary colors must be a matter of inner necessity, not a merely technical procedure. Here one can note an implied critique of the nineteenth-century Divisionists and perhaps of the Neo-Impressionists as well. The Futurists wished to preserve the spontaneity of the artist, and a brushstroke that responded to variations in mood or in the objects to be depicted was regarded as an index of this spontaneity. To adopt a regular brushstroke or a strictly scientific use of complementary colors would have been to introduce an element of predetermination into the process of artistic making, and this the Futurists were anxious to avoid.

The aim of the Futurists at this time was to find an adequate means of reproducing their sensations

on the canvas. These sensations, of course, had been dramatically altered by the inventions of science and industry. The "Technical Manifesto" cites, in particular, the artificial glare of electric lights, the power of speed to transform traditional concepts of space and time, and the ability of the X ray to penetrate the very opacity of bodies. This new, multipled, dynamic vision required a correspondingly dynamic pictorial technique, which like the data of vision should be grounded in the discoveries of science. If Divisionist theory answered this demand, it was because it seemed to be based on the objective laws governing perception.

By the latter part of the nineteenth century, these laws could be studied in a number of well-known treatises, including O. N. Rood's *Modern Chromatics* (1879) and M. E. Chevreul's *De la Loi du contraste simultané des couleurs et de l'assortiment des objets colorés* (1839). While Divisionists such as Pelizza da Volpedo and Angelo Morbelli read these and other treatises in Italian translations, the Futurists tended to rely on subsequent theorists, especially Gaetano Previati. From his diaries we know that Boccioni read and was greatly impressed by Previati's *I Principii scientifici del Divisionismo* (1906) and that his admiration for the older artist led him to visit Previati several times during the spring of 1908. By 1911, Boccioni may have also been familiar with the famous treatise of Paul Signac published in 1899 and subsequently reprinted and translated into many languages: *D'Eugène Delacroix au néo-impressionnisme*. This seems likely given his close friendship with Severini, who continued to define himself as a follower of Seurat at this time, and the fact that the first Futurist exhibition held in Paris (in February 1912) was organized by Fénéon, who was the artistic director of the Galerie Bernheim-Jeune. Boccioni

may have discussed Signac's theories with Severini or Fénéon during his visit to Paris in September and October of 1911, a visit insisted upon by Severini, who felt that the Futurists should become familiar with recent developments in the French capital before exhibiting their works there.

According to Signac, the goal of the Neo-Impressionists was to attain a maximum of luminosity, color, and harmony—a goal that accorded well with the aims of the Futurists. Relying on the important precedent of Delacroix and on the studies of Ogden Rood, Chevreul, and others, the Neo-Impressionists believed that the most brilliant, and therefore most emotionally affective, color contrasts were those that appeared on opposing sides of the color wheel. These complementaries were to be juxtaposed in small, unmixed, precise touches so that a vibrant "optical mixture" might be obtained in the eye of the spectator. Although Signac and others later abandoned the idea of optical mixture, the principles of dividing color into pure, contrasting elements and the use of a regular, disciplined brushstroke were retained as means of achieving harmony and luminosity. Adherence to scientific laws of color seemed to hold the promise of a universal symbolic language.

Signac submitted form, and especially the emotional effect of line, to a similarly "scientific" analysis. Seurat had based his own study of line on the theories of Humbert de Superville as reformulated by Charles Henry and Charles Blanc later in the century.[16] According to Superville, the naturally expressive features of the human face pointed to the existence of three "unconditional signs" of human emotion: lines moving upward were generally agreeable and signified agitation, explosion, and joy; horizontal lines signified equilibrium, calm, and order; and lines moving downward, which were

generally disagreeable, signified concentration, so-
lemnity, depth, and sadness. Three colors could be
associated with these affective qualities: red, white,
and black, respectively. Thus for Superville and for
Henry, who further developed these ideas, both
color and the directional movement of line ex-
pressed universal human emotions independently
of their descriptive or anecdotal function.

Writing at the end of the nineteenth century, Sig-
nac synthesized these ideas for the artists of the
following generation:

> Guided by tradition and science, he [the Neo-
> Impressionist] will harmonize the composition
> with his conception, that is to say that he will
> adapt the lines (directions and angles), chiaro-
> scuro (tones), the colors (hues) to the character
> that he wishes to prevail. The predominant lines
> will be horizontal for calmness, ascending for
> joy, and descending for sadness, with all the in-
> termediary lines to express all the other sensa-
> tions in their infinite variety. A play of colors, no
> less expressive and diverse, will be joined to this
> linear play: to the ascending lines will corre-
> spond warm colors and light values; with the de-
> scending lines, cold colors and dark values will
> predominate; a more or less perfect equilibrium
> of warm and cold colors, and of pale and intense
> values will add to the calm of horizontal lines.[17]

By thus translating his emotions into the "natural"
language of color and line, Signac believed the art-
ist would create truly original, poetic works.

Boccioni, who was largely responsible for the
wording of the "Technical Manifesto" of 1910, em-
barked in 1911 on a series of three works designed
to exemplify the Futurist interpretation of Division-
ism, or what he preferred to call "innate comple-
mentariness." Titled *States of Mind: The Farewells,
Those Who Go,* and *Those Who Stay,"* these can-

vases were executed on the basis of aesthetic prin-
ciples similar to those which had guided both the
Divisionists and Neo-Impressionists. In *The Fare-
wells,* Boccioni translated the tumultuous emotions
of several embracing couples at a train station into
a conflict of swirling, ascending "force-lines" and
static geometric planes and into the contrast of
fiery red and dull green. He expressed the sensa-
tions of those who go in terms of an onslaught of
oblique force-lines, which all but obliterate the
fragmented faces of the passengers and the scat-
tered bits of landscape. The dejected sentiments of
those who stay demanded an opposing vocabulary.
These figures are rendered in curves rather than
straight lines, and they seem to wander through an
oppressive atmosphere thick with pale-green, verti-
cally descending paint strokes. In a brochure
handed out at the exhibition, Boccioni explained
the expressive devices he used in this series in
terms strikingly similar to those set forth by
Signac in describing the techniques of the Neo-
Impressionist:

> In the pictural description of the various states
> of mind of a leave-taking, perpendicular lines,
> undulating and as it were worn out, clinging here
> and there to silhouettes of empty bodies, may
> well express languidness and discouragement.
>
> Confused, and trepidating lines, either straight
> or curved, mingled with the outlined hurried ges-
> tures of people calling on another, will express a
> sensation of chaotic excitement.
>
> On the other hand, horizontal lines, fleeting,
> rapid and jerky, brutally cutting into half lost
> profiles of faces or crumbling and rebounding
> fragments of landscape, will give the tumultuous
> feelings of persons going away.[18]

The invention of force-lines as a means of convey-
ing a sense of the inner dynamism or rhythm of ob-

jects can be associated with the attempt of the Neo-Impressionists to interpret ascending, descending, and horizontal lines as universal symbols of human emotions. Charles Henry had viewed lines as the schematic traces of movement, and movement as the revealed response of an individual to an event or perception.[19] The association of sensation with movement in this theoretical framework may have stimulated the Futurists to think about the depiction of movement and of the inner dynamism of objects in relation to their environment in terms of the visible marking of their real or potential trajectories into space.

Although not all the Futurists shared Boccioni's psychological interests or his theory of innate complementariness,[20] the fundamental premises of their work resembled his. The aim of these artists was to express specifically modern sensations in works that reached out to and encircled the viewer through the empathetic power of lines, forms, and colors.[21] For the most part, they sought to do this by adapting the visual techniques of Divisionism to their new subjects. The wheatlike strokes of the Divisionists became even more spontaneous and exuberant in Futurist paintings and many of the Symbolist overtones were abandoned, but the principle that formal elements express emotions independently of imitation continued to guide their art. In this their work diverged noticeably from that of the Cubists, who had rejected the sensuous appeal of brilliant color and spontaneous brushwork. The Futurists, adhering to the tradition of Divisionism, believed that "*painting* and *sensation* are two inseparable words,"[22] whereas the Cubists had severed their links to immediate sensation, choosing instead to emphasize the conventional and conceptual aspects of representation. Not surprisingly, when the Futurists began to experiment with col-

lage in 1912, their understanding of the possibilities of this new technique would also diverge from that of the Cubists.

Transcendental Realities: The Futurist Collages of Severini, Boccioni, and Soffici

Not enough is known at present about the exact chronology of the Futurists' use of collage, but most of the evidence suggests that Gino Severini was the first to experiment with the new technique. Because of his close friendship with Picasso and Apollinaire[23] in the spring of 1912, he was probably aware early on of Picasso's inclusion of foreign elements like stamps and oilcloth in oil paintings. In his memoirs, however, he recalled that it was during a discussion with Apollinaire toward the end of 1912 that the idea of affixing various real objects to the canvas was first discussed:

My friendship with Apollinaire had become intimate. Until 1912 he often came to visit me while I was working. It was towards the end of that year, I can't remember anymore whether at the Hermitage, or at the Lapin or at my studio, that he spoke to me of certain Italian primitives who had put elements of true reality in their pictures, observing that this presence, and the contrast that it provoked augmented the life of paintings and all their dynamism. He gave me the example of a St. Peter exhibited in the Brera Academy in Milan, who has in his hand real keys, and of other saints with other objects, without counting the haloes made with real precious stones and real pearls.

It was thus that I conceived the idea of making a portrait of Paul Fort with the covers of "Vers et Prose" and of his other books of poetry, and of constructing a ballerina with forms in relief upon which I glued real ballerina's sequins.[24]

The St. Peter referred to by Apollinaire in this passage (and in *Les peintres cubistes*) was the subject of the left-hand panel of a large altarpiece by Carlo Crivelli titled *Trittico del Duomo di Camerino,* painted in the latter part of the fifteenth century (fig. 103). This altarpiece, memorable for its imposing grandeur and prominence in the Brera, contained a number of real and illusory elements, intended no doubt to impress the faithful. The Madonna in the center wears a real brooch, and there is heavy embossing applied to her sleeves, halo, and crown, with added gold leaf. The St. Peter carries two enormous real keys and a staff sculpted in relief, and he wears a large brooch and embossed crown. The artist also had recourse to other illusionistic devices, including faux marbre, faux bois, and a trompe l'oeil cloth bearing his name. Apollinaire was obviously struck by the analogy between this strange work with its interplay of the real and the illusory and the contemporary work of Picasso, Braque, and Gris. Yet the lesson Severini derived from this example led him to make collages quite different in intent and effect from those produced by the Cubists. For Severini the interest of such juxtapositions lay in the potential they held for a dynamic *contrast* of elements. The emphasis on contrast, of course, issued from Severini's Divisionist frame of reference and from his interest in finding new expressive contrasts to exploit. Unlike the Cubists, who maintained a more self-conscious and often ironic attitude toward the use of collage elements, Severini sought expressive intensity from the collision of disparate kinds of objects and representations on his canvases. As Severini explained in relation to his earlier use of realistic details in the *Pan-Pan,* "the contrast between a realistic element (a transcendental realism, you understand) and other elements brought to a level of absolute abstraction, generates, like all contrasts, dynamism and life."[25] This sense of dynamism, moreover, depended on the immediate presence of the actual work: "In photographs, these applications have little effect, but the original work gained much in expressive intensity."[26]

A work such as *The Blue Dancer* of late 1912 (fig. 22) is characteristic of Severini's first collages, many of which included colored sequins. Severini glued these sequins to the canvas in lieu of painting them because of the real luminosity they would bring to his works. The Divisionists had sought to express the effects of light through the scientific use of complementaries; Severini had now found a way of capturing real, flickering light from the surrounding ambience and holding it on the surface of his paintings. Like the ornaments and gold leaf in Crivelli's altarpiece, these sequins were intended to enhance both the preciosity and material presence of the work.

In some of his later paintings with sequins, Severini tried to exploit their more abstract qualities. He did this by creating nondescriptive, decorative patterns that function as independent expressive elements. According to Severini, in these pictures he succeeded in "creating zones for the sequins, which therefore were not there to describe a reality, but to express it in a transcendental way."[27] This principle can be observed in a collage of 1913, *Sea = Dancer* (fig. 104). Whereas in *The Blue Dancer,* the sequins glued to the canvas represent the sequins on the dancer's dress, here they establish lines and arabesques that contribute to the empathetic force of the work without assuming a mimetic function. Guided by the Divisionist ideal of treating colors and lines as elements of a universal formal language, Severini sought to avoid using collage techniques as a substitute for imitating reality. The term *transcendental* was intended to convey a sense of the abstract value of these new pictorial materials.

The distinction between a realistic and abstract use of collage elements eventually came to be an issue of central concern to the Futurists. In Severini's earliest collages, however, the pasted papers and objects serve as bits of reality and play a descriptive role within the work. The *Portrait of Paul Fort* (fig. 105), which Severini recalled as being one of his earliest collage works, displays title pages from two publications associated with the poet: the

103. Carlo Crivelli, *Trittico del Duomo di Camerino,* late
fifteenth century. Pinacoteca di Brera, Milan.

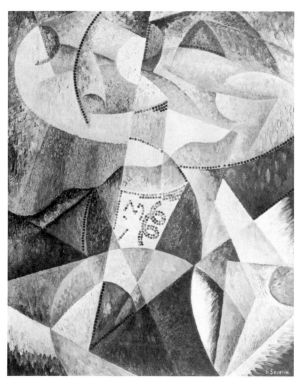

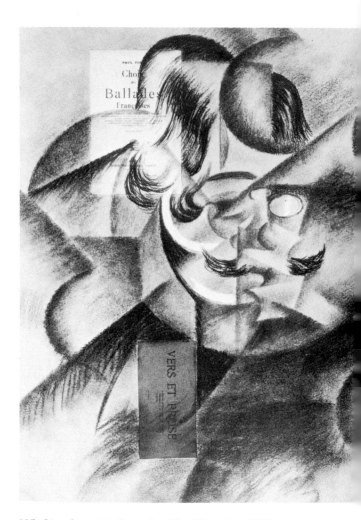

104. Gino Severini, *Sea = Dancer,* 1913, oil and sequins on canvas. Private collection.

105. Gino Severini, *Portrait of Paul Fort,* late 1912 or early 1913, oil and pasted papers on canvas. Private collection.

journal *Vers et Prose* and his book of poems *Ballades Françaises*. These collage elements are of topical interest; they recreate a sense of the environment in which Paul Fort worked and of his accomplishments. As Severini noted in his comments on this work, they also provide a pictorial contrast to the other, more abstract elements, especially to the fragmentary drawing and dynamic lines of force. Severini avoided letting the collage materials serve as simple substitutes for reality, however, by scattering them about the surface of the canvas. The illogical placement of these elements corresponds to Severini's interest in depicting his subjects in all their dynamic simultaneity, without regard for unity of time or place.[28]

Unlike Picasso, then, Severini did not introduce mass-produced materials into his paintings in order to render problematic the notion that a work of art was the unique, original expression of an individual. In principle, Severini was against the use of mechanical procedures in the execution of works of art, since these could only negate the immediacy and spontaneity of the artist in translating his sensations and memories. Futurism, after all, stood for a total rejection of preexisting formulas; once the museums had been destroyed, only the artist's original gestures would remain. For these reasons, Severini had understood Picasso's use of stenciled letters in some of his paintings as a means of achieving a dynamic contrast of real and abstract elements. He could not, however, fully approve the adoption of such "mechanical" procedures. On the subject of dynamic contrasts in Cubist painting, Severini wrote, "I assume that this was the reason for which Picasso even put numbers and letters made with a stencil in certain pictures. But later he abandoned this mechanical means and he too painted realistic elements, which were clear

enough to contrast with the abstraction with which the rest of the picture was made."[29] The inclusion of mass-produced materials in Severini's collages, therefore, was intended to institute a dialogue not between the handmade and the machine-printed, but between bits of transcendental reality and abstraction.

If Severini occasionally affixed newspaper to his canvases, then, it was because of his desire to allude to the totality of sensations afforded by a particular moment of experience. In *Still Life: Bottle, Vase and Newspaper on a Table* of late 1914 or early 1915 (fig. 106), for example, Severini included two newspaper clippings from *La Presse* dated 3 September 1914, one of which bears the clearly visible headline "LE ROLE DE L'ITALIE." The presence of such a clipping with its reference to the war may seem paradoxical given the traditional still life subject. Beginning in late 1913, however, Severini had begun to explore an analogical approach to painting. This approach, a pictorial adaptation of Marinetti's theory of poetic analogies, called for the juxtaposition (or superposition) of disparate images to create new, synthetic images. In his manifesto of 1913 titled "The Plastic Analogies of Dynamism," Severini explained that in works such as *Sea = Dancer + Bunch of Flowers*, the dynamic motion of the sea might initially suggest a "real" analogy to the zigzag movements of a dancer, but that this analogy would in turn give rise to the "apparent" analogy with a bunch of flowers, thereby intensifying the expressive power of the work.[30] The aim was to move beyond obvious comparisons, which were like poetic metaphors, to the creation of new realities. Severini viewed the invention of these "plastic analogies" as a logical development of the Divisionist theory of contrasts: "The theory of contrasts could also be developed in terms of

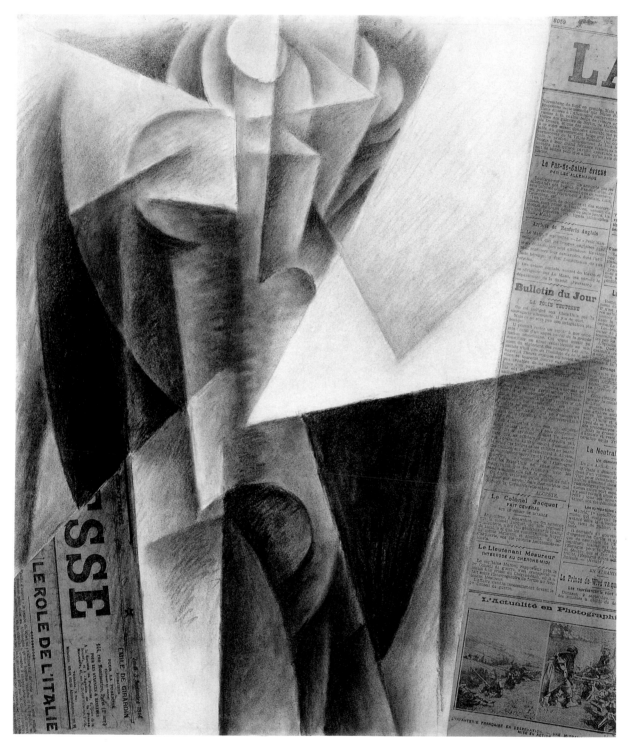

106. Gino Severini, *Still Life: Bottle, Vase and Newspaper on a Table,* late 1914 or early 1915, pasted papers, charcoal, and white chalk. The Alfred Stieglitz Collection, The Metropolitan Museum of Art.

analogies, above all as a poetic inspiration. A complementariness of images, used not to render an image more clearly through the correct juxtaposition of its analogue, but to create a new image; that was my aim. In conclusion I wished, always remaining within the spirit of painting, to bring the image beyond metaphor to a higher poetic plane."[31] The newspaper clippings in *Still Life: Bottle, Vase and Newspaper on a Table* provide a pictorial contrast to the geometrical forms and arabesques of the vase and flowers; here the world of actuality jostles the world of still life objects. A new dynamic unity arises from this confrontation, which for Severini no doubt reflected the multiplicity of contemporary sensations, for news of the war had begun to penetrate the private sphere. Yet all of this takes place "within the spirit of painting." For a time in 1914 and 1915, Severini responded to Marinetti's call for works of art inspired by the war, making collages with newspaper clippings referring to the war and paintings of soldiers in trenches and wounded soldiers returning from the front in trains. By 1916, however, he had abandoned these subjects in favor of a renewed classical naturalism; the *rappel à l'ordre* began before the war was concluded. When the world of reality threatened to become more dynamic than Futurism could ever be, Severini retreated to the peaceable realm of mothers holding infants and to the wistful characters of the commedia dell'arte.

Boccioni's first experiments with the use of mixed media, in particular constructed sculpture, also date from 1912. Like Severini, Boccioni seems to have been inspired to explore the expressive qualities of diverse materials by the things he saw and heard discussed in Paris. Indeed, it is possible that he saw Braque's painted paper reliefs during his visits to the artist's studio in February or March

of 1912 and that these works sparked a sense of the still-unexplored possibilities of sculpture. The first sign of Boccioni's obsession with sculpture can be seen in a letter he wrote on 15 March 1912 while in Paris: "These days I am obsessed with sculpture! I believe I have seen a complete renovation of this mummified art."[32] While traveling with the Futurist exhibition later that spring, Boccioni began to formulate a desire to challenge the Cubists with a series of new, ambitious works. From Berlin he wrote to Carrà: "Marinetti tells me that I have a tendency to exaggerate the value of others. . . . But I cannot negate my own pleasure in considering the work of certain young Frenchmen as excellent and in declaring to myself that Picasso is an extraordinary talent, but they lack completely all that which I see and feel, and through which I believe and hope to surpass them before long."[33] Severini reports that Boccioni returned to Paris for a few days in June of 1912, "demonstrating, during this time, a great interest in sculpture. Every day, and at every moment, there were discussions or conversations on this subject."[34] In order to further Boccioni's knowledge of avant-garde sculpture, Severini took him to visit Archipenko, Brancusi, Duchamp-Villon, and others. (Picasso was in the south of France by this time, but Boccioni may have been able to visit Braque.)[35] After he returned to Milan he wrote again to Severini, asking for information about the latest works of Picasso and Braque: "Acquire all available information on the Cubists and on Picasso and Braque. Go to Kahnweiler and if there are photographs of the *most recent* works (made after my departure) buy one or two."[36] On 30 September 1912, several months after Boccioni's return to Milan,[37] the "Technical Manifesto of Futurist Sculpture" appeared, setting forth ideas that Boccioni had discussed with artists and sculptors in Paris.[38] But if

inspired by things seen in Paris, Boccioni's ideas were also indebted to Marinetti's innovations in poetry and to his own ideal of embracing modernity in its most dramatic forms.

In the "Technical Manifesto," Boccioni asserted that "in sculpture as in painting, renewal is impossible without looking for the STYLE OF MOVEMENT."[39] In order to achieve this renewal, the sculptor should begin with the central core of an object and from this ideal point intuit its projection into space through the development of force-lines. No longer considered from the traditional, static point of view, the object could now be opened to enclose within itself elements of the surrounding environment. Ultimately, the object and the environment should fuse, creating a new whole with little or no visible connection to any prior, logical conception of the object. Just as Marinetti would attempt to cast his ever-expanding net of poetic analogies over the universe, Boccioni sought to reach out and grasp not distinct objects, but a field of energy radiating into infinity.

Once sculpture could be conceived in this exhilaratingly new manner, adherence to the traditional separation of media no longer made sense. Boccioni therefore declared, "There is neither painting nor sculpture, neither music or poetry: there is only creation!"[40] Similarly, reliance on the conventional materials of sculpture now seemed passéiste. In the most noteworthy innovation of the manifesto, Boccioni called on sculptors to "destroy the literary and traditional 'dignity' of marble and bronze statues. Refuse to accept the exclusive nature of a single material in the construction of a sculptural whole. Insist that even twenty different types of materials can be used in a single work of art in order to achieve plastic movement. To mention a few examples: glass, wood, cardboard, iron,

cement, hair, leather, cloth, mirrors, electric lights, etc."[41] Boccioni attributed to these materials an inherently expressive force based on purely physical properties. By way of examples, he explained that the intersecting planes of an object could be constructed of wood or metal, that spherical fibers could take the place of hair, semicircles of glass could signify the forms of a vase, and that the interconnecting "atmospheric planes" could be evoked with wire and netting.[42] This, however, was to take a rather literal view of the signifying possibilities of materials and is similar in effect to Severini's early literal use of sequins.

Braque's Cubist sculptures, in contrast, were constructed only of paper and therefore retained a classical unity of material. If indeed Boccioni saw these works while in Paris, they seem to have sparked the realization that a sculpture need not be made of marble or bronze, and that it could enclose the space of the surrounding environment through open, intersecting planes. Because these works were painted, they may have also encouraged Boccioni to envision an end to the traditional separation of painting and sculpture.

The ideas expressed in Boccioni's manifesto, however, were obviously intended to surpass those of his French contemporaries. Whereas Braque had used paper, Boccioni advocated the inclusion of even twenty different materials in a single work. And these materials were conceived as a means of creating a style of movement, an aim foreign to the Cubists. Most important, however, Boccioni sought to overcome the arbitrariness he believed characterized Cubist works through the dynamism of an intuited central core.

Even as he was writing the "Technical Manifesto of Futurist Sculpture," Boccioni began to put his ideas for a new, environmental sculpture into prac-

tice. Evidently it was not an easy task, and Boccioni wrote to Severini frequently to express his confusion and despair:

> I work a great deal but I don't conclude anything, it seems. That is, I hope that what I make will signify something because I don't understand what I'm doing. It is strange and terrible but I am calm. Today I worked for six consecutive hours on sculpture and I don't understand the result. . . .
>
> Planes on planes, sections of muscles, of face, and then? And the total effect? Does what I make live? Where am I going to end up? Can I ask for the enthusiasm and understanding of others when I myself ask myself what is the emotion that springs forth from what I am making? Enough there is always a revolver . . . and yet I am extremely calm.[43]

A short while later he wrote to Severini again, to express his confusion but also his desire to overcome "the chaos of the arbitrary":

> Your dear postcard reached me at a terrible moment. What we must do is enormous; the task I have taken on is terrible and the plastic means appear and disappear at the moment of realization. It's terrible!
>
> I don't know what to say, what to do.
> I don't understand anything anymore! . . .
> Is it the chaos of the arbitrary? What is the law? It's terrible!
> I am battling with sculpture: I work, work, work and I don't know what results . . .
> The Cubists are wrong . . . Picasso is wrong.[44]

The first fruits of these labors were indeed disappointing. Boccioni's now destroyed *Fusion of a Head and a Window* of 1912 (fig. 21), suggests a crucifixion more than a dynamic interpenetration of a figure with elements of the environment. The frame and glass of the real window seem to impale a horribly grimacing head, while other bits of reality, such as the braided chignon to the right of the figure's head, remain discrete and isolated. Partly modeled and partly constructed, the work also reveals some technical uncertainty about how to achieve the ideal of dynamic synthesis.

In his paintings of this period, Boccioni frequently used a brightly colored stippled stroke to convey a sense of the ability of light to dissolve mass, thereby creating a unified ambience. In *Fusion of a Head and a Window,* however, the plastic realization of streams of light has the opposite effect, turning the immaterial play of light and color into a static object. The result suggests an unwitting parody of a Baroque sculptural ensemble. What might have been a successful evocation of the interpenetration of objects and light in painting required a different treatment in sculpture. Ironically, most of Boccioni's later sculptures, like the *Development of a Bottle in Space* or the *Unique Forms of Continuity in Space* gave more convincing form to the idea of an object projecting into the surrounding space through the creation of synthesized profiles. Significantly, these works were executed in a single, *passatista* material—plaster—to be cast later in bronze.

By the time of his exhibition of sculpture at the Galerie la Boétie in June of 1913, Boccioni had begun to conceive the expressive value of diverse materials in a more abstract sense. Whereas the use of a single, "noble" material had made sculpture the static art par excellence, a diversity of materials would necessarily introduce a sense of dynamism through contrast. For Boccioni, as for Severini, the idea of breaking an apparently unified form or color into its constituent contrasting elements was

part of the Divisionist legacy; it was a technique designed to enhance intensity of expression or dynamism. In the "Preface to the First Exhibition of Futurist Sculpture" Boccioni stated, "I therefore thought that one could obtain a basic dynamic element by breaking down this unity of material into a certain number of different substances, each of which could, but its very diversity, characterize a difference of weight and expansion of the molecular volumes."[45]

This attempt to render the molecular composition of objects is also analogous to Marinetti's idea that words could convey the capacity of objects for flight or dispersal into the environment in terms of their molecular properties (weight, smell, and sound.)[46] Viewing materials as aggregates of molecules in motion was a way of grounding the Futurist study of the expressive properties of matter in the latest discoveries of science. These tended to discredit the old, static view of matter as solid substance in favor of a new vision of matter as a dynamic field of energy. Superimposed on the discoveries of science were the axioms of Henri Bergson's philosophy of élan vital, of reality as flux and transformation, which necessarily demolished the old, arbitrary distinctions between an object and its environment. The Futurists believed the artist was ideally suited to intuit these dynamic relationships, which, according to Bergson, remained impervious to the static analyses of science.

Despite their recognition of his talent, Boccioni's critics remained skeptical when confronted with his works at the Galerie la Boétie. Gustave Kahn viewed the attempt to fuse an object with its environment as wrongheaded, a misunderstanding of the scientific discoveries it was based on: "If reflections have a composed and interpenetrable life, is it the same for forms? I think not. The science that

one can evoke to prove their interpenetrability does not claim that this penetration occurs with solid masses."[47] More disturbing, however, was Boccioni's use of "vulgar" materials, which Kahn criticized in terms similar to those he had used when discussing the first collages of Juan Gris: "In addition, it is annoying that an artist like Boccioni condescends to these little games of juxtaposition of the material of art with vulgar materials, games which have been practiced and wrongly, except for the most gifted, by several lost children of Cubism. It will never be artistic to mix with clay or to glue onto a canvas glass, hair, cut wood."[48] Kahn concluded by calling Boccioni "un premier chef antiplastique."[49]

The critic Roberto Longhi was far more sympathetic to Boccioni's aims but came to similar conclusions.[50] Like Kahn, he believed that each medium was distinctive and regretted that much contemporary sculpture had pictorial qualities. More significantly, he felt that Boccioni's earliest sculptures, such as *Fusion of a Head and a Window* (fig. 21) and *Head + House + Light* did not achieve the sense of dynamic interpenetration the artist advocated in his manifestos but remained a static enumeration of diverse elements: "Organic deformations of lightly radiating abstraction and an imposed static architecture of blocks of atmosphere, of ambience, of light; squared mass and linear profile of twisted volumes encounter each other, and without being able to fuse, remain side by side. . . . *Head + House + Light* will never become *Head-houselight*."[51] For Longhi, the static quality of these works was also associated with their pictorial basis, most evident in their frontality. Like Kahnweiler, he believed that true works of sculpture should be autonomous and freestanding. Thus, he interpreted Boccioni's preference for radial compo-

sitions as derived from painting and argued that it did not lead to "genuine circumnavigation."[52] As Longhi put it, in Boccioni's early sculptures, "We have not yet arrived at a true conception of the organism, isolated and situated."[53] As we have seen, in 1912 Salmon had observed a similarly skeptical response to the constructed works Picasso hung on his studio walls, which seemed to defy categorization as painting or sculpture.

On the whole, Boccioni achieved more success in working with diverse materials in his collages than in his sculptures. Difficult to date, these collages were probably executed during 1913 and 1914, after the first experiments with multimedia sculpture. The *Still Life with Glass and Siphon* (fig. 107), which probably dates from 1914, is characteristic of his collage works. Unlike Picasso and Braque, Boccioni did not tend to assert the identity of each pasted element by allowing its boundaries to remain visible. In *Still Life,* for example, he covered almost the entire surface of his canvas with various kinds of paper and cardboard, so that the glass and siphon seem embedded within a textured ground. Because Boccioni painted over the layered materials glued to his canvases, Herta Wescher was led to claim that these materials served no particular expressive purpose.[54] This is patently mistaken: they provided Boccioni with a plastic means of suggesting the "molecular" interpenetration of the depicted object and its environment. Just as Boccioni had once rejected a too rigorous application of separate strokes of pure color, he now rejected a collage technique based on a play of clearly defined edges and on the relations between distinct elements. His ideal, on the contrary, was to suggest a shattering of preconceived boundaries through the intuitive vision of the artist.

Boccioni's choice of a still life subject in this collage may seem curious given the Futurists' predilection for modern, heroic themes. But Boccioni seems to have wanted to demonstrate that given sufficient intuitive power, "all things move."[55] The artist's understanding of motion at this time was directly influenced by the theories of Henri Bergson, from whom he took the distinction between absolute and relative motion.[56] In a manifesto of 1914 titled, "Absolute Motion + Relative Motion = Dynamism,"[57] Boccioni explained that "relative motion" was the movement of one object in relation to another, while "absolute motion" was the inherent dynamism of the object itself, determined by the characteristics of its material substance. Of the two, Boccioni considered absolute motion to be the more important, for it implied that all things, even when not apparently moving, project an inner dynamism and interact with their surrounding environment. In *Still Life,* Boccioni sought to convey the absolute motion of the siphon and glass; these objects do not appear as figures against the ground of the picture plane but are fused with a ground that is itself in flux (owing to the variety of juxtaposed materials that compose it). Whereas Picasso had sought both to assert and to undermine the classical opposition of figure and ground through a series of clever figure / ground reversals, Boccioni brought this opposition to a point of near extinction.

If figure and ground were to be fused in a new dynamic continuum in Boccioni's collages, so too were the spectator and the work of art. Following his own dictum, Boccioni organized his *Still Life* around a central core, from which force lines radiate into the surrounding environment. He intended these lines both to reveal how the glass and siphon would develop in space, given the tendencies of their absolute motions and to "encircle and

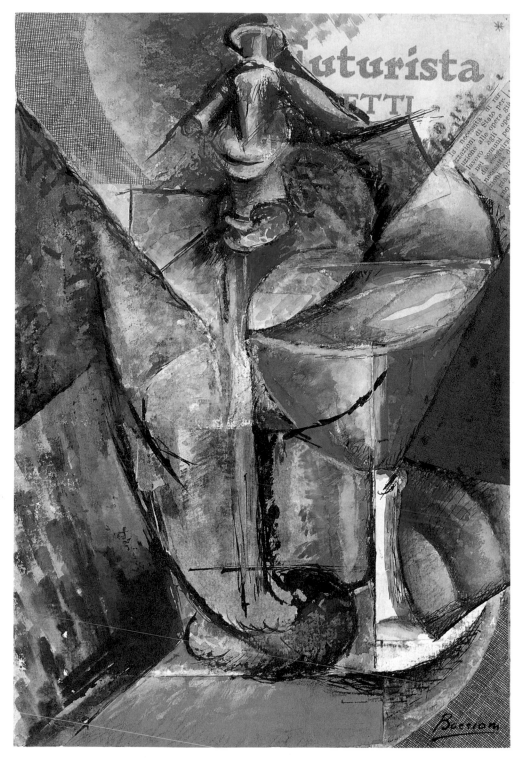

107. Umberto Boccioni, *Still Life with Glass and Siphon,*
c. 1914, pasted papers, gouache, and ink on paper. Yale
University Art Gallery. Gift of Collection Société
Anonyme.

involve the spectator."[58] Boccioni further pointed to the specifically Futurist character of this collage by including a fragment of the "Founding and Manifesto of Futurism" in the upper right corner. This *Still Life* can be interpreted as the Futurist answer to Cubist collage, transforming what the Futurists regarded as static forms and fragmentary analyses of objects into a new, dynamic unity. For whereas Cubist collages were frequently characterized by a nonhierarchical manipulation of formal oppositions, Futurist collages such as these of Boccioni sought to engage the viewer through the magnetic attraction of the absolute center, unregulated by the contrasts exploited elsewhere in their works.[59]

A similar use of collage materials to create complex, layered grounds occurs in two portraits Boccioni executed in the late summer or fall of 1914. In *Dynamism of a Woman's Head* (fig. 108), Boccioni rendered the head (probably that of his mother) in a series of curving, fragmented planes and overlapping profiles. The texts of various newspaper fragments remain barely legible beneath the stippled tempera and ink overdrawing, which serve to bring out certain planes and to cause others to fuse with those nearby. The only pasted element that remains unobscured is the small fragment of a magazine picture showing a young gesturing woman, which Boccioni affixed just above the figure's right eye. He may have intended it to provide a pictorial contrast to his own more dynamic restructuring of form or to recall a memory associated with the woman. Curiously, a guitarlike profile appears at the extreme left, probably in imitation of, or homage to, Picasso's anthropomorphized guitars, although here it plays no structural role.

In *Dynamism of a Man's Head* (fig. 109) Boccioni adopted a more closeup view and opposed the curving profiles of the woman's head with a series of geometric, straightedged profiles. The layered papers, gouache, and drawing, however, create a similarly dense surface. Nonetheless, a few words and phrases do emerge from the nearly obscured newspaper text placed across the man's head: "serbie," "imperiali," "guerra," "lotta," "l'Ungheria," "della patria." At the lower right, similarly violent images are evoked by the text: "pistola," "grande crudeltà," "una gran folla di gente," "spaventa." Boccioni undoubtedly intended these words, bellicose in spirit, to enhance the viewer's experience of the dynamism of the man's archetypally Futurist state of mind. Yet the artist chose to paint over these texts with gouache so that the prowar message became nearly submerged in the speckled surface. In the collages of this period, Boccioni seems to have struggled to balance the importance of the subject with attention to the expressive properties of his materials. Of the Cubists, only Gris's collages rival Boccioni's in terms of sheer textural richness. Boccioni's collages, however, resist the decorative impulses found in Gris's work of 1914. Boccioni would have objected to the generation of fragmented or distorted profiles from the imposition of an a priori grid. He believed that only through the spontaneous, empathetic fusion of the artist with his subject could a true sense of dynamism and vitality be achieved.

The comparatively abstract treatment of materials in Boccioni's collages of 1914 may be seen, in part, as the artist's response to the criticism of Giovanni Papini published in *Lacerba* in February and March of that year. Papini launched his attack on the inclusion of bits of reality in works of art in an acrimonious article titled "Il Cerchio si chiude" (The circle closes). According to his argument, art originated in imitation but progressed as "deformation," by which Papini meant free, lyrical expression. With the recent inclusion of elements of

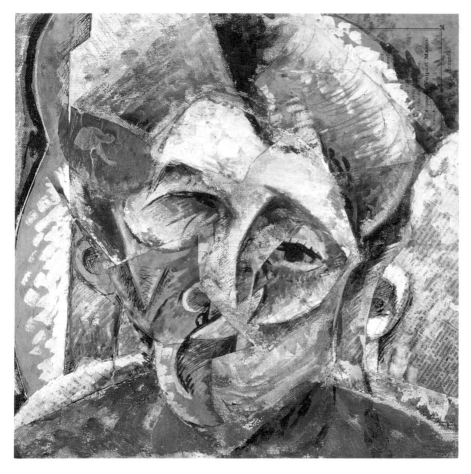

108. Umberto Boccioni, *Dynamism of a Woman's Head*,
1914, pasted papers, watercolor, gouache, ink, and oil
on canvas. Civico Museo d'Arte Contemporanea,
Palazzo Reale, Milan. Photo Saporetti.

109. Umberto Boccioni, *Dynamism of a Man's Head,*
1914, pasted papers, watercolor, gouache, ink, and oil
on canvas. Civico Museo d'Arte Contemporanea,
Palazzo Reale, Milan. Photo Saporetti.

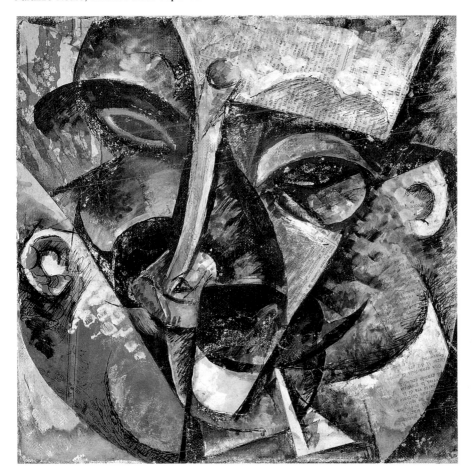

untransformed reality in painting, sculpture, po-
etry, and music, however, the autonomy of art as
creation was negated, the circle of art's history
closed. As Papini put it, "Creation is transformed
into simple action; art returns to brute nature."[60] In
making this accusation, Papini cited many of the
most fundamental innovations of Futurism: Mari-
netti's rejection of syntax and "return" to the on-
omatopoeic effects and concrete images of a

seemingly primitive language, Russolo's introduction of the noises of everyday life into his music, Severini's use of a real[61] moustache in a portrait, and Boccioni's sculpture, in which wood, glass, and metal replaced the usual materials of art. According to Papini, these innovations shared a single characteristic: "It is a question of substituting things themselves for the lyrical or rational transformation of things."[62] If carried to its logical extreme, Papini warned, such a substitution of mere things for representations would utterly negate the personality of the artist, and art would become indistinguishable from reality.

Boccioni, always anxious to defend his ideas and works, countered these claims with an equally aggressive rebuttal titled "Il Cerchio non si chiude" (The circle isn't closing). In this reply, Boccioni described Papini's article as a "cry of alarm," uttered in a moment of weakness. Evidently Papini had forgotten one of the basic principles of Futurism—that new experiences require new means of expression. Moreover, Boccioni asserted that once an element of reality entered a work of art, it was necessarily transformed: "As soon as this reality becomes part of the elaborated material of a work of art, the lyrical function it must fulfill, its position, its dimensions, the contrast to which it gives rise, all transform the anonymous objectivity, and guide it to become an elaborated element."[63]

Indeed, Boccioni attributed the lack of vitality in traditional sculpture to an overelaboration of primary materials. In order to redress this flaw, he advocated renewed contact with reality, but only as a means of constructing a "new reality." Emphasis on the creation of a new reality, however, led to a curious paradox in Boccioni's thinking at this time. In his earlier statements, he had called for the use of a variety of materials previously unknown in the realm of art, suggesting that materials have an inherent expressive value based on their qualities as physical substances. In "Il Cerchio non si chiude," however, Boccioni described these new materials as bits of "anonymous objectivity" awaiting the creative intervention of the artist to take on meaning.

Boccioni's collages of this period reflect a similar paradox. A variety of materials were brought together on the canvas to establish a highly complex surface, which Boccioni then used as a ground for further elaboration. The expressive qualities of materials as such became nearly submerged in this transformative process. As Boccioni explained to Papini, "In our most recent works the elements of crude reality, as you say, become diminished, *absorbed, synthesized* and *deformed in the dynamic abstraction*."[64] Again, this entailed a critique of Cubist collages and constructions, for Picasso's work remained the primary challenge, and Boccioni hoped to surpass it at all costs. He therefore claimed that, "in Picasso, on the other hand, logically, the elements of crude reality are actually being augmented in his most recent production."[65] (Boccioni, in this passage, may be referring to the constructions reproduced in *Les Soirées de Paris* for November 1913.) Papini, in his reply to Boccioni, countered that Picasso never employed the bits of reality that appeared in his works in a literal sense. To prove his point he stated that during a recent visit to Paris, Picasso had shown him several photographs, perhaps including the *Assemblage with Guitar Player* (fig. 61): "Picasso showed me the photographs of walls in his studio where there were various objects (arranged by himself) and told me that according to someone, those groupings of real objects were already pictures."[66] Papini went on to claim that Picasso was too so-

phisticated to be taken in by such ideas, but others obviously had been, and therein lay the danger.

Given the terms of this dispute, Boccioni's highly elaborated collages of 1914 seem to have been intended to dramatize the power of the artist to transform elements of unrefined matter into works of art, both in self-conscious opposition to what he perceived as Cubist practice and as a refutation of Papini's ideas. Severini's creation of abstract zones of sequins issued from a parallel desire to distinguish between a literal and an abstract use of collage materials or, as he put it, between mere reality and transcendental reality. Soffici's collages, also executed during the spring of 1914, were founded on similar premises. In his essay titled *Primi principi di una estetica futurista,* written during the war, Soffici declared that the task of the artist was to "spiritualize" matter: "The material employed by an artist remains completely and always inert, dead, inexpressive, if it is not brought by genius to become SPIRITUALIZED; to become, that is, a pure element of lyrical symbolic transfiguration. This is equivalent to its disappearance inasmuch as it is material."[67]

Thus materials, for Soffici, must efface themselves in the process of becoming vehicles of expression. In theory at least, Soffici therefore assigned a purely formal, rather than representative, value to the bits of reality that Futurist artists introduced into their works. As such, he claimed, they did not differ essentially from the traditional materials employed by artists. Responding no doubt to the reservations of his friend Papini, Soffici wrote in *Primi principi* regarding the use of unusual materials in art,

It is true that an objection presents itself immediately to the mind on this subject: and it is that an object, a fragment of newspaper, of a poster, of cloth, or of any other thing, affixed to a picture or a sculpture to avoid the labor of representing them, cannot but remain extrinsic and dead, besides being a sign of spiritual coarseness or of weakness. And one shouldn't have to repeat it, if it was really their absurd function. But if instead, and precisely, these things have no *representative* function in a work where, it is not even a question of representing something; but the object, the bit of paper, or of material, etc. only function as color, or as value, or as plastic form, or in any case as a harmonious element, as technical means, just as colors, ceramics, stones, metals, etc. in the place of which they are employed?[68]

Soffici, it seems, would have had difficulty justifying the early collage practice of Braque or Gris, in which bits of "reality" (mirrors, labels, pages from a book, or newspaper clippings) were introduced precisely to signify the artist's refusal to copy, to do, that is, the work of sign painters or illustrators. Yet ultimately Soffici's attitude did not differ fundamentally from that of the Cubists, for they too believed that the true value of a work of art lay in the artist's conception.

Soffici's theoretical justification of collage techniques was intended, at least in part, to illuminate his own practice. In February of 1914 Soffici returned to Paris after an absence of over a year and, once again in contact with his Cubist friends, began to execute a series of collages designed to clarify his own position vis-à-vis both Cubism and Futurism. Indeed, a collage such as *Still Life with Matches* (fig. 110) owes as much to French as to Italian attitudes. The subject, a still life with bottle, glass, matches, and a cigarette, was a mainstay of the Cubist repertory and at once associated his work with that milieu. Even the diagonal pattern on

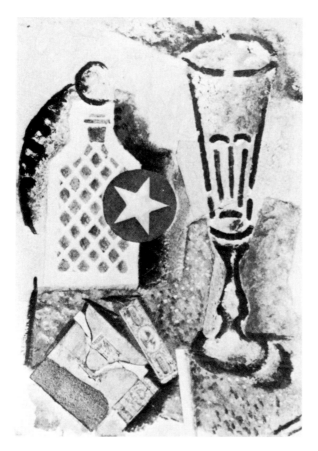

110. Ardengo Soffici, *Still Life with Matches,* 1914, pasted papers, gouache on paper. Jucker Collection, Milan.

the bottle seems to derive directly from Picasso's *Construction with Guitar* (fig. 54), which Picasso had published in *Les Soirées de Paris* the previous November.[69] He may also have seen the bottle hanging as an independent piece on Picasso's wall.[70] The various labels and other bits of paper affixed to the surface of this collage function, despite Soffici's avowed formalism, in a variety of ways. The label from the package of matches, for example, retains its identity and indeed represents a package of matches in this work. Yet Soffici's elegant composition, the speckled patterns in gouache, and the way the objects seem to hover above the surface of the tilted tabletop all serve to remove this café still life from the actuality of the represented scene.

Another collage, titled *Still Life (Piccola Velocità)* (fig. 111), initially seems more Futurist in character. In addition to the bottle with the diagonal pattern and the glass, we find references to the "ferrovie dello stato" (national railways) and to the idea of velocity. But Soffici's *Still Life,* while composed of free-floating fragments, does little to convey the power of speed or the dynamic interpenetration of objects. There are no force-lines in this work, and individual objects are not significantly broken open or recomposed from an imaginary center. These objects are released, however, from the downward pull of gravity and, suspended lightly against the picture plane, suggest the simultaneity of a particular moment of experience in which logical spatial relations have been superseded.

Other aspects of this collage relate it more closely to Cubist works. The newspaper clipping advertising "Splendour du Buste" may have been inspired by Picasso's *Still Life: "Au Bon Marché"* (fig. 94), in which similar advertisements appear. The stenciled letters "SOF" (for Soffici) and "WY," juxtaposed with a variety of other printed letters, could also have been derived from the use of such devices in Cubist works, specifically from Braque's frequent inclusion of the letters "BACH" and "BOCK" as disguised homonyms for his missing signature.

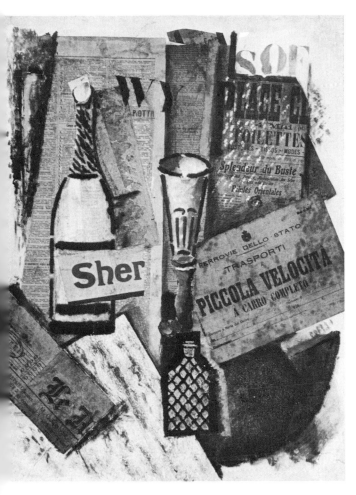

111. Ardengo Soffici, *Still Life* (*Piccola Velocità*), 1914, pasted papers and gouache on paper. Jucker Collection, Milan.

Soffici's collage, however, suggests the artist had a greater interest in the pictorial possibilities of typography for its own sake than the Cubists. This is borne out by later poetic works such as "Tipografia" (fig. 112), in which individual letters and fragments of poetry seem to take on life through their dynamic disposition on the page.

Despite these adaptations and responses to Cubist innovations, Soffici's work remains resolutely distinctive. What comes to the fore in his collages is not an attempt to parody or subvert the fine art status of works of art, but an attempt to transfigure commonplace objects. Unlike the other Futurists, Soffici's formative experiences lay in French Impressionism rather than in Italian Divisionism. In his writings, he frequently praised the Impressionists for having demonstrated that even humble, everyday objects could be invested with aesthetic value: "The Impressionist painter . . . came to feel that everything could be the subject of beauty and of poetry if contemplated with the eye of a creator . . . the human face, animals, the most insignificant nook in nature, the same for inanimate things—utensils, an empty glass, whatever you like, a crumpled rag—had the same value as *pure artistic elements,* only differentiated by their color and their form."[71] In his collages, Soffici sought to produce a similar transformation through an emphasis on expressive deformations of color, line, and form.[72] If the objects in his collages were of humble origin, then, it was in part to emphasize the artist's magical powers of creation.

According to Soffici, the Impressionists had also revealed that objects do not have an absolute, unchangeable form, but that the perception of form itself is subject to the variable conditions of light. This, too, had been the lesson of Medardo Rosso's sculpture, for which Soffici had the highest regard: "Medardo Rosso, similar in this to the French Impressionists . . . , does not conceive things if not as a rapid succession of movements in a mutual continuous relation of colors and lights. According to him, as according to his painter colleagues, the

color and the aspect of an object vary relentlessly
according to the ambience in which it finds itself,
or the nearness of one or another object that influ-
ences it with its reflections or its contrast."[73] Soffici
further described the effect of Rosso's sculptures in
terms that are strikingly similar to those he would
later use to describe Futurist works: "According to
him [Rosso] the movement of a figure does not
have to end at the lines of a contour, like sound
at the walls of a crystal bell jar, but through an im-
pulsion produced by the intensity of the play of
values, of the jolts and the lines of a work, propels
itself into space, spreading to infinity, in the way a
wave of electricity emitted from a well-constructed
machine, flies forth to reintegrate itself with the
eternal force of worlds."[74]

 As this passage suggests, Soffici, whose classical
tastes prevented him from fully endorsing Marinet-
ti's iconoclasm or his ideal of representing the
beauty of speed, nevertheless found the idea of the
mutual interpenetration of objects compelling. In
Cubismo e oltre of 1913, reissued the following year
with the more explicit title *Cubismo e Futurismo,*
Soffici argued that Futurism represented a dynamic
synthesis of the two dominant forces in contempo-
rary art: Impressionism with its exclusive attention
to the fleeting sensations of light and color, and
Cubism with its exclusive attention to (static) solid
form. His collage *Still Life with Lacerba* of 1913 (fig.
24) seems intended to exemplify this moment of
dialectical synthesis. Fragments of Futurist texts,
including the title *Lacerba* and a section of Mari-
netti's free-word poem "Adrianopoli Assiedo Or-
chestra," take their place within an animated
environment of abstract, colorful planes and still
life objects, including a pear, slice of watermelon,
and bottle.[75] Firmly positioned in the center of
these juxtaposed and partly overlapping elements
is the title "CUBISMO E OLTRE," discretely suggesting
that in this and other Futurist works the construc-
tive goals of the Cubists had been absorbed and
surpassed.

 Collages such as this—and what they implied—
did not go unnoticed by Soffici's Cubist friends. Pi-

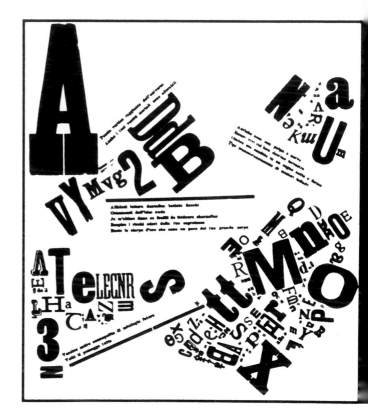

112. Ardengo Soffici, "Tipografia," from *BiF § ZF + 18,*
1915.

casso's *Still Life: "Almanacco Purgativo"* of spring
1914 is a rather malicious parody of the complex
surfaces of interpenetrating planes and self-adver-
tising texts of Futurist collages (fig. 113). The line
of print on the limp, undulating fork, reads "profili
dei nostri più infelici contemporanei" (profiles of
our most unfortunate contemporaries), while the
proffered meal is jokingly referred to as a purga-
tive. Most subversive of all is the fact that these
collage texts were excerpted from the pages of *Lac-
erba* itself. Braque responded to the rhetoric of Fu-
turism by inserting fragments of *Lacerba* into the
Cubist order of things in a collage of 1914 titled
The Violin (fig. 114). Soffici's name appears, not
surprisingly, on a triangular bit of text glued near
the center of Braque's work.

Because of their stylistic variety and the some-
times opposing aims they reveal, Soffici's collages
demonstrate many of the tensions and contradic-
tions to be found in Futurism at this historical
juncture. These tensions went beyond the debate
over the role of new and unusual materials in
works of art and the role of the artist in transform-
ing them. Ultimately the primary question facing
the Futurists as 1914 drew to a close concerned the
role art should play in the life of the nation. Should
the work of art remain autonomous and pure, for-
ever effacing itself in the experience of the viewer,
as Soffici maintained? or should it join forces with
the increasingly political movements of the day, as
Marinetti believed?

Carrà, who went to Paris in the spring of 1914 in
the company of Soffici and Papini, also began to
address these issues in his work. Like Soffici, Carrà
believed works of art originated in the artist's act
of expressive deformation, yet he was unwilling to
seal his works against the demands and interests of
everyday life, and especially those of politics. Some
of his collages, executed shortly after his sojourn
in Paris, where he renewed his contacts with Pi-
casso and Apollinaire, indicate a desire to break
through the enclosing frames that designate the
limits of a work and allow it to be perceived as an
autonomous entity. Some of these experiments

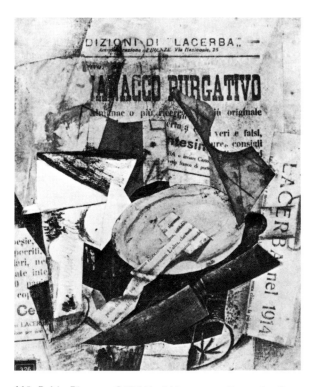

113. Pablo Picasso, *Still Life: "Almanacco Purgativo,"*
spring 1914, pasted papers, gouache, and charcoal.
Private collection.

demonstrate an awareness of Picasso's contemporary play with frames and framing devices. Indeed, it is interesting to compare Picasso's construction *Glass, Die and Newspaper* of the spring of 1914 (fig. 63) to Carrà's *Still Life: Noises of a Night Café* of late summer or fall 1914 (fig. 115). In both constructions, still life elements project beyond the frame into the viewer's space. And in both works, the subject is the urban café and the pleasures it offers.[76] Carrà's construction, however, makes far greater use of words, whether hand-printed or in the form of collage elements glued to the surface. Whereas Picasso's construction bears only the fragmentary, crudely painted letters "URN," Carrà's work explodes with a variety of typefaces and dynamically disposed words alluding to popular songs, poetry, illuminated advertisements, and newspaper clippings. The vertically displayed label "BOTTIGLI SILURO" (bottles torpedo) introduces a typically Futurist note in the impulse to discover analogical connections between disparate objects. It also announces Carrà's increasingly virulent prowar position, as does the newspaper headline: "Le ultime dichiarazioni di guerra" (The latest declarations of war).

In order to understand Carrà's innovative use of verbal fragments and his desire to respond aggressively to the war, however, we must turn to contemporary developments in Futurist poetry. For in Marinetti's invention and elaboration of the new poetic form he called parole in libertà, we encounter the equivalent in poetry of Futurist collage in the visual arts. By late 1914, when *Noises of a Night Café* was executed, the distinction that had previously obtained between Futurist poetry and Futurist painting had been largely obliterated. This collagelike form of writing was originally invented by Marinetti to create a dynamic means of expression suited to the goal of promoting Italy's rising nationalism and, more specifically, an atmosphere of enthusiasm for war. The result was a new synthetic form the Futurists called the Free-Word Picture. Of the Futurist painters, Carrà became its most inventive practitioner.

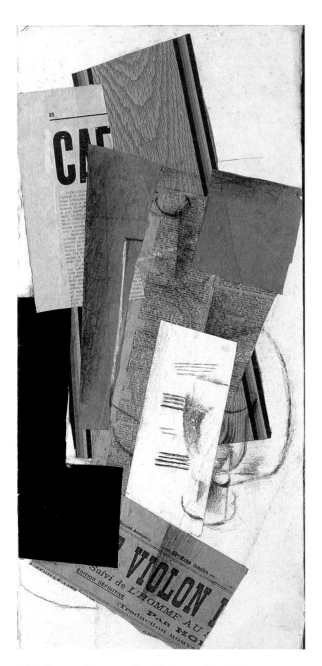

114. Georges Braque, *The Violin,* spring 1914, pasted papers and charcoal on paper. Private collection.

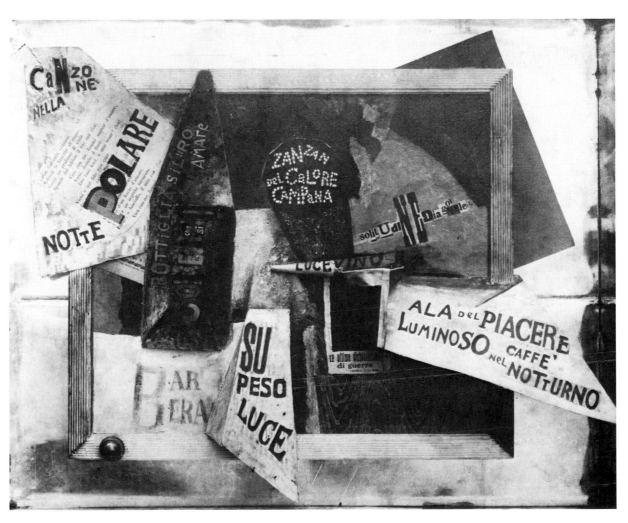

115. Carlo Carrà, *Still Life: Noises of a Night Café,* late
summer or fall 1914, mixed media assemblage.
Location unknown.

Collage Poems:

From Words

in Freedom

to Free-Word

Pictures

Au fond, des estampes. Je crois que toute phrase ou pensée, si elle a un rythme, doit le modeler sur l'objet qu'elle vise et reproduire, jetée à nu, immédiatement, comme jaillie en l'esprit, un peu l'attitude de cet objet quant à tout.
—Stéphane Mallarmé, letter to Camille Mauclair

In the spring of 1912, shortly after Picasso executed the *Still Life with Chair-Caning,* Marinetti proclaimed the invention of a dramatically new poetic form—parole in libertà. This invention, designed to liberate words from the shackles of traditional prosody and syntax, produced a revolution in poetry comparable in many ways to that inaugurated in painting by the invention of collage. Although Marinetti was probably unaware of Picasso's first collage, striking parallels between the two revolutionary techniques indicate a shared desire to break the unified syntax and material homogeneity of inherited means of expression. These parallels are not entirely fortuitous, however, since contacts between Italian and French circles reached a high point during the winter and spring of 1912. Marinetti's poetic ideas were partly inspired by conversations with Boccioni, who, as we have seen, returned from his tour of Europe in the spring obsessed with the idea of creating a new, multi-media sculpture. Boccioni's notion that a variety of heterogeneous and specifically modern materials must replace the "static" use of bronze and marble finds its correlative in Marinetti's rejection of traditional verse forms and syntax in order to allow disconnected words to collide on the activated space of the page. The immediate juxtaposition of disparate elements was common both to Boccioni's new sculptural ideals and to the new poetry. Whereas the Futurists emphasized the volatility and explosive power of their new forms and materials, however, the Cubists emphasized formal play and wit.

Despite these important differences, Cubists and Futurists both sought a new language of rupture, not only with the past but within the work of art. Just as Picasso incorporated fragments of cheap, mass-produced materials into the realm of paint-ing, Marinetti advocated the use of brutally direct words and untransformed "noise" in poetry. Moreover, Marinetti understood onomatopoeia as a bit of reality, akin therefore to the bits of reality[1] that had begun to appear in Picasso's collages and that were soon to appear in Boccioni's sculpture. Eventually the Futurist poet began to introduce other kinds of found materials into his compositions. "Aeroplano Bulgaro," one of the poems published in *Zang Tumb Tumb* (1914), for example, includes the entire text of a leaflet dropped by a Bulgarian airplane in the First Balkan War. Other free-word poems contain elements cut from earlier Futurist texts or newspapers and glued to the page in a technical procedure indistinguishable from pictorial collage—except insofar as most of these collage poems were intended to be photographed and then published as leaflets or in journals rather than to exist as unique works.

Although cautious at first about the pictorial deployment of his innovations, Marinetti eventually came to see the development of free-word poetry as leading to a synthesis of visual and verbal means of expression. In July 1914 he wrote to Severini to argue that the new effort "to fuse plastic dynamism with words in freedom," to be seen in works by Severini and Carrà, be called "disegno o dipinto parolibero" (free-word drawing or painting).[2] In 1919 Marinetti would designate as "Tavole parolibere e Poesie murali" (Free-word pictures and poetic murals) those free-word compositions of Carrà, Severini, Cangiullo, Soffici, and others that had a strong pictorial character and were meant to be viewed rather than read or declaimed.[3]

Marinetti's innovations were quickly taken up by poets and artists in Italy, but they had an important effect on French poetry as well. Between October and November 1912, Apollinaire suppressed the

punctuation on the proofs of *Alcools,* in spite of his frequently voiced reservations about Futurism. The poem "Zone," the most recent to be included in *Alcools,* bears several notable similarities in theme and structure to Marinetti's writings.[4] From the first line, "A la fin tu es las de ce monde ancien" (In the end you are tired of this ancient world), the author embarks on a fantastic journey that takes him from the Eiffel Tower to the industrial zone on the outskirts of Paris, to the Mediterranean coast, Rome, Amsterdam, and so forth, all recounted with many abrupt and incongruous juxtapositions in imagery and tone. The nearly exclusive use of the present tense in this poem seems to collapse past and present, near and far, onto a single, simultaneous plane of experience. Yet in comparison to Marinetti's contemporary free-word poems, Apollinaire's "Zone" retains a sense of narrative and a personal lyrical quality.

Shortly thereafter, Apollinaire began to compose his poèmes conversation, in which he took the principle of simultaneity to a new extreme. These poems are a form of verbal collage comprising fragments of overheard speech, random impressions, and onomatopoeic effects "pasted" together without connecting links. The earliest of these was "Les Fenêtres," written collaboratively by Apollinaire, André Billy, and René Dalize while they drank vermouth at the Crucifix, a café in the rue Daunou. According to Billy, Apollinaire suddenly remembered that he had promised to write a preface for a catalogue of Robert Delaunay's paintings, which was due that very day. Beginning with Apollinaire, they took turns composing "Les Fenêtres" line by line, even including Billy's comment that perhaps they should send the preface by telephone.[5] The result was a juxtaposition of apparently unrelated phrases, which nonetheless evoked Delaunay's interest in simultaneity of color, time, and place:

Du rouge au vert tout le jaune se meurt
Quand chantent les aras dans les forêts natales
Abatis de pihis
Il y a un poème à faire sur l'oiseau qui n'a qu'une
 aile
Nous l'enverrons en message téléphonique

[From red to green all the yellow dies
When parakeets sing in their native forests
Giblets of pihis
There's a poem to be done on the bird with only
 one wing
We'll send it by telephone][6]

While this poem retains elements of lyricism, in "Rue Lundi Christine" of December 1913, Apollinaire appropriated banal, ordinary phrases overheard at a café. The result was disjointed but not without humor:

Ces crêpes étaient exquises
La fontaine coule
Robe noire comme ses ongles
C'est complètement impossible
Voici monsieur
La bague en malachite
Le sol est semé de sciure
Alors c'est vrai
La serveuse rousse a été enlevée par un libraire

[Those pancakes were divine
The water's running
Dress black as her nails
It's absolutely impossible
Here sir
The malachite ring
The ground is covered with sawdust
Then it's true
The redheaded waitress eloped with a
 bookseller][7]

The only unifying element here lies in the poet's immediate experience; he is the necessary though invisible center of this poem despite the multiplicity of voices.

In 1914 Apollinaire would give a radial structure to two sections of "Lettre-Océan" (fig. 116), his first truly visual poem, or calligramme, so that fragments of speech and onomatopoeic sounds seem to converge upon the consciousness of the poet. In part, this format renders visible the implied centralized structure of the earlier conversation poems.[8] The radial format of "Lettre-Océan" was probably also derived from Marinetti's "Decagono

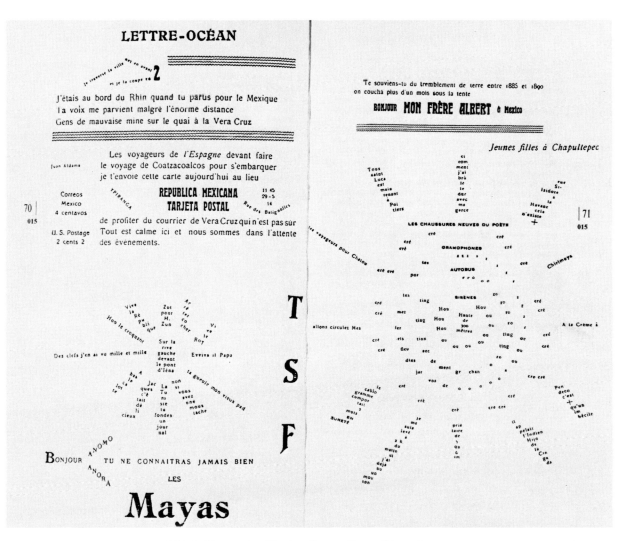

116. Guillaume Apollinaire, "Lettre-Océan," from *Les Soirées de Paris,* June 1914.

della sensibilità motrice" (fig. 117), published in
Lacerba on 15 February 1914, only four months be-
fore "Lettre-Océan." The onomatopoeic effects
("cré cré" for the poet's new shoes) and the cele-
bration of gramophones, autobuses, and sirens also
suggest a Futurist "sensibilità motrice."

Like Marinetti, Apollinaire at times adopted the
practice of collage in composing his calligrammes.
While he designed the text of "Il Pleut" (It's raining)
(fig. 118) by hand, trusting a typographer to trans-
late his words into falling lines of type, in "Visée"
(Aim) Apollinaire cut out printed letters and words
and arranged them in a coherent visual pattern on
the page (fig. 119).[9] The triangle formed by the
lines of print in "Visée," one of Apollinaire's war
poems, achieves its ideogrammatic effect through
the use of literally collaged strophes, each a rocket
seeking a single target. Together they suggest the
action of aiming with a *triangle de visée,* the instru-
ment used to ascertain the position of enemy artil-
lery. Yet these lines of elegantly curving text also
become a visual metaphor for the projection of
the poet's thoughts into the unknowable space
of the future.[10] As in Marinetti's parole in libertà,
here the poetics of rupture points to a new world
to be engendered by the destructive force of the
war: "Et l'avenir secret que la fusée élucide" (And
the secret future that the rocket elucidates). For
Apollinaire, as for Marinetti and the other Futurists,
the creation of visually expressive verbal patterns,
often achieved through the use of collage, also
seemed to enhance the aural mobility of language.
In "Visée," for example, we find the following evoc-
ative phrase: "Entends nager le Mot poisson sub-
til" (Listen to the Word swim subtle fish). In his
calligrammes, Apollinaire sought to achieve a new
synthetic form of poetry, addressed to the ear and
to the eye. The original title for *Calligrammes* had
been *Moi aussi je suis peintre.*

In his memoirs, Severini recalled how pleased he
was by Apollinaire's response to his *poema diseg-
nato* "Danza Serpentina" (fig. 120), which had been
reproduced in *Lacerba* on 1 July 1914:

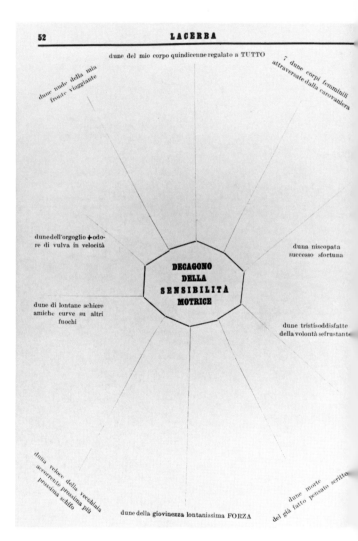

117. F. T. Marinetti, "Decagono della Sensibilità
Motrice," from *Lacerba,* 15 February 1914.

118. Guillaume Apollinaire, "Il Pleut," July 1914, published in *SIC,* December 1916.

119. Guillaume Apollinaire, "Visée," June 1915, published in *Calligrammes,* 1918.

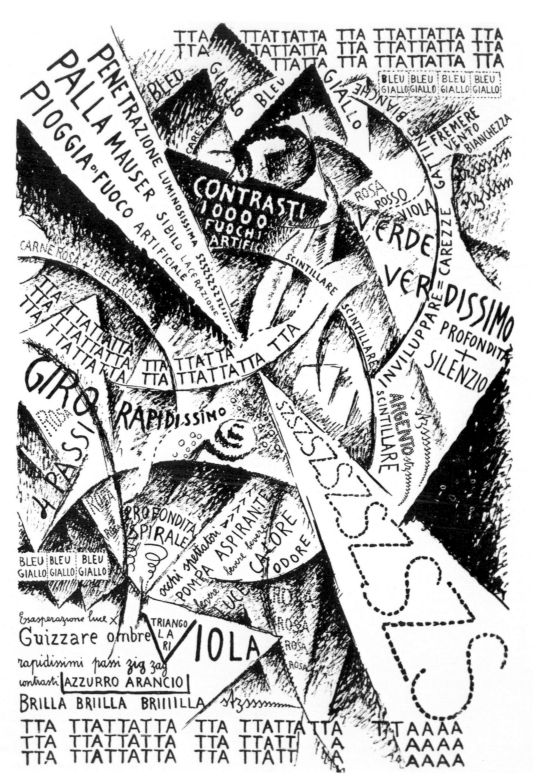

120. Gino Severini, "Danza Serpentina," from *Lacerba,* 1 July 1914.

What pleased me most were two lines of Apollinaire in a postcard, in which he told me that my intuition brought to his memory the little poems of the 17th century, in which the words were disposed in order to suggest the form.

And in fact shortly thereafter appeared the "calligrammes" that everyone knows, and to which, I suppose, the memory of Mallarmé must also have contributed; as it contributed to my first pictures with applications of printed pages, etc.[11]

In a note, Severini further specified Mallarmé's "Un Coup de dés jamais n'abolira le hasard" as having had an important influence on contemporary poetry.[12] The ideas of the Symbolist master were no doubt discussed at the popular *mardis* of *Vers et Prose,* the journal published by Paul Fort, whose very title and choice of "evening" reflected the influence of Mallarmé. Severini had begun attending these evenings at the Closerie de Lilas in 1911, first brought there by Marinetti.[13] Soffici was a habitué during 1911–12; numerous references to the Closerie de Lilas occur in his memoirs. Picasso and his circle frequently attended these evenings as well.[14] Of course, attitudes toward Mallarmé were highly ambivalent, characterized by interest in his typographical and ideogrammatic innovations, but also by a rejection of his preciosity on the part of many.[15] It is, therefore, in the Symbolists that we must seek the first significant impulses to liberate verse from the strictures of traditional forms—in spite of Marinetti's battle cry, "Rénions nos maîtres les symbolistes!"

The Symbolist Legacy

Marinetti's early debt to the poetry and critical writings of the Symbolists, especially Stéphane Mallarmé and Gustave Kahn, provides an essential context within which to measure his post-Symbolist innovations. In an "Enquête" of 1902[16] Marinetti named Mallarmé the greatest poet of the nineteenth century, an unpopular selection at this time. Marinetti's fully annotated copy of Mallarmé's *Vers et Prose* of 1899 reveals the extent to which the young Italian poet studied the ideas of the French master and indeed tried to emulate his style. In some cases, Marinetti went so far as to append his own verses to those of Mallarmé, adding several (rather badly written) stanzas to the poem "Hérodiade," for example. In the margins of *Vers et Prose,* then, we find the young Marinetti actively engaged in an imaginative dialogue with his chosen mentor. This dialogue would pervade his Futurist poems and manifestos, many of which were designed to challenge and defeat the preciosity of Symbolist aesthetic ideals while retaining the poetic freedom associated with those ideals. This freedom was exemplified, for both Mallarmé and one of his successors, Gustave Kahn, by a loosening of the classical structure of the alexandrine, which allowed for greater rhythmic variety and attention to the purely sonorous qualities of words. In advancing related goals, however, Marinetti eventually broke with the Symbolist tradition and proclaimed the invention of parole in libertà—a new collagelike style of writing.

As early as 1894, Mallarmé had called the attention of the English public to the storm brewing among contemporary French poets in an address to the colleges of Oxford and Cambridge titled "Music and Literature." Not without a measure of mock sensationalism,[17] Mallarmé declared, "Indeed I bring you news. The most surprising. Nothing like this has ever happened before. They have tampered with the rules of verse."[18]

According to the analysis Mallarmé then proceeded to develop, the recent attempts by a

younger generation of poets to liberate poetry from the strictures of the traditional alexandrine had led to a decisive rupture between old and new forms of poetry. Earlier efforts to write in a more freely cadenced, "ornamental" style had occasioned the flowering of the prose-poem, which could still be thought of as "broken verse, playing with sounds and even hidden rhymes according to a more complex thyrsus."[19] Contemporary poets, however, had wished to go farther in this direction and had invented *vers libre* (free verse). In the future, Mallarmé predicted, official prosody would be reserved for grand ceremonies, while more personal, lyrical expressions would be written in vers libre.

Among the poets Mallarmé cited as having contributed to the retempering of verse were Paul Verlaine, Jules Laforgue, Charles Morice, Emile Verhaeren, and Gustave Kahn. According to Mallarmé, these poets and many of their *confrères* no longer required the accompaniment of "the great organs of official meter," and each had "gone off by himself to his own corner, to play on a flute of his own, the melodies that please him."[20]

As early as 1885, Gustave Kahn, the self-proclaimed originator of vers libre, had announced his program for the renewal of poetry in *La revue indépendante*. In 1897, the year Mallarmé's influential collection of poems and critical writings titled *Divagations* appeared, Kahn once again took up his pen to defend his priority in having "given the signal and direction of this poetic movement"[21] and to express his theoretical views on the subject of free verse. These ideas were set forth in the Preface to a new edition of Kahn's poetry that included *Les Palais Nomades,* his first book of vers libre. Notably, the ideas Kahn developed in this "Préface sur le vers libre," although indebted in many ways to the doctrines of Mallarmé, also differed from them on several essential points.

Unlike Mallarmé, who tended to stress the formal separation of contemporary and traditional verse, Kahn preferred to emphasize the logical continuity that united the Romantics and Parnassians with their heirs, the Symbolists.[22] Times had changed, however, and inevitably a younger generation of poets had become sensitive to a range of sounds and rhythms that had remained beyond the scope of the older poets, who had been trained to appreciate only a certain number of familiar harmonies and cadences. Indeed, the Symbolists, inspired by the evolution of pure music, had soon felt the necessity of a new, more fluid, more lyrical style. Nonetheless, Kahn made a point of accepting the definition of poetry formulated by Théodore de Banville, chief theorist of the Parnassians: "Poetry is human speech rendered rhythmic in such a way that it can be sung, and properly speaking, there is no verse that is not song."[23]

Professing allegiance to Banville's definition, however, allowed Kahn to criticize other aspects of his classicizing theory. Banville's *Petit traité de poésie française* of 1871, reissued in 1878, provided Kahn with an essential counterpoint against which he might advance his own ideas. For in the *Petit traité* Banville had expressed the central Parnassian belief that the alexandrine was the most perfect and noble of French verse forms. This was due to the great variety and flexibility of the twelve-syllable line. The cornerstone of Banville's theory, however, was the essential role played by rhyme in poetry of all kinds. This, for Banville, was "an absolute LAW, like physical laws,"[24] and he therefore devoted much of his treatise to describing various methods by which a student of poetry might learn the art of rhyming. In a chapter titled "Poetic Licenses," the Parnassian had only this to say: "There are none."[25]

Banville's dogmatic emphasis on strict adherence to the rules of proper rhyming and on a lawful distribution of accents and caesurae presented an easy target for Kahn, who saw that it could lead to a celebration of technical mastery for its own sake. And although Banville had proposed that a single rule had governed the poetry of all times and peoples, which he summed up as "variety in unity,"[26] it was evident that this unity could be achieved only through formal perfection. In opposition to Banville's purely formal criteria, Kahn asserted that true poetic unity did not lie in a particular number of syllables or in perfect rhymes but in the coincidence of meaning and spacing or natural resting points. This implied that unity should be based on an organic principle of phrasing rather than on an arbitrary structure imposed from without. Kahn believed that although this principle had not always been recognized, the great classical poets had nonetheless instinctively followed it. Kahn therefore defined poetic unity in the following terms: "True unity does not lie in the conventional *number* of a line, but in a simultaneous pause of meaning and rhythm, in any organic fraction of verse and thought. This unity consists in the number or rhythm of vowels and consonants that form an organic and independent cell. . . . The unity of poetry can be even further defined: the shortest possible fragment representing a pause in the voice and a pause in meaning."[27] According to this definition, one should first seek a sense of meaningful unity in self-sufficient fractions of verse, rather than in the overall structure of a poem. This, in turn, allowed Kahn to refocus attention on the expressive qualities of sound and rhythm in every part of a line instead of on what he ironically called the "all too predictable *coup de cymbale*" at the end.[28] By giving primacy to the natural coherence of rhythm and meaning, Kahn believed that the technique of vers libre would allow composition *(ordonnance)* to give way to pure music and individual freedom to triumph over preestablished, worn-out formulas.

Although he prided himself on having attended Mallarmé's mardis in the late 1870s, at a time when the master was still largely unknown,[29] Kahn was one of the younger generation of poets who eventually rejected the preciosity and hermeticism exemplified by his writing. In 1885, after a tour of military service in Tunisia, Kahn returned to Paris and was immediately struck by Mallarmé's growing influence in literary circles and by the inescapable fact that the literature of the past as well as the contemporary writing of the Symbolists was incomprehensible to the great majority of people: "First of all, I became aware of the perfect impermeability of the literature of our elders to the popular masses, and their art appeared illegitimate [*bâtard*] to me, incapable of satisfying the populace, incapable of charming the elite."[30] Kahn therefore rejected Mallarmé's aristocratic stance toward the public as well as his desire that literature be clothed in mystery. Rather than move poetry in the direction of ever-greater formal precision in the distribution of essential elements, which Kahn described as an "affair of foundations and of the choice of syllables,"[31] the champion of vers libre advocated an art of greater spontaneity and freedom. Believing that "art should be social," Kahn addressed his poetry to "proletarian intellectuals" in the hope that eventually the people would become interested as well. He refused to accept the prevalent Symbolist idea that to be understood meant that one's poetry was banal.[32]

Despite Kahn's belief in the potential social value of art, his attitude toward art for art's sake remained somewhat equivocal. He continued to insist on the freedom of the poet to express his individuality and advocated the creation of self-sufficient,

organically unified, pure works of art. And although Kahn's notion of purity was broad enough to encompass sounds and rhythms that previously would have been considered dissonant and disruptive, he repeatedly affirmed his belief that artists should work within the dictates of a given medium without transgressing its boundaries. Thus the notion that poetry was an art addressed to the sense of hearing alone led him to reject typographical artifice as a mistaken appeal to the eye. Kahn did not share Mallarmé's interest in the physical dimensions of the book or his sense that one should, as Kahn put it, "renounce the vulgar square format of the *mise en page* of an idea."[33] Poetry originated in song, and its visual transcription was to be understood as a merely secondary factor: "The line and the stanza are all, or in part, sung phrases and belong to speech before being written down. In virtue of our definition, all typographical artifices used to render two lines homologous (rhymes for the eyes) are, at a single stroke, swept aside. The poet speaks and writes for the ear, and not for the eyes."[34] Later, in 1912, this attitude would lead Kahn to protest against the inclusion of printed numbers and letters in paintings, since he believed they could have no pictorial (visual) value.[35] This was the limit beyond which Kahn felt no renovation in poetic form could go.

Marinetti, however, in calling for a new poetry of parole in libertà, chose to transgress this very boundary. The poetic technique advocated by Marinetti, in which words, letters, and numbers would be scattered dynamically across the page without regard for narrative development or even syntax, was intended to appeal simultaneously to the eye and ear (and when possible to convey a sense of smell and tactile sensations as well). This, in turn, led to a new concept of the Futurist work of art as an ideal synthesis of verbal and visual elements in which the practice of collage played a dominant role.

Marinetti announced the invention of parole in libertà in the "Technical Manifesto of Futurist Literature," dated 11 May 1912.[36] This document, eventually published in a variety of formats and languages,[37] made one of its earliest appearances halfway through the preface to a collection of free verse, *I poeti futuristi,*[38] and was followed by Marinetti's first free-word poem, "Battle of Weight + Smell." The placement of the "Technical Manifesto" between past and future styles of poetry is noteworthy, for Marinetti until this moment had been an advocate of vers libre in the French tradition. The editorial policy of Marinetti's journal *Poesia* (1905–09), dedicated to the publication of new or hitherto unpublished works, was somewhat eclectic, but the general trend favored free verse. Gustave Kahn, a good friend of Marinetti, was a frequent contributor,[39] along with Emile Verhaeren, Alfred Jarry, and other members of the Parisian avant-garde. In 1909 *Poesia* had sponsored an international "Enquête" on the subject of free verse since 1905. Among other things, the responses revealed that many Italian poets were hostile to or unconcerned with contemporary developments in French poetry, a situation Marinetti would endeavor to change. By early 1912, however, when Kahn spoke at the Maison des Étudiants about the history and theory of free verse, his lecture was retrospective in tone, concerned with the crises and controversies of the 1880s and 1890s. This lecture may have encouraged Marinetti to feel that the moment for a bold, new initiative in poetic technique had come.

The Invention of Parole in Libertà

Just as Kahn had first become aware of the inadequacies of contemporary styles of writing after a tour of military service, so Marinetti was inspired by his experiences, during the autumn of 1911, as a correspondent at the front lines of the Italo-Turkish War in Libya.[40] Marinetti described his poetic innovations—which included the final destruction of all vestiges of traditional unity and meaning in poetry—as the necessary consequences of a new, dynamic perception of the world afforded by the aerial perspective and speed of the airplane. For Marinetti, the literary correlative of this exhilaratingly modern experience was a telegraphic style of writing:[41] "Sitting on the gas tank of an airplane, my stomach warmed by the pilot's head, I sensed the ridiculous inanity of the old syntax inherited from Homer. A pressing need to liberate words, to drag them out of their prison in the Latin period! Like all imbeciles, this period naturally has a canny head, a stomach, two legs, and two flat feet, but it will never have two wings. Just enough to walk, to take a short run and then stop short, panting! This is what the whirling propeller told me."[42] The "propeller" went on to propose the elimination of syntax and punctuation and to call for the exclusive use of infinitives so that the writer's "I," no longer dominant, might merge with the dynamic continuity of life. In addition, the propeller advocated the suppression of all nonessential words (adverbs and adjectives) that give particular inflections or nuances to other words and thereby suppose a pause or mediation in the flow of images. For, as Marinetti remarked, a man excited by an event he has just witnessed will not take time to convey his impressions and emotions in a logically ordered narrative; rather he will assault his listeners with "fistfuls of essential words" just as they come to him.[43]

Marinetti believed such an assault would express the speaker's sensations telegraphically, with the same speed and economy that the telegraph imposes on war correspondents.[44]

In describing his poetry as originating in flight, Marinetti was reworking a central metaphor in Mallarméan aesthetics, for the Symbolist poet had frequently evoked a sense of the ideality of writing through images of flight from the earth: "Writing, silent flight of abstraction regains its rights as naked sounds fall away. . . ."[45] In this overcoming of brute materiality, of the here and now, writing, like music, demanded "a preliminary separation from speech, of course for fear of contributing to mere prattle."[46] It was *writing,* then, removed from the banalities of everyday *speech,* that Mallarmé believed to be a vehicle of transcendence. Marinetti inverted this proposition while retaining some of its features. Poetry continued to symbolize the power of flight as a triumph over material limitations, but only in order to transform life itself. It did so by embracing crude, naked, unmediated sounds, whether in the form of the speech of the traumatized individual or of the blast of a machine gun. For Marinetti, like Kahn, had rejected the Mallarméan tendency toward preciosity and elegance both in the choice of words and in their disposition on the virginal space of the page. As we have seen, in 1902, Marinetti had named Mallarmé as the greatest poet of the nineteenth century.[47] By 1913, however, in his manifesto "Destruction of Syntax—Imagination without Strings—Words in Freedom," Marinetti stated unequivocally, "I oppose Mallarmé's decorative and precious aesthetic, and his search for the rare word, for the unique, irreplaceable, elegant, suggestive, exquisite adjective . . . [his] static ideal."[48]

This rejection issued to some extent from Marinetti's desire to impose a masculine form on

Mallarmé's feminine ideal. The coquetry suggested by Mallarmé's "abrupt high flutterings" of language gives way in Marinetti to the collision of words conceived as projectiles, bombs, or the harsh sputtering of machine guns. The role played by syntax in this conversion is crucial. For Mallarmé had viewed syntax as the structural device that guaranteed the successful operation of his intricate word-plays: "What guide is there to intelligibility in the midst of these contrasts? A guarantee is needed—Syntax—."[49] Mallarmé continued this passage to describe syntax as the vehicle which allows French, a quintessentially elegant and feminine language, to take flight:

> The French language is elegant especially when it appears in negligée and the past is witness to this quality . . . but our literature surpasses the "genre," correspondence or memoirs. The abrupt, high flutterings will admire / mirror themselves as well: whoever guides them perceives an extraordinary appropriation of limpid structure from the primitive thunderbolts of logic. A stuttering, which seems a phrase, here held back in incidental bits, multiplies, and taking on order, rises up in a certain superior equilibrium, to a balancing of knowing transpositions.[50]

In Mallarmé's view, "limpid structure" could be achieved only by transforming the primitive (masculine) demands of logic. For Marinetti, however, *structure, logic,* and *syntax* were largely synonymous. Marinetti too viewed syntax as an instrument of "limpid structure," but one which an immediate, volatile poetry must do without. By eliminating the "knowing transpositions" made possible by the play of syntax, Marinetti hoped to transform words themselves into primitive thunderbolts.

In the "Technical Manifesto of Futurist Literature" Marinetti also called for the elimination of all transitions (conjunctions) so that the immediate juxtaposition of "liberated" words might create unexpected analogies. This is the heart of his theory, and although there are sources in Baudelaire's "correspondences," in the theories of Edgar Allan Poe, and in much Symbolist poetry Marinetti surpassed his predecessors in the ruthlessness of his program:

> Every noun should have its double; that is, the noun should be followed, with no conjunction, by the noun to which it is related by analogy. Example: man-torpedo-boat, woman-gulf, crowd-surf, piazza-funnel, door-faucet.
>
> Just as aerial speed has multiplied our knowledge of the world, the perception of analogy becomes ever more natural for man. One must suppress the *like,* the *as,* the *so,* the *similar to.* Still better, one should deliberately confound the object with the image that it evokes, foreshortening the image to a single essential word.[51]

Traditional poetry, one should note, had abounded with just these sorts of connectives. Indeed, *comme* (like) was the single most frequently used word in Baudelaire's poetry,[52] and it played a crucial role in much of Mallarmé's poetry as well. By advocating the elimination of such familiar poetic devices, Marinetti sought to emphasize the element of shock in the collision of highly disparate images. Once again, Marinetti claimed that the new perceptual possibilities afforded by aerial perpectives required this form of poetic foreshortening.

Marinetti further asserted that "analogy is nothing more than the deep love that assembles distant, seemingly diverse and hostile things."[53] These far-ranging and unpredictable analogies were to be

discovered through the faculty of intuition. Only through this nonrational means could the poet seize the simultaneity of the heightened moment of awareness. Above all, the reader was not to understand the free-word poem in the traditional sense. Indeed, Marinetti predicted that in the future poets would "dare to suppress all the first terms of [their] analogies and render no more than an uninterrupted sequence of second terms."[54] In advocating this apotheosis of free intuition, Marinetti deliberately rejected the efforts of poets like Kahn to avoid the incomprehensibility of past literature but without reverting to a Mallarméan notion of the ideality of a purified language. On the contrary, Marinetti's parole in libertà were to be fully grounded in the dynamic materiality of life as well as of language: "To catch and gather whatever is most fugitive and ungraspable in matter, one must shape STRICT NETS OF IMAGES or ANALOGIES, to be cast into the mysterious sea of phenomena."[55] Moreover, the nineteenth-century obsession with human psychology, with lyrical expressions of the self, must now give way to "the lyric obsession with matter."[56] Matter itself was to be apprehended in terms of its dynamic potential for flight or dispersal into the surrounding environment. These qualities were manifested as the sound, weight, and smell of objects, elements Marinetti believed to have been overlooked by traditional literature.

Immediately putting this program into practice, Marinetti titled his first free-word poem "Battle of Weight + Smell."[57] The subject concerns a battle of the Italo-Turkish War in Libya. True to his new aesthetic, Marinetti conceived this poem primarily as a chain of images, giving special attention to the material or sensory aspects of objects and environment, conveyed at times through the use of numbers and symbols:

eroismo Avanguardie: 100 metri mitragliatrici fucilate eruzione violini ottone **pim pum pac pac tim tum** mitragliatrici **tataratataraata**

Avanguardie: 20 metri battaglioni-formiche cavalleria-ragni strade-guadi generale-isolotto staffette-cavallette sabbie-rivoluzione obici-tribuni nuvole-graticole fucili-martiri . . .

Avanguardi: 3 metri miscuglio andirivieni incollarsi scollarsi lacerazione fuoco sradicare cantieri frana cave incendio pànico acciecamento schiacciare entrare uscire correre . . .

[heroism Avant-gardes : 100 meters machine guns fusillade eruption violins brass **pim pum pac pac tim tum** machine guns **tataratatarata**

Avant-gardes : 20 meters battalions-ants cavalry-spiders roads-fords general-island couriers-locusts sands-revolution howitzers-grandstands clouds-grates guns-martyrs . . .

Avant-gardes : 3 meters jumble coming-and-going to collage to de-collage laceration fire to uproot timber-yard landslide quarries conflagration panic blindness to smash to enter to leave to run . . .][58]

Its military subject and rapid-fire of uninflected images notwithstanding, this first parole in libertà makes only tentative use of the literary devices enumerated in the manifesto. The poem conserves the traditional format of the page: words are not scattered explosively but appear in conventional lines to be read from left to right. Adjectives, adverbs, conjunctions, and most forms of punctuation have been eliminated, but so have most verbs. Even verbs in the infinitive were evidently less suitable for the creation of a great chain of analogies than nouns. The typographical innovation of having the "avant-gardes" advance diagonally across the page (from right to left) as they advance toward the enemy is a timid gesture in comparison to

Marinetti's later treatment of words as visual torpedoes. The full flowering of parole in libertà would not take place until 1914–15, with the publication of *Zang Tumb Tumb*,[59] a collection of free-word poems on the battle of Adrianopolis in Turkey during the First Balkan War,[60] and related works.

The further development of free-word poetry seems to have depended on Marinetti's ability to expand its verbal and pictorial resources. In this he was no doubt inspired by the contemporary experiments of the Futurist painters, who had begun to seek new means of conveying a sense of simultaneity and dynamism in their art. In two extraordinary manifestos, "Destruction of Syntax—Imagination without Strings—Words in Freedom" (1913) and "Geometric and Mechanical Splendor and the Numerical Sensibility" (1914), Marinetti elaborated his ideas on poetic form, especially the roles to be played by onomatopoeia and typography. Both techniques implied an attack on the *passatista* form of the book and on conventional methods of reading. And both were instrumental in Marinetti's attempt to discover a new, more vital coherence of subjective experience and expressive form.

Onomatopoeia, employed to some extent in "Battle of Weight + Smell," quickly emerged as one of the leading characteristics of parole in libertà. In "Destruction of Syntax" Marinetti described onomatopoeia as a means of "revivifying lyricism with crude and brutal elements of reality."[61] This was essentially a technique that would allow poets to mold language to their needs and was associated with "free expressive spelling" and a revolution in typography. All three departures from the conventional transcription of words had the effect of calling the reader's attention to the visual aspect of the page, which was to be as dynamic as possible.

The use of onomatopoeia in poetry, of course, was not unprecedented. Symbolist poets especially tended to advocate an emphasis on the aural effects of language in order to motivate otherwise arbitrary linguistic signs and in order to highlight the formal self-sufficiency and unity of the poem. This did not usually imply, however, a direct, imitative equivalence between a word and its signification. More often, the expressive potential of pure sound was viewed in abstract, musical, or even coloristic terms, and some attempts were made to determine the value of individual sounds according to quasi-scientific laws. Frequently, this led to an interest in the correspondences between sounds and colors. Rimbaud's sonnet "Voyelles" is an early example of this effort to associate vowels with specific colors. René Ghil, who had made a study of Helmholz's color theory, later corrected Rimbaud's sonnet.[62] Ghil's own theory of "verbal instrumentation," based on correspondences between vocal sounds, musical (instrumental) sounds, and color, was intended to result in "a true bit of music, infinitely suggestive and 'instrumentalizing itself' autonomously: music of words evoking colored images, without, one should remember, the ideas suffering at all!"[63] Mallarmé, who supported Ghil's endeavors, regarded the musical and hieroglyphic effect of letters in a similarly mystical way, although he emphasized the priority of sound over sense.

Marinetti, as we have seen, was indebted to Mallarmé for his early formation as a poet, and he was also undoubtedly familiar with Ghil's theories.[64] Yet Marinetti's understanding of the expressive value of sound diverged from that of the Symbolists in several respects. Whereas poets of the late nineteenth century aspired to assimilate poetry to the seemingly abstract or pure condition of music, Marinetti sought the disruptive power of noise. Onomatopoeia provided him with a means of shattering the self-mirroring flow of musical sounds that

characterized Symbolist poetry with the brutal immediacy of life at its most violent. Opposing Mallarmé's ideal of the perfectly structured, hermetically folded, "spiritual book," Marinetti advocated "a telegraphic lyriclsm with no taste of the book about it but, rather, as much as possible of the taste of life. Beyond that the bold introduction of onomatopoetic harmonies to render all the sounds and noises of modern life, even the most cacophonic."[65] Thus, whereas Symbolist poets tended to stress assonance, creating a unifed, mellifluous rhythm, Marinetti and the Futurists emphasized the harsher, more dissonant effects of alliteration and high-pitched vowels that shriek across the page.

Sensing perhaps that the Futurist theory of onomatopoeia was needlessly limited to imitative effects, Marinetti developed a broader, more complex theory in his manifesto of 1914, "Geometric and Mechanical Splendor and the Numerical Sensibility." In this manifesto, he distinguished four types of onomatopoeia in order of growing abstraction. The first type, "direct, imitative elementary realistic onomatopoeia," was exemplified by the adoption, in *Zang Tumb Tumb,* of a strident "siiiiii" to evoke the whistle of a boat on the Meuse River, followed by the softer "ffiiii ffiiii" for the echo from the opposite bank.[66] Marinetti characterized the second type as "indirect, complex, and analogical onomatopoeia," citing his poem "Dune" as an example. Here, he asserted, the repeated sounds "dum-dum-dum-dum" expressed the "circling sound of the African sun and the orange weight of the sun, creating a rapport between sensations of weight, heat, color, smell and noise."[67] Not satisfied with Symbolist correspondences between sound and color, Marinetti added weight, heat, and noise, which serve to emphasize the overtly material (rather than ideal or rarefied) aspects of the represented objects. Indeed, the objects and events that populate Marinetti's poetic universe are not negated, and they are not made to evoke a sense of their own *absence,* as they might have been in a poem by Mallarmé. Rather they are intended to appear as dramatically *present* to all the senses. Marinetti completed his list with two additional categories: "abstract onomatopoeia," a means of expressing a state of mind, and "psychic onomatopoeic harmony," a fusion of two or three "abstract onomatopoeias." Certainly the distinctions between these categories remained a matter of intuition, yet they allowed Marinetti to suggest a means of advancing beyond the *passatista* notion of imitation.

Imitation, of course, had already been banished as an outmoded practice by the Futurist painters. The "Technical Manifesto of Futurist Painting" of 1910 had declared as its first principle, "That all forms of imitation must be despised, all forms of originality glorified."[68] Marinetti, in turn, had argued that the syntactic sentence was a form of "photographic perspective" that free-word poetry would necessarily destroy, so that a "multiform emotional perspective" might take its place.[69] Yet Marinetti seems to have been unsure about the value of imitation (whether phonic or visual) as a principle of representation in poetry. For as narrative conventions were shattered, the reader's attention naturally turned to the more purely aural and pictorial qualities of the free-word poem. From the beginning, the emphasis on onomatopoeia had implied a corresponding revolution in orthography and typography, so that it became difficult to separate the aural and visual aspects of language. Words deformed, stretched, or pulled for onomatopoeic purposes tended to become visually interesting, and Marinetti did not hesitate to declare, "It

matters little if the deformed word becomes ambiguous."[70] The implication, of course, was that a new intuitive and dynamic form of apprehension would replace traditional forms of cognition.

Perhaps owing to the lingering influence of Kahn, Marinetti expressed some reluctance, as late as 1914, to affirm the pictorial aspect of his free-word poetry. Referring to the "synoptic tables of lyrical values" in which lists of "parallel sensations" appeared configured in groups on the page to suggest a number of intertwined relationships (fig. 121), Marinetti wrote, "These synoptic tables should not be a goal but a means of increasing the expressive forces of lyricism. One must therefore avoid any pictorial preoccupation, taking no satisfaction in a play of lines or in curious typographic disproportion."[71] Indeed, a glance at the "Synchronic Chart" in *Zang Tumb Tumb* suggests that Marinetti conceived the typographical distribution of elements in the anti-aesthetic mode of the scientific chart combined with certain features drawn from algebraic equations. Words tend to be arranged within parallel columns, and there are mathematical symbols to suggest patterns of relation and the directional flow of (multiple) sensations. Yet the content of this free-word poem, described in the title as the "trace" of the aviator Y. M. (in the act of bombing Adrianopolis), seems at odds with its excessively symmetrical and orderly appearance. Even the aerial viewpoint does little to evoke a sense of the drama of war or of the exhilarating simultaneity of the aviator's experience. As Marjorie Perloff has observed, "The variety of typefaces, the use of plus (+) signs and phonic spelling, the heavy alliteration and assonance cannot disguise the fact that Marinetti's *parole in libertà* are basically just lists."[72] Yet *Zang Tumb Tumb* did, in a few cases, reveal the direction *parole in libertà* would take beginning in 1915, when Marinetti increasingly affirmed the pictorial qualities of his poems. In the page titled "Captive Turkish Balloon," for example, Marinetti created an image of a military balloon through a circular arrangement of the words "Pallone Frenato Turco" (fig. 122). The letters "TSF" (*télégraphie sans fils*) emit "vibrations" that, the

121. F. T. Marinetti, "Synchronic Chart," from *Zang Tumb Tumb*, 1914.

poem tells us, have penetrated and scrambled Turkish communications (represented by the balloon.) In his manifesto "Geometrical and Mechanical Splendor," Marinetti drew attention to this poem as an example of the tendency to "self-illustration" characteristic of parole in libertà. As the poet explained, "The words-in-freedom, in this continuous effort to express with the greatest force and profundity, naturally transform themselves into *self-illustrations,* by means of free, expressive orthography and typography, the synoptic tables of lyric values and designed analogies."[73]

The traditional perspectival form of imitation, then, has been exchanged for the new concept of self-illustration based on the more "natural" aural and visual properties of words in freedom. Yet as John White has emphasized, the Futurist principles of self-illustration and designed analogies were not always based on a simple iconic relationship between signifier and signified.[74] Often, as in "Captive Turkish Balloon," the pictorial disposition of the words suggests not a direct visual impression, but an ideogram—a sign, that is, whose visual qualities have been highly schematized. Other designed analogies prove even more conceptual in their approach, often achieving nonvisual effects with visual patterns. An example can be found in Cangiullo's use of the typographically stretched word "FUMARE" (fig. 123), which Marinetti described as evoking "the long and monotonous reveries and self-expansion of the boredom-smoke of a long train journey."[75] Obviously these typographic manipulations depend on the reader's ability to recognize their meaning, and this may call for a familiarity with types of representational systems such as diagrams, maps, and the layout of contemporary advertisements or posters. As White has argued, iconicity here may be best defined as the similarity that obtains between a specified set of relations, rather than as a simple isomorphism between the sign and the thing or concept signified. Even with this proviso, however, it must be conceded that Marinetti's innovations aimed at subverting the two primary characteristics of language

122. F. T. Marinetti, "Pallone Frenato Turco," from *Zang Tumb Tumb,* 1914.

as set forth by contemporary linguistic theory: the "arbitrary nature of the sign" and its "linear" character.[76]

Marinetti's initial resistance to the full pictorial development of parole in libertà may be attributed in part to his gifts as an orator. It was still possible to read *Zang Tumb Tumb*, and Marinetti did so in a series of notorious performances in cities throughout Europe during 1913 and 1914. Marinetti amplified the well-known rhetorical power of his voice by utilizing a full range of dramatic gestures and mime. Performances were further enhanced by the crashing sounds of drums and hammers (to imitate machine-gun fire) and by Marinetti's frenetic drawing of diagrams and equations on the three blackboards positioned about the stage. He intended his poem to come alive, to be experienced as an assault on the astonished senses of his audiences. The thundering crescendos, onomatopoeic effects, and visual pantomime would have been signaled by the typeface and disposition of the words on the page. Yet, it must have been difficult to give "Captive Turkish Balloon" an adequate reading, as Marinetti's recourse to visual enhancements demonstrates. To the extent that Marinetti's subsequent free-word poems became increasingly pictorial in character, the nonlinear act of viewing displaced the act of reading. Ultimately, it seems, the Futurist ideal of simultaneity demanded the demise of narrative, although one might argue that the most successful parole in libertà achieved their effect through a combination of verbal and visual modes of address.

Despite Marinetti's initial ambivalence, mimesis, whether aural, gestural, or typographic, proved essential to parole in libertà insofar as this new poetic technique strove to achieve an identity of form and content.[77] The Russian poet Benedikt Livshits called attention to this fact and to the curious paradox it engendered on the occasion of Marinetti's performance of *Zang Tumb Tumb* in St. Petersburg in the winter of 1914: "What is the point of piling up amorphous words, a conglomeration which you call 'words at liberty'? To eliminate the intermediary role of reason by producing disorder, right?

123. Francesco Cangiullo, first page of "Fumatori," from *Lacerba,* 1 January 1914.

However, there's a large gulf between the typographical composition of your *Zang-Tum-Tumb* [sic] and your recitation. . . . Is it worth destroying the traditional sentence, even the way you do, in order to reinstate it, to restore its logical predicate by suggestive gestures, mime, intonation and onomatopoeia?"[78] Although he boldly asserted the opposite, Marinetti clearly wished to communicate with his audiences. If his dramatic readings restored what the destruction of syntax had eliminated, it was because in practice, if not in theory, Marinetti still conceived of poetry as a form of narrative. Indeed, he seems to have regarded parole in libertà as a heightened mode of storytelling or journalistic *reportage*. His free-word poems continue to have a plot that unfolds in time and leads toward the inevitable climax and its aftermath. And the story told is always that of victorious battle, over the sun, the earth's gravity, or, most frequently, a military enemy.

Lacerba and the Explosion of Parole in Libertà

Marinetti's poetic innovations eventually inspired nearly all the Futurists, both poets and visual artists, to compose free-word poems and pictures. By early 1914 the pages of *Lacerba* were transformed by the dynamic designs and typography of the new poetic form. Indeed, some of these works, executed before Italy's declaration of war in May of 1915, surpassed Marinetti's in the imaginative use of visual design.

Francesco Cangiullo's *tavole parolibere*, which he preferred to call *tavole cangiulliane*, were among the most inventive to be produced during the early period of Futurist experimentation. Free-word poems such as "Fumatori" (Smokers) (fig. 123) and "Serata in Onore di YVONNE" (Evening in honor of Yvonne) of 1914 reveal a debt to Marinetti in their recourse to lists of analogies, in their use of mathematical symbols, and in the general diagrammatic character of their compositions. Like Marinetti, Cangiullo was a masterful performer of his own works and thoroughly enjoyed the opportunity to scandalize his native Neapolitans. The onomatopoeic and typographic innovations of his

early works can be understood, therefore, as means of evoking an appropriate dramatic response from the reader / performer. Yet Cangiullo's free-word poems of 1914 were also meant to be viewed and suggest an interest in the pictorial possibilities of typography for their own sake.

Indeed, Cangiullo's "Fumatori," published in *Lacerba* on 1 January 1914, seems to have set off a veritable explosion of more visually expressive parole in libertà. Comparison with Marinetti's "Ponte," printed in the same issue of *Lacerba* and later included in *Zang Tumb Tumb,* shows Cangiullo's work to be far more inventive in using typography and onomatopoeically stretched words to animate the page. Cangiullo was perhaps the first free-word poet to take full advantage of the large format of *Lacerba*'s newspaperlike pages and to work with a full double-page spread in mind. Among his innovations were the distribution of the word "BAGAGLI" (baggage) in such a way as to suggest a number of suitcases of different sizes piled up against each other and the amplified word "FUMARE" to evoke, as Marinetti explained, the monotonous dreams and "self-expansion of the boredom-smoke" typical of long train journeys. In parallel fashion, Cangiullo used the diminishing word "VELOCITÀ" to suggest the rapid disappearance of a train hurtling into the distance. One might argue that this is to reintroduce a form of photographic perspective, but Marinetti had no objection. Indeed, Cangiullo's "FUMARE" and related devices seem to have spurred Marinetti's interest in developing the abstract possibilities of onomatopoeia and of typographic deformation.

Eventually Cangiullo found even the large format of *Lacerba* restrictive, and he began to work in brightly colored tempera, gouache, and ink on large sheets of paper, much as an artist might. *Pisa* of May 1914 (fig. 124) records the sensations and fragmentary conversations of passengers on a train. The composition is organized as if it were a pane of glass: the word "VETRO" (glass) slashes across the sheet twice so that the letters converge toward a vanishing point at the right. Even the paper support is cut to evoke the forward trajectory of the train as it crosses the Arno (designated by

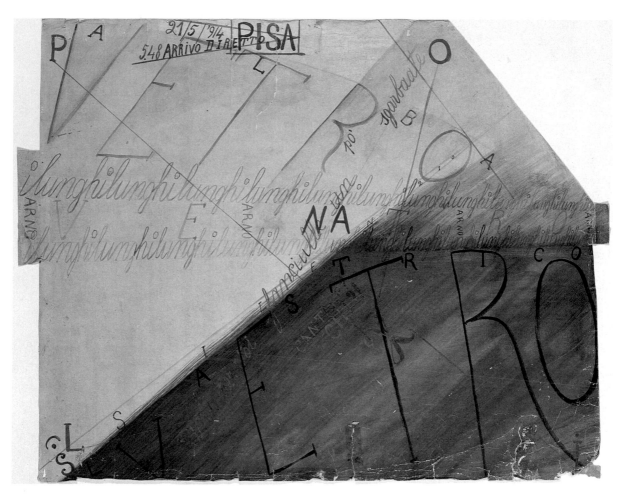

124. Francesco Cangiullo, *Pisa,* 1914, watercolor and
pencil on paper. Calmarini Collection, Milan.

the length of the projecting section), to arrive in Florence in the silence of the early morning. "5.48 ARRIVO DIRETTO PISA," "SSILENZIO," "ALBA," and other snatches of conversation scattered about the surface of this work provide the appropriate clues, but the reader / viewer must recreate the relationships between them.

The large-scale *Great Crowd in the Piazza del Popolo* of 1914 (fig. 125), a work executed in watercolor and ink, carries even further Cangiullo's growing interest in the visual aspect of his work at the expense of readability. Vividly colored, stretched, and deformed letters dominate the pale green surface of this *tavola,* creating a cacophany of jumbled sounds and slogans. Only disconnected fragments, like the fragments of overheard speech in Apollinaire's conversation poems, emerge: "a mia nonna" (to my grandmother), "CAPPELLI vvveeNTO" (hair wwwiiND), "FFFiiiiischia" (whistle), "villano in casa tua" (a villain in your house), "profumato" (perfumed). The overall effect evokes the totality of memories and sensations that bombard the visitor to Rome's teeming Piazza del Popolo, although the "TUTTO VENTRE" (all belly) that slices diagonally across the composition suggests that these sensations are now located in the digestive tract rather than in the brain. The absence of references to the war suggests that this work was executed before the political crises of the summer of 1914; during that time Cangiullo became one of the most active proponents of Italian intervention.

One of Cangiullo's collaborators in the writing and performance of parole in libertà was the artist Giacomo Balla. Like Cangiullo's *Great Crowd in the Piazza del Popolo,* Balla's polychrome "wall-poem" titled *Rumoristica plastica* BALTRR of 1916–17 (fig. 126) was conceived as a work to be viewed as much as read. The onomatopoeic "plip," "plap," "plep," "plut" and "tich," "teth," "tach," "tech" create visual patterns out of pseudogrammatical progressions of sound and give this wall-poem a convincing sense of energetic movement. Although difficult to decipher, *Rumoristica plastica* BALTRR was inspired by an incident from Balla's life.[79] Visiting a friend, the artist found himself unable to use

the keys and was forced to enter through the transom on the second floor and open the door from the inside. The final entry and action of the keys is conveyed by the red and blue metallic paper collaged to the center of the work. A line drawn diagonally to the right from this point of entry reads "APERTO" (open). Balla enhanced the drama of this episode through the dynamic use of vectors and curving lines, suggesting the flow of energy in all directions. With some humor, he directs the viewer to "seguire circoli" (follow the dots), a dizzying task.

This "plastic" realization of noise grew out of Balla's earlier proto-Dada experiments in sound orchestration. In 1914, Balla had written an onomatopoeic composition for twelve typewriters to be played simultaneously, each performer repeating a single sound for two continuous minutes. Other experiments included a "Sconcertazione di stato d'animo" (Disconcert of states of mind) (fig. 127), in which four differently dressed persons were to declaim simultaneously their states of mind, expressed by repeated sounds, numbers, and gestures. These noise compositions and the practice of simultaneous reading manifest a subversive, antirational attack on bourgeois sensibilities, similar in spirit to the poetry of Dadaists such as Tristan Tzara, Hugo Ball, and Richard Huelsenbeck.[80]

During his Futurist phase, Ardengo Soffici also experimented with various forms of parole in libertà. More cautious and respectful of tradition than some of the other Futurists, his work reflects the influence of the Cubists and of his friend Apollinaire. Nonetheless, "Al Buffet della Stazione" (fig. 128), published in *Lacerba* in August 1914, demonstrates an imaginative use of collage techniques and typographic design in creating freeword pictures. In "Al Buffet della Stazione," Soffici juxtaposed a cup of coffee with a spent cigarette in the saucer with a fragment of a Futurist newspaper[81] lying on a table, whose edge recedes diagonally across the upper right. The words beneath this edge read, "The wood of the little diagonal table departing with the air and the railroad tracks toward the primordial norths of the forgot-

125. Francesco Cangiullo, *Great Crowd in the Piazza
del Popolo,* 1914, watercolor and pencil on paper.
Private collection.

126. Giacomo Balla, *Rumoristica plastica* BALTRR, 1916–
17, pasted papers and watercolor on board. Private
collection, Paris.

127. Giacomo Balla, "Disconcert of States of Mind,"
1916, ink on paper. Calmarini Collection, Milan.

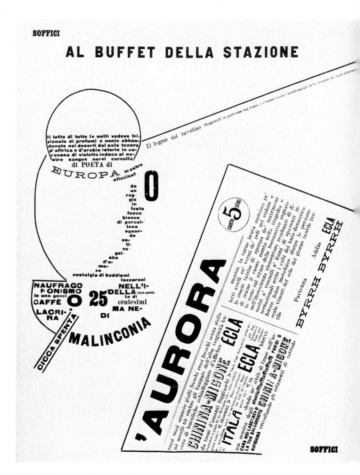

128. Ardengo Soffici, "Al Buffet della Stazione," from
Lacerba, 1 August 1914.

ten mythical forests." All the forms in this still life are closed on the left and open on the right; thus they parallel the movement of the table edge off the page, suggesting the projection of objects into the surrounding environment. Interestingly, Soffici played on the ability of printed words to function as the equivalent of pictorial openness or transparency in comparison to a closed edge, just as Picasso had done in many of his collages of 1912 and 1913.

Like Marinetti, Soffici was interested in expressing the simultaneity of a single moment of experience in terms of analogies. In *Primi principi di una estetica futurista,* he explained the Futurist concept that the subject of a work should be "a flux, a weave of diffuse sensations"[82] by providing the following example: "The box of matches that is before me is connected as an image, to one of my thoughts about the world, a romantic memory, and this is connected to the evening in the country that I see from my window which is the direct complementary of the black title *Corriere della Sera.*"[83] For Soffici, unlike Marinetti, an experienced moment included memories as well as immediate sensations. This may account for the sardonic nostalgia that infuses much of his work, as in the words that form the saucer in "Al Buffet della Stazione": "shipwreck in the irony of the cigarette butt in a drop of coffee 25 cents black tear of melancholy." Elsewhere, however, Soffici exhibits a biting humor similar to that of Apollinaire.

In addition to the mixture of humor and ironic melancholy, the figurative qualities of "Al Buffet della Stazione" suggest that this work was inspired by Apollinaire. Twelve of his calligrammes had been published in the July-August issue of *Les Soirées de Paris* (which appeared on 15 July). These were arranged in four groups, each a still life comprising two or more picture-poems. "Coeur Couronne et Miroir" (fig. 129), for example, was composed of three pictures—each drawn with words that both reflect and give new meaning to the image they embody. The mirror was formed of a sentence that reads, "Dans ce miroir je suis enclos vivant et vrai comme on imagine les anges et

129. Guillaume Apollinaire, "Coeur Couronne et Miroir," June 1914, published in *Les Soirées de Paris,* July-August 1914.

non comme sont les reflets" (In this mirror I am enclosed living and true as one imagines angels and not like reflections). In the center appears the name "Guillaume Apollinaire," taking the place of the expected image and rendering the poet's presence more fixed and eternal than would be possible with mere reflections. The crown, shaped by the sentence "Les Rois Qui Meurent / Tour a Tour / Renaissent au Coeur des Poètes" (The kings who die / one by one / are reborn in the heart of poets), enhances the allusion to a link between yesterday's kings and the poets of today, although the word *crown* is not mentioned. Finally, the heart, which reads "Mon Coeur pareil à une flamme renversée" (My heart like a flame reversed), evokes a lyrical analogy between heart and flame. By asking us to recognize a flame in a drawing of a heart, Apollinaire's calligramme does more than endow verbal concepts with pictorial form in a self-reflexive manner. These calligrammes give rise to a new and at times humorous interplay between word and image, rather than establish a simple coherence of form and verbal content.

In "Al Buffet della Stazione" Soffici adopted Apollinaire's figurative use of words, which differed considerably from the contemporary free-word pictures of Severini or Carrà. Unlike their works, which were frequently organized centrifugally to suggest explosive force, Soffici created a classically unified still life out of his disparate elements, even introducing an allusion to perspective in the diminishing words beneath the table edge.[84]

In 1915 Soffici published an anthology of his works, including parole in libertà and more conventional writings, titled *BiF § ZF + 18 simultaneità e chimismi lirici*. The cover of this anthology, composed of a variety of brightly colored printed collage materials, was Soffici's most original and dynamic work to date (fig. 130). Its appearance approximates that of a poster board with overlapping pasted advertisements competing for visibility. Whereas "Al Buffet della Stazione" was notable for its crisp clarity, each line and word subordinate to its descriptive function, in *BiF § ZF + 18* Soffici began to play with certain (calculated) effects of

130. Ardengo Soffici, Cover of *BiF § ZF + 18,* 1915.

chance. The fragment of a Futurist poem at the lower left, for example, seems to have been selected precisely because it was printed off-register. Yet this element, like the bits of torn paper, has been carefully set into a structuring grid. Ultimately a sense of order and symmetry prevails, since the top and lower sections of this collage exactly replicate each other.

In one of the tavole published in this anthology, Soffici explores the opposing compositional principle: random disorder. Titled "Tipografia" (fig. 112), this page celebrates the pictorial possibilities of printed letters and numbers through sheer multiplicity and profusion. Many of these letters were taken from the pages of *La Voce,* just as in "Al Buffet della Stazione," Soffici had included one of his own previous Futurist texts. Here, however, the jumbled letters, freed from the linear progression of the sentence, seem to take on new life. In *Primi principi di una estetica futurista,* Soffici had praised the typographic character of street signs, posters, and modern spectacles, claiming that this could make one conceive typography as an expressive element in a work of art.[85] Soffici considered the abstract, mechanical quality of the alphabet to be a degeneration from the ancient hieroglyphic nature of the sign. Nonetheless, the pure letter had an emotional value ("virtu emotiva") that the artist might reclaim by liberating it from conventional usages: "Animated then with colors and lights, in surprising combinations, set into motion in the most lively spilling forth of our existence, its [the letter's] efficacy becomes even more evident. Efficacy of suggestion and of the figurative complement. No longer a silent conventional sign, but a living form among living forms, the letter can become one with the subject of representation."[86] In his desire to restore life to printed letters, Soffici revealed his distance from the Cubists, who tended to emphasize the arbitrary and clichéd character of verbal signs.

The painter Carlo Carrà also turned his attention to visual poetry during this period, creating several of the most successful examples of Futurist tavole parolibere. His earliest works in this new genre, published in *Lacerba* in January and February 1914, follow the model provided by Marinetti; syntax is abolished and the verbal text becomes a field of typographic and onomatopoeic deformation. Yet for the most part, free-word poems such as "Immobilità + Ventre" (Immobility + Belly) and "Bilancio" (Balance sheet), published on 1 January and 1 February 1914, respectively, in *Lacerba,* preserve the conventional left-to-right reading pattern and the traditional squared layout of the page, even as they adopt many features of the chart or diagram. By the summer of 1914, however, Carrà began to organize his free-word pictures around a central fulcrum, from which streams of words, onomatopoeic sounds, and images radiate in all directions. Carrà's circular "spoke and wheel" compositions were directly inspired by Apollinaire's "Lettre-Océan" (fig. 116), published in *Les Soirées de Paris* on 15 June 1914. On 23 June 1914, Carrà wrote to Soffici that he had seen "the parole in libertà of Apollinaire" and liked them, noting further that "I immediately began the pictorial painting Poem [*Free-Word Painting—Patriotic Festival*]—maybe it will be interesting."[87] Apollinaire's influence can also be observed in Carrà's collage-poem "Rapporto di un Nottambulo Milanese" (fig. 131), dated July 1914, which reproduced the parallel wavy lines that had appeared in "Lettre-Océan" as well as the words "ta gueule mon vieux." It also included the famous "merde" from Apollinaire's manifesto of 1913, "L'antitradition futuriste."[88] In appropriating these fragments from Apollinaire's works, Carrà extended the principle of verbal collage already exemplified by "Lettre-Océan" and the earlier poèmes-conversation to his own production. In "Lettre-Océan," which in many ways is itself indebted to Marinetti's parole in libertà,[89] the structural center of the right side forms a physical and perceptual vantage point, which, we learn, is at the top of the Eiffel Tower ("haute de 300 mètres"). From this ideal aerial location, the poet's consciousness becomes analogous to a telegraphic station, simultaneously receiving and emitting signals.

The words Apollinaire used to describe the simultaneity of spirit and letter in his poèmes-conversation might also be applied to "Lettre-Océan": "It is impossible to read them without immediately conceiving the simultaneity of that which they express, conversation-poems where the poet at the center of life registers in some way the surrounding lyricism."[90]

Carrà's "Rapporto" conveys a similar sense of lyricism, although it is conceived in more characteristically Futurist terms. For example, Carrà exploits the precision and brevity of mathematical symbols, adding the people he has encountered in Milan's Galleria at 4:30 in the morning (two policemen, eleven ruffians, three loan sharks, fifteen prostitutes, and so on) for a total of forty-nine noctambulists. Snatches of overheard conversation ("Signori si chiude") compete with onomatopoeic effects, fragments of popular song, and a notation of the current temperature. Among these rather conventional and mundane elements, Carrà introduced a more sinister, political note. As Willard Bohn has observed, the words "Serajevo" and "Corrriere della Seeeeraaaaa" refer to the newspaper headlines about the assassination of the archduke Franz Ferdinand (28 June 1914).[91] Moreover, the names "Berchtold + di S. Giuliano" in the upper right suggest the ensuing controversy over Italian intervention in the Balkans as well as Italy's continued alliance with Austria. (Count Leopold Berchtold, the Austro-Hungarian foreign minister, was a strong advocate of militarism; his counterpart in Italy, Marchese Antonino di San Giuliano, favored maintaining Italy's membership in the Triple Alliance. Added together, they spelled disaster for Italy's patriotic, anti-Austria, prowar position.) Once the war had erupted, Carrà's interventionist views would take center stage; here, however, the political controversy is simply another element in the sensory environment. This emphasis on evoking the *totality* of sense impressions, signaled by the propensity to add them up, makes Carrà's "Rapporto" an exemplary Futurist *tavola parolibera*.

131. Carlo Carrà, "Rapporto di un Nottambulo Milanese," July 1914, pasted papers and ink on graph paper. Calmarini Collection, Milan.

Gino Severini's "Danza Serpentina" (Serpentine dance) (fig. 120), published in *Lacerba* on 1 July 1914, exhibits a similar centralized, radiating structure and a similar interest in expressing the totality of sensations received in the urban café or dance hall. Characteristically, Severini has chosen to represent dance as the archetype of contemporary dynamism. Colors, sounds, lights, smells, and heat are all designated verbally and then set into motion through the centrifugally organized composition. "Danza Serpentina" renders the synaesthetic experience visible as an exchange of energies; an analogical synthesis of electrical light ("PENETRAZIONE LUMINOSISSIMA"), the hiss of a Mauser pistol shot ("PALLA MAUSER SIBILO LACERAZIONE"), and a deluge of fireworks ("PIOGGIA DI FUOCO ARTIFICIALE") at the upper left turning into sizzling sound ("SZSZSSZZSZS") as it moves to the lower right. As in Carrà's "Rapporto," a previously absent militaristic component makes its appearance here. In Severini's earlier analogical equations, flowers, the sea, and dancing girls had predominated. Now the "Palla Mauser" and "tatatatata" of machine-gun fire enter the pictorial / poetic field to intensify the swirling dynamism of the analogy "dancer = sea." (Severini's original title for this free-word drawing was "Danseuse = Mer.")[92] Severini, a man of gentle, lyrical sensibilities, was undoubtedly influenced by Marinetti to respond to the bellicose atmosphere of Europe in the summer of 1914 by introducing such elements into his compositions. Yet the artist's discussion of the analogies created by such comparisons remained curiously formal, concerned above all with expressive techniques, for Severini did not fully share Marinetti's political program. As Severini explained in a note intended to accompany the publication of "Danza Serpentina," "the sensation of luminous penetration of two electric reflectors—to which that of a hissing mauser bullet rending the air is attached by analogy—is rendered by the contrast of two acute angles, which meet at their points."[93] In addition, the broken strokes used to write the onomatopoeic "szszszszsz . . ." were intended to suggest a quantitative intensification of

expression, just as the use of small touches of pure color had been in the artist's Divisionist paintings.[94] Obviously Severini was still thinking in terms of expressive contrasts.

Severini at this time was more interested in the American dancer Loïe Fuller's use of electricity to enhance the motion of her swirling veils with fantastic colored lights than by the Marinettian ideal of war. Indeed, "Danza Serpentina" may have been inspired by the many posters advertising Loïe Fuller's dances to be seen in Paris. Jules Chéret's poster of 1897 for Fuller's Folies-Bergères performance of *La Danse du Feu* (fig. 132), for example, displays a similarly radiant swirl of colored veils. The names of Fuller's dances may even have suggested some of the analogies evoked in Severini's many works on the theme of dance.

Like Carrà, Severini made the center of his freeword picture a maelstrom of circulating, interpenetrating sensations. Only by positing such a dynamic core could the Futurists conceptualize the psychic location from which the totality of sensations could be perceived. This was the ideal point into which they wanted to project the spectator, who would thereby overcome the traditional passive stance of the viewer / reader and empathetically relive the work with Futurist immediacy. Interestingly, Severini acknowledged that these new poetic compositions would be difficult to read: "The works of the new lyricism certainly cannot be read, but can we possibly read our canvases, and can the musician read his symphony? Does one read the song of birds?"[95] Whereas Marinetti believed parole in libertà gave words the force of projectiles, for Severini the new lyricism still evoked the traditional (peaceful) image of song.

Carrà, who had been experimenting with centrifugally organized compositions independently of Severini, was quite surprised to see "Danza Serpentina" when it was published in *Lacerba*. He wrote to Severini shortly after it appeared to express his interest in this new style: "I saw in the latest number of *Lacerba* [1 July 1914] one of your drawings, which from a certain point of view interested me

very much, because I too have recently made a work, which I have called "Patriotic Festival—Pictorial Poem" and that has many points of contact with yours . . . 2 days ago I brought it to a photographer to have it photographed."[96] Carrà's "pictorial poem," given the slightly revised title *Dipinto Parolibero—Festa Patriottica* (Free-word painting—patriotic festival) at Marinetti's instigation, was published in *Lacerba* on 1 August 1914 (fig. 25). Like Severini's "Danza Serpentina," it exemplifies the Futurist attempt to "put the spectator in the center of the picture."[97] But in order to accomplish this, the spectator must adopt the vertiginous viewpoint and speed of an aviator. As Linda Landis has argued, Carrà's *Festa Patriottica* reproduces the whirling action of an airplane propeller[98] spewing forth a collage of sounds, slogans, fragments of parole in libertà, and even advertisements for toothpaste and an antiheartburn pill, "TOT."

Most notable, however, are the handwritten slogans that circle around the center suggesting popular political graffiti: "EVVIVAAA L'ESERCITO" (Long live the army), "EEVViiivaaa il RÉÉÉÉ"[99] (Long live the king), "ABBASSOOOO (L'AUSTRIA)" (Down with Austria). The Irredentist goal of recovering Trieste from the Austrian enemy is clearly stated in the lower center, where Carrà wrote "W TRIESTE ITALIANA MILANO" over the tricolor of the Italian flag. This was a call for war with Austria, executed during the tense months of June and July and published just as the war erupted.

Although individual verbal fragments demand to be read (and, significantly, to be read from left to right and in clockwise fashion), the invention of the circular composition represents an advance in terms of achieving the Futurist goal of synaesthetic simultaneity. The visual effect of the spoke and wheel structure imposes itself on the viewer and dominates the disparate verbal elements. As suggested above, this compositional pattern corresponds to the parallel innovation presented by Apollinaire's "Lettre-Océan," in which the successive *verbal* order of the poème-conversation gives way to the simultaneous *visual* order of the picture

132. Jules Chéret, *La Danse du Feu*, 1897, lithographic poster.

poem. Apollinaire described this simultaneity as an attempt to habituate "the eye to read in a single glance the whole of the poem, like an orchestra conductor reads with a single glance the superimposed notes of a musical score, as one sees in a single glance the plastic and printed elements of a poster."[100] The ideal, for Apollinaire and the Futurists, was perceptual simultaneity—the poetic sign fully motivated and charged with the chaotic immediacy of life itself. Insofar as a Futurist *tavola parolibera* was successful in putting the spectator in the center of the work, traditional perceptual boundaries would necessarily collapse, the viewer's ego dissolved into the work, and the work as sign dissolved into pure energy.

With *Festa Patriottica* the Futurist effort to synthesize the resources of poetry and the visual arts reached its apogee. Poets and artists continued to experiment with collage techniques and with combining verbal and visual elements, but their works rarely achieved the unity and sense of explosive power that characterizes *Festa Patriottica*. Like the construction *Noises of a Night Café* (fig. 115), which Carrà executed shortly afterward, this work seems to propel itself beyond the edges proposed by the rectangular format into the viewer's space. In this it resembles the posterlike qualities of Severini's "Danza Serpentina," which also addresses the viewer as if it were a poster or a flashing electric light. Once the war had erupted, Carrà, like the other Futurists, would turn his attention to creating a visual language in keeping with the bellicose spirit of the time. In those collages and free-word pictures, the power of forms and words to address the viewer in a direct and empathetically charged manner would enhance the force of prowar, anti-German political propaganda.

Presence and Voice in Parole in Libertà

Critics have at times made the claim that in granting primacy to the visual and spatial aspects of writing, Marinetti and the Futurists emphasized the objecthood of their works. Luigi Ballerini, for

example, believes that Marinetti's tavole parolibere, especially those in *Les mots en liberté futuristes,* "point already to a type of language in which signs, linguistic or otherwise, are treated primarily as objects, or in any case, postulated as such, prior to any decodification as vehicles of semantic rationalism."[101] Similarly, Luciano Caruso and Stelio M. Martini have claimed that Futurist free-word pictures constitute an "absolutely new conception of writing": "A writing therefore no longer regarded as a means of the expressive-communicative function of language, . . . but a writing finally concerned with liberation from every problem of the denotation of independently existing objects, liberation, that is, from its typical platonism, finally an object itself and the place of invention and imagination, the last step on the road to the liberation of reality."[102] Yet to suggest that the Futurists were interested in liberating language from its communicative function in order to reveal its independent status as object is to ignore their effort to motivate poetic form precisely in order to regain contact with brute reality. For Marinetti and the Futurists, linguistic and visual signs did not have meanings prior to, or separable from, their visual or aural appearance. Indeed, the Futurist concept of expressive self-illustration depends on the visible cohesion of form and meaning in the linguistic sign. Ideally, the sign was to efface itself in the consciousness of the spectator / reader as it was transformed into pure sensation. Ballerini, Caruso, Martini, and others may have been led to discuss the objecthood of Marinetti's poems because in 1915 the poet described Balla's "plastic complexes" as self-sufficient objects, whose *presence* constituted a victory over the nostalgic evocation of a lost or absent object in traditional representations.[103] Balla's sculptural compositions, by comparison, were completely nonreferential and therefore constituted the abstract elements of a new reality, like the reality of the onomatopoeic elements in Marinetti's poetry. Marinetti himself seems to have wanted to have it both ways: to

motivate poetic signs through the principle of self-illustration and onomatopoeia and to claim that these signs were self-sufficient bits of reality and therefore nonreferential. In either case, the goal was to create an art of presence.

Paradoxically, Marinetti's notion of linguistic presence or immediacy was not intended to affirm the unified selfhood of the artist or spectator, and in this respect his work is comparable to that of the Cubists insofar as their works also do not celebrate self-expression. Yet where Cubist collages reveal a self mediated by language or pictorial codes, for Marinetti the self is absorbed and transformed by the superior force of the machine. This self was a changeable entity, always ready to take on different, although always heroic, roles. For example, the many simultaneous selves that dominate Marinetti's free-word picture *Premier Record* of 1914 (fig. 133) are each identified with a powerful machine or racehorse in the process of establishing a world record. Easily traversing space and time through the force of these vehicles, the self expands ("MOI + MOI + MOI + MOI") yet remains dispersed and, finally, impersonal. Marinetti emphasizes this point by defining the self as a carburetor minus eight grains of sand but plus good luck ("MOI −8 grains de sable dans le carburateur + CHANCE"). In 1916, Marinetti would write of the need for the Futurist poet to become dehumanized and "disappear": "In the new Futurist lyricism, an expression of geometrical splendor, our literary *I* consumes and obliterates itself in the grand cosmic vibration, so that the declaimer himself must also somehow disappear in the dynamic and synoptic manifestation of words-in-freedom."[104]

Moreover, in keeping with the times, Marinetti called for a "warlike declamation" of parole in libertà. To achieve this effect, the poet must dress anonymously, completely dehumanize his voice and face, and gesticulate geometrically, "in all ways imitating motors and their rhythms."[105] The Futurists, then, no longer conceived the self on the Romantic model of an ideal organic whole in opposition to the increasingly mechanized, fragmented,

and commercialized world. On the contrary, the self was to be modeled upon and fully integrated with that new, mechanically conceived world. This in turn accounts for the Futurists' frequent recourse to collage techniques and use of mass-produced materials in communicating their immediate sensations. Apollinaire's calligrammes, written just before and during the war, provide an interesting point of comparison. Whereas Marinetti had rejected a humanistic notion of the self in favor of anonymous, machinelike behavior, Apollinaire continued to grant primacy to personal lyrical expression. Marinetti's parole in libertà celebrate violence and depersonalized cognition, an attitude designed to facilitate a cold, bellicose attitude and to promote a fascination with power in all its manifestations. In political terms, this accorded well with Italy's rising nationalism and imperialist aspirations. Apollinaire, on the other hand, gradually came to reject the use of machine-printed, ready-made collage elements in order to emphasize the lyrical qualities of his calligrammes. Poems such as "Il Pleut" (fig. 118) and "Coeur couronne et miroir" (fig. 129) function as self-illustrations in Marinetti's sense, but they also convey a sense of individual sentiment and a concern with self-definition. Many of Apollinaire's later calligrammes were handwritten, thereby further enhancing their unique, personal qualities.

In contrast, Marinetti's parole in libertà are born in the consciousness of the poet, but that consciousnesss can no longer be distinguished from the machines that infiltrate and produce it: airplanes, the telegraph, trains, telephones, machine guns, and the printing press. These machines and the language they emit increasingly displace the poet's voice as a lyrical expression of the self. Correspondingly, the center of sensation itself shifts from the mind to take up lodging in the voracious entrails of the new man multiplied by the machine, as Cangiullo's "TUTTO VENTRE" indicates (fig. 125). This was a process, as Marinetti had observed, already at work in the war.

133. F. T. Marinetti, *Premier Record,* 1914, ink and
pasted papers on paper. Location unknown.

Futurist Collage

and

Parole in Libertà

in the Service

of the War

La guerre actuelle est le plus beau poème futuriste jamais apparu.

—**Marinetti,** *La Guerre et le futurisme*

In the Preface to *Les mots en liberté futuristes,* published in 1919, Marinetti praised the Futurists for their successful efforts to provoke Italy to abandon its alliance with Germany and Austria and to enter the war on the side of France and England: "The Futurist movement practiced, first of all, an artistic action while indirectly influencing Italian political life with a propaganda of revolutionary, anti-clerical patriotism, which was launched against the Triple Alliance and which paved the way for our war against Austria."[1] Even in 1909, however, in the "Founding and Manifesto of Futurism," Marinetti had proclaimed his belief in the "hygienic" value of war. The poet's enthusiasm for violent conflict was further stimulated by his experiences as a war correspondent in both the Italo-Turkish War in Libya and in the First Balkan War in Turkey and continued unabated throughout World War I. This enthusiasm tends to arouse both surprise and dismay today but was not unusual in Marinetti's time. Apollinaire too occasionally wrote glowing, lyrical accounts of the experience of being in a trench with rockets exploding overhead,[2] and Blaise Cendrars extolled the virtues of the war even after he had lost an arm in battle.[3] Certainly it is difficult for us now to understand this optimistic mixture of youthful naiveté and aggression. This perhaps was the last time in modern European history when one could still find such a positive view of war as a powerful unleashing of vital energies, as an exhilarating challenge for the romantic hero, and as the necessary (only) vehicle of rupture with the past.

Shortly after the long-awaited war erupted, Marinetti began to encourage the Futurists to make it the subject of compelling, synthetic new works. He wrote to Severini in November of 1914 to advocate a plastic expression of the war that would be effective in reaching the broadest possible public:

What we need is not only direct collaboration in the splendor of this conflagration, but also the plastic expression of the Futurist hour. I mean a more ample expression that is not limited to a small circle of experts, an expression so strong and synthetic that it will hit the eye and imagination of all or almost all intelligent readers . . . Try to live the war pictorially, studying it in all its marvellous mechanical forms (military trains, fortifications, wounded men, ambulances, hospitals, funeral processions etc.).[4]

Marinetti lost no time in carrying out his own prointerventionist program by organizing a series of violent manifestations in Italian theaters, squares, and universities (during several of these the flag of Austria was burned) and by launching new prowar manifestos. These did not differ essentially from those of the prewar period. In October of 1913, Marinetti had published the "Futurist Political Program" in *Lacerba* in which he advocated

The absolute sovereignty of Italy.—The word ITALY must dominate over the word LIBERTY.
All liberties, except that of being cowardly, pacifist, anti-Italian.
A greater navy and a greater army; a populace proud of being Italian, for the War, only hygiene of the world, and for the greatness of an Italy intensely agricultural, industrial and commercial. Economic protection and patriotic education for the proletariat.
A cynical, astute, and aggressive foreign policy.—Colonial expansion.—Free Trade.
Irredentism.—Pan-Italianism.—The primacy of Italy. . . .[5]

This political program, signed by Marinetti, Carrà, Boccioni, and Russolo, is assertively nationalistic and prowar, but as Soffici would later complain it

does not take sides. Written by Marinetti, it advocates war as a means of achieving a powerful imperialist state without addressing the issue of adversaries. These, however, were all too easily found after August 1914, despite an initial period of Italian neutrality. In July of 1915, shortly after Italy abandoned her former allies and declared war on Austria and Germany, Marinetti, Boccioni, Russolo, Sironi, and others joined the Lombard Volunteer Cyclist Battalion and were then transferred for active service to the Alpine regiment. This period spent in the Alps proved to be a source of poetic inspiration for Marinetti, just as his experiences in Libya and Turkey had been.

Marinetti responded to the war by creating a series of poetic compositions best described as *tavole parolibere* (free-word pictures). Some of these were originally distributed in leaflet form and only later were republished in *Les mots en liberté futuristes*. Whether owing to the example of Cangiullo and the other free-word poets or to the experience of the war, these works no longer suggest any ambivalence toward the full development of the visual resources of dynamic typography or self-illustration that at times had characterized Marinetti's previous parole in libertà. Many of these free-word pictures are now contained within the space of a single page so that the viewer may take them in at a glance. Significantly, the use of collage, a compositional technique implied by Marinetti's interest in creating analogies between "distant, seemingly diverse and hostile things,"[6] becomes a striking feature of the post-1914 work. Some of the mock-ups for these free-word pictures are composed of elements appropriated from existing Futurist manifestos and parole in libertà, as if Marinetti wished to rework these earlier texts in accordance with his new ideas. In "Bombardment" of circa 1915 (fig.

134), for example, Marinetti cut out several words from his book *Zang Tumb Tumb* and superimposed them on other paper fragments that suggest the shape and trajectory of torpedoes.[7] As early as 1912, in his introduction to *I poeti futuristi*, Marinetti had drawn an analogy between bombs and the Futurists' poetry: "Their free verses are bombs, in fact, or better, torpedoes. The image can seem excessive only to myopic brains incapable of profound intuition."[8] Only in 1915, however, with works such as "Bombardment," did Marinetti give convincing form to this analogy. Here a more vital interplay between visual and verbal elements begins to replace the strings of juxtaposed words that had dominated the earlier parole in libertà. Even the spattered glue and crudely cut paper contribute to the sense that this work was created during a moment of intense exhilaration, perhaps even while Marinetti was still at the front.

An examination of one of the mock-ups for a tavola parolibera published in *Les mots en liberté futuristes*, "Vive la France"[9] of early 1915 (fig. 135), casts light on the integral role played by collage techniques in the development of Marinetti's mature style. Here Marinetti juxtaposed the ubiquitous "Zang Tumb Tumb" with lists of numbers (collage elements), "liberated" letters, and crisscrossing curved lines. The letters and numbers, deprived of the useful function they once served, seem to float mysteriously on the page. Their meaning can be elucidated, however, by comparison with the first published version of this work as a flyer dated 11 February 1915 and titled "Montagne + Vallate + Strade × Joffre" (fig. 136). The title reveals that in this work Marinetti exploited the hieroglyphic value of individual letters: the M's stand for mountains, the V's for valleys, the S-curves for the path *(strade)* taken by General Joffre. The lists of num-

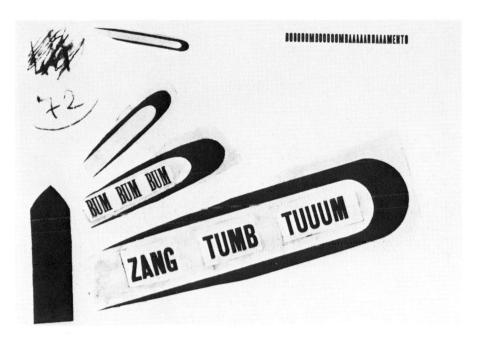

134. F. T. Marinetti, "Bombardment," 1915, pasted
papers on paper. Private collection.

135. F. T. Marinetti, "Vive la France," late 1914–February
1915, pasted paper and ink on paper. Collection,
Museum of Modern Art, New York. Gift of the Benjamin
and Frances Benenson Foundation.

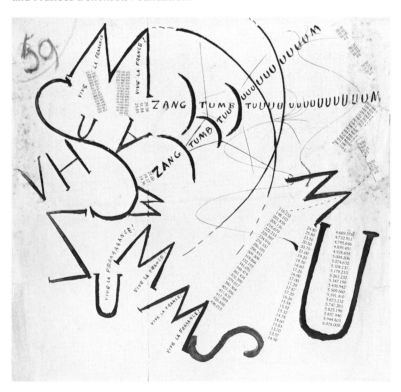

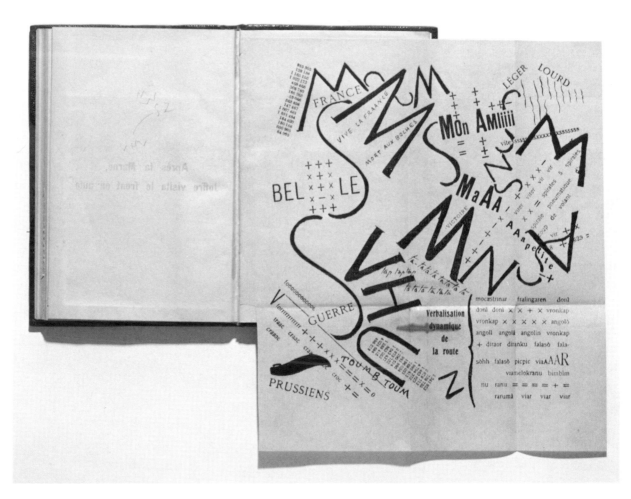

136. F. T. Marinetti, "Montagne + Vallate + Strade ×
Joffre," published as a pamphlet in February 1915,
republished in *Les mots en liberté futuristes* in 1919 with
the title "Après la Marne, Joffre visita le front en auto."

bers represent the soldiers he visited, for in 1919 Marinetti republished this tavola parolibera with the new narrative title "After the Marne, Joffre Visited the Front in an Automobile."

Mathematical symbols (\times, $+$, $=$, $-$) appear as a means of intensifying the dynamic reenactment of the journey. Marinetti considered the lyrical use of numbers, born of the modern "love of precision and essential brevity," one of the most important innovations of his new style.[10] At times, there are subtle elements of humor in the disposition of these numerical elements. The "amplified" word "BEL\times $+$ \timesLE," for example, seems to refer to the beauty of Joffre's speeding automobile as it careens around a curve in the road. The use of mathematical symbols, however, was also part of Marinetti's strategy to depersonalize descriptive accounts of experience. Here, for example, it allowed Marinetti to evoke the destructive effects of war in cold, impersonal, algebraic terms. In one of the mock-ups for the section labeled "Dynamic verbalization of the route" (fig. 137), Marinetti adds the "résistance terrain" (40 kilometers) to the "résistance air" (120 kilometers) to arrive at "1 trillion foul odors $+$ 3000 torn ammoniacs $+$ infinite obscurity lit by a 6 candle electric lamp." This kind of heroic objectivity, Marinetti implies, is a prerequisite for military victory. Contemporary journalistic accounts, by comparison, described the horrific conditions of the war in order to elicit a sense of sympathy for the dead and wounded soldiers from their readers. Within this context, Marinetti's detachment must have appeared deliberately shocking and sensationalist.

The existence of at least three mock-ups for individual sections of this tavola parolibera is also significant from a technical point of view. Once these pages had been printed, Marinetti could cut them into appropriate fragments so that they functioned as the equivalent of ready-made collage elements. This new means of composing visual poems through the appropriation and redistribution of machine-produced words and images accorded well with Marinetti's ideal of depersonalization.

137. F. T. Marinetti, "Dynamic Verbalization of the Route," 1914–15, corrected typeset for a section of "Après la Marne." Private collection.

The volatile, fragmentary appearance of "A Tumultuous Assembly: Numerical Sensibility" (fig. 28), a work closely related to "Vive la France," takes Marinetti's ideal of depersonalization to a further extreme. He composed "A Tumultuous Assembly" by gluing fragments of numbers, letters, and words, including a variety of typefaces, to the surface of his paper. Unlike "Vive la France" and "After the Marne," however, here no handwritten or hand-drawn elements appear. The juxtaposition of the date "1918" with the torpedolike forms, the small drummer (from a ready-made printer's block), and the overlapping fragments of numbers (which convey a sense of the jostling of large crowds) suggests that this free-word picture describes an Italian celebration on the occasion of the victorious end of World War I.

This work, along with "After the Marne" and seven other parole in libertà, was published in 1919 in *Les mots en liberté futuristes*. Several of these parole in libertà, including "A Tumultuous Assembly," were printed on sheets of paper that had to be unfolded individually from the body of the book in order to be viewed. This format gave Marinetti more space for the visual composition of his works, and it also forced the viewer to participate more actively in the process of reading / viewing. No doubt Marinetti considered the inclusion of these pages an attack on the *passatista* form of the book. In a letter to Cangiullo, written in September 1914 while in prison for instigating a prointervention riot in Milan, Marinetti equated the square format of the book with a prison cell: "Square books = cell / Flattened ideas = butterflies between square pages."[11] Opening and unfolding the pages of a book meant setting ideas free, putting them into flight.

While some of the free-word pictures in *Les mots en liberté futuristes,* including "After the Marne," recalled the folded pages of war maps in contemporary history and military books,[12] others recalled the folded pages of the many letters sent home from the war. "In the Evening, Lying on Her Bed, She Reread the Letter from Her Artilleryman at the Front" (fig. 138), one of the most visually interesting free-word pictures in the collection, reads as if it were composed while the artilleryman was engaged in active duty.[13] The author, of course, is Marinetti himself, as the words "Ho ricevuto il vostro libro mentre bombardavo il Monte C [?] F.T.M." (I received your book while bombing Monte C [?] F.T.M.) indicate. In keeping with the idea that this is a letter from the front, we find the dynamic onomatopoeic and typographic effects of words like "SCRABrrRrraaNNG" and "TRAC" suggesting artillery fire, incongruously juxtaposed with polite, handwritten expressions such as, "grazie e auguri a lei e ai suoi arditi[14] compagni" (thank you and best wishes to you and your daredevil companions). But this contrast serves to emphasize the heroism of the poet, just as the presence of the silhouetted recipient of the letter emphasizes the difference between the masculine world of action and the quiet feminine world at home. For Marinetti's dynamic, prowar ideal was defined in opposition to the sentimental, pacifist attitudes associated with women. In a characteristic refusal of the lyrical expressions of the past, Marinetti addressed this female reader as a Futurist comrade.

In "The Painter of Modern Life" (1863), Charles Baudelaire suggested that the ideal modern artist (exemplified by Constantin Guys) would return from a day of absorbing impressions in the urban landscape to engage in a kind of private duel with the tools of his trade: pencil, brush, pen, water, and

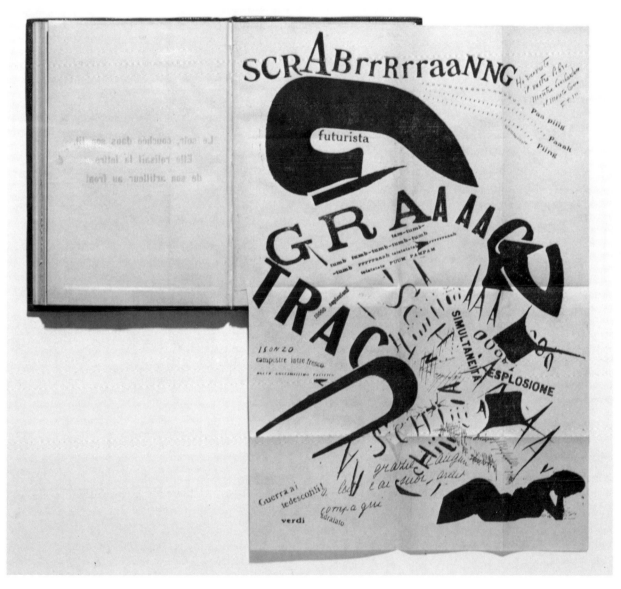

138. F. T. Marinetti, "In the Evening, Lying on Her Bed,
She Reread the Letter from Her Artilleryman at the
Front," 1917, published in *Les mots en liberté futuristes*,
1919.

paper. Baudelaire described the artist in the process of working as "hurried, vigorous, active, as though he was afraid the images might escape him, quarrelsome though alone, and driving himself relentlessly on."[15] According to this passage, the artist must struggle to transform the obsessive images that crowd his memory into drawings that will capture the vitality of his experiences. The tavole parolibere Marinetti executed during the war convey a similar picture of the overwrought, "intoxicated" artist / poet at work. But whereas Baudelaire's artist retires to the serenity of his room to distill the essence from his memories of the day, Marinetti emphasizes the temporal congruence of experience and the act of creation. The Futurist poet is not an elegant, detached *flâneur* by day, an impassioned creator by night. For Marinetti, the ideal poet composes his free-word poems while in the thrall of the heightened moment, indeed, even while bombing the enemy. (Here Marinetti would seem to surpass even Apollinaire, who was known to compose his poems while promenading along the streets of Paris or while conversing with friends in a café.) This focus on immediacy of expression, signaled by the absence of syntax and the use of infinitive verbs, allowed Marinetti to resolve the traditional disjunction between the time of the story and the time of its telling in favor of a new (mythical) unity.[16] The form his parole in libertà and tavole parolibere take, then, seem to mirror the chaotic totality of the poet's sensations, as yet unordered by reflection or convention. Of course, Marinetti was well aware that the poet "orchestrates" this appearance of chaos: "All order being necessarily a product of crafty intelligence, one must orchestrate images, arranging them according to a *maximum of disorder.*"[17]

This was the Futurists' frequently stated aim, to render not a "fixed *moment* of universal dynamism"

(not, that is, a specific external event), but "*dynamic sensation* itself."[18] If onomatopoeia and typographic self-illustration replaced syntax in their poetic works, it was because the Futurists believed them to be techniques for motivating poetic expression. The conventions of Latin syntax were clearly arbitrary, as were those of standardized typography. By rejecting these mediated forms of communication, Marinetti and the Futurists sought to close the gap between the signifier and what it signified, to breathe life into the static literary devices of the past. This implied a return to the very origins of language in immediate *sensation;* the poet must seize and scatter nouns "as they are born."[19] Expression here is understood on the model of the primitive cry, which seems to appear spontaneously, before the articulations and spacings of syntax. Yet if the autonomous birth of isolated nouns suggests a return to an archaic, Adamic conception of language as a piecemeal process of naming, this birth also has a specifically modern mother in the machine. For in Marinetti's parole in libertà, the human cry has been made the equivalent of the inarticulate blasts and sputterings of machine guns, whirring propellers, and bombs.

Despite this emphasis on the "naturally" expressive properties of sounds, Marinetti found it necessary at times to interpret his onomatopoeic effects for his readers. In "Geometric and Mechanical Splendor" he explained that in the free-word poem *Zang Tumb Tumb,* "tatatata" represented the fire of machine guns against the "Hoooraaaah" of the Turks.[20] And in a page titled "Bombardement" from *Zang Tumb Tumb,* we find a veritable catalogue of Marinetti's favorite onomatopoeic effects accompanied by identifying clues: "Zang tumb tumb" expresses the sounds (and echoes) of exploding cannons, "traak-traak" evokes the crack of a whip

or a slap, "pic-pac-poum-toum" suggests the sound of air fire, and "croooc-craaac" conveys the slow rumble of three marching Bulgarian battalions. Many of these noises became standardized in Marinetti's later works, although he was always inventive in creating new sound effects as well. In tavole parolibere such as "After the Marne" and "She Reread the Letter from Her Artilleryman," the familiar "Tumb Tumb," "tatatatata," and "traac craac" function as ready-made elements, much like the other printed materials Marinetti used. Yet if the disorder in these free-word pictures now seems consciously, even artfully arranged, and if the onomatopoeic effects seem mass-produced, this need not imply they were experienced as conventional representations by Marinetti's contemporaries. Indeed, an account of a performance of Zang Tumb Tumb by Henry Nevinson, the well-known British war correspondent, suggests the contrary: "Antiquity exploded. Tradition ceased to breathe. . . I have heard many recitations and have tried to describe many battles. But listen to Marinetti's recitation of one of his battle scenes . . . the noise, the confusion, the surprise of death, the terror and courage, the shouting, curses, blood and agony—all were recalled by that amazing succession of words, performed or enacted by the poet with such passion of abandonment that no one could escape the spell of listening."[21]

Futurist Collage and the War

Among the Futurist artists, Marinetti's unbridled enthusiasm for the war was shared by Boccioni, Carrà, Soffici, and Balla. The works these artists executed during late 1914 and 1915 were often designed to function as efficient tools of propaganda, analogous in content to the violent interventionist demonstrations then being staged by the Futurists.

In his letter of November 1914 to Severini, Marinetti had emphasized the need for Futurist works to "incite" the viewer, stating that he did not see this as a "prostitution" of Futurist dynamism: "I don't see in this a prostitution of plastic dynamism, but believe that the great war, intensely lived by the Futurist painters, can produce in their sensibility real convulsions, pushing them toward a brutal simplification of the most clear lines, pushing them that is, to strike and incite the reader, as it strikes and incites the combatants."[22] Marinetti went on to predict that this focus on the war would lead to a new realism in Futurist works: "Probably there will be less abstract paintings or sketches, a little too realistic and in a certain way, a kind of advanced post-impressionism."[23] This realism no doubt was necessary in order to reach the broadest possible public and to establish a concrete sense of connection to the war. Collage answered this need, and it became the central compositional technique of the Futurists who responded to Marinetti's plea for a united front at this time of crisis. For unlike the Cubists, the Futurists tended to regard collage elements and onomatopoeia as bits of reality, rather than as culturally constituted signs. During the course of 1914, a number of splits within the ranks of the Futurists had begun to appear as individual artists and poets began to chafe under Marinetti's leadership. Nonetheless, for a final, brief period Marinetti was largely successful in producing a unified response to the war and in sparking a renewed concern with easily identifiable subject matter. Frequently, a desire to react to the most recent events of the day led Boccioni, Carrà, and Soffici to employ newspaper and other printed matter of a political nature as pictorial or textual elements in collages. Balla's interventionist works tended to be more abstract, although he too used a variety of materials to im-

ply the construction of a new world upon the ruins of the old.

One of the earliest Futurist efforts to dramatize the war through the use of collage can be seen in Boccioni's *Charge of the Lancers* of January 1915 (fig. 23). A small fragment of newspaper in the upper right corner bearing the title "Punti d'appoggio tedeschi presi dai francesi" (German strategic points taken by the French) both anchors the collage formally and reveals its subject, a French victory in the Oise Valley. This is a work intended to celebrate a moment of contemporary history, and the newspaper, with its date well in evidence ("4 gennaio"), contributes to the urgency and topicality of the depicted event.[24] Another strip of text, comprising several fragments pasted horizontally across the right edge, supplies further commentary: the Austro-Germans and Russians have arrived in France and Belgium, war has erupted. As in Severini's nearly contemporary collage *Still Life* (fig. 106), the role of Italy, scandalously absent from these headlines, remains in question.

The newspaper, which acts to frame the upper right corner, also serves as a pictorial ground for this collage. It is a ground that the charging cavalry seem to pierce with their rushing forms and dramatically poised lances. As the pictorial enactment of a text, this collage can be compared to Marinetti's "She Reread the Letter from Her Artilleryman" (fig. 138); in both works the chaotic conflict of forms and figures is a dynamic realization of a text that must be experienced as fully *present* and alive rather than as a stillborn progression of verbal signs. In Boccioni's collage, the lancers seem to burst through the newspaper into the (male) viewer's space, as a means of signaling that he will be forced to participate in the battle and ultimately to relinquish a position of neutrality for one of active

intervention. Putting the viewer in the center of the work in this case means propelling him out of his armchair, where he could read the newspaper, and into the field of war.

The fact of victory, of course, has been predetermined by the text, even though the French cavalry have been equipped only with anachronistic (but chivalrous) lances. Boccioni depicted the combatants in ink and tempera on a ground littered with fragments of various kinds of paper and board, intended to suggest a dynamic interpenetration of forces. The lancers, however, do battle not only with the ground but also with the small, dark, silhouetted shapes of German artillerymen in the lower left corner and along the left edge. Granted a clearly subordinate, defensive position, and no corporeal weight or substance, these artillerymen will clearly be crushed by the swift, penetrating attack of the French. A small bit of newspaper near the lower center of the collage, seemingly displaced from the upper right, drifts along in the wake of their tumultuous advance, hinting at the destruction that will follow.

Boccioni's *Charge of the Lancers* may be compared to Carrà's *Pursuit* of late 1914 or early 1915 (fig. 139) in the representation of dynamic movement. In Carrà's collage, a variety of pasted papers, in French, Italian, and English, vie for the spectator's attention. These fragments include references to French "music halls" and other *"spectacles,"* as well as to the publication of "The Car Illustrated," calling to mind the languages and cultures of Italy's intended allies. Within this chaotic jumble of references, the stenciled letters "JOFFRE" and "UUUUU" (for the French general and the sound of bursting shells,) celebrate the early triumphs of the war. The colors of the Italian flag and the small star affixed to the body of the galloping horse, silhouetted

139. Carlo Carrà, *Pursuit,* late 1914, pasted papers,
charcoal, and gouache on paper. Mattioli Collection,
Milan.

aggressively in black, advocate Italy's entry into the battle. A small news clipping near the center of this collage reads: ". . . ei Balcani . . . Italia e Rumania . . ."; it alludes to Italy's conflict with the Austro-Hungarian Empire over control of the Balkans, in which Rumania was viewed as an ally. One of Italy's first goals in the war, this clipping seems to say, will be the heroic pursuit of the Austrians and the recovery of Italian territory.

Despite this concentration of contemporary texts and symbols, Carrà's collage remains relatively static; the forms do not convincingly suggest an interpenetration of dynamic forces, and the toylike horse, with a rider huddled inconspicuously over his back, whip held back in readiness, seems arrested in midair. Boccioni's *Charge of the Lancers* was more successful in conveying the drama of an equestrian charge by eliminating extraneous references and by emphasizing the unified directional force of the French cavalry as an abstract, synthesized shape.

In several of the collages and parole in libertà reproduced in a volume titled *Guerrapittura* of 1915, Carrà strove to represent the war in a more innovative manner, employing both empathetically charged abstract forms and pasted materials designed to enhance a sense of realism. One of these collages, *The Night of January 20, 1915 I Dreamed This Picture (Joffre's Angle of Penetration on the Marne against Two German Cubes)* (fig. 27), presents an interesting synthesis of elements, at once abstract and referential. As the title indicates, this work celebrates General Joffre's dramatic military victory against the German army at the Marne River, west of Paris. Linda Landis has shown that the flat, maplike background of this work describes the specific site of the battle.[25] The focal point is marked by a fragment of newspaper cut out in the

shape of a star so that the word "*ici*" (here) emerges from the cropping. Two broken lines near the center indicate the Marne, with the German forces, symbolized by the Iron Cross, ranged to the right and the French forces ranged to the left. A dynamic "perspective plane" cuts through the composition, dividing the enemies and giving rise to several three-dimensional projections in the form of a shaded cone at the left and two cubes and a commalike form at the right. Landis has convincingly argued that these forms represent the three types of reconnaissance aircraft involved in the battle at the Marne.[26] The two cubes, connected by broken lines to the Iron Cross, identify the German Albatros B II, which was notable for its two-bay wing structure. Directly beneath the Albatros, Carrà drew a commalike form representing the similarly shaped tail of the German Fokker monoplane. On the French side, the white wedge shape, over which Carrà drew guy wires and inverted V-struts, alludes to the sharply tapered fuselage of the French Morane monoplane. These simple geometrical forms referred to the most visually memorable characteristics of each type of reconnaissance plane.

Interestingly, however, these forms also dramatize Carrà's theory, set forth in *Guerrapittura* and elsewhere, that abstract forms, lines, and colors can be associated with particular emotional and physical qualities. For example, Carrà attributed to the acute angle or cone the power to achieve dynamic penetration, while the cube and the right angle symbolized stasis and neutrality: "The right angle, for example, serves to express austere calmness and serenity, when the composition requires a simple, non-passionate, neutral rhythm. With this same intent of neutrality, one uses, in other cases, horizontal lines and pure verticals. . . . The acute angle, instead, is passionate and dynamic, ex-

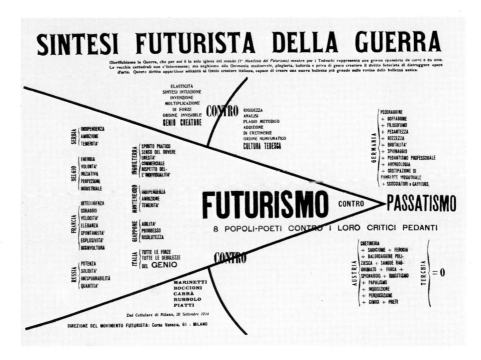

140. Carlo Carrà, "Sintesi Futurista della Guerra," from
Guerrapittura, 1915.

presses will and penetrating force."[27] Carrà's "Sin-
tesi Futurista della Guerra" (fig. 140), also
reproduced in *Guerrapittura,* makes this interpreta-
tion of the dynamism of acute angles visually ex-
plicit. All the peoples associated with *Futurismo* are
contained within the arc of a projecting angle that
seems to force the *Passatisti,* who are contained
within a circle (the Germans, Turks, and Austrians),
nearly off the page. The racial characteristics of
each people are enumerated within brackets; not
surprisingly, Italy is described as having "all the
strengths and weaknesses of GENIUS," while the Aus-
trians turn out to be "stupid and filthy" and the
Turks to have no identifiable characteristics at all!

Severini held a similar view of the expressive
qualities of geometric forms, although he did not
focus on giving these forms distinct racial associa-
tions. In a recently published essay intended to ac-
company his free-word picture "Danza Serpentina"
of 1914 (fig. 120) he wrote, "The way to express the
intense realism of our emotions with new means of

lyrical synthesis was suggested to me by my free-word drawing in which I *knowingly* accorded acute forms and angles with special words, and round forms and oblique angles with others."[28] As Severini further explained, in "Danza Serpentina" he rendered the sensation of luminous penetration by two electric beams of light ("PENETRAZIONE LUMINOSISSIMA SZSZSZSZ") through the contrast of two acute angles which meet at their points. Similarly, Carrà used the acute angle of the Morane monoplane to suggest the penetrating force of the French in deliberate contrast to the static forms of the German cubes. This formal vocabulary was intended to give visible confirmation to his view that the Latin races, and especially the Italians, were naturally dynamic, while the Germans suffered from congenital stodginess. In an essay in *Guerrapittura* titled "The Germans Begging for Love," Carrà set forth the terms of the innate hostility of the Italian and Germanic peoples:

> We are agile, multiformed, and you are hard, uniform, grey.
>
> We are *hot, passionate,* and you are cold, dispassionate.
>
> You are for erudition, for the intellectual, professordom and the academy, and we are for intuition, rapid experiences, and we adore ignorance, spirited ignorance that we judge an essential virtue and hygienic force of the brain.
>
> We are sensibility rendered anatomy, and you are insensibility made brain.
>
> As you can see, we are dealing with a true reversal of values—and agreement will never be possible.[29]

Thus, in Carrà's collage the battle at the Marne is enacted in terms which are at once historically specific and charged with ahistorical, seemingly

natural meaning. By conflating the two levels of meaning, casting the acute angles and cubes in double roles, Carrà hoped to reach his audience not rationally but empathetically, just as Boccioni had hoped to do in *Charge of the Lancers*. As a collection of works on the theme of war, *Guerrapittura* was meant to arouse hatred for the Germans at a time when Italy was still technically a member of the Triple Alliance and to provide a racial motive for an alliance with France.

Carrà enhanced the empathetic immediacy of the work by pasting and stenciling additional bits of symbolic reality to his surface. The canceled Italian postage stamp, positioned next to the acute angle, suggests that Italy *is* on the French side and can be counted as an ally. The letters "SILURARE" (torpedo) and "WW" (victory) reveal Marinetti's influence, as does the onomatopoeic "music" of the two pairs of "grrrrriiiiillliiiiii" (crickets). This sound effect, which may be an intuited analogue for screeching torpedoes, contributes to the sensory fullness of the viewer's experience of the battle. Carrà's collage further suggests that it is primarily the *poeti* (and perhaps artists) who are *contro* the Germans and who will lead the way to an interventionist Italy.

Shortly after the outbreak of the war, Balla was persuaded by Marinetti to publish a Futurist manifesto advocating "antineutral" clothing.[30] Like Carrà, he cast his argument in racial terms, as a sartorial conflict between Latin dynamism and Teutonic "pedanticism." In designing antineutral clothing, Balla stated that his goal was to create a visible symbol of an aggressive, bellicose state of mind, which would prepare Italy to intervene in the war: "We Futurists want to free our race from every form of *neutrality,* from frightened and silent indecision, from negating pessimism and from nostalgic romantic, mollifying inertia. We want to color Italy

with Futurist audacity and danger, and at long last, give the Italians aggressive and cheerful clothes."[31] Like Carrà, Balla sought the plastic equivalents of an antincutral stance in the emotional force of specific forms, colors, and lines. Departing from the premise that "one thinks and one acts as one dresses,"[32] Balla designed "aggressive," "dynamic," and "joyful" Futurist clothing. These qualities were signified through the use of streamlined, violent patterns and "muscular" colors (bright violets, reds, turquoises, greens, and so on). Furthermore, Balla proposed the introduction of luminous materials to encourage boldness and asymmetrical sleeve ends and coat fronts to symbolize a state of readyness for spirited "counterattacks." Balla concluded his manifesto by declaring, "If the Government does not discard its traditional clothes of fear and indecision, we shall *double,* WE SHALL MULTIPLY BY A HUNDRED THE RED *of the tricolor flag which we wear.*"[33] Wearing the red of the Italian flag certainly had patriotic value, as Balla asserted, but there could not have been a more dangerous color to wear on the battlefield. This emphasis on the symbolic rather than practical effect of forms and colors, however, is symptomatic of Futurist interventionist tactics. The war was regarded more as a glorious symbol of patriotic dynamism than in terms of the grim reality of the trenches.

In "The Founding and Manifesto of Futurism," Marinetti had proclaimed war the world's only hygiene,[34] thereby deliberately excluding revolution as a means of achieving political change or renewal at a time of great social unrest in Europe. As Walter Benjamin has argued, Marinetti chose to celebrate war as an aesthetic phenomenon in order to mobilize the technological forces of the modern epoch without disturbing the prevailing class structure or property relations.[35] An analysis of Marinetti's polit-

ical views confirms this analysis, although no simple equation between Futurism and Fascism can be made. Unlike the Fascists of the postwar period, Marinetti was against traditional values and against the Catholic church; eventually his ideas proved too idiosyncratic and subversive for Mussolini's regime. But in political terms there was agreement on the need to make Italy a powerful, imperialist nation, and much of Marinetti's interventionist propaganda was directed toward this goal. Nationalism in this sense was defined as a collective affirmation of an expansive will to dominate. According to the Futurists, this will to domination was a healthy sign and could be ignored only at great peril to the existing power structure. Carrà summarized the alternatives facing Italy in a warning to King Victor Emmanuel III in *Guerrapittura:* "We shout today:— War or Revolution! Hear this, you who should hear it."[36]

Ironically, several of the Futurists had, in their youth, participated in the anarchist and socialist humanitarian movements that swept through Europe at the turn of the century. Severini recalled in his memoirs that around 1900, he had briefly entertained "revolutionary ideas" and that he had read and discussed with his friends the works of Marx, Engels, Bakunin, Tolstoy, Nietzsche, and others.[37] His early interest in Seurat may have been stimulated, in part, by his sympathy with the French artist's social anarchism. Carrà, perhaps the most politically active of the Futurist artists, frequented anarchist circles during 1900 and 1901 while working in Paris and London, and he later took part in anarchist manifestations in Italy as well.[38] Balla had also been profoundly influenced by the writings of Tolstoy and by the Italian socialist humanitarians Giovanni Cena and Cesare Lombroso. Early works such as *Bankruptcy* (1903) and *The Worker's Day*

(1904) reflect his interest in the condition of workers and of the poor, without, however, succumbing to facile sentimentality or pathos.

Yet mixed with these humanitarian sentiments was a strong, patriotic attachment to Italy and her heritage that could not be forgotten despite the Futurists' abjuration of tradition. Before the war, this patriotism was expressed primarily in terms of a desire for artistic preeminence. Carrà spoke for all the Futurists when he wrote to Soffici in 1913,

> We must have faith and courage in ourselves, as artists and as Italians. To renounce nationalism means being subjugated by the nationalism of others.
>
> If we don't work with audacity against the French, believe me my friend, we will have to bear their yoke for still some time. Futurism, born in us, wants Italy to have again a great art—wants foreigners, barbarians or emasculated as they are, from this time forward to look to Italy and no longer to France.[39]

Indeed, all of the Futurists were keenly aware of the fact that the artistic glory of Italy lay far in the past and that their country remained largely oblivious of events transpiring in other European centers, especially Paris. As the war approached, their sense of nationalism began to take precedence over all previous philosophical ideas and alliances. Only a shared belief in the necessity to wrench Italy into the twentieth century through aggressive tactics and a variety of publicity stunts could have united men as different as Marinetti, Carrà, Severini, Boccioni, Balla, Soffici, and Papini. During the prewar period, Carrà rejected his prior sympathy for anarchism and denounced the pacificism of the socialists.[40] He thereby allied himself more closely with Soffici and the circle of *La Voce*. Soffici, for his part, considered himself a member of the intellectual elite and had always abhorred the socialists and the proletariat.[41] In *Primi Principi di una estetica futurista,* he was, with considerable imaginative effort, able to take the view that socialism was simply another way of representing the world, of constructing a drama of opposing forces: "And thus, now it became clear, how that capitalist and that proletarian were nothing but dramatic figures, and their economic relations nothing but the poetic elements of their contrast, a social contrast, all together: a harmony imagined and posited as the law of that creation of a *sui generis* world, non-existent in reality, but true in the infinite sphere of the Spirit."[42] Just as Marinetti had transformed war into an aesthetic phenomenon, Soffici transformed class struggle into a harmonious composition, a matter of art. This led him ultimately to his belief in "tutto arte," or the aestheticization of all things.[43] Seen in these terms, political and social realities fade before the autonomy and spirituality of the aesthetic sphere; for Soffici, like Mallarmé, asserted that art should remain free of utilitarian and political concerns.[44] But even Soffici did not always succeed in neutralizing politics and returning to an imperturbable ideal of classical order. If one reads between the lines of the simple, elegant drawing *Bottle and Glass* of 1915 (fig. 141), for example, one notes the strident headlines of a page from the *Corriere della Sera* of 21 April 1915: "Recentissime: Altura dei Carpazi tolta dai russi ai tedeschi. Attacco di insorti albanesi alla frontiera serba" (News flash: Carpathian Heights seized by the Russians from the Germans. Attack of Albanese insurgents on the Serbian front.) By this time Soffici had joined Papini in advocating Italian intervention in the war in the pages of *Lacerba,* which was now given over entirely to political matters.[45] For Soffici, the war

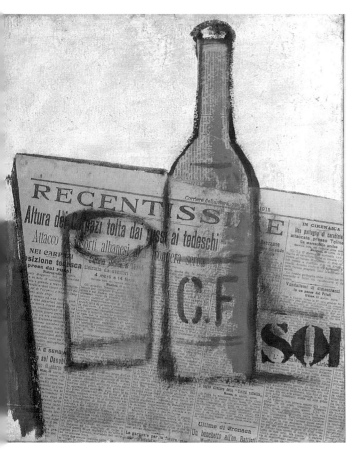

141. Ardengo Soffici, *Bottle and Glass,* spring 1915, pasted paper and gouache on thick paper mounted on canvas. Civico Museo d'Arte Contemporanea, Palazzo Reale, Milan. Photo Saporetti.

must be fought not for its own sake, but to preserve the values of peace and of Latin civilization. The confrontation of classicizing forms and contemporary political news in *Bottle and Glass* seems to argue that it is order and rationality that Italy must now defend in the war. These traditional values, newly affirmed with the prospect of war with Germany, contributed to Soffici's rejection of Futurist aesthetics. *Bottle and Glass* is an early example of the *rappel à l'ordre* among Italian artists.

Balla's philosophy led him in an opposing direction. He designed and created decorative, utilitarian objects intended to transform the everyday world of a broad public. Like the other Futurists, Balla was inspired briefly to participate in the fostering of an interventionist climate through the creation of polemical, prowar works. These works, however, reflect a utopian vision absent from the more concrete, directly political works of Carrà, Severini, and Boccioni. Balla, more than the other Futurist artists, was concerned with the way the world would look once the past had been destroyed. His manifesto, written with Fortunato Depero in March 1915 and titled "Futurist Reconstruction of the Universe," provides a glimpse of Balla's proposal for a new, colorful environment filled with abstract, kinetic plastic constructions, Futurist toys, an artificial landscape, and millions of metal animals.

Reconstructing the Universe

Like the antineutral suit, the objects Balla conceived as the elements of his reconstructed universe generally had a useful as well as symbolic value. They were, for the most part, built of new, industrial materials that lay claim to the tangible space of the everyday, three-dimensional world in a manner comparable to Tatlin's contemporary coun-

terreliefs. As Balla and Depero explained in the "Futurist Reconstruction of the Universe," the three-dimensionality of Balla's "plastic complexes" grew directly out of his earlier research into the laws of velocity: "Balla began by studying the velocity of automobiles; this led him to discover its laws and essential linear-forces. After more than twenty paintings in the same research, he realized that the flat surface of the canvas did not permit him to render in depth the dynamic volume of speed. Balla felt the need to build—using wire, pieces of cardboard, cloth and tissue-paper, etc.—the first dynamic plastic construction."[46]

The desire to build in three dimensions culminated, initially, in a construction of iron wire, *Line of Speed + Vortex* (fig. 142). This work consists of two dynamically interpenetrating "trajectories," one describing a convex curve, the other the rise and spiraling descent of a vortex. The pattern traced by these lines in space anticipates Balla's free-word picture *Rumoristica plastica* BALTRR of 1916–17 (fig. 126), in which the dynamic, spiral path of the artist intersects a staccato zigzag punctuated with dots and sound effects.

Line of Speed + Vortex is analogous in concept to the many colorful collages Balla executed during this period on the theme of an abstract line or path of velocity superimposed on (added to) a landscape. An example is *Line of Velocity + Landscape* (fig. 143) of 1915. In this context one should note the series of collages Balla excuted in 1915, in which swirling spirals and vectors made of semi-transparent tissue paper suggest the dynamic action of a patriotic demonstration (fig. 144). In these collages, Balla continued to explore his interest in giving material form to those events and forces that seemed most impalpable and elusive. In this respect, as in the positivist frame of mind in which he conducted his research into motion, his work

diverged sharply from that of Boccioni and Soffici. Whereas they wished to spiritualize the real, Balla wished to materialize abstract forces in the process of becoming. As he and Depero put it in "Futurist Reconstruction of the Universe": "We will give skeleton and flesh to the invisible, the impalpable, the imponderable and the imperceptible. We will find abstract equivalents for all the forms and elements of the universe, and then we will combine them according to the caprice of our inspiration, to shape plastic complexes which we will set in motion."[47] Nonetheless, like Boccioni, Balla attributed a specific "absolute motion" to particular material substances and believed materials should be employed with a view to their inherent expressive qualities. For example, he claimed that the new constructions should be "EXTREMELY TRANSPARENT—For the speed and volatility of the plastic construction which must appear and disappear, light and impalpable."[48] Consequently he tended to use materials that reflect light or patterns created out of taut string. Moreover, through sheer diversity of materials—including wire, cotton, colored glass, tissue paper, celluloid, metal screens, mirrors, springs, levers, and mechanical, electrical, musical, and noisemaking devices—Balla could build constructions that would overcome the stasis of traditional sculpture, not only through a collision of different material substances, but also through the production of literal movement and noise. This emphasis on literalism can be traced back to Balla's early verist style, typified by works like *Bankruptcy,* in which he attempted to approximate the apparent objectivity of photography. As Balla later explained with regard to the door depicted in *Bankruptcy,* "Having arrived at this point of my art I thought, moreover, that I had only painted a simple door and that it would have been much better for the spectator to look at a *real* door rather than see it

142. Giacomo Balla, *Line of Speed + Vortex,* 1915, iron wire construction. Private collection.

143. Giacomo Balla, *Line of Velocity + Landscape,* 1915, pasted papers on paper. Private collection.

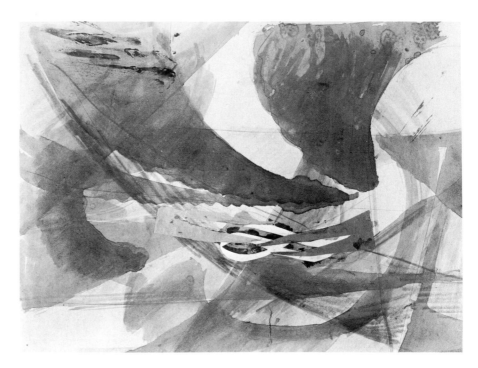

144. Giacomo Balla, *Dimostrazione patriottica,* 1915,
pasted papers and gouache on paper. Calmarini
Collection, Milan.

reproduced on a canvas. All the more so because I
would not have been good at *exactly* reproducing
the real."[49]

The plastic complexes Balla reproduced in the
"Futurist Reconstruction of the Universe" can be
seen as part of the artist's continuing effort to work
with real objects and materials rather than to cre-
ate images or reproductions of previously existing
objects. Whereas for Soffici artistic autonomy im-
plied a refusal of utilitarian values, for Balla it im-
plied that a work of art only resembled itself.[50]
Indeed, his plastic complexes are startling in their
emphasis on the concrete relations and physical
qualities of materials, far surpassing those of Boc-
cioni in this respect. Even Boccioni's *Horse +
Rider + Houses* of 1914 (fig. 145), composed of a
variety of materials and containing some movable
parts, seems to belong to the tradition of naturalis-
tic sculptural representation in comparison to
Balla's abstract constructions. Only Tatlin's coun-

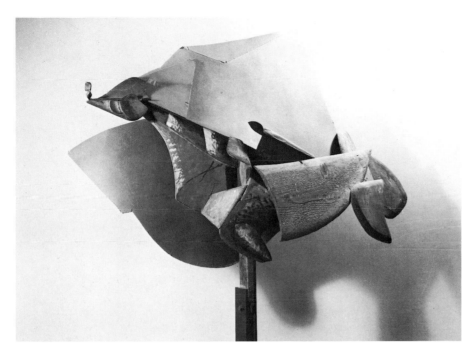

145. Umberto Boccioni, *Horse + Rider + Houses,* 1914, wood, cardboard, tin, copper, and oil, reconstructed. Peggy Guggenheim Collection, Venice, (The Solomon R. Guggenheim Foundation).

terreliefs reveal a similar anti-idealism and desire to base the work of the future in the realm of *material* construction.

Unfortunately, a detailed analysis of Balla's plastic complexes is difficult because they have been lost and can be studied only in poor reproductions. *Colored Plastic Complex of Noise + Dance + Joy* (fig. 146), the caption tells us, comprised mirrors, tin foil, talcum powder, cardboard, and wire. From the photograph it is impossible to determine whether the construction moved or made noise, although most likely it did, given Balla's stated intent. Certainly the appearance of this work suggests a dynamic contrast of materials and forces. The curved wire introduces the sensation of swirling movement, evoking perhaps the arabesque of Loïe Fuller's electrically illuminated colored veils.[51] This wire is attached to the mirror side of a folded, projecting wedge, which in turn is set against the curved plane of the background. An-

other element, suspended horizontally above the ground by wires on either end, may have been capable of rotating or making noise. Additional arc-like and wedge-shaped elements also produce a sense of interpenetrating force-lines and dynamically projecting vectors. All of these materials were affixed to a trapezoidal, reflective surface, so that the play of light and shadow on the work must have significantly multiplied the dynamism and luminosity of the analogy noise + dance + joy.

Even more abstract in appearance was *Colored Plastic Complex of Force-Lines* (fig. 147), which also was reproduced in the "Futurist Reconstruction of the Universe." Here Balla stretched a series of red and yellow strings across the folded, wedgelike planes of an irregular piece of cardboard. The strings create a pattern of intersecting force-lines against a background of light and dark planes bent in space. Existing as an abstract, three-dimensional object of unknown but possibly utopian function,

146. Giacomo Balla, *Colored Plastic Complex of Noise
+ Dance + Joy,* 1915, mirrors, tinfoil, talcum powder,
cardboard, wire. No longer extant.

147. Giacomo Balla, *Colored Plastic Complex of Force-
Lines,* 1915, cardboard and colored string. No longer
extant.

this work seems to anticipate some of the more elegant constructions of Naum Gabo. In order to enhance the autonomy and objecthood of the work, Balla did not give it a base, thereby removing it from the purview of the museum. He regarded this work as entirely self-sufficient, as a new, fully *present* object rather than as a nostalgic image of an *absent* reality. Balla quoted Marinetti on this point in his manifesto:

> Before us, art consisted of memory, anguished re-evocation of the lost Object (happiness, love, landscape), and therefore nostalgia, immobility, pain, distance. With Futurism art has become action-art, that is, energy of will, aggression, possession, penetration, joy, brutal reality in art (e.g. onomatopoeia; e.g. noise-intoner = motors), geometric splendor of forces, forward projection. Consequently art became Presence, the new Object, the new reality created with the abstract elements of the universe. The hands of the traditionalist artist ached for the lost Object; our hands suffered agonies for a new object to create. That is why the new object (plastic complex) appears miraculously in yours.[52]

According to this interpretation of Balla's plastic complexes, the new object was to be an original creation, not a reinterpretation or deformation of an existing reality. The artist would thereby triumph over nature, over distance, over loss, over absence as the necessary condition of representation, bringing all things into the realm of pure presence. But Balla's works suggest a more complex interaction with the existing world than the mere refusal to resemble it. They remain open to change, inviting playful participation on the part of the viewer. His objects resemble the Futurist toys announced in the manifesto, whose goal was to effect spontaneous laughter and "the infinite stretching

and animation of the sensibility."[53] Perhaps more than any other works produced by the Futurists, these plastic complexes evaded the prevailing conditions of museum art, while participating in a proto-Dada spirit of provocation, willful nonsense, and self-decomposition. Among the "necessary means" Balla listed in the "Futurist Reconstruction of the Universe" were a series of decompositions, or ways in which plastic complexes might be altered and made to appear and disappear.

Marinetti's remarks, cited above, while calling for an art of presence, implied the dissolution of the aura of traditional works of art. In "The Work of Art in the Age of Mechanical Reproduction," Walter Benjamin called attention to a change in contemporary modes of perception wrought by "the desire of contemporary masses to bring things 'closer' spatially and humanly."[54] Balla's objects, which were meant to be handled, set in motion, and thereby energized, seem to reflect this desire. In this sense they are not autonomous—for they depend on human interaction—and were intended to have an ephemeral life.

In spite of the violence and destruction of the ongoing war, Balla proceeded to develop a whole range of colorful, decorative objects destined ultimately for use in a happier world. He chose to surround himself with lighthearted, simple things that defied contemporary bourgeois taste, but to which one might still apply the term *beautiful*. With these brightly painted objects—tables, chairs, modular furniture, letter holders, coat hangers, eggcups, umbrella stands—Balla set out to reconstruct the universe according to his own joyful vision. In its union of utopianism and utility, this vision anticipated the constructive efforts of the twenties and thirties.

Chapter 9

Collage

and the

Modernist

Tradition

The invention of collage in 1912 coincided with a growing awareness of the role that the machine and mechanical reproduction had begun to play in all areas of life, especially in the visual arts. As Walter Benjamin observed in "The Work of Art in the Age of Mechanical Reproduction," prior to the changes wrought by the revolution in lithography and photography during the course of the nineteenth century, the authenticity of works of art was guaranteed by their unique physical existence and by the cult practice that granted them what Benjamin called aura. Around 1900, however, the ease and efficiency of technical reproduction had begun to threaten even the aura of original works of art. Their singular presence and connection to tradition were diminished by the sheer multiplicity of copies, which could be placed and viewed in a variety of previously unforeseen situations. Severed from tradition and cult practices, original works of art now took on a new status as objects to be exhibited and, of course, bought and sold. Moreover, not only were works of art shown to be subject to market conditions like other commodities, but new works were now designed specifically *for* reproduction, so that for these works at least, questions of authenticity became increasingly irrelevant.

This situation gave rise to the phenomenon now known as kitsch. Yet even in the nineteenth century art of this kind was recognized as posing a serious threat to the continued existence of authentic art. Just as Mallarmé denounced the infiltration of journalistic style into the domain of literature proper, many nineteenth-century artists rejected the slick, "photographic" realism, preoccupation with extra-artistic, literary themes, and sentimentality of official salon painting. In order to reaffirm the authenticity of painting, it became increasingly necessary to emphasize unreproducible formal qualities, and this led to a concern with the purity of the medium

itself. As Thomas Crow and others have pointed out, for the Symbolists and their heirs the purity of modernist art was defined in explicit opposition to the debased forms of mass-produced, popular culture.[1]

Parallel with these developments, one can note a vast rise in the number of individuals professing to be artists and devoting their newfound leisure to painting and drawing. Record numbers of artists began to submit works to the annual Salon des Indépendants in the early years of the twentieth century, a sign that the stigma of having been refused entry to the official salons had been transformed into a mark of distinction or originality. Yet critics observing trends at this time were quick to point out that it was becoming more difficult to make shocking works of art after the recent succession of avant-garde movements. The pace with which avant-garde styles were being absorbed, moreover, had quickened. In 1912 André Salmon described the situation that prevailed when the Fauves first gained attention: "The Pointillists were no longer scandalous; the Salon des Artistes Français was becoming the refuge of an Impressionism tolerated by the moderates as an inoffensive radicalism; Bonnard and Vuillard could only shock certain amateurs from the suburbs, while the others, old readers of the *Revue Blanche,* found their intellectual 'paintings of the countryside' infinitely charming. Things were generally peaceful; one industrialized Cézanne and Gauguin. . . . Had the revolutionaries become bourgeois?"[2]

For Picasso in 1912, this industrialization of Cézannes and Gauguins must have seemed to cast doubt on the prevailing styles of authenticity, which demanded sincerity and an unmediated, spontaneous response to nature but produced so many paintings that looked alike. Metzinger reported in 1910 that the Cubists—he could only

have meant Picasso—"condemned the absurdity of the theoreticians of 'emotion.'"[3] If emotion could be produced and reproduced at will, if spontaneous brushwork and naive *gaucherie* could be manufactured by the most intellectual and sophisticated artists, then clearly the signs of originality were just that: signs. Raynal described Picasso's response to the expressive deformations of the Fauves and of the many followers of the Impressionists in just these terms: "Picasso, his eyes inflamed by the crude deformations that had become more and more unbearable, for after all, if there are indeed to be deformations, not everyone is capable of them, Picasso, I say, soon saw in them only laborious improvisations, far too willful brutalities, painful labors seemingly painted from the imagination, to the point where these endeavours became tiring, and we were not afraid to say it, even in the responsible work of Cézanne."[4] Originality, then, could only be sought elsewhere, in the imaginative reordering of signs, in the gestures of the mind rather than in those of the hand.

Later in life, Picasso was to speak disparagingly of the works he had executed before his Iberian and African periods: "Tout cela, c'est du sentiment."[5] The masklike visages he began to insert into his paintings as early as 1906 and 1907 with no concern for the overall coherence and unity of style reveal a desire to challenge the immediate identification of the personality of the artist with a particular style. With the invention of collage, Picasso would continue to subvert expectations of stylistic unity and to make style a property that might be appropriated and satirized. In this respect, Picasso's Cubism proves to be far more ironic and subversive than that of Braque or Gris, although they shared in the spirit of humor that pervades the works of 1912 to 1914.

Within the development of Cubism, the notion that works of art are constituted by the manipulation of iterable signs rather than from original, unique gestures culminated in collage, a compositional technique that calls attention to the diverse origins of the disparate elements affixed to a particular surface. In a recent essay, Marjorie Perloff described collage as a means of transferring "reference from the impersonal to the personal domain."[6] Yet within the context of early twentieth-century painting, to substitute ready-made elements for the indexical traces of the hand, as Picasso did in his first series of collages, is to demonstrate the impersonal, conventional aspects of personal expression. Moreover, because these elements were drawn from the familiar realm of mass-culture, they provoke a reevaluation of the attempt to found the authenticity of painting on its *difference* from popular cultural artifacts.

Picasso's collages point to the fact that insofar as a work of art is conceived as representational, it depends on the prior existence of a system of signs. Repetition is therefore a constituent factor in visual representation, just as it is in more obviously coded systems such as writing. But to recognize that the signifying elements of painting or sculpture are iterable is to discover a repressed link to the products of mass culture. Picasso made this link explicit by introducing fragments of mass culture into the ostensibly pure and autonomous realms of painting and sculpture, thereby subverting the very founding premises of modernism.

In an essay of 1961, Clement Greenberg proposed this definition of modernism: "The essence of modernism lies, as I see it, in the use of the characteristic methods of a discipline to criticize the discipline itself, not in order to subvert it, but in order to entrench it more firmly in its area of competence."[7] Picasso, for Greenberg, was one of the

major exponents of this critical enterprise. In an essay of 1958, "The Pasted-Paper Revolution" (revised and reprinted in 1959 as "Collage"), Greenberg had described collage as a technique designed to affirm the flatness of the medium of painting.[8] This was of crucial importance for Greenberg because he believed that each medium must emphasize those qualities which pertained to it alone, and flatness served to distinguish painting from sculpture. Indeed, it was a concern with the "fact" of painting's flatness and the inevitable conflict this presupposed with the representation of depth that provided modernist art with its raison d'être. Writing of early Cubism, in which individual planes seemed to fluctuate between a position in illusory depth and one that adhered to the flat picture plane, Greenberg stated, "Painting had to spell out, rather than pretend to deny, the physical fact that it was flat, even though at the same time it had to overcome this proclaimed flatness as an aesthetic fact and continue to report nature."[9] Given this imperative, it is no surprise that Greenberg then interpreted the invention of papier collé as a means of further asserting—in the most literal way—the flatness of the picture plane. The pieces of paper glued to the picture surface cast the other, more unstable and fluctuating aspects of painting or drawing into a semblance of depth behind that plane and, at times, of relief before it. Ultimately in this system of constantly shifting relations between surface and depth, an oppositional structure emerges to which even the collage elements are subject: "Thus every part and plane of the picture keeps changing place in relative depth with every other part and plane; and it is as if the only stable relation left among the different parts of the picture is the ambivalent and ambiguous one that each has with the surface."[10]

Here a curious paradox in Greenberg's line of reasoning should be observed. Having begun by asserting the a priori fact of painting's flatness, Greenberg ends by showing that flatness must be depicted, and that Cubist collages construct flatness out of opposing elements which prove to be interchangeable: "Flatness may now monopolize everything, but it is a flatness become so ambiguous and expanded as to turn into illusion itself—at least an optical if not, properly speaking, a pictorial illusion. Depicted, Cubist flatness is now almost completely assimilated to the literal, undepicted kind, but at the same time it reacts upon and largely transforms the undepicted kind—and it does so, moreover, without depriving the latter of its literalness; rather, it underpins and reinforces that literalness, re-creates it."[11]

If flatness must be "depicted" and "re-created," however, it is no longer one of the given properties of a medium. The immediate perceptible presence of flatness itself turns out to be founded on illusion. Thus in the end, Greenberg's sophisticated formal analyses undermine his initial premises, although he does not acknowledge this.

Paradoxically, Picasso and Braque seem to have followed a line of reasoning similar to that of Greenberg, although they were bolder in pursuing its consequences. Cubist paintings of 1910 to 1912 *do* exhibit a play of contradictory clues regarding the position of any single plane in relation to the surface on which it is depicted. By 1912, however, the realization that flatness must be depicted or signified meant that it could no longer be considered an a priori constituent of painting, and the distinction between painting and sculpture thereby came to seem arbitrary. Curiously, Greenberg noted that Picasso's constructions, made by folding "pictorial" planes of paper in space, founded a new genre of sculpture in which "there clung only the vestige of a picture plane. The affixed elements of

collage were extruded, as it were, and cut off from the literal pictorial surface to form a bas-relief."[12] There was little further commentary on this development except to say that "though construction-sculpture was freed long ago from strict bas-relief frontality, it has continued to be marked by its pictorial origins."[13] Clearly Greenberg was reluctant to acknowledge that in Picasso's constructions the formal distinctions between painting and sculpture have been undermined. His emphasis on flatness had been intended, after all, to preclude such an erosion of limits. The innovations of Cubism, and of Picasso's Cubism especially, must be claimed for modernism, and Greenberg's criticism provided a framework in which this could be accomplished.

Contemporary criticism, drawing many of its insights from postmodernist theories of representation, has been much more alert to the subversive rather than affirmative function of collage. Rosalind Krauss, as noted earlier, interprets the invention of collage as an effort to render the immediate presence of the ground problematic by masking it and rendering it absent to vision.[14] The pasted element, a flat, bounded plane, then functions to represent the delimited flatness of the ground itself in the form of a depiction. Rather than suggest a formal coherence of figure and ground, then, Cubist collage planes emphasize the difference between two structurally similar representational fields. The constant oscillation of figure and ground in Cubist collage reveals a refusal to determine or fix this relation, which is the basis of classical representation.

Picasso and Braque, however, were not inspired to "use a little dust against our horrible canvas"[15] merely in order to undermine it as a ground or origin. Their attack on modernist purity and autonomy was the result of a broader challenge to the mythical aura of painting and sculpture and to the notion that these media constituted eternal forms of expression devoted to the revelation of truth, whether of the object represented or of the work of art as object. Everywhere that the modernist tradition sought a sense of necessity or certainty, the Cubists substituted the ambiguous fragment, the formal paradox, the opposition of conflicting signs. The homogeneous, unified field of representation was thereby ruptured and opened to a different process of cultural exchange, one in which the signs of the fine arts and those of popular culture proved to be of equal value.

In taking up the practice of collage, the Futurists were inspired by a similar desire to subvert existing categories and to create open sites where a variety of verbal and visual elements might be brought together. Whereas the Cubists emphasized paradox and uncertainty, however, the Futurists sought to create synthetic forms and a new perceptual unity. Their goal was to convey their sensations with the greatest possible immediacy. If verbal texts were included in their collages, it was not in order to suggest that the signs of the visual arts were ultimately as conventional as those of writing. On the contrary, they advocated the use of onomatopoeia and expressive typography in order to overcome the arbitrariness of writing. The innovations of parole in libertà were conceived as a means of motivating language, of giving it greater empathetic force by achieving a greater coherence of form and content. Early critics such as Kahnweiler called attention to the conventional aspects of Cubist form, comparing it to the forms of writing. Marinetti, in contrast, conceived his poetry as approximating the immediacy of voice and whenever possible emphasized the attendant performative aspects of dramatic delivery and gesture. Ideally, the spectator would be projected into the center of the work, where he or she would relive

the artist's own experience, thereby dissolving perceived boundaries between the self and the world of matter. Like the ephemeral signs of voice, the physical qualities of Futurist works of art were intended to disappear in the heightened moment of experience.

Despite this emphasis on immediacy, the Futurists devoted considerable time to studying the empathetic effects of forms, colors, and materials in order to discover universal laws of expression. As the laws regulating these formal and material properties were eventually codified and described in various manifestos, they took on the character of conventional signs to which specific meanings might be attributed; we know that an acute angle denotes dynamism, just as we know that "Zang Tumb Tumb" refers to the sound of exploding cannons. There is therefore a recurring tension in their production, between the desire for an absolute origin in immediately perceived sensations, conveyed through spontaneous gestures, and an equally strong desire to formulate laws and to base their work on a language of established signs. The syntax banished by Marinetti's invention of parole in libertà thereby returns in the guise of universal laws of poetic and visual expression.

A similar tension can be found in the Futurists' relation to the past. Tradition is denounced at every opportunity, but at the same time the Futurists took care to rewrite the history of art so that their own work appears as the dialectical culmination of an avant-garde tradition stemming from French Impressionism, and including the Symbolists, Fauves, and Cubists.[16] In spite of the evident nationalistic and cultural biases of constructing such a lineage, there is some justice in the Futurists' claims to be the heirs of Manet and the Impressionists. For if the modernist tradition, beginning with these artists, is defined as an effort to recover a childlike naiveté and spontaneity in the expression of sensations, then the Futurists take their rightful place within it. But if modernism is defined as an effort to preserve the purity and autonomy of the medium, then the collages of the Futurists, like those of the Cubists, must be interpreted as posing a critique of its premises. In the development of both Cubism and Futurism, the invention and elaboration of collage marks the decisive moment of rupture with the past, when the autonomy of painting gave way to a vast array of new signifying practices. More important than the relation to past, then, is the relation to the future.

The years that followed the invention of collage witnessed one of the most astonishing revolutions in the history of art. Artists as different as Marcel Duchamp, Vladimir Tatlin, Jean Arp, John Heartfield, Kurt Schwitters, Hannah Höch, Max Ernst, Joseph Cornell, Louise Nevelson, Jasper Johns, Robert Rauschenberg, Betye Saar, Barbara Kruger, and Mary Kelly have made collage, photomontage, and assemblage an integral part of their art-making process. The coexistence of images, words, and objects is now a familiar feature of twentieth-century art one we sometimes take for granted. But the freedom to mix materials and media to emphasize abrupt juxtapositions and discontinuities, to give works of art an ephemeral life, to explore the possibilities of kineticism and viewer interaction, and to invent new media stems from the initial innovations of the Cubists and Futurists. In retrospect we can see that the invention of collage, scarcely noted in the critical literature of its time, founded an alternative to the modernist tradition in twentieth-century art. This alternative tradition continues to challenge the values and premises of modernism, even as the conditions of mechanical reproduction and of a commodity culture continue to affect our lives.

Notes

Preface

1. "Il est curieux que presque personne n'ait semblé prendre garde à une occupation singulière, dont les conséquences ne sont pas encore toutes appréciables, à laquelle certains hommes se sont livrés ces temps-ci d'une façon systématique qui rappelle plus les opérations de la magie que celles de la peinture. Outre qu'elle met en question la personnalité, le talent, la propriété artistique, et toutes sortes d'autres idées qui chauffaient sans méfiance leurs pieds tranquilles dans les cervelles crétinisées. Je veux parler de ce qu'on appelle pour simplifier *le collage*, bien que l'emploie de la colle ne soit qu'une des caractéristiques de cette opération, et même pas une caractéristique essentielle. Sans doute que ce sujet avait en soi quelque chose qui effrayait les esprits, car, dans toute la critique volumineuse consacrée depuis sa naissance au cubisme, par exemple, on ne trouve que quelques mots superficiels pour noter l'existence des papiers collés, comme on disait d'abord, pour désigner cette première apparition du collage par laquelle se révèle l'inquiétude de Braque et de Picasso dès 1911. . . . Pour mieux comprendre ce qui s'est produit depuis bientôt vingt années, il nous faudra donc, suivant de préférence la démarche historique, commencer par parler du papier collé tel qu'il apparut à sa naissance." "La peinture au défi" (preface to a catalogue for an exhibition of collages at the Galerie Goemans in Paris, March 1930; repr. in *Les Collages*, 44–45).

2. There is some evidence that Braque was making sculpture out of paper as early as 1911, but none of these works has survived.

3. "Je ne ai trouvé 'La Voce' que ici et je ai lue avec emotion votre article [*sic*]." Letter from Picasso to Soffici on 12 September 1911. On 9 November 1911 Picasso wrote to Soffici to request additional copies of *La Voce*. Cited in *5 Xilografie e 4 Puntesecche di Ardengo Soffici con le lettere di Picasso*, ed. Luigi Cavallo (Milan: Giorgio Upiglio, Edizioni d'Arte Grafica Uno, 1966), 50–51; partial reproduction of the French letters and full Italian translations in Luigi Cavallo, *Soffici: Immagini e documenti (1879–1964)*, 130.

4. Letter from Marinetti to Severini dated 20 November 1914, repr. in *Archivi del Futurismo*, 1:350.

5. This is the title of a manifesto written by Giacomo Balla and Fortunato Depero, originally published as a leaflet dated 11 March 1915, repr. in Umbro Apollonio, *Futurist Manifestos*, 197–200.

Chapter 1. The Invention of Collage

1. This collage was executed some time before 18 May 1912, the date of Picasso's departure for Sorgues with his new mistress, Eva Gouel (Marcelle Humbert). In a letter to Kahnweiler dated 5 June 1912, Picasso provided his dealer with a list of the works that he might remove from his apartment in Paris. He specifically excluded the *Still Life with Chair-Caning* and a related work which also has a rope frame, *Still Life: "Notre Avenir est dans l'Air"* (fig. 16). For a partial reproduction of this letter, see *Donation Louise et Michel Leiris, Collection Kahnweiler-Leiris*, ex. cat. (Paris: Centre Georges Pompidou, Musée national d'art moderne, 22 November 1984—28 January 1985), 166–68.

2. In an article of 1932, certainly based on conversations with the artist, Christian Zervos states that Braque began making paper sculptures in 1911. See "Georges Braque et le développement du cubisme," 23.

3. William Rubin has published this letter as evidence that Braque was making paper sculptures for some time before September 1912. He also cites a text by Jean Paulhan of 1939–45, in which Braque specifically says that the "scaffoldings" of his paper sculptures reminded Picasso of Wilbur Wright's biplanes, leading him to nickname Braque "Wilbourg" by the spring of 1912. See "Picasso and Braque: An Introduction," in *Picasso and Braque: Pioneering Cubism*, 1: 32–34, 380.

4. "De 1911 datent aussi les premières sculptures en papier imaginées par Braque et bientôt abandonnées par lui car il n'y voyait qu'une expérience pour enrichir et organiser sa peinture." Zervos, "Georges Braque et le développement du cubisme," 23. This statement probably reflects Braque's own views on the role of his paper sculptures.

5. See Douglas Cooper, "Braque as Innovator: The First *Papier Collé*," in *Braque, The Papiers Collés*, ex. cat. (Washington, D.C.: National Gallery of Art, 1982), 19 This catalogue was initially published in French as *Georges Braque, les papiers collés*, ex. cat. (Paris: Centre Georges Pompidou, Musée national d'art moderne, 17 June—September 1982). Further references to the essays in this catalogue will be cited in the French or English version depending on the original language of the essay quoted. A similar version of this story appears in André Verdet, *Entretiens, notes et écrits sur la peinture*, 22–24.

6. This collage, now lost, is probably contemporaneous with the *Still Life with Chair-Caning*. Apollinaire mentions Picasso's use of a "timbre-poste veritable" in a section of *Les peintres cubistes*, written during the spring of 1912. The

stamp, which bears the image of Victor Emmanuel III, had been mailed from Italy. Because the cancellation mark reads "FIRE[ENZE]," Joan Rosselet speculates that it may have been sent to Picasso by Ardengo Soffici. See Pierre Daix and Joan Rosselet, *Le Cubisme de Picasso*, 272, no. 451.

7. In a 1913 version of this theme titled *Fruitdish and Cards* (R 151), Braque retranslated his first papier collé into painting, even copying the dark parallel stripes that simulate the separation of wood panels in the wallpaper. Here the wood grain's primary reference is not to wood, but to a prior work of art.

8. Of course, for Picasso, the stamp and oilcloth are already constituted as signs and do not mark a return to reality, as has sometimes been thought. Nonetheless, there is a difference between using a stamp to signify a stamp, and Picasso's later use of a wood grain pattern to signify hair and a moustache in *The Poet*. The example of the oilcloth with imitation chair-caning is already more ambiguous, since it remains uncertain whether it signifies real chair-caning (through metaphoric resemblance) or oilcloth (through metonymy).

9. "Mon cher ami Braque, je emploie tes derniers procédés paperistiques et pusiereux. Je suis en train de imaginer une guitare et je emploie un peu de pusière contre notre orrible toile [sic]." The full text of this letter was published for the first time in Isabelle Monod-Fontaine, "Braque, la lenteur de la peinture," in *Georges Braque, les papiers collés*, 40.

10. Picasso's interest in alternate grounds can be seen in the fall of 1912 in *Violin and Newspaper* (fig. 52), which is executed on glass and includes areas of sand. We also know that during the summer in Sorgues, Picasso painted what he called a fresco directly on the wall of the living room of his rented villa (D / R 486). This necessitated its later removal in order to preserve it and the payment of damages for "deterioration of the paper" to the owner of the villa. See Rubin, "Picasso and Braque: An Introduction," 404.

11. Rosalind Krauss was the first to call attention to the way in which Picasso's collage elements mask and re-present the ground, thereby founding representation on the absence of the material referent. See "In the Name of Picasso."

12. This became apparent as a result of Pierre Daix's research for the new edition of the catalogue raisonné of Picasso's cubist years: *Le Cubisme de Picasso*. For Daix's dating of Picasso's collages into three distinct series, see

"Des Bouleversements chronologiques dans la révolution des papiers collés (1912–1914)," 217–27, and "Les trois séjours 'cubistes' de Picasso à Céret (1911–1912–1913)," n.p.

13. *Tutta la vita di un pittore*, 91, 146.

14. Yve-Alain Bois has observed that Picasso abandoned a unitary system of notation in several works executed during the spring of 1912, introducing emblematic, unfragmented signs and areas of flat local color into otherwise homogeneous canvases. He argues that this acceptance of heterogeneity led directly to the *Still Life with Chair-Caning*, which dates from the same period. See "The Semiology of Cubism."

15. The green and pink areas are painted in Ripolin, while the yellow area appears to be oil. I am grateful to Benjamin Buchloh for his insightful comments on the role of color in Cubism and on Picasso's use of Ripolin enamel in *Landscape with Posters* in particular.

16. "Je voyais combien la couleur dépend de la matière. Prenez un example: trempez deux tissus blancs, mais de matière différente dans la même teinture, leur couleur sera différente." "Braque, la peinture et nous" [Propos de l'artiste receuillis par Dora Vallier], 17.

17. "On change son fusil d'épaule." Cited in Severini, *Tutta la vita di un pittore*, 141.

18. "La mise au point de la couleur est arrivée avec les papiers collés. C'est un fait que la critique n'a jamais bien compris. Là on est arrivé à dissocier nettement la couleur de la forme et à voir son indépendance par rapport à la forme, car c'était ça la grande affaire: la couleur agit simultanément avec la forme, mais n'a rien à faire avec elle." "La peinture et nous," 17.

19. "L'Exposition de la Section d'Or," *La Section d'Or* (Paris, 9 October 1912), in Fry, *Cubism*, 100. This is one of the first published essays to discuss a collage.

20. Raynal and Gris had been close friends for several years by 1912 and undoubtedly discussed the ideas that inspired Gris's most recent innovations. Unlike Picasso, who generally limited his explanations to witty aphorisms or sheer sarcasm, Gris seems to have enjoyed theorizing about his art.

21. "Pour bien indiquer que dans sa conception de la peinture pure il existe des objets absolument antipicturaux, il n'a pas hésité à en coller plusieurs véritables sur la toile. Les surfaces planes ne peuvent, en effet, être peintes, puisqu'elles ne sont pas des corps; si on le fait nous retombons dans l'imitation ou dans la recherche de l'habilité

qui spécialise les peintres d'enseignes. Si je conçois un fla-
con et que je veuille le traduire tel quel, l'étiquette qui le
couvre ne m'apparaît que comme un accessoire néglige-
able que je pourrais omettre, car il n'est qu'une image. Ce-
pendant si je tiens à la faire figurer, je pourrais la copier
exactement, mais c'est un travail inutile, aussi bien je pose
la véritable étiquette sur le tableau après l'avoir cependant
découpée suivant la forme que j'ai donnée au flacon, ce
qui constituera le point délicat le plus important de l'idée
et qui en déterminera le charme. Juan Gris a appliqué le
même principe à la glace qu'il a posé sur sa toile. Ce fait a
amené bien des discussions, mais on peut dire qu'il ne nuit
en rien à l'oeuvre et qu'il dénote l'originalité curieuse de
l'imagination de Juan Gris." "L'Exposition de La Section
d'Or," in Fry, *Cubism,* 100. I would like to thank Edward Fry
for sending me a photocopy of this rare journal as well as
a photocopy of the catalogue of the *Section d'Or*
exhibition.

22. Daniel-Henry Kahnweiler, *Juan Gris, His Life and Work,*
trans. Douglas Cooper, 87–88.

23. While in Paris Boccioni stayed in Severini's studio,
which was located just below that of Braque at 5 Impasse
de Guelma.

24. "In questi giorni sono ossessionato dalla scultura!
Credo di aver visto una completa rinnovazione di quest'-
arte mummificata." Letter from Umberto Boccioni to Vico
Baer, in *Archivi del futurismo,* 2: 43, ed. Maria Drudi Gam-
billo and Teresa Fiori.

25. See "Technical Manifesto of Futurist Sculpture," in
Apollonio, *Futurist Manifestos,* 51–65.

26. A few of these were exhibited in the Salon d'Automne in
1912, although they are not identified.

27. *Tutta la vita di un pittore,* 174–75.

28. See Papini, "Il Cerchio si chiude," *Lacerba* (15 February
1914), Boccioni, "Il Cerchio non si chiude," *Lacerba* (1
March 1914), and Papini, "Cerchi aperti," *Lacerba* (15
March 1914), repr. in *Archivi del futurismo,* 1:189–96.

29. See Patricia Leighten, "Picasso's Collages and the
Threat of War, 1912–13," 643–72, and *Re-Ordering the Uni-
verse: Picasso and Anarchism, 1897–1914,* esp. chap. 5.

30. "Mon cher ami. Donnez nous des vos nouvelles. Com-
ment vas tu? Nous sommes en guerre en France depuis le
moi d'Aout ets ce que vous etes en guerre ausi en Italie? Je
voudrais que tout ça soit fini quand je pense à mes ami et
à moi ausi. [sic]

Bien à toi mon cher ami mon cher ami et vive la France.
Picasso." Reproduced in Luigi Cavallo, *Soffici: Immagini e
documenti 1879–1964,* 244.

31. After his return to Paris from Avignon in late October
or early November 1914, Picasso executed only three con-
structions which are tentatively dated to autumn 1915 (see
D / R 833, D / R 834 and D / R 835). The only collage ele-
ment he continued to use at this time in his oil paintings
was sand.

32. I am grateful to Massimo Carrà for identifying the sub-
ject of this news photo for me.

33. "Mais on ne peut pas le faire seul, il faut être avec
d'autres. . . . Il faut un travail d'équipe." Daniel-Henry
Kahnweiler, "Huit Entretiens avec Picasso [3 July 1952],"
30.

Chapter 2. Picasso's Earliest Constructions and Collages

1. Picasso made a statement to this effect to William Rubin
on the occasion of his donation of a reconstructed sheet
metal *Guitar* to the Museum of Modern Art in 1971. Origi-
nally, Rubin took this to mean before the collage *Still Life
with Chair-Caning* of May 1912, and he therefore dated the
Guitar to early 1912. See *Picasso in the Collection of the
Museum of Modern Art,* 74, 207. This dating was challenged
both by Edward F. Fry and Yve-Alain Bois, who pointed to
the morphological similarities between the *Guitar* and the
papiers collés Picasso executed in the fall of 1912 as well
as to the important role played by the Grebo mask Picasso
seems to have purchased in Marseilles in August. See Ed-
ward F. Fry, "Review of Daix and Rosselet, *Le Cubisme de
Picasso,*" 91–99, and "Picasso, Cubism, and Reflexivity,"
296–310, and Yve-Alain Bois, "Kahnweiler's Lesson," 33–68.
Rubin now believes that Picasso was referring to his first
series of collages, executed in the fall of 1912, when he
stated that the *Guitar* predated his first collages (or pa-
piers collés). For this discussion and an analysis of the re-
lationship of the *Guitar* to the papiers collés of the fall
1912 as well as to Braque's experiments with paper sculp-
tures, see Rubin, "Picasso and Braque: An Introduction,"
Picasso and Braque: Pioneering Cubism.

2. Published in Isabelle Monod-Fontaine, "Braque, la len-
teur de la peinture," 40. See chapter 1, note 9 for the
French text.

3. William Rubin discusses the letter of 9 October 1912 in
relation to the date of the *Guitar* in "Picasso and Braque:
An Introduction," 31–32. I find his reasoning convincing
and have followed it closely here.

4. See Bois, "Kahnweiler's Lesson," 42–44. Rubin accepted
and elaborated upon the consequences of the new chro-
nology in "Picasso and Braque: An Introduction," 30–35.

5. "The Pasted-Paper Revolution," repr. as "Collage" in *Art
and Culture,* 79. Bois cites this passage and discusses its
implications in "Kahnweiler's Lesson," 42–44.

6. Ibid., 43.

7. Bois does discuss the importance of Picasso's work at
Cadaqués during the summer of 1910 for his subsequent
understanding of the Grebo mask. In particular, he empha-
sizes the dissociation of chiaroscuro from its function as
modeling, so that volume is no longer conceived in terms
of solid mass. See ibid., 45, and "The Semiology of Cub-
ism." My own view is that Picasso's work from this period
not only dissociates volume from mass, but does so
through a relational and arbitrary use of the conventions
of illusion: chiaroscuro and perspective.

8. These oppositions will be discussed more fully in the following chapter.

9. Despite his emphasis on the "inaugural character" of the *Guitar* in relation to the works that followed, Bois has devoted considerable attention to analyzing the path Picasso followed to arrive at that point of departure. Many of the precedents he cites in "The Semiology of Cubism" will be discussed here as well. Although there are some differences in our views, my interpretation is indebted to his.

10. In conversation with the author, October 1989. Steinberg made the same observation in a lecture titled "The Intelligence of Picasso," delivered at Johns Hopkins University on 19 November 1989.

11. Leo Steinberg was the first scholar to call attention to the principle of stylistic multiplicity in Picasso's work and to analyze the important role it plays in *Les Demoiselles d'Avignon.* See "The Philosophical Brothel."

12. William Rubin has discussed the opposition of the two halves of this painting in "From Narrative to 'Iconic' in Picasso: The Buried Allegory in *Bread and Fruitdish on a Table* and the Role of *Les Demoiselles d'Avignon.*"

13. Benjamin, *The Origin of German Tragic Drama,* 177–82.

14. The term *ostranenie,* usually translated as "estrangement," was first used by Victor Shklovsky in his seminal article of 1917, "Art as Technique," to describe techniques for "laying bare the device" in art or literature. Repr. in Lee T. Lemon and Marion J. Reis, eds., *Russian Formalist Criticism: Four Essays* (Lincoln: University of Nebraska Press, 1965), 3–24. The relevance of this concept to an analysis of Cubist formal devices is discussed by Bois in "The Semiology of Cubism."

15. Kahnweiler interpreted the deeply gouged forms in the bronze *Head of a Woman* as a means of making the figure independent of ambient light by giving it its own internal shadows. This might be compared to the way Picasso sought to disengage shadow from a particular source of light in his contemporary painting. See "Negro Art and Cubism," 416. In 1914 Picasso would again transfer pictorial conventions to sculpture when he applied areas of pointillist patterning and dark "outlining" to the surfaces of his six bronze "Absinthe glasses." Here these displaced pictorial effects are perhaps even more comic.

16. Of course, in a very real sense, there is never a first time with Picasso, as Leo Steinberg and others have noted; one can always find an earlier example. Nonetheless, *Still Life with Chair-Caning* is usually regarded as the first deliberately executed collage.

17. For a discussion of the *bricoleur* in primitive societies, see Claude Lévi-Strauss, *The Savage Mind,* 16–33.

18. "Marcelle est très gentille et je l'aime beaucoup et je le écrirais sur mes tableaux." Cited in *Donation Louise et Michel Leiris, Collection Kahnweiler-Leiris,* 168. In several earlier works of 1912 Picasso had merely printed or stenciled the words "Ma Jolie" to his canvases. This was a less overt means of referring to his new love, since these words were part of the refrain of a popular song by Fragson.

19. The evidence that the collage element was a piece of gingerbread comes from the testimony of Kahnweiler. See Daix and Rosselet, *Le Cubisme de Picasso,* 282, no. 485. When one views the photograph, it is difficult to ascertain whether the heart was in fact gingerbread or paper cut to signify gingerbread. The fact that the collage element has disappeared lends credence to the former view. Picasso probably bought the gingerbread heart at a "foire aux pains d'épice" in Céret or Sorgues and may have had it inscribed by the vendor. If so, this would further contribute to the popular, clichéd value of the sentiments expressed, however heartfelt they were.

20. During this summer, Picasso also frequently signed his letters "artiste-peintre" or simply "AP," possibly another humorous reference to Rousseau, who had signed the invitations to his evenings in this manner.

21. "Huit entretiens avec Picasso," 22. Kahnweiler also refers to this experiment in "Negro Art and Cubism," 416.

22. In "Negro Art and Cubism" Kahnweiler states that Picasso introduced light relief in this work in order to "avoid the *simulated* shadow." Ibid., 416.

23. Postcard from Braque to Kahnweiler, dated 11 August 1912: "Après avoir acheté tous les nègres, et fait visiter la ville à Picasso, je retourne à Sorgues où je m'installe." Cited in *Georges Braque, les papiers collés,* 180.

24. "Nous avons acheté des nègres à Marseille j'ai acheté un masque très bien et une femme avec des grands nichons et un jeune nègre." (We bought African objects in Marseilles I bought a very fine mask and a woman with big tits and a young black man). Cited in *Daniel-Henry Kahnweiler, marchand, éditeur, écrivain,* ex. cat. (Paris: Centre Georges Pompidou, 1984), 112.

25. Edward F. Fry has argued that these drawings from the Sorgues sketchbook, which follow *Souvenir de Marseille,* record Picasso's first response to the Grebo mask. His argument is based on a convincing analysis of the order of the drawings in the sketchbook (inverted and from back to front), which allows the sequence of the drawings and the developing logic of Picasso's response to the Grebo mask to become clear. See "Picasso, Cubism, and Reflexivity," 300, and Appendix I, 307–09.

26. Unlike most of Picasso's drawings from this period, here there are no contradictory or ambiguous spatial relations.

27. "Je travaille bien et je profite de mon séjour à la campagne pour des choses que l'on ne peut pas faire à Paris entre autres choses de la sculpture en papier. Ce qui ma donné beaucoup de satisfaction." Cited in *Donation Louise et Michel Leiris, Collection Kahnweiler-Leiris,* 27. This letter is undated, but William Rubin has suggested a date of on or after 24 August. See "Picasso and Braque: An Introduction," 32, 57, n. 61.

28. Picasso had already dramatically distorted the shape and placement of the ear in a number of figural drawings related to *Les Demoiselles d'Avignon* (D / R 47). *Head of a Man* (D / R 44) of spring 1907 exemplifies the peculiar treatment of the ear in these works, which derived from Picasso's study of Iberian sculpture in 1906–07. In 1912, however, a similarly conceptual depiction of the ear may have had another source as well—the portraits of Henri Rousseau. Rousseau had made a practice of depicting the majority of his subjects with a single, prominent ear in order to suggest that the figure had been rendered from a three-quarter view, even when the figure was in fact seen from a fully frontal point of view. This ear, however, was always brought emphatically forward, as if flattened against the picture plane, in a gesture that denied any possibility of rotation in space. (On those rare occasions when a full-face view was intended, Rousseau would give his figure two characteristically flattened ears, placed symmetrically on each side of the head.) A notable example of this convention occurs in Rousseau's *Portrait of a Woman* of circa 1895, which Picasso had bought for five francs from Père Soulier's curio shop in 1908. Picasso later recalled that this painting, which had initially attracted his attention because of the "stony look" on the woman's face, "took hold of [him] with the force of obsession." Cited in Roger Shattuck, *The Banquet Years,* 66. Another example, in which the shape of the single ear more closely resembles the double arc typical of Picasso's works, can be found in the *Portrait of Pierre Loti* of circa 1891.

29. Edward F. Fry has argued that, "for Picasso, the pictorial equivalent of the Grebo mask was Braque's first *papier collé,* of September 1912. . . . Whether deliberate or not, this uncoupling of form from color and outline was the pictorial equivalent of the disassociation of mass from volume in a Grebo mask." See "Picasso, Cubism, and Reflexivity," 300.

30. For a discussion of the significance of surface as the expression of a logically defined inner core in traditional sculpture, see Rosalind E. Krauss, *Passages in Modern Sculpture,* chap. 1.

31. Edward F. Fry has argued that comparative measurements of the cardboard and sheet metal versions indicate that the cardboard *Guitar* served as a maquette for the metal *Guitar.* He believes the metal *Guitar* may have been assembled as late as 1914 in the artist's new studio in the rue Schoelcher at a time when he also made a second construction out of sheet metal (D / R 835). See "Picasso, Cubism, and Reflexivity," 305, n. 24.

32. "Nous cherchions à exprimer la réalité avec des matériaux que nous ne savions pas manier, et que nous apprecions précisément parce que nous savions que leur aide ne nous était pas indispensable, et qu'ils n'étaient ni les meilleurs, ni les mieux adaptés." Cited in Jaime Sabartés, *Picasso: portraits et souvenirs,* 212; cited in translation in Dore Ashton, ed., *Picasso on Art: A Selection of His Views,* 60. The term *reality* in this statement should not be understood unequivocally, since in numerous other statements the artist emphasized the nonrealism of Cubism. Del Pomar, e.g., records the following statement by Picasso: "The goal I proposed myself in making cubism? To paint and nothing more. And to paint seeking a new expression, divested of useless realism, with a method linked only to my thought—without enslaving myself or associating myself with objective reality." Cited in ibid., 59–60.

33. Kahnweiler, *The Rise of Cubism,* 10. "Picasso hat die geschlossene Form durchbrochen." *Der Weg zum Kubismus,* 49.

34. Kahnweiler, *The Rise of Cubism,* 10–11.

35. Ibid. Kahnweiler, who was firmly convinced that Cubism was an art of realism, believed that Picasso and Braque were anxious to avoid perspective and chiaroscuro because they led to the distortion of the true form and the true local color of objects. This is far more plausible in the case of Braque than Picasso. When Braque did introduce color into his early collages, it was with a view toward signifying the uninflected local color of an object, hence the faux bois paper. Picasso, who first attempted to reintroduce color into his painting in 1910, seems not to have been concerned with true local color. The color he introduced into some these canvases—later painted out—was shocking pink. The colors in his collages, as discussed above, was usually arbitrary with respect to the represented objects.

36. Ibid., 11. "Einerseits gestattete Picassos neue Methode, die Körperlichkeit der Dinge und ihre Lage im Raume 'darzustellen', anstatt sie durch illusionistische Mittel vorzutäuchen. Es handelt sich um eine Darstellungsweise, die mit der geometrischen Zeichnung eine gewisse Ähnlichkeit hat, wenn es sich darum handelt, einen Körper darzustellen. Das ist selbstverständlich; haben doch beide als Ziel die Darstellung, auf der zweidimensionalen Fläche, der dreidimensionalen Körper." *Der Weg zum Kubismus,* 50.

37. Kahnweiler, *The Rise of Cubism,* 11. "Der Maler beschränkt sich ferner nicht darauf, den Gegenstand so zu zeigen, wie er von einem gegebenen Standpunkte aus gesehen würde, sondern stellt ihn, wenn das zur Anschaulichmachung nötig ist, von mehreren Seiten dar, von oben, von unten." *Der Weg zum Kubismus,* 50.

38. This, of course, had already been a long-standing practice in Picasso's work. In the *Portrait of Wilhelm Uhde* (D / R 338) from this period, Picasso juxtaposed frontal and side views of the two eyes, but this is another example of a formal opposition, rather than an attempt to convey more information about the sitter. The figure is otherwise depicted from a strictly frontal point of view.

39. Picasso himself pointed out the presence of these figures in the background of his portrait of Kahnweiler to John Richardson. See *Picasso: An American Tribute,* ex. cat. (New York: Public Education Association, 1962), n.p. William Rubin also discusses this in "Picasso," in *"Primitivism" in Twentieth Century Art,* 1:310.

40. Kahnweiler, *The Rise of Cubism,* 16.

41. "Negro Art and Cubism," 418–20. William Rubin has pointed out that the Ivory Coast Wobé mask Kahnweiler referred to was in fact a Grebo mask in "Modernist Primitivism: An Introduction," in *"Primitivism" in Twentieth Century Art,* 18.

42. "Modernist Primitivism," 18–19.

43. In Grebo masks, this plane is typically slightly concave, another reversal of a natural relationship. Picasso retained this slight curvature in the ground plane of his sheet metal *Guitar.*

44. The first critic to draw a parallel between Cubism and Saussure's linguistics was Pierre Dufour in a remarkably intelligent and too little known article: "Actualité de cubisme," *Critique* 25, nos. 267–68 (August-September 1969): 809–25. Dufour called attention to the Cubists' discovery of "the arbitrariness of forms" (813), which led to the destruction of traditional images and their implied "presence" in the Derridean sense (817). The result was an elaboration of "the practically limitless possibilities of a *painting of difference,* founded on deliberate gaps between the sign and the thing signified" (818). Jean Laude elaborated on Dufour's ideas, noting in particular the Russian formalists' interpretation of Cubism as an art concerned with the relations between signs. See "Picasso et Braque, 1910–1914: La transformation des signes," 7–28. Although Laude mentioned Saussure and supported Dufour's notion of the disjunction between the signifier and the signified, he did not directly discuss the important concept of the arbitrariness of pictorial forms. For the most part, the analyses of Dufour and Laude remained at the level of theory, and they did not produce readings of individual Cubist works. Pierre Daix also referred to the Saussurian model in his catalogue raisonné *Le cubisme de Picasso* (1979). Like Laude, his understanding of the sign is as much indebted to Claude Lévi-Strauss as it is to Saussure.

The first art historian to articulate the similarities between Saussure's linguistics and the specific formal structure of Picasso's Cubist works was Leo Steinberg. He has argued that the notion of the arbitrariness of the sign is a heuristic model that accounts for Picasso's treatment of the third dimension (which must necessarily be subject to semiotic transformation, since the pictorial ground is flat). Unfortunately, Steinberg's ideas have remained unpublished to date. He first gave a lecture on the Picasso / Saussure parallel at the American Academy in Rome in March 1976, followed by another lecture on 11 May at the Petit Palais in Paris. There have been many subsequent reworkings of these ideas, including a lecture delivered at the Guggenheim Museum in New York in November 1985. Steinberg credits Rosalind Krauss with the suggestion that he read Saussure sometime in 1974 or 1975, although she did not at that time posit any direct connection between Picasso and Saussure. (Letter to the author, 23 December

1985). Krauss subsequently published her own interpretation of the relation between Saussure's theories and Picasso's collages in two articles: "Re-Presenting Picasso," and "In the Name of Picasso." Yve-Alain Bois has made the most recent contributions to this literature. See "Kahnweiler's Lesson" and "The Semiology of Cubism."

45. Saussure's theories were published posthumously in 1916 when a group of his students at the University of Geneva collated their notes from his "Course in General Linguistics," supplementing them with the few outlines and notes in Saussure's own hand that were discovered after his death. Saussure taught the course three times between 1906 and 1911, and the published version represents a synthesis of all three. Before accepting a post at the University of Geneva, Saussure had taught comparative grammar in Paris at the École des hautes études from 1881 to 1891. Hans Aarsleff has argued that Saussure's theories are indebted to late nineteenth-century intellectual currents in France, especially Hippolyte Taine's influential theories on the concept of *valeur,* and his belief that sensation does not reveal substances, but only a system of signs. See "Taine and Saussure," in *From Locke to Saussure: Essays on the Study of Language and Intellectual History,* 356–71. One can speculate that Picasso might also have been aware of these ideas.

46. Ferdinand de Saussure, *Course in General Linguistics,* 117.

47. Ibid., 120.

48. See "Kahnweiler's Lesson," 52–55.

49. Bois has discussed Picasso's exploration of the minimum condition of iconicity for a signifier to remain legible in "The Semiology of Cubism."

50. Nicolas Deniker, a friend of Apollinaire, was one of the poets associated with Picasso's circle.

51. Fernande Olivier, *Picasso and His Friends,* 175.

52. "La ressemblance, fort négligée sur cette toile au profit des volumes, frappa tout aussitôt les peintres, et ils firent la remarque que les boutons dorés de la tunique de frère de Max n'étaient point représentés à leur place ordinaire, mais disposés en auréole autour de son visage. Découverte surprenante! La dissociation des objets était trouvée, admise, acquise, et cela dut inspirer Picasso dans ses toutes premières recherches, car il décréta peu après: 'Si tu peins un portrait, tu mets les jambes à côté sur la toile.'" Francis Carco, *De Montmartre au Quartier Latin,* 35.

53. *Picasso,* 14.

54. "The African artist creates real *objects* which, with their possibility of being put anywhere, demanding neither base nor plinth, and with no connexion to any pre-existing architecture, are pre-eminently real *sculpture.*" Kahnweiler, "Negro Art and Cubism," 414. Kahnweiler, of course, is not here referring to the masks, which present a more complex case, but to the free-standing sculptures. His remarks are in keeping with his aversion to the decorative arts in any

form. His position seems to be far more rigid than the position of Picasso, for whom the status of the work of art as an object was also subject to the play of oppositions.

55. See Kahnweiler, *Juan Gris, His Life and Work,* 84. Picasso's exploration of the paradoxical status of the work of art as a *tableau-objet,* that is, as both a representation and a self-sufficient object, is the subject of the following chapter.

56. "Des témoins, déjà choqués par ces choses dont ils voyaient les murs couverts, et qu'ils se refusaient à nommer des tableaux parce que fait avec de la toile cirée, du papier d'emballage et des journaux, dirent en montrant d'un doigt supérieur l'objet des soins intelligents de Picasso.

—Qu'est-ce? Cela se pose sur un socle? Cela s'accroche au mur? Qu'est-ce, de la peinture ou de la sculpture?

Picasso, vêtu du bleu des artisans parisiens, répondit de sa plus belle voix andalouse:

—Ce n'est rien, c'est el guitare!" André Salmon, *La jeune sculpture française,* 103–04.

57. "Et voilà. Les cloisons étanches sont démolies. Nous sommes délivrés de la peinture et de la sculpture déjà libérées de la tyrannie imbécile des genres. Ce n'est plus ceci et ce n'est plus cela. Ce n'est rien. C'est el guitare!" Ibid., 104.

58. *L'art des nègres,* 325. Markov wrote this text (*Iskusstvo negrov*) in 1914 after two years of visiting ethnographic museums throughout Europe and photographing their collections. It was published posthumously in Petrograd in 1919.

59. Ibid. Bois discussed the relevance of Markov's analysis for an interpretation of Picasso's interest in African masks and sculpture in the fall of 1912 in "Kahnweiler's Lesson," 47–49.

60. Cited in André Salmon, *La jeune peinture française,* 43. The full citation reads: "Déjà l'artiste s'était passionné pour les nègres qu'il plaçait bien au-dessus des Egyptiens. Son enthousiasme n'était pas soutenu par un vain appétit du pittoresque. Les images polynésiennes ou dahoméennes lui paraissaient 'raisonnables.'" (English translation in Fry, *Cubism:* "Already the artist had taken ardently to the sculpture of the Negroes, whom he placed well above the Egyptians. His enthusiasm was not based on any trivial appetite for the picturesque. The images from Polynesia or Dahomey appeared to him as 'reasonable'" [82].) In emphasizing the reasonableness of African art, Picasso rejected the nineteenth-century tendency to see in "primitive" art only the expression of an instinctual or emotional response to nature. Further evidence of Picasso's attitude toward African art can be gleaned from a comment made by the artist to Tugendhol'd and cited by Markov: "When I went to Picasso's atelier and I saw the African fetishes from the Congo, wrote Tugendhol'd (*Apollon,* 1914), I asked the painter if it was the mystical character of these sculptures that interested him. He responded:

'Absolutely not, what interests me is their geometric simplicity.'" Cited in *L'art des nègres,* 324.

61. Picasso, however, paradoxically undermines the reading of the white piece of paper at the lower right corner as opaque, by depicting a transparent glass on its surface.

62. Rosalind Krauss has analyzed the way in which collage elements function as miniature facsimiles of the pictorial ground: affixed to the "master plane," they render it absent in order to re-present it in the form of a depiction. See "In the Name of Picasso," 19.

63. A painting with sand on glass, *Violin and Newspaper,* also executed at this time, is an interesting exception, but it presents paradoxes of a different type. This work (fig. 52) is discussed in the next chapter.

64. The difficulty of seeing this work seems to be an aspect of its structure. The photograph of this collage reproduced here is deceptive in that it transforms this work into one which is easily legible. This photograph must have been made by shining a very bright light against the back of the collage.

65. Of course, given the relational value of these silhouettes, it is misleading to describe one as the flipped-over version of the other. Each form is the negative or reverse of the other.

66. "In the Name of Picasso," 15–16.

67. Ibid., 19.

68. In his Blue period, Picasso had at times exploited the popular notion that the form of a guitar is similar to the form of a woman. The guitar was associated with the expression of sentiment, intended to be held, played, etc. It may be significant, therefore, that in these works the guitar or violin is almost always transformed into a head, and more particularly, into a man's head. Later, in 1926, in a more Surrealist mood, Picasso would once again explore the analogies of the guitar and female sexuality, this time creating a series of collages on the theme of the *vagina dentata* (see Picasso Museum nos. 86–95). For discussions of the significance of the guitar in Picasso's art, see two articles by Ronald Johnson: "Picasso's 'Old Guitarist' and the Symbolist Sensibility" and "Picasso's Musical and Mallarméan Constructions." Werner Spies discussed Picasso's practice of anthropomorphizing musical instruments during his Cubist period in "La guitare anthropomorphe."

69. Marjorie Perloff was the first to point out this visual pun in "The Invention of Collage," in *Collage,* ed. Jeanine Parisier Plottel, *New York Literary Forum* 10–11 (New York, 1983), 12. Picasso enhanced the figure / ground confusion here by drawing the glass / man on a piece of newspaper which he then cut out and glued onto another piece of newspaper already in place. Picasso achieves an effect of transparency through the economical device of misaligning the two newspaper elements; this misalignment suggests the distortion of forms seen through glass.

70. The fragment of a newspaper title suggesting the word "[app]arition" appears at the upper right.

71. Saussure, *Course,* 113.

72. Picasso preferred to view the African objects in his studio as witnesses [*temoins*] rather than as examples [*exemples*]. See Florent Fels, *Propos d'artistes,* 145.

73. See n. 57 above.

74. See "Negro Art and Cubism."

Chapter 3. Frames of Reference

1. Braque was interviewed in 1908 by the American journalist Gelett Burgess, who published portions of the interview in *The Architectural Record* 27 (May 1910): 400–14. In this interview Braque suggested that he could overcome the inadequacy of a single view by multiplying the number of figures: "He gave me a sketch for his painting entitled 'Woman' in the Salon des Indépendants. To portray every physical aspect of such a subject, he said, required three figures, much as the representation of a house requires a plan, an elevation and a section." (405) The illustration accompanying these remarks is titled *La Femme* and shows three women in different poses, much like traditional representations of the Three Graces. In subsequent analyses, such as those of Jean Metzinger or Jacques Rivière, the various views of an object are said to be combined in a single image.

2. Jean Metzinger, "Note sur la peinture," *Pan* (October-November 1910), in Fry, *Cubism,* 59–60. See also "Cubisme et Tradition," *Paris-Journal* (16 August 1911); Fry, *Cubism,* 66–67.

3. Leo Steinberg was the first art historian to question seriously the notion that the Cubists' fragmentation of form resulted from a desire to depict simultaneously various views of an object. See: "The Algerian Women and Picasso at Large," in *Other Criteria,* esp. 154–73. Steinberg points out that Cubist "simultaneities" are "disjunctive" and therefore hostile to synthesis in the sense of "corporeal integrity." The aim of Picasso and Braque is not to create a summation of different views but to "impress the theme of discontinuity upon every level of consciousness" (160).

4. See "Re-Presenting Picasso," and "In the Name of Picasso."

5. See "Kahnweiler's Lesson" and "The Semiology of Cubism."

6. Christopher Gray, *Cubist Aesthetic Theories.*

7. Douglas Cooper, *The Cubist Epoch.* Cooper confirmed his view of the realist intent of Picasso and Braque in the recent essay, "Braque as Innovator: The First *Papier Collé,*" in *Braque, The Papiers Collés.*

8. John Golding, *Cubism, A History and an Analysis 1907–1914.*

9. Ibid., 81.

10. Ibid., 94.

11. Ibid., 105.

12. Ibid., 117–18.

13. Nelson Goodman offers a useful refutation of the information theory of realism in *Languages of Art,* 35–36. Interestingly, artists such as Gleizes and Metzinger, and early supporters of their "informational realism" theory, specifically rejected ease of interpretation as a requirement of the new style. Not taken into account, however, was the impossibility of ever achieving a "total" image of an object through an additive process of representation. It seems evident that more views might always be added, leading eventually to "total" incomprehension on the part of the viewer. And indeed, hostile early critics already attributed this result to Cubist art.

14. Contemporary scholarship has been revisionist on the notion of unity in Cubist works. For example, until recently most scholars accepted Kahnweiler's early view that Picasso abandoned *Les Demoiselles D'Avignon* in an unfinished state and that the right and left sides of this painting remained radically disunified. In most accounts, this led to criticism of the painting. The first scholar to challenge this interpretation was Leo Steinberg in "The Philosophical Brothel." In a more recent study, William Rubin has pointed to the deliberate disunity of Picasso's *Bread and Fruitdish on a Table* of 1909. See "From Narrative to 'Iconic' in Picasso: The Buried Allegory in *Bread and Fruitdish on a Table* and the Role of *Les Demoiselles d'Avignon.*"

15. *The Rise of Cubism,* 7. "[Mit] den Urproblemen der Malerei: der Darstellung des Dreidimensionalen und Farbigen auf der Fläche, und seiner Zusammenfassung in der Einheit dieser Fläche. . . . Keine gefällige 'Komposition', sondern unerbittlicher, gegliederter Aufbau." *Der Weg zum Kubismus,* 26–27.

16. "Le retour à l'unité de l'oeuvre d'art, dans la volonté de créer non des esquisses, mais des organismes autonomes et accomplis." "Accomplissement classique du cubisme. Juan Gris [1928]," in *Confessions esthétiques,* 51.

17. *The Rise of Cubism,* 12. "Statt einer analytischen Beschreibung kann der Maler auch, wenn er das vorzieht, auf diese Weise eine Synthese des Gegenstandes schaffen, das heißt, nach Kant, 'dessen verschiedene Vorstellungen zueinander hinzutun, und ihre Mannigfaltigkeit in einer Erkenntnis begreifen'." *Der Weg zum Kubismus,* 61.

18. In Fry, *Cubism,* 118. "L'objet réel ou en trompe-l'oeil est appelé sans doute à jouer un role de plus en plus important. Il est le cadre intérieur du tableau et en marque les limites profondes, de même que le cadre en marque les limites extérieures." *Méditations esthétiques, les peintres cubistes,* 77.

19. Francis Carco suggests that Picasso "instructed" Apollinaire on the chapter of *Méditations esthétiques, les peintres cubistes* in which the remarks on collage appear: "La fréquentation des peintres a ceci d'excellent qu'elle vous apprend à faire passer, bien avant la critique, le profit qu'on en peut tirer. Picasso avait enseigné Guillaume sur ce chapitre et, ma foi, l'avait convaincu. 'Il est temps d'être les maîtres', écrivait en effet l'auteur de *Calligrammes* dans ses *Méditations esthétiques* et, plus loin, dans le même ouvrage, il ajoutait: 'On peut peindre avec ce qu'on voudra, avec des pipes, des timbres-poste, des cartes postales, ou à jouer, des candélabres, des morceaux de toile cirée, des faux cols, des papiers peints, des journaux.'" See *De Montmartre au Quartier Latin*, 186–87.

20. For an analysis of the dates of the various manuscripts of "Les Peintres Cubistes," see J.-C. Chevalier and L. C. Breunig, "Apollinaire et Les Peintres Cubistes," 98–99, and, edited by the same authors, "Notes et commentaires sur le texte," in Apollinaire, *Les peintres cubistes*, 117–59.

21. *Les peintres cubistes*, 107.

22. Fernande Olivier recounts Picasso's love for "ordinary objects" in her memoirs of this period: "En matière de décoration, Picasso avait un goût qui le portait à acheter, souvent par ironie, les objets les plus ordinaires; il avait des manies de collectionneur pour toutes sortes de petites choses. . . . Il aimait les vieux morceaux de tapisserie, Verdures, Aubussons, Beauvais dont il était parfois difficile de reconnaître le sujet à cause de leur mauvais état. Des instruments de musique, des boîtes, des vieux cadres dédorés. De frais chromos encadrés de paille ornaient les murs de la salle à manger. Ils eussent été à leur aise dans une loge de concierge. Lui-même riait de cela." *Picasso et ses amis*, 171.

23. Robert Rosenblum has suggested that Picasso may have seen such a mirror during his trip to Le Havre, which preceded his making of this collage. He reproduces a mirror of this type in "Still Life with Chair Caning," *Picasso, from the Musée Picasso, Paris,* ex. cat. (Minneapolis: Walker Art Center, 1980), 43.

24. Rosenblum has also noted that the frame in this collage can be read as both a picture frame and as a reference to the carved edge of a table. Ibid., 42. Rosalind Krauss called attention to the way the rope frame in the *Still Life with Chair-Caning* doubles as furniture moulding and to the way the oval canvas can be alternately interpreted as a horizontal tabletop or as a vertically displayed pictorial field, in "The Cubist Epoch," 33.

25. William Rubin cites a long discussion he once had with Picasso on his feelings for the tasseled furniture fringes he often used in his Cubist collages and constructions as proof of the "secret metaphoric value" that materials had for the artist, in "Picasso," in *"Primitivism" in 20th Century Art,* 316. My analysis of Picasso's use of these fringes suggests that he was interested in them because of their function as frames. Picasso may have also enjoyed the use of

such fringes, especially when they imitated architectural motifs precisely because they were considered, by some, to be in bad taste. See the review of an exhibition of decorative art in Stuttgart chosen by the curator precisely to demonstrate faults in taste: C. S., "Aberrations du Goût en Matière d'Art Décoratif," *Art et Industrie* (October 1909), n.p. According to the author, the problem with such "trucs employés par les faussaires" is that "ils sortent un peu du cadre du musée."

26. See "Braque 1912–1918, repères chronologiques" in *Georges Braque, les papiers collés,* 180.

27. Olivier, *Picasso et ses amis,* 171 (see n. 22 above).

28. Henri Rousseau's painting *Portrait of a Woman,* which Picasso bought in 1908, displays a related use of a curtain pulled back by a curtain loop and tassel.

29. One can trace this interest in conflating vertical and horizontal orientations to Picasso's *Les Demoiselles D'Avignon,* in which the demoiselle second from the left appears as a reclining figure catapulted into an upright position. Leo Steinberg discusses this phenomenon and its relation to similarly "reclining" nudes in Matisse in "The Philosophical Brothel." Steinberg also discusses the relation of vertical and horizontal planes in the combine paintings of Robert Rauschenberg in "Other Criteria," *Other Criteria,* 82–91.

Yve-Alain Bois has called attention to two early texts by Walter Benjamin that discuss the relation of painting and drawing / writing in terms of the opposition between vertical and horizontal fields. See "Walter Benjamin: 'Peinture et graphisme,' 'De la peinture ou le signe et la marque,'" *La Part de l'Oeil,* no. 6 (1990): 10–13. Interestingly, Benjamin sent these texts to Gershom Scholem in the fall of 1917 in the context of a discussion of Cubism. Bois has elaborated on the significance of Benjamin's ideas for an interpretation of the relation of vertical and horizontal fields in Cubist works in "Piet Mondrian: New York City," *Critical Inquiry* 14 (Winter 1988): 271–73, and "The Semiology of Cubism."

30. Alfonso Procaccini has analyzed the dual role of the frame in Renaissance art to establish the difference of the fiction within the frame from the reality beyond it and to define this fictional world as reality. "To define *istoria,* then, means essentially to form a frame, which like a frame around a painting, serves the double role of distinguishing the story (fiction) from history (reality out there), as well as insuring the autonomy of the story itself precisely because it is fiction, and therefore an end in itself." In Procaccini's view, the invention of Renaissance perspective necessitates the presence of a frame to contextualize the image and therefore "lays the foundation for all succeeding theories regarding the autonomous nature of art." (36) See "Alberti and the 'Framing' of Perspective," 29–39. In this context, Picasso's use of an "inner frame" can be understood as an attack on the very principle that art establishes an autonomous, internally coherent, fictional realm.

Rather than make truth claims for his fictions, Picasso preferred to point to the fact that "art is a lie," as he so often remarked.

31. "Pensées et réflexions sur la peinture," in Fry, *Cubism,* 147–48.

32. Braque's use of the housepainter's comb also represents a negation of real skill in that a tool associated with commercial practice is used to supplement the craft of the painter. The imitation wood grain is eye-fooling then, in two senses. It fools one into thinking that one is viewing a real piece of wood, and then, with the realization that the wood grain is painted, into admiring the craft of the painter, when in fact this craft is one of the tricks of the housepainter's trade.

33. Robert Rosenblum has discussed these possibilities in his analysis of this collage: "Still Life with Chair Caning," in *Picasso from the Musée Picasso, Paris,* 43.

34. See Jean Laude's introductory essay in Nicole Worms de Romilly and Jean Laude, *Braque, le cubisme fin 1907–1914,* 48.

35. Douglas Cooper interpreted the words as belonging to a poster hanging on a wall, in *An Exhibition of Paintings: G. Braque* (London: The Tate Gallery, 28 September—11 November 1956), 32, while for the author of the catalogue entry on *The Portuguese* [F.M.], in "Picasso," ex. cat. (Kunstmuseum Basel, 1976), 46, the rope is a motif used by Braque to evoke a mariner's milieu. William Rubin has published a letter from Braque to Kahnweiler (25 September or 2 October 1911), which seems to refer to *The Portuguese,* in which the artist describes the painting as "an Italian emigrant standing on the bridge of a boat with the harbor in the background." See *Picasso and Braque: Pioneering Cubism,* 1:380. While Braque may indeed have begun this work as a depiction of an Italian emigrant standing on the bridge of a boat, there seem to be few traces of this subject in the final painting. It is not unusual for paintings described in Braque's letters to be transformed in the process of several months' work. Based on the visual appearance of *The Portuguese,* I believe it is likely the rope and tassels and stenciled letters denote the presence of a windowpane and pulled-back curtain, although this would not exclude the rope and tassels evoking a mariner's milieu as well.

36. This painting on glass, from 1912, predates Duchamp's related experiment with glass as a ground, in the *Large Glass.*

37. The chair rail refers to the table edge both metaphorically, by resembling it, and metonymically, by its placement just at the lower edge of the violin. The painted fragment of newspaper is also placed so that it can be read as a section of the chair rail in relation to the violin. Horizontally placed strips of newspaper frequently refer to the chair rail of a wall in Picasso's collages.

38. *Violin* hangs on the lower portion of the right wall, the second work in from the corner.

39. Stein, *Picasso,* 12.

40. I use the term *modernism* here to refer to artistic and critical practices that advocate the formal purity and autonomy of art through self-conscious affirmation of the distinctive properties of a given medium or process. This affirmation is an aspect of modernism's general effort to motivate artistic form, to endow it with a sense of necessity. Within the parameters of modernist criticism, references to "real-world" or literary subjects, or to an artist's traffic with popular or "low" cultural forms, will usually be denied or granted little importance. As an artistic phenomenon, modernism was never monolithic; it coexisted with antimodernist tendencies to be seen in the subversive ready-mades of Marcel Duchamp as well as in most Russian Constructivist and Dada and Surrealist work. In my view, modernism is best described as a philosophical attitude rather than in strictly chronological terms. Much modernist art continues to be made today in an era of postmodernism, even as much art made prior to the "official" advent of postmodernism in the 1960s qualifies as antimodernist in its aesthetic and ideological assumptions.

My analyses of the antimodernist aspects of Cubist collage are indebted to the very different formulations of Thomas Crow and Rosalind Krauss. Crow criticized the modernist interpretation of collage in "Modernism and Mass Culture in the Visual Arts," 215–64. As discussed in the previous chapter, Krauss views Picasso's collages as initiating an important break with the modernist emphasis on perceptual plenitude in the structure of the sign. See "Re-Presenting Picasso" and "In the Name of Picasso."

41. In Fry, *Cubism,* 108.

42. "Pablo Picasso," *Paris-Journal* (21 September 1911), in Fry, *Cubism,* 68.

43. See Daniel-Henry Kahnweiler, with Francis Crémieux, *My Galleries and Painters,* 43.

44. "Picasso Speaks," 319.

45. In "Re-Presenting Picasso," Krauss compares Picasso's formal oppositions to those established in the modernist writing of the history of art and finds that they are based on the very same bipolar system that structures Wölfflin's *Principles of Art.* "The predicates fixed by the Cubist collage bits operate as the integers of such a system, the very same formal system as Wölfflin's set of master terms: closed / open, line / color, planarity / recession. . . . In the great, complex Cubist collages, each element yields a matched pair of formal signifieds: line *and* color, closure *and* openness, planarity *and* recession" (96). Picasso's matched pairs of formal signifieds, however, do not draw directly on Wölfflin's historical schema, and to the extent that there are parallels, this reflects a parallel historical

perception. Many of Picasso's formal oppositions derive from contemporary aesthetic antinomies, such as the distinction between popular or decorative and fine art or that between curved and straight lines.

46. Stein, *Picasso,* 18.

47. I am grateful to Celeste Brusati for the observation that the reversal of the guitar recalls the reversal of objects in prints and certain other kinds of reproductive media.

48. In a similar vein, Yve-Alain Bois has argued that Picasso's transformation of "empty" space into a formal mark, and his incorporation of fully three-dimensional objects in this assemblage, be read in a sense as a "manifesto" against the rejection of "objecthood" advocated by critics such as Adolf Hildebrand and, more recently, Clement Greenberg and Michael Fried. In *The Problem of Form in Painting and Sculpture* (1893), Hildebrand held that forms articulated in three-dimensions threatened to dissolve the distinction between art and life. Picasso, however, understood that once three-dimensional objects and space itself were caught in a network of differences, they could be transformed into signs. See "Kahnweiler's Lesson," 54–55.

49. There is at least one precedent in Picasso's collages for an allusion to a painting by Manet. As Daix has shown, Picasso's first collage, the *Study for "L'Offrande"* of early 1908, refers to Manet's *Déjeuner sur l'herbe* and its central cavity of light. See "Braque et Picasso au temps des papiers collés," in *Georges Braque, les papiers collés,* 14–15.

50. For references to the early critical response to Manet's *The Spanish Singer,* see George Heard Hamilton, *Manet and His Critics* (New Haven and London: Yale University Press, 1986), 24–28.

51. Anne Coffin Hanson first called my attention to the "proplike" character of the costume worn by Manet's guitarist.

52. I do not wish to claim that Picasso's assemblage necessarily makes a conscious reference to Manet's *The Spanish Singer,* although there is ample evidence that Picasso was fascinated by the work of Manet both before and after his execution of *Assemblage with Guitar Player.* I merely wish to suggest this reference as a tantalizing possibility. Picasso's reversal of the guitar, however, is meaningful even if it does not invoke Manet's *The Spanish Singer.*

53. Interestingly, Picasso used collagelike techniques to obtain at least three progressively altered versions of this photograph. He made these versions by placing oblong strips of paper over parts of the light-sensitive paper during its exposure to the negative, so that parts of the negative were not printed. Two of these altered photographs are reproduced in Werner Spies and Christine Piot, *Picasso: Das plastiche Werk,* 66–68.

54. I am grateful to John McCoubrey for calling the angle of this tabletop to my attention.

55. "Sur ce thème nouveau, Picasso et Braque brodèrent les plus délicates et les plus sages arabesques. Ils imaginèrent d'assimiler la table au tableau." See "Naissance du Cubisme," in René Huyghe, *Histoire de l'art contemporain* (New York: Arno Press, 1968), 216.

56. Kahnweiler, *Juan Gris, His Life and Work,* 68.

57. For the Latin etymology of *tabula,* see Eugène Benoist and Henri Goelzer, *Nouveau Dictionnaire Latin-Français,* 10th ed. (Paris: Librarie Garnier Frères, 1922), 1550, and P. G. W. Glare, ed. *Oxford Latin Dictionary* (Oxford: Clarendon Press, 1982), 1898–99.

58. For a discussion of the meaning of *tableau* in the eighteenth century, particularly in the criticism of Diderot, see Michael Fried, *Absorption and Theatricality: Painting and Beholder in the Age of Diderot,* 89–96.

59. Picasso did not play the musical instruments or cards he so frequently represented. He tended to regard these objects as props and has stated that his interest in the guitar was primarily symbolic. See Werner Spies, *Sculpture by Picasso,* 47.

60. "Un atelier de peintre doit être un laboratoire. On n'y fait pas un métier de singe, on invente. La peinture est un jeu d'esprit." "En peinture tout n'est que signe."

Chapter 4. Conception and Vision in the Collages of Braque and Gris

1. Cited in Burgess, "The Wild Men of Paris," 405.

2. Werth, "Exposition Picasso," in Fry, *Cubism,* 57.

3. "Nous comprenons maintenant par son origine quel est le sens véritable de la peinture. Elle représente les objets tels qu'ils sont, c'est-à-dire autrement que nous les voyons. Elle tend toujours à nous donner leur essence sensible, leur présence: c'est pourquoi l'image qu'elle forme, ne ressemble pas à leur apparence. . . .

Essayons maintenant de déterminer avec plus de précision quelle sorte de transformations le peintre doit faire subir aux objets tels qu'il les voit pour les exprimer tels qu'ils sont. Ces transformations sont à la fois négatives et positives: il faut qu'il fasse abstraction de l'éclairage et de la perspective et qu'il mette à la place de ces deux valeurs d'autres valeurs vraiment plastiques." "Sur les tendances actuelles de la peinture," 387–88, in Fry, *Cubism,* 76.

4. "L'éclairage empêche les choses *d'apparaître telles qu'elles sont.*" Ibid., 389.

5. "Un livre, vu en perspective, peut apparaître comme un mince ruban rectangulaire, alors qu'il est en réalité un héxaèdre régulier. Et cette déformation, qui est celle des objets placés au premier plan, est bénigne auprès des mutilations que subissent les autres: partiellement masqués, découpés arbitrairement par ceux qui les précèdent dans l'ordre de la profondeur, ils apparaissent contrefaits, ridicules, méconnaissables." Ibid., 392 [not in Fry].

6. "Picasso, qui un moment se montra tout prés d'avoir du génie, s'est égaré dans des recherches ocultes où il est impossible de le suivre." Ibid., 406, in Fry, *Cubism,* 80. David Cottington has analyzed Rivière's criticism as a manifestation of his conservative political views, which led him to interpret Cubism within the framework of classical principles of law and order: see "Cubism, Law, and Order: The Criticism of Jacques Rivière," 744–49.

7. "Conception et vision," in Fry, *Cubism,* 94–97.

8. Ibid., 94.

9. *Salon de juin: Troisième exposition de la Société normande de Peinture Moderne,* ex. cat. (Rouen: 15 June – 1 July 1912), in Fry, *Cubism,* 93.

10. For an excellent analysis of the often overlooked differences within Cubist criticism, see J. M. Nash, "The Nature of Cubism: A Study of Conflicting Explanations," 435–47. I would add only that the neo-Kantianism Nash has identified as the basis for the views of critics such as Olivier-Hourcade, Raynal, and Kahnweiler is based, at least in part, on a (creative) misreading. While it is true that these writers cite Kant approvingly for having distinguished between the phenomenon and the "thing in itself," they seem to have forgotten in practice his claim that the "thing in itself" cannot be known. The neo-Kantianism of Kahnweiler especially is, in my view, a distortion of Kant's thought, in favor of retaining the idea that the absolute truth can be known through recourse to the a priori structures of the mind. Cubism becomes for Kahnweiler a vehicle of this superior knowledge. This deformation of Kant's thought occurs despite the fact that, of all the early Cubist theorists, Kahnweiler had devoted the most serious study to Kant's philosophy, and thus demonstrates the enormous need to explain Cubism as an art concerned with the revelation of truth.

11. "Des critiques bien intentionnés expliquent la différence remarquable entre les formes attribuées à la nature et celles de la peinture actuelle, par la volonté de représenter les choses non telles qu'elles paraissent mais telles qu'elles sont. Comment sont-elles? D'après eux l'objet posséderait une forme absolue, essentielle, et ce serait pour la délivrer que nous supprimerions le clair obscur et la perspective traditionnels. Quelle simplicité! Un objet n'a pas une forme absolue, il en a plusieurs, il en a autant qu'il y a de plans dans le domaine de la signification." *Du Cubisme,* 30, in Fry, *Cubism,* 110 (translation amended).

12. "Die moderne Malerei," *Der Sturm,* nos. 148–49 (Berlin: February 1913), in Fry, *Cubism,* 112.

13. Ibid., 113.

14. "Pensées et réflexions sur la peinture," 3–5, in Fry, *Cubism,* 147. See especially the statements numbered 15, 16, and 17 in Fry, which form a group. In proposing the following interpretation of Braque's early *papiers collés,* I have relied to a great extent on the few existing statements made by the artist. This is obviously open to the objection that statements made at later periods of Braque's life cannot be taken as reliable evidence of ideas he held before the war. Braque's published statements and interviews, however, are remarkably consistent in their insistence upon his interest in local color, the materialization of space, the tactility of objects and of the work of art. Unlike Picasso's statements, which are notoriously contradictory and sometimes deliberately misleading, Braque's seem to me to be an honest attempt to recall the issues important to him before the war. This is not to say that they provide an adequate interpretation of the early papiers collés, for I will argue that in the end the works are more contradictory and paradoxical than the ideas expressed verbally.

15. Kahnweiler, *The Rise of Cubism,* 10–15.

16. This is one of the canonical interpretations of the invention of papier collé. See, for example, Golding, *Cubism,* 105.

17. Richard Shiff discusses the classical distinction between the imitation and the copy in "Representation, Copying, and the Technique of Originality," 333–63, and "The Original, the Imitation, the Copy, and the Spontaneous Classic: Theory and Painting in Nineteenth-Century France," 27–54.

18. In the critical formulation proposed by Quatremère de Quincy, the "imitative arts" were called on to distinguish themselves from the products of purely mechanical reproduction, in which the necessary *difference* between an image and its model was effaced by the *identity* of mere repetition. Despite claims to universality, Quatremère's ideas are poised at a particular transitional historical moment: just after the potentially negative effects of the industrial revolution on the fine arts could be seen, but just before the equally dramatic effects of the mechanical reproduction of images (photography, cheap chromolithography) would become a social fact of life. Thus Quatremère does not consider the role of the mechanically produced image in his schema, but only mechanically produced objects in general. See Antoine Chrysostome Quatremère de Quincy, *An Essay on the Nature, the End, and the Means of Imitation in the Fine Arts,* trans. J. C. Kent (London: Smith, Elder and Co., [1823] 1837).

19. See *Grammaire des arts du dessin,* 488.

20. Unlike Quatremère, Blanc emphasizes a conception of art in which the ideal and the real are synthesized.

21. Cited in Eugenio Donato, "The Museum's Furnace," 214. This is one of the possible scenarios for the ending of the novel, which was left unfinished on the author's death.

22. "Tant il est vrai que l'homme est impuissant à imiter matériellement l'inimitable nature, et que dans l'art du peintre les objets naturels sont introduits, non pas pour se

représenter eux-mêmes, mais pour représenter une conception de l'artiste; tant il est vrai, enfin, que le signe est plutôt un moyen convenu d'expression qu'un procédé absolument imitatif, puisque le dernier degré de l'imitation est précisément celui où elle ne signifie plus rien." Blanc, *Grammaire des arts du dessin,* 488.

23. "L'artiste, de toute nécessité, aura la tâche de soigneusement éviter cette antinomie de tout art: la vérité concrète, l'illusionnisme, le trompe-l'oeil, de façon à ne point donner par son tableau cette fallacieuse impression de nature qui agirait sur le spectateur comme la nature elle-même, c'est-à-dire sans suggestion possible." Albert Aurier, "Le Symbolisme en peinture," 162.

24. In her memoirs, Fernande Olivier asserted, "On sait que le petit bourgeois français n'admire en art que ce qui lui paraît la copie exacte de la nature." [One knows that the French petit bourgeois doesn't admire anything in art but that which appears to him to be the exact copy of nature.] *Picasso et ses amis,* 6.

25. "Quant à moi je n'ai jamais eu un but en tête. 'Le but est une servitude', a écrit Nietzsche, je crois, et c'est vrai." [As for me, I have never had a goal in mind. 'A goal is a servitude,' wrote Nietzsche, I believe, and it's true.] "La Peinture et nous," 14.

26. "Si j'ai eu une intention, elle a été de m'accomplir au jour le jour. En m'accomplissant il se trouve que ce que je fais ressemble à un tableau. Chemin faisant je continue, voilà." Ibid., 14.

27. Gris shared this desire to distinguish himself from the artisan. According to Raynal, if he did not wish to imitate already flat images, it was in order *not* to "[fall] back into imitation or into the preoccupation with skill which is the preserve of the painters of shop signs." "L'Exposition de la Section d'Or," 100.

28. "On en vint à vanter l'habileté des peintres en bâtiment qui tirent tant de marbre et tant de bois précieux de carrières et de forêts imaginaires." *La jeune sculpture française,* 13, in Fry, *Cubism,* 140.

29. "Personne ne songeait, toutefois, à imiter ces adroits artisans." Ibid., 14, in Fry, *Cubism,* 141.

30. In Fry, *Cubism,* 141, *La jeune sculpture française,* 14.

31. "La vraisemblance n'est que trompe-l'oeil." *Le Jour et la nuit, Cahiers de Georges Braque, 1917–1952,* 15.

32. "Il faut choisir: une chose ne peut être à la fois vraie et vraisemblable." Ibid., 20.

33. "La Peinture et nous," 13.

34. "L'espace visuel sépare les objets les uns des autres. L'espace tactile nous sépare des objets. Le touriste regarde le site. L'artilleur touche le but (la trajectoire est le prolongement du bras)." *Le Jour et la nuit,* 26.

35. "Bientôt j'ai même inversé la perspective, la pyramide des formes, pour qu'elle aille vers moi, pour qu'elle aboutisse au spectateur." Jacques Lassaigne, "Un Entretien avec Georges Braque," 4.

36. "Alors je commençai à faire surtout des natures mortes, parce que dans la nature il y a un espace tactile, je dirais presque manuel. Je l'ai écrit du reste: 'Quand une nature morte n'est plus à la portée de la main, elle cesse d'être une nature morte.' Cela répondait pour moi au désir que j'ai toujours eu de toucher la chose et non seulement de la voir." "La peinture et nous," 16.

37. Some critics of the late nineteenth and early twentieth centuries, such as Adolf Hildebrand, argued that strictly speaking one cannot *see* the third dimension since the optical image is two-dimensional. If human beings nevertheless learn to "perceive" depth, it is by associating visual clues such as perspectival diminution, light and shade, relative distinctness, etc. with prior kinetic and tactile experiences. See Adolf Hildebrand, *The Problem of Form in Painting and Sculpture.* This book, translated into French from the original German in 1903, seems to have been familiar to many artists and theorists, including Gleizes and Metzinger. See *Le problème de la forme dans les arts figuratifs,* trans. Georges M. Baltus (Paris: E. Bouillon, [1903]). For a discussion of the two senses of tactile—texture and proximate space—in Braque's work, see Yve-Alain Bois, "The Semiology of Cubism."

38. "Du reste, je travaillais d'après nature. C'est même ce qui m'a aiguillé vers la nature morte. Je trouvais là un élément plus objectif que le paysage. La découverte de l'espace tactile qui mettait mon bras en mouvement devant le paysage m'invitait à chercher un contact sensible plus proche encore." Cited in Lassaigne, "Un Entretien avec Georges Braque," 6.

39. This might also be read as an attempt to privilege the index over the icon. In this sense there is, of course, a link with the nineteenth-century tendency to emphasize the artist's touch and the materiality of the paint itself. Richard Shiff has discussed the relation of icon and index in Picasso's collage practice in "Picasso's Touch: Collage, *Papier Collé, Ace of Clubs,*" 38–47.

40. I am grateful to John McCoubrey for his observations on the spatial ambiguities of this papier collé.

41. "C'est ce goût très prononcé pour la matière elle-même qui m'a poussé à envisager les possibilités de la matière. J'ai voulu faire de la touche une forme de matière." "La peinture et nous," 17.

42. "Je voyais combien la couleur dépend de la matière. Prenez un exemple: trempez deux tissus blancs, mais de matière différente dans la même teinture, leur couleur sera différent. Il va de soi que cette dépendance qui lie la couleur à la matière est encore plus sensible en peinture. Et ce qui me plaisait beaucoup était, précisément cette 'matérialité' qui m'était donnée par les diverses matières que j'introduisais dans mes tableaux." Ibid., 17.

43. "La couleur agit simultanément avec la forme, mais n'a rien à faire avec elle." Ibid.

44. The rest of this papier collé, executed in friable charcoal, was left unvarnished. Braque frequently used pins to determine the placement of his faux bois paper. This also allowed him to remove his collage elements for varnishing prior to the final process of gluing them to the paper support.

45. That Braque thought of overlapping as a substitute for classical perspective can be seen from the description he gave Lassaigne of his method of painting the Estaque landscapes: "I say farewell to the vanishing point. And, to avoid a projection towards the infinite, I interpose planes overlapping a short distance. To let it be understood that things are in front of each other instead of departing into space." [Je dis adieu au point de fuite. Et, pour éviter une projection vers l'infini, j'interpose des plans superposés à une faible distance. Pour faire comprendre que les choses sont l'une devant l'autre au lieu de se répartir dans l'espace.] "Un Entretien avec Georges Braque," 4. Leo Steinberg has noted the existence of this method of overlapping in Braque's work as early as the *Large Nude* of 1908 (conversation with the author).

46. "Statements to Tériade, 1929–30," in *Matisse on Art,* ed. Jack Flam, 58. Interestingly, Gleizes and Metzinger expressed a similar view of "the connectedness of color and form" in their book, *Du Cubisme*: "Toute inflexion de la forme se double d'une modification de la couleur, toute modification de la couleur engendre une forme," 28–29. [All inflexion of form is doubled in a modification of color, all modification of color engenders a form.] These comments, which were published in October of 1912, just one month after the invention of papier collé, demonstrate the distance that separates the ideas of Picasso and Braque from those of the Puteaux Cubists.

47. "Les sens déforment, l'esprit forme." "Pensées et reflexions sur la peinture," 4, in Fry, *Cubism,* 147.

48. "C'étaient des formes où il n'y avait rien à déformer parce que, étant des aplats, les lettres étaient hors l'espace et leur présence dans le tableau, par contraste, permettait de distinguer les objets qui se situaient dans l'espace de ceux qui étaient hors l'espace." "La peinture et nous," 16.

49. In Fry, *Cubism,* 148, "Pensées et réflexions sur la peinture," 5. Recent publication of the manuscript version of Braque's "text" reveals that it was much elaborated on by Reverdy prior to publication in *Nord-Sud*. In portions of this text, which is entirely in Reverdy's hand, the opposition of faux bois and trompe l'oeil emerges more clearly than it does in the published version, which reads: "Le trompe l'oeil est dû à un *hasard anecdotique* qui s'impose par la simplicité des faits." [Trompe l'oeil is due to an *anecdotal* accident that makes its effect through the simplicity of the facts.] In the manuscript version it becomes

evident that what is meant by *anecdotal* are the contingent (changing) effects of light and shadow: "Le trompe l'oeil n'est que l'illusion du réel dû à une coïncidance qui constitue *un fait simple.*—exemple—un crayon noir sur un papier blanc que l'ombre portée détache." Below this, in two opposing columns one reads: "1. fait simple (relief) coïncidance—opposition lumière ombre" and "1. f. simple sans coïncidance—faux bois." For a reproduction of this text, see *Braque, les papiers collés,* 182. Although Braque undoubtedly provided Reverdy with these ideas, the presence of this text in the poet's hand reveals that he was responsible for the final wording of the statement,

50. "Ce n'est pas assez de faire voir ce qu'on peint, il faut encore le faire toucher." *Le Jour et la nuit,* 10.

51. *Le Lavabo* must have been completed or nearly completed by 1 October 1912, when a review discussing this collage was published in *Gil Blas,* in advance of the opening of the exhibition.

52. Gris would have been unable to see Braque's early papiers collés since the latter remained in the south of France until November. It is possible he heard about them from Picasso, who returned to Paris from Sorgues on 23 September, but this leaves very little time indeed for Gris to react to news of Braque's innovations.

53. Mark Rosenthal called attention to the allegorical juxtaposition of "an anecdotal world of appearance and a realm of metamorphosis," in both *Man in the Café* and *The Watch* in *Juan Gris,* 34. As Rosenthal remarks, "It is as if the curtain is pulled back for our entrance from the perceptual world to another, Cubist milieu" (34).

54. This antinomy was clearly articulated by Maurice Raynal, a close friend of Gris, in an article titled "Conception et vision," published in *Gil Blas* on 29 August 1912, shortly before the opening of the Section d'Or exhibition. See n. 7 above.

55. All the works exhibited by Gris at the Section d'Or were given numbers instead of conventional titles in order to emphasize their conceptual status. Critics reviewing the exhibition occasionally made up titles in referring to Gris's works, and this has caused some confusion in subsequent histories as to which works were actually exhibited.

56. See statement by Raynal concerning *Le Lavabo* above, chap. 1.

57. "Il parait qu'il est impossible à un artiste consciencieux de reproduire un miroir sur la toile. Si l'on veut en faire une imitation parfaite, celà semble, en effet, pratiquement impossible. On ne peut arriver à donner l'éclat de la glace, et comme elle reflète des milliers d'objets qui passent devant elle, on ne peut, à moins d'être futuriste, les reproduire tous. C'est à la suite de le raisonnement assez curieux que le cubiste Juan Gris a décidé de n'y pas aller par ruses. Quant à peindre une table de toilette bien achalandée, il a tout simplement collé une véritable glace sur

son tableau." "Les Arts," *Gil Blas* (1 October 1912), 4. The author of this note was probably Louis Vauxcelles, who would have been told about this innovation and the line of reasoning behind it by Apollinaire and Raynal. The author clearly had not yet seen the collage in question, since he wondered whether Gris had included other objects as well.

58. See "Les Arts," *Gil Blas* (14 October 1912), 4.

59. "Mais si on demeure devant l'effort cubiste porté la plus bienveillante sympathie, il n'est point encore temps d'admirer; il faudrait d'ailleurs que l'on renonçât à quelques fantaisies baroques, à l'insertion d'éclats de verre dans les tableaux, qu'on ne cherche pas à faire croire qu'un chiffre ou qu'un caractère d'imprimerie a une valeur picturale." "La Section d'Or (Galerie la Boétie)," 181–82.

60. Douglas Cooper, *Juan Gris,* 1:xxi.

61. Leon Battista Alberti, *On Painting,* 51, 56, 64.

62. Leonardo da Vinci, *A Treatise on Painting,* 57–58, 60, 216–17.

63. Alberti, *On Painting,* 94.

64. Letter from Gris to Kahnweiler dated 17 September 1913 from Céret, cited in Kahnweiler, *Juan Gris, His Life and Work,* 86.

65. James Thrall Soby, for example, in citing Gris's letter, cannot help but express his "astonishment" at the artist's statement and his relief that no substitutions were made. See *Juan Gris,* 22–26.

66. The radical nature of Gris's assertion that the engraving in *Violin and Engraving* could be replaced is somewhat undercut in the case of *The Guitar,* by the harmony of light brown and black tints that Gris established between the collaged print and the painted guitar.

67. For this reason Gris did not generally paint or draw over his collage elements in his earliest collages. This would have been to integrate more fully the "image" into the realm of the imagination and, consequently, to diminish the contrast between those elements the artist has merely appropriated and those he has transformed according to a conceptual schema.

68. In another work of 1913, *Pears and Grapes on a Table,* Gris used paint to simulate not only wood grain, but also chair-caning and the newspaper title "Le M[atin]."

69. "Je emploie un peu de pusière contre notre orrible toile [sic]." Cited in Isabelle Monod-Fontaine, "Braque, la lenteur de la peinture," in *Georges Braque, les papiers collés,* 41.

70. Jean Cocteau reported that Gris was proud of having been the first artist to paint a siphon (as early as 1910). See Rosenthal, *Juan Gris,* 40. He was preceded in this, however, by Gauguin's *Night Café* of November 1888.

71. "Pensées et réflexions sur la peinture," in Fry, *Cubism,* 148.

72. "J'ai l'esprit trop précis pour salir un bleu ou tordre une ligne droite." Letter to Kahnweiler dated 4 December 1914, cited in *Donation Louise et Michel Leiris,* 55.

73. Maurice Raynal, "Juan Gris et la métaphore plastique, (A propos de son Exposition à la Galerie Simon)," 63–65.

74. "Le calembour ne répond à aucune nécessité constructive," Ibid., 64.

75. "Au contraire, la métaphore plastique, elle, contient une vérité de jugement, elle est une sorte de synthèse qui découle légitimement de la confrontation d'éléments de même qualité." Ibid.

76. "Lorsque Juan Gris dans le domaine plastique estime, sur l'injonction de son imagination que plusieurs groupes d'éléments parallèles sont nécessaires à l'harmonie générale de son tableau, il n'hésite pas, à répéter la même idée plastique en termes différents." Ibid., 65.

77. It is possible to establish an order among these images like the order that distinguished the reflections in Plato's cave on the basis of how removed from reality (the idea) the various images of images had become. On the other hand, Gris might have regarded the most concretely present images (including, for example, the real page of a novel) as those which were least true since they had not originated in his mind.

78. The story Gris cut out of *Le Journal* was a protest against the deplorable influence of bad German taste on the women of Paris. It reads: "[. . .] la deplorable influence de [. . .] goût teuton qui corrom[pt] les [. . .] de Paris que je proteste, que tout le monde proteste! La Parisienne est no[tre] idole; c'est la charmante incarnation de notre goût, de notre chic national, et traditionnel. On a classé et mis sous la protection de la lois les monuments, les rues, les places, les églises de Paris. Eh bien! nous demandons que l'on [. . .]" Perhaps Gris intended to allude indirectly and humorously to contemporary attacks on Cubism itself as a German art movement that was having a nefarious influence on traditional French taste and values in art.

79. "Je crois que j'ai fait depuis quelque temps assez de progrès et que mes toiles commencent à avoir une unité dont elles manquaient. Ce ne sont plus ces inventaires d'objet qui tant me décourageaient autrefois." Letter from Gris to Kahnweiler dated 26 March 1914, cited in *Donation Louise et Michel Leiris,* 55.

80. "Evidemment c'est de la décoration. Il ne faut pas avoir peur des mots lorsqu'on sait ce qu'ils signifient, mais tout la peinture a toujours été de la décoration." Letter from Gris to Kahnweiler dated 20 February 1921. Ibid., 58.

81. ". . . de subdivisions prismatiques de l'Idée . . . "Préface" to "Un Coup de dés," *Oeuvres,* 455.

82. "La poésie consistant à *créer,* il faut prendre dans l'âme humaine des états, des lueurs d'une pureté si absolue que, bien chantés et bien mis en lumière, cela constitue en effet les joyaux de l'homme: là, il y a symbole, il y a création, et le mot poésie a ici son sens: c'est, en somme, la seule création humaine possible." "Sur l'évolution littéraire," *Oeuvres,* 870.

Chapter 5. Cubist Collage, the Public, and the Culture of Commodities

1. See P. M. Adema, *Guillaume Apollinaire,* 232. According to Adema, the subscribers who did *not* cancel included Jean Seve, Raoul Dufy, Sonia Delaunay, Stuart Merrill, Molina, and Ambroise Vollard. This was the first issue to appear under the new direction of Apollinaire.

2. Gertrude Stein, *Picasso:* "Life between 1910 and 1912 was very gay . . . at this time Picasso commenced to amuse himself with making pictures out of zinc, tin, pasted paper. He did not do any sculpture, but he made pictures with all these things. There is only one left of those made of paper and that he gave me one day and I had it framed inside a box." (26) The construction referred to in this passage is D / R 582, *Guitarist with Sheet Music.*

3. Braque exhibited for the last time at the Salon des Indépendants in the spring of 1909.

4. Picasso did exhibit one painting, titled *Derniers Moments,* at the Universal Exhibition of 1900.

5. Vollard did, however, resume buying some of Picasso's paintings in 1909 and 1910.

6. Malcolm Gee, *Dealers, Critics, and Collectors of Modern Painting: Aspects of the Parisian Art Market between 1910 and 1930,* 14.

7. Fernande Olivier, *Picasso et ses amis,* 158.

8. Principal among these were Gertrude and Leo Stein, Hermann Rupf, Roger Dutilleul, Wilhelm Uhde, Sergeï Shchukin, and Vicenč Kramař.

9. Daniel-Henry Kahnweiler, *Mes galeries et mes peintres,* 58–59.

10. "Nous n'avons plus jamais exposé publiquement, ce qui vous prouve bien le mépris absolu dans lequel nous tenions non seulement la critique mais aussi la grande foule. . . . Or, à cette époque, les gens se rendaient aux Indépendants pour se fâcher et pour rire. Il y avait des bandes de gens devant certains tableaux qui se tordaient ou qui poussaient des cris de fureur. Nous n'avions aucune envie de nous exposer ni à leur fureur ni à leur rire; donc, nous ne montrions plus les tableaux." Ibid., 59–60.

11. It should be remarked, however, that Picasso attended the salons he refused to participate in, and that several of his friends have recorded the caustic remarks he made in front of the works of the "Cubists." Thus he became part of the mocking public who derided the works of the Puteaux Cubists and other artists.

12. "C'est très bien comme ça. Qu'il n'aime pas ça! Nous arriverons bien à dégouter tout le monde." Cited in Kahnweiler, *Mes Galeries et mes peintres,* 62. More information on this letter, including the date, is provided in Werner Spies, "Vendre des tableaux—donner à lire," in *Daniel-Henry Kahnweiler, marchand, éditeur, écrivain,* 20, 110.

13. This forty-page brochure was published on 1 February 1912 to encourage the development of military aviation. See Daix and Rosselet, *Le Cubisme de Picasso,* 278.

14. Kahnweiler, who demanded above all moral integrity, autonomy, and purity of a work of art, felt that these newspaper drawings did not represent the true Gris. He did not even believe they had the value of drawing exercises for Gris. Kahnweiler regretted that some of these old journals, turning up at auctions, had begun to sell for high prices. He asserted that Gris, who had renounced these drawings and who had done them only in order to earn his living, would have been displeased at this turn of events. See Kahnweiler, *Mes Galeries et mes peintres,* 69–70.

15. "A une époque de grande détresse, on lui proposa de faire une *Assiette au beurre,* journal humoristique en vogue à l'époque et dont il eût pu tirer sept à huit cents francs. Il refusa énergiquement, voire héroïquement." Olivier, *Picasso et ses amis,* 55–56.

16. Thomas Crow has brought attention to the importance of this issue for modernist art in general in a seminal article: "Modernism and Mass Culture in the Visual Arts," 215–64.

17. Douglas Cooper and Gary Tinterow, *The Essential Cubism: Braque, Picasso and their Friends, 1907–1920.*

18. This exhibition, occasioned by the donation of a substantial number of works in the Kahnweiler-Leiris collection, was accompanied by two catalogues, both of which published much previously unknown correspondence between Kahnweiler and the artists he represented. See *Donation Louise et Michel Leiris, Collection Kahnweiler-Leiris,* and *Daniel-Henry Kahnweiler, marchand, éditeur, écrivain.*

19. Baxandall, *Patterns of Intention: On the Historical Explanation of Pictures,* 41–72.

20. David Cottington, "What the Papers Say: Politics and Ideology in Picasso's Collages of 1912," 350–59. Similar views are expressed in Cottington's article "Cubism, Aestheticism, Modernism," in Rubin, *Picasso and Braque: Pioneering Cubism,* vol. 2.

21. "What the Papers Say," 353–54.

22. See n. 12 above.

23. For the full citation, see chap. 1, n. 9.

24. This debate, which took place in the pages of *Lacerba* in February and March of 1914, is discussed more fully in chapter 6 below.

25. "What the Papers Say," 356–58.

26. "Je jugeais que la personne du peintre n'avait pas à intervenir et que par conséquent les tableaux devaient être anonymes. C'est moi qui décidai qu'il ne fallait pas signer les toiles et pour un certain temps Picasso en fit autant. Du moment que quelqu'un pouvait faire la même chose que moi, je pensais qu'il n'y avait point de différence entre les tableaux et il ne fallait pas qu'ils soient signés." "Braque, La peinture et nous," 18. Later Braque reversed his position, coming to believe in the value of the revelation of the self. The statement quoted above is followed with this reflection: "Later I understood that all that was not true, and I began again to sign my canvases. Besides Picasso had also recommenced. I understood that without 'tics,' without the sensible trace of the person, one cannot reveal oneself. But all the same, one shouldn't exaggerate in this sense . . ." [Après je compris que tout cela n'était pas vrai et je recommençai à signer mes toiles. Picasso du reste, avait recommencé lui aussi. Je compris que sans "tics" sans la trace sensible de la personne, on ne peut pas se révéler. Mais tout de même il ne faut pas exagérer dans ce sens . . .], 18.

27. "Les belles inventions de notre temps, . . . inspirées par la pensée de diminuer les privilèges de la fortune, en faisant participer le grand nombre aux bienfaits de l'industrie humaine et aux jouissances que procure le beau. Il était naturel au surplus que l'avènement de la démocratie coïncidât avec un désir presque universel d'augmenter le bien-être de la classe la plus nombreuse, et d'inventer pour elle, sinon l'équivalent du luxe, au moins ce qui pourrait lui en donner le mirage." Charles Blanc, "Du papier peint," *Grammaire des arts décoratifs,* 58.

28. Ibid. There is some irony in Blanc's association of the Revolution and Reveillon. This industrialist, whose wallpapers had born the royal arms from 1784 to 1789, was one of the Revolution's first victims. Reveillon's factory was pillaged, and he lost all his stock of paper, drawings, and printing equipment as well as his Royal Medal. Afraid of further reprisals, Reveillon turned himself in as a voluntary prisoner to the Bastille, where he remained during most of May 1789. After this interlude, he fled across the English Channel and later died in England. For the history of the French wallpaper industry, see Henri Clouzot, *Le papier peint en France du XVIIe au XIXe siècle* (Paris: Les Éditions G. van Oest, 1931), and Henri Clouzot and Charles Follot, *Histoire du papier peint en France* (Paris: Éditions d'art Charles Moreau, 1935). Catherine Lynn, *Wallpaper in America from the Seventeenth Century to World War I* (New York: W. W. Norton, 1980), also contains some valuable information on French wallpaper.

29. "Dès que la sensation que procurent ces belles productions de l'industrie n'est troublée sur aucun point, n'est gâtée par aucune appréhension, par aucun scrupule du re-gard, il importe peu que la substance soit vraie, puisque la contrefaçon n'a pas été imaginée, cette fois, dans l'intention de rançonner l'acheteur, mais, au contraire, afin de multiplier ses plaisirs en ménageant ses ressources." Blanc, "Du papier peint," 59–60.

30. "C'est surtout par la bordure que les tableaux, gravures ou dessins doivent s'enlever sur le papier peint, parce qu'une fois isolées par leur encadrement, les choses encadrées auront toute leur valeur si le papier du fond n'a rien qui attire l'oeil." Ibid., 76.

31. Ibid., 76–77.

32. "Le papier peint avec les moyens les plus rudimentaires de gravures, tirage et matières, nous a laissé des décors que l'on souhaiterait d'égaler aujourd'hui. Depuis un demi-siècle l'emploi et la perfection des machines avaient contribué à supprimer tout l'intérêt artistique. Ces recherches se bornant à l'imitation de matières différentes (cretonnes, soies, velours, cuirs, etc.) et allant ainsi à l'encontre du but proposé." See André Mare, "Le papier peint," 13.

33. "Le papier de tenture pendait en lambeaux des murs en planches." Kahnweiler, *Mes Galeries et mes peintres,* 55.

34. The Musée des arts décoratifs opened in 1905. For the history and purpose of this new museum, see the *Mercure de France* (1 August 1905), 459–60.

35. The wallpaper border of Picasso's collage *Glass* (Jucker Collection) was removed at some point and replaced with a real, carved frame. Both *Glass and Bottle of Bass* (private collection) and *Pipe and Musical Score* (Museum of Fine Arts, Houston) have real frames which now enclose the wallpaper frames but leave them visible.

36. "A l'origine, l'arabesque pure, aussi peu trompe-l'oeil que possible; un mur est vide: le remplir avec des taches symétriques de forme, harmonieuses de couleurs (vitraux, peintures égyptiennes, mosaïques byzantines, kakémonos).

Vient le bas-relief peint (les métopes des temples grecs, l'église du Moyen-Age.

Puis l'essai de trompe-l'oeil ornemental de l'antiquité est repris par le XVe siècle, remplaçant le bas-relief peint par la peinture au modelé de bas-relief, ce qui conserve d'ailleurs l'idée première de décoration . . .

Perfectionnement de ce modelé: modelé de ronde bosse; cela mène des premières Académies des Carraches à notre décadence. L'Art c'est quand ça tourne." "Définition du Néo-Traditionnisme," *Art et critique* (23 and 30 August 1890), repr. in *Théories, 1890–1910,* 7.

37. "La peinture décorative c'est, à proprement parler, la vraie peinture. La peinture n'a pu être créée que pour *décorer* de pensées, de rêves et d'idées les murales banalités des édifices humains. Le tableau de chevalet n'est qu'un illogique raffinement inventé pour satisfaire la fantaisie ou l'esprit commercial des civilisations décadentes." Aurier, "Le Symbolisme en peinture, Paul Gauguin," 163.

38. "Ils pensèrent ramener l'Art à la simplesse de son début, alors que sa destination décorative était encore incontestée." Maurice Denis, "A propos de l'exposition d'A. Séguin," *La Plume* (1 March 1895), repr. in *Théories 1890–1910,* 23.

39. Quoted in Pierre Schneider, *Matisse,* 177.

40. "A Talk with Matisse," in Flam, *Matisse on Art,* 51.

41. These paintings were commissioned by the wealthy Russian collector, Sergeï Shchukin, to decorate a stairway in his palace.

42. For an excellent analysis of Matisse's *Interior with Eggplants* as an expression of the artist's decorative ideal, see Dominique Fourcade, "Rêver à trois aubergines . . . ," 467–89. According to Fourcade, Matisse painted an original "faux cadre," consisting of a pink five-petal flower motif, on the same canvas as the tableau. Although later cut off, a few centimeters of this frame are still extant, nailed to the edge of the stretcher. Analysis of the black and white photograph of the definitive version of *Interior with Eggplants* suggests that this frame was then replaced with another in which Matisse seems to have reversed the relation of the colors with respect to the tableau; the flowers may have been brownish-red on a blue ground, for example (472–74). According to Alfred H. Barr, Jr., Matisse claimed that the frame was removed against his wishes: see *Matisse, His Art and His Public,* 540, n. 7. Fourcade, however, in the article cited above, argues it was probably Matisse himself who cut off the frame for aesthetic reasons. *Interior with Eggplants* proposes a centrifugal view of the decorative work of art, which overflows its boundaries to merge with the world beyond the frame. According to Fourcade, Matisse may have felt that the frame, although painted with the same decorative motif as the tableau, limits the possibility of infinite extension, and therefore decided to suppress it. (485)

43. "Estienne: Interview with Matisse, 1909," in Flam, *Matisse on Art,* 49. This interview, printed just four months after "Notes of a Painter," omits the famous reference to painting being like a "good armchair," which may have given rise to some misunderstanding, but otherwise it repeats the earlier statement.

44. "Matisse's Radio Interview: First Broadcast, 1942," in Flam, *Matisse on Art,* 91.

45. "On s'est mépris sur le vrai sens du cubisme qui était une *écriture* qui se voulait sévère, ferme, précise, et on a cru qu'il s'agissait simplement de *décoration.*" *Mes Galeries et mes peintres,* 90.

46. Ibid.

47. "Si, comme je le soutiens, la peinture est une écriture, il est bien évident que toute écriture est une convention. Il faut donc accepter cette convention, apprendre cette écri-ture. C'est ce qui se fait généralement par la simple habitude." Ibid., 88.

48. Emile de Girardin first experimented with cutting subscription costs in early 1835, when he founded *Le Journal des connaissances utiles.* This journal's successor, *La Presse,* first appeared on 1 July 1836 at a cost of forty francs per year rather than the standard eighty francs. Girardin reasoned that it would be easier to acquire ten thousand subscribers at the lower rate than one thousand at the higher rate. His success was even greater than he had anticipated; after three months, *La Presse* counted twenty thousand subscribers. See Henri Avenel, *Histoire de la presse française depuis 1789 jusqu' à nos jours,* 368.

49. Walter Benjamin made this observation in his discussion of the *feuilleton* in *Charles Baudelaire: A Lyric Poet in the Era of High Capitalism,* 35.

50. Notably, the conservative *Journal des Débats* was the only paper not to reduce its price of eighty francs without suffering diminished influence or prosperity. Ibid., 369.

51. For a fascinating discussion of the new serial form and the narrative structures it engendered, see Peter Brooks, "The Mark of the Beast," in *Reading for the Plot: Design and Intention in Narrative,* 143–70.

52. This newspaper, founded the same day as *La Presse,* and with nearly identical principles, eventually became even more successful than its competitor, attaining a circulation of thirty-eight thousand in a few years.

53. Balzac, who had incurred great debts during his brief attempt to establish his own printing press, was only too well aware of the choices faced by a young aspiring writer of his day: an unscrupulous but financially successful career as a journalist or a long, arduous attempt to be a writer of literature, with little hope of recompense. This theme is the subject of the second part of his three-part novel *Lost Illusions,* in which journalists are characterized as men of little principle who have turned the press into an instrument for achieving social advancement and political power. Balzac himself, however, had contributed to many newspapers during the twenties and thirties and had even played a role in founding and directing some of them.

54. *Le Petit Journal,* founded by Moïse Millaud, revolutionized the French press by achieving, almost immediately, the unheard of circulation of one hundred thousand copies per day. By 1900 the figure had surpassed one million. This wide distribution was made possible by use of the rolling press, invented by Hippolyte Marinoni, who eventually became director of the paper. The *presses rotatives* could print forty thousand papers per hour. Other papers were forced to follow suit and eventually five centimes became the standard cost of a daily paper. See Avenel, *Histoire de la presse française,* 491, 853–65.

55. Ibid., 468.

56. Norman Stone, *Europe Transformed, 1878–1919,* 14.

57. "Le vers est partout dans la langue où il y a rythme, partout, excepté dans les affiches et à la quatrième page des journaux." "Sur l'évolution littéraire," *Oeuvres,* 867. Not surprisingly, Mallarmé at times also expressed a fascination for this demonized other. In the notes to "La Musique et les lettres," we find the following remark on the poster and the newspaper: "L'affiche, lapidaire, envahissant le journal—souvent elle me fit songer comme devant un parler nouveau et l'originalité de la Presse," *Oeuvres,* 655. [The poster, with its pithy phrases, invading the newspaper—often it sets me dreaming as if before a new speech and the originality of the press.]

58. From the context of this statement, it is clear that Mallarmé intends to contrast literature with journalism. At times in his critical essays, however, the term *literature* assumes a negative value in relation to the pure art of poetry.

59. "Un désir indéniable à mon temps est de séparer comme en vue d'attributions différentes le double état de la parole, brut ou immédiat ici, là essentiel. Narrer, enseigner, même décrire, cela va et encore qu'à chacun suffirait peut-être pour échanger la pensée humaine, de prendre ou de mettre dans la main d'autrui en silence une pièce de monnaie, l'emploi élémentaire du discours dessert l'universel *reportage* dont, la littérature exceptée, participe tout entre les genres d'écrits contemporains." "Crise de vers," *Oeuvres,* 368.

60. "Plutôt la Presse, chez nous seuls, a voulu une place aux écrits—son traditionnel feuilleton en rez-de-chaussée longtemps soutint la masse du format entier . . . Mieux, la fiction proprement dite ou le récit, imaginatif, s'ébat au travers de 'quotidiens' achalandés, triomphant à des lieux principaux, jusqu'au sommet; en déloge l'article de fond, ou d'actualité, apparu secondaire." "Étalages," *Oeuvres,* 376.

61. "Personne ne fit d'allusion aux vers." Ibid., 373.

62. Here Mallarmé is speaking of debased forms of literature, such as the *roman feuilleton.* This negatively valued literature is opposed to poetry in the ideal form of the book. See n. 58 above.

63. "Je . . . techniquement, propose, de noter comment ce lambeau diffère du livre, lui suprême. Un journal reste le point de départ; la littérature s'y décharge à souhait.
 Or—
 Le pliage est, vis-à-vis de la feuille imprimée grande, un indice, quasi religieux: qui ne frappe pas autant que son tassement, en épaisseur, offrant le minuscule tombeau, certes, de l'âme." *Oeuvres,* 379. Mallarmé had also compared literature to a "tomb" in a passage in "The Evolution of Literature": "For me, the situation of the poet in this society that does not permit him to live, is the situation of a man who isolates himself in order to sculpt his own tomb."

[Pour moi, le cas d'un poëte, en cette société qui ne lui permet pas de vivre, c'est le cas d'un homme qui s'isole pour sculpter son propre tombeau.] "Sur l'évolution littéraire," *Oeuvres,* 869.

64. "Le reploiement vierge du livre, encore, prête à un sacrifice dont saigna la tranche rouge des anciens tomes; l'introduction d'une arme, ou coupe-papier, pour établir la prise de possession. . . . Les plis perpétueront une marque, intacte, conviant à ouvrir, fermer la feuille, selon le maître. Si aveugle et peu un procédé, l'attentat qui se consomme, dans la destruction d'une frêle inviolabilité." "Le Livre, instrument spirituel," *Oeuvres,* 381.

65. Jacques Derrida has discussed the paradoxical meanings of the "fold" in Mallarmé's writing in "The Double Session," 173–286. As Derrida puts it, "But in the same blow, so to speak, the fold ruptures the virginity it marks as virginity. . . . But after the fact, it still remains what it was, a virgin, beforehand, faced with the brandished knife . . ." (259).

66. "Journal, la feuille étalée, pleine, emprunte à l'impression un résultat indu, de simple maculature: nul doute que l'éclatant et vulgaire avantage soit, au vu de tous, la multiplication de l'exemplaire et, gise dans le tirage." "Le Livre," *Oeuvres,* 380. The use of the word *gise* should be noted. Mallarmé had already suggested that a *tome* (book) was like a *tombeau* (tomb) for the writer of literature. Here, however, through the conjunctions of the sounds *gise dans* (*gisant*), he implies that the improper use of the press results in a stillborn (horizontal) writing, incapable of flight from the earth. Death and flight are metaphors that circulate throughout Mallarmé's opposition of poetry and journalism, and sometimes they serve to suggest a hidden relationship between these two apparently contradictory forms of writing.

67. "Une monotonie—toujours l'insupportable colonne qu'on s'y contente de distribuer, en dimensions de page, cent et cent fois." Ibid., 381.

68. See Marinetti, "Destruction of Syntax—Imagination without Strings—Words-in-Freedom," in Apollonio, *Futurist Manifestos,* 96.

69. "Mon sens regrette que le discours défaille à exprimer les objets par des touches y répondant en coloris ou en allure, lesquelles existent dans l'instrument de la voix, parmi les langages et quelquefois chez un. A côté d'*ombre,* opaque, *ténèbres* se fonce peu; quelle déception, devant la perversité conférant à *jour* comme à *nuit,* contradictoirement, des timbres obscur ici, là clair. Le souhait d'un terme de splendeur brillant, ou qu'il s'éteigne, inverse; quant à des alternatives lumineuses simples—*Seulement,* sachons *n'existerait pas le vers:* lui, philosophiquement rémunère le défaut des langues, complément supérieur." "Crise de vers," *Oeuvres,* 364.

70. Mallarmé writes of "le hasard vaincu mot par mot" in "Le Mystère dans les lettres," *Oeuvres,* 387.

71. Mallarmé's famous definition of the symbol appeared in his essay "Sur l'évolution littéraire": "*Nommer* un object, c'est supprimer les trois quarts de la jouissance du poëme qui est faite de deviner peu à peu: le *suggérer,* voilà le rêve. C'est le parfait usage de ce mystère qui constitue le symbole: évoquer petit à petit un objet pour montrer un état d'âme, ou, inversement, choisir un objet et en dégager un état d'âme, par une série de déchiffrements." [*To name an object is to suppress three-quarters of the pleasure of a poem which is the product of divining little by little: to suggest it, there is the dream. It is the perfect use of this mystery that constitutes the symbol: to evoke a bit at a time an object in order to reveal a state of mind, or, inversely, to choose an object and to disengage from it a state of mind, through a series of decipherings.] *Oeuvres,* 869.

72. In his "Autobiographie," Mallarmé described his "spiritual book" or "Great Work" as "L'explication orphique de la Terre," *Oeuvres,* 663.

73. "La constellation y affectera, d'après des lois exactes, et autant qu'il est permis à un texte imprimé, fatalement une allure de constellation. Le vaisseau y donne de la bande, du haut d'une page au bas de l'autre, etc.; . . . le rythme d'une phrase au sujet d'un acte, ou même d'un objet, n'a de sens que s'il les imite, et figuré sur le papier, repris par la lettre à l'estampe originelle, n'en sait rendre, malgré tout, quelque chose." Letter from Mallarmé to André Gide written in 1897. *Oeuvres,* 1582.

74. "Le livre, expansion totale de la lettre, doit d'elle tirer, directement, une mobilité et spacieux, par correspondances, instituer un jeu, on ne sait, qui confirme la fiction. Rien de fortuit, là, où semble un hasard capter l'idée, l'appareil est l'égal: ne juger, en conséquence, ces propos—industriels ou ayant trait à une matérialité." "Le Livre," *Oeuvres,* 380.

75. "A mon tour, je méconnais le volume et une merveille qu'intime sa structure, si je ne puis, sciemment, imaginer tel motif en vue d'un endroit spécial, page et la hauteur, à l'orientation de jour la sienne ou quant à l'oeuvre. Plus le va-et-vient successif incessant du regard, une ligne finie, à la suivante, pour recommencer: pareille pratique ne représente le délice, ayant immortellement, rompu, une heure, avec tout, de traduire sa chimère. Autrement ou sauf exécution, comme de morceaux sur un clavier, active, mesurée par les feuillets—que ne ferme-t-on les yeux à rêver?" Ibid., 380.

76. Charles Morice, for example, writing in 1889, shared Mallarmé's views on the distinction between journalism and literature: "I don't think I have to specify in what ways literature and journalism, although they employ the same alphabet, constitute two arts absolutely foreign to each other." [Je ne pense pas avoir à spécifier en quoi la Littérature et le Journalisme, bien qu'ils emploient le même alphabet, constituent deux Arts absolument étrangers l'un à l'autre.] *La littérature de tout à l'heure,* 292, n. 1. Morice explained his aversion to journalism in the following terms: "The very idea of *selling* a poetic object is repugnant to one's honor: an archaic and epic point of view . . . But this very action is contrary to logic since it is *la rue du Sentier,* in the last analysis, that is the arbiter of art as well as of commerce, since in other terms, art has become a trade." [L'idée seule de *vendre* la chose poétique répugne à l'honneur: point de vue archaique et légendaire. . . Mais le fait même répugne à la logique depuis que c'est *la rue du Sentier,* en dernière analyse, qui est l'arbitre de l'art aussi bien que du commerce, depuis, en d'autres termes, que l'art est devenu un commerce.] (291).

77. "Le travail d'après nature était la dernière sauvegarde du métier de peintre. On est arrivé ces dernières années à s'en passer complètement. On ne fait plus que noter des sensations, l'art n'est plus que le journal de la vie. C'est le journalisme dans la peinture c'est l'oeil qui mange la tête." Maurice Denis, "Les Arts à Rome ou la Méthode Classique," *Le Spectateur catholique,* nos. 22, 24 (1896), repr. in *Théories 1890–1910,* 52–53.

78. Rosalind Krauss, in "The Motivation of the Sign," in *Picasso and Braque: Pioneering Cubism,* vol. 2, argues that in the collages executed during the fall of 1912, Picasso's use of newspaper represents a demonstration of the way even this commercial material can assume the characteristics Mallarmé had reserved for poetry: the fold, the presence of white spaces, a play on the absence of the material referent. For Krauss, this takes on special significance in the context of Apollinaire's new interest in Futurism and theories of simultaneity, which would have dismayed Picasso. While I agree that in Picasso's collages, newspaper can and often does take on Mallarméan formal qualities, I also wish to maintain a sense of Picasso's positive engagement with mass-cultural forms of expression. This fascination with commercial artifacts can be observed as early as the spring of 1912 in Picasso's use of machine-printed oilcloth in the *Still Life with Chair-Caning* and in his use of Ripolin paint and stenciled letters. Indeed, Apollinaire's celebration of urban posters and advertisements in his poem *Zone,* written in September and October of 1912, not only suggests a rapprochement with Blaise Cendrars and the Futurists, but may also reflect his awareness of Picasso's prior interest in this theme, as exemplified by *Landscape with Posters* of the summer of 1912.

79. *Selected Writings of Guillaume Apollinaire,* 116–17.

80. Maurice Raynal reported seeing books by Verlaine, Rimbaud, and Mallarmé in Picasso's studio in the rue Ravignan (that is, before 1909), in *Picasso,* 52–53. Picasso would also have had occasion to discuss the poetry of Mallarmé with his many poet friends, including Apollinaire and Soffici. The latter described Picasso's treatment of form as similar to the elliptical syntax and grammatical transpositions in Mallarmé's poetry in his *La Voce* article

of 24 August 1911, "Picasso e Braque," which he sent to Picasso. Picasso read the article in November of 1911 and probably discussed it with Soffici when he visited Paris during the spring of 1912.

Despite the fact that *Un Coup de dés* was published in *Cosmopolis* in May 1897 and was not republished in its definitive typographical version by Gallimard until 1914, the poem and its unusual format seem to have been familiar to members of the Parisian avant-garde, especially those who frequented the Closerie des Lilas. Paul Valéry, who had seen the original manuscript and heard Mallarmé read it, no doubt did a great deal to keep the legend surrounding this poem alive, as did André Gide. Also, Albert Thibaudet's intelligent book *La Poésie de Stéphane Mallarmé* of 1912 contained a chapter on *Un Coup de dés* in which the author described the innovative aspects of the poem: "Mallarmé wanted, for this poem, a visual aesthetic, typographic, constructed through the difference of characters, the breadth of the white spaces, the dimension of the lines, all the architecture of the page." [Mallarmé a voulu, pour ce poème, une esthétique visuelle, typographique, bâtie par la différence des caractères, l'ampleur des blancs, la dimension des lignes, toute l'architecture de la page.] (338). Because he recognized that few people had seen *Un Coup de dés,* Thibaudet reproduced the first page of the *Cosmopolis* version of the poem (even while noting that it did not follow Mallarmé's manuscript faithfully) and several other fragments in his book.

81. Mallarmé advises those who would *read* to confront the whiteness of the page "forgetful even of the title which would speak too loudly." [oublieuse même du titre qui parlerait trop haut.] "Le Mystère dans les lettres," *Oeuvres,* 387.

82. Robert Rosenblum, "Picasso and the Typography of Cubism," 33–47.

83. Patricia Leighten, "Picasso's Collages and the Threat of War, 1912–13." See also her *"La Propagande par le rire:* Satire and Subversion in Apollinaire, Jarry and Picasso's Collages," 163–72, and *Re-Ordering the Universe: Picasso and Anarchism, 1897–1914.*

84. Ronald Johnson mentions Mallarmé's aversion to the newspaper in connection with his analysis of Picasso's collages and constructions but does not emphasize its commercial associations. He is more interested in demonstrating the similarities between Picasso's constructions and Mallarmé's aesthetics than the differences. Thus his analysis turns on concepts of chance, suggestion, and creativity as a destructive process. Of the newspaper he says, "Picasso in fact became a poet of puns and word fragments, turning to printed words, whereas Mallarmé used visual processes to add another dimension to his poetry. Mallarmé thought of the book as a spiritual instrument in contrast to the newspaper which he compared to the sea. It was the newspaper and its mechanical sense of lettering that Picasso subverted to his own semiotic purposes. He not only used the newspaper for its form (flatness) and value (stark dark light contrasts) with many reversible effects, but began using the letters to create an abreviated [sic] telegraphic poetry. . . . Perhaps there is a more immediate relationship to Apollinaire's *Calligrams* and to Alfred Jarry's puns in this fragmentation process, sense of surprise, and humor than to Mallarmé, but it is the latter who began the process." "Picasso's Musical and Mallarméan Constructions," 127.

85. Musée Picasso, Carnet 109, 1865 / 45.

86. Rosenblum, "Picasso and the Typography of Cubism," 36.

87. Apollinaire continued to supplement his meager income as poet and critic by writing and editing pornography, and Picasso was certainly aware of this activity. It is also interesting to note that Apollinaire's first work to be published, albeit under another man's name, was the bulk of the serial novel *Que faire?,* which appeared in *Le Matin* in 1900. Apollinaire was never paid by the hack journalist Esnard, who signed the installments written by various authors. For an account of Apollinaire's publications, see Roger Shattuck, "The Impresario of the Avant-Garde," in *The Banquet Years,* 253–97.

88. Benjamin, *Charles Baudelaire: A Lyric Poet in the Era of High Capitalism,* 37.

89. The lyrical fragment *Ma Jolie* was excerpted from the refrain of Fragson's *Dernière chanson,* written in 1911 and popular during 1911 and 1912. The refrain was as follows: "O Manon, ma jolie, mon coeur te dit bonjour!" See Rosenblum, "Picasso and the Typography of Cubism," 38. Rosenblum credits Maurice Jardot with this reference.

90. "Car l'oeuvre, seule ou préférablement . . . " "Le Livre," *Oeuvres,* 381.

91. "L'oeuvre pure implique la disparition élocutoire du poète, qui cède l'initiative aux mots, par le heurt de leur inégalité mobilisés; ils s'allument de reflets réciproques comme une virtuelle traînée de feux sur des pierreries, remplaçant la respiration perceptible en l'ancien souffle lyrique ou la direction personnelle enthousiaste de la phrase." "Crise de Vers," *Oeuvres,* 366.

92. "Quoi? c'est difficile à dire: un livre, tout bonnement, en maints tomes, un livre qui soit un livre, architectural et prémédité, et non un recueil des inspirations de hasard fussent-elles merveilleuses. . .

Voilà l'aveu de mon vice, mis à nu, cher ami, que mille fois j'ai rejeté, l'esprit meurtri ou las, mais cela me possède et je réussirai peut-être; non pas à faire cet ouvrage dans son ensemble (il faudrait être je ne sais qui pour cela!) mais à en montrer un fragment d'exécuté, à en faire scintiller par une place l'authenticité glorieuse, en indiquant le reste tout entier auquel ne suffit pas une vie.

Prouver par les portions faites que ce livre existe, et que j'ai connu ce que je n'aurai pu accomplir." *Oeuvres,* 662–63.

93. "Surtout manqua cette notion indubitable: que, dans une société sans stabilité, sans unité, il ne peut se créer d'art stable, d'art définitif. De cette organisation sociale inachevée, qui explique en même temps l'inquiétude des esprits, naît l'inexpliqué besoin d'individualité . . ." "Sur l'évolution littéraire," *Oeuvres,* 866–67.

94. "Car moi, au fond, je suis un solitaire, je crois que la poésie est faite pour le faste et les pompes suprêmes d'une société constituée où aurait sa place la gloire dont les gens semblent avoir perdu la notion. L'attitude du poëte dans une époque comme celle-ci, où il est en grève devant la société, est de mettre de côté tous les moyens viciés qui peuvent s'offrir à lui. Tout ce qu'on peut lui proposer est inférieur à sa conception et à son travail secret." Ibid., 869–70.

95. Robert Rosenblum discusses the unusual date of these newspaper clippings in "Picasso and the Coronation of Alexander III: A Note on the Dating of Some *Papiers Collés,*" 605.

96. The first line of the article, small bits of which are missing, reads, "La cérémonie qui s'est déroulée sous / mes yeux dépasse tout ce qu'on peut rê- / [. . .] grandeur véritable en pitt[ore]s- / " [the text is cut off here].

97. *Philosophical Investigations,* trans. G. E. Anscomb, 3d ed. (Oxford: Basil Blackwell, 1968), 153, §584.

98. "L'homme peut être démocrate, l'artiste se dédouble et doit rester aristocrate. . . .

L'heure qui sonne est sérieuse: l'éducation se fait dans le peuple, de grandes doctrines vont se répandre. Faites que s'il est une vulgarisation, ce soit celle du bon, non celle de l'art, et que vos efforts n'aboutissent pas—comme ils n'y ont pas tendu, je l'espère—à cette chose, grotesque si elle n'était triste pour l'artiste de race, le *poëte ouvrier.*" "L'art pour tous," *Oeuvres,* 259–60.

99. "On va répétant, non sans vérité, qu'il n'y a plus de lecteurs; je crois bien, ce sont des lectrices. Seule, une dame, dans son isolement de la Politique et des soins moroses, a le loisir nécessaire pour que s'en dégage, sa toilette achevée, un besoin de se parer aussi l'âme." "Chronique de Paris," *La Dernière Mode, Oeuvres,* 716.

100. Crow, "Modernism and Mass Culture in the Visual Arts," 224.

101. For an analysis of the early buyers of works by Picasso, Braque, Gris, and Léger, see Douglas Cooper, "Early Purchasers of True Cubist Art," *The Essential Cubism 1907–1920,* 15–31.

102. J. André Faucher describes *Le Matin* in the following terms: "*Le Matin* at this time presented itself as very modern. It had special telegraph wires connecting it to London

and New York. It counted innumerable correspondents. It was the businessman's newspaper par excellence." [*Le Matin* fait alors figure de journal très moderne. Il a des fils spéciaux qui le relient à Londres et à New York. Il compte d'innombrables correspondants. . . . C'est par excellence le journal que lisent les hommes d'affaires.] *Le Quatrième Pouvoir: La presse, de 1830 à 1930,* 55. Gris's *A Man in a Café* seems to play on this commercial association.

103. Picasso, who met Matisse in 1906, agreed to an exchange of works and selected the *Portrait de jeune fille.* According to Salmon, "These small gifts did little to bring about a good friendship, and a certain *Portrait de jeune fille* was subjected to the most burlesque outrages by its owner and his guests." [Ces petits cadeaux contribuèrent peu à entretenir la bonne amitié, et certain *Portrait de jeune fille* dut subir de son propriétaire et de ses hôtes les plus burlesques outrages.] *La jeune peinture française,* 16.

104. Paradoxically, to make fragile works out of the debris of a commodity culture was both to associate the work with the inherent obsolescence of the commodity and to satirize contemporary expectations of preciosity, thereby making works that were less saleable.

105. Eagleton, *Walter Benjamin, or Towards a Revolutionary Criticism,* 11.

Chapter 6. The Futurist Collage Aesthetic

1. Marinetti, "The Founding and Manifesto of Futurism," in Apollonio, *Futurist Manifestos,* 22. "Musei: cimiteri! . . . Identici, veramente, per la sinistra promiscuità di tanti corpi che non si conoscono. Musei: dormitori pubblici in cui si riposa per sempre accanto ad esseri odiati o ignoti! Musei: assurdi macelli di pittori e scultori che vanno trucidandosi ferocemente a colpi di colori e di linee, lungo le pareti contese!" "Fondazione e Manifesto del Futurismo," in Apollonio, *Futurismo,* 48–49.

2. Ibid., 22. "Perché volersi avvelenare? Perché volere imputridire?" In Apollonio, *Futurismo,* 49.

3. Ibid., 23. "E vengano dunque, gli allegri incendiari dalle dita carbonizzate! Eccoli! Eccoli! . . . Suvvia! date fuoco agli scaffali delle biblioteche! . . . Sviate il corso dei canali, per inondare i musei! . . . Oh, la gioia di veder galleggiare alla deriva, lacere e stinte su quelle acque, le vecchie tele gloriose!" In Apollonio, *Futurismo,* 49.

4. "Mentre i nostri predecessori, tutti indistintamente (Cézanne e Renoir compresi) avevano come sogno e punto d'arrivo il MUSEO, noi pittori futuristi avremo creato un tipo concreto di sintesi plastica, frutto della nostra sensibilità futurista ormai stanca e nauseata di avere davanti a sé dei cadaveri imbalsamati da contemplare." "Vita moderna e arte popolare," *Lacerba* (1 June 1914), repr. in Carlo Carrà, *Tutti gli scritti,* 38.

5. "Anche per noi futuristi 'la pittura non risiede nei tubetti Lefranc'. Se un individuo possiede senso pittorico, qualsiasi cosa crea, guidato da questo senso, sarà sempre nel dominio della pittura. Legno, carta, stoffa, pelli, vetro, corda, telacerata, maiolica, latta e tutti i metalli, colori, mastici, ecc. ecc., entreranno come materiali legittimissimi nelle nostre presenti costruzioni artistiche.

La quantità e la scelta di questo materiale sarà regolata caso per caso dal nostro spirito creatore il quale in materia d'arte è il solo autorevole arbitro che ammettiamo.

Cosí, se saranno modificate e distrutte le categorie, tutt'affatto arbitrarie del resto, che facevano della pittura un *giuoco artificioso perpetrato con dei colori e della tela* l'art se ne avvantaggerà poiché sarà resa libera da ogni pregiudizio e si manifesterà nella sua massima sincerità e purezza." Ibid.

6. "Se noi accusiamo i cubisti, . . . di non creare opere ma soltanto frammenti, è perché nei loro quadri si sente la necessità di un ulteriore e più vasto sviluppo. Inoltre, è perché le loro tele mancano di un centro essenziale all'organismo dell'opera intera, e di quelle forze circostanti che confluiscono a tale centro e gravitano intorno ad esso.

Infine, è perché si nota che l'arabesco dei loro dipinti è puramente accidentale, mancando di un carattere di totalità indispensabile alla vita dell'opera." "Da Cézanne a noi futuristi," *Lacerba* (15 May 1913), repr. in Carrà, *Tutti gli scritti,* 14.

7. "Noi futuristi cerchiamo invece, con la forza dell'intuizione, d'immedesimarci nel centro delle cose, in modo che il nostro io formi colla loro unicità un solo complesso." "Piani plastici come espansione sferica nello spazio," *Lacerba* (15 March 1913), repr. in Carrà, *Tutti gli scritti,* 9.

8. "cadrebbe ogni accusa di arbitrario . . . " "Da Cézanne a noi futuristi," 16.

9. "Balla dipingeva con colori separati e contrastanti, come i pittori francesi; la sua "qualità pittorica" era di prim'ordine, genuina, con qualque analogia con la materia e la qualità di un Pissarro. Fu una grande fortuna per noi d'incontrare un tale uomo, la cui direzione decise forse di tutta la nostra carriera." Severini, *Tutta la vita di un pittore,* 22.

10. Ibid., 47, 117–18.

11. "Mentre Picasso e Braque, forse per meglio accentuare la loro reazione all'impressionismo, avevano adottata la gamma dei colori di Corot, io conservavo come base la formula dei neo-impressionisti, aggiungendovi però il nero puro, il bianco e il grigio, convinto che tale formula della divisione dei colori, meglio di ogni altra, si adattava al divisionismo delle forme." Ibid., 88–89.

12. Ibid., 91.

13. ". . . non può sussistere pittura senza *divisionismo*." "La Pittura Futurista—Manifesto Tecnico," in Apollonio, *Futurismo,* 57.

14. *Tutta la vita di un pittore,* 116–18.

15. "Futurist Painting: Technical Manifesto," in Apollonio, *Futurist Manifestos,* 29. "Il divisionismo, tuttavia, non è nel nostro concetto un *mezzo* tecnico che si possa metodicamente imparare ed applicare. Il divisionismo, nel pittore moderno, deve essere un COMPLEMENTARISMO CONGENITO, da noi giudicato essenziale e fatale." "La Pittura Futurista—Manifesto Tecnico," in Apollonio, *Futurismo,* 57.

16. For a discussion of the role of these theories in the development of Seurat's mature style, see Robert L. Herbert, "'Parade de Cirque' de Seurat et l'esthétique scientifique de Charles Henry," *Revue de l'art,* no. 50 (1980): 9–23.

17. "Guidé par la tradition et par la science, il harmonisera la composition à sa conception, c'est-à-dire qu'il adaptera les lignes (directions et angles), les clair-obscur (tons), les couleurs (teintes) au caractère qu'il voudra faire prévaloir. La dominante des lignes sera horizontale pour le calme, ascendante pour la joie, et descendante pour la tristesse, avec toutes les lignes intermédiaires pour figurer toutes les autres sensations en leur variété infinie. Un jeu polychrome, non moins expressif et divers, se conjugue à ce jeu linéaire: aux lignes ascendantes, correspondront les teintes chaudes et des tons clairs; avec les lignes descendantes, prédomineront des teintes froides et des tons foncés; un équilibre plus ou moins parfait des teintes chaudes et froides, des tons pâles et intenses, ajoutera au calme des lignes horizontales." *D'Eugène Delacroix au néo-impressionnisme,* 76.

18. "The Exhibitors to the Public," (Galerie Bernheim-Jeune, Paris), English version from the catalogue of the "Exhibition of Works by the Italian Futurist Painters," (Sackville Gallery, London, March 1912), in Apollonio, *Futurist Manifestos,* 49.

19. See Herbert, "'Parade de Cirque' de Seurat," 13–14.

20. Severini regarded the painting of "states of mind" as a mistaken "literary" enterprise and Boccioni's concept of "divisionismo congenito" as meaningless jargon. See *Tutta la vita di un pittore,* 124, 136.

21. "The Exhibitors to the Public," 48.

22. Ibid., 46

23. Severini recalled in his memoirs that during this period he went almost every night to the Brasserie dell'Hermitage with Picasso, Fernande, Marcoussis, and Eva Gouel. See *Tutta la vita di un pittore,* 150–52. He also recalled that it was after the Futurist exhibition of February 1912 that he became a close friend of Apollinaire: "I saw him [Apollinaire] everyday, at Picasso's, at my place or at Braque's, who had his atelier above mine, or at Dufy's, who had his atelier next to mine. He saw me work on very well-known canvases, because he came very often to my atelier." [Moi

je le voyais tous les jours, chez Picasso, chez moi, ou chez Braque, qui avait son atelier au-dessus du mien, ou bien chez Dufy, qui avait son atelier à côté du mien. Il m'a vu travailler à des toiles bien connues, car il venait très souvent à mon atelier.] See Gino Severini, "1960, Souvenirs sur Apollinaire: Lettre à Sangiori," *Ecrits sur l'art,* 355.

24. "La mia amicizia con Apollinaire era divenuta intima. Fin dal 1912 veniva spesso da me mentre lavoravo. Fu verso la fine di quell'anno, non ricordo più se all'Hermitage, o al Lapin o al mio studio, che mi parlò di alcuni primitivi italiani che avevano messo nei quadri degli elementi di vera realtà; osservando che tale presenza, e il contrasto da essa provocato, aumentavano la vita delle pitture e tutto il loro dinamismo. Mi portò l'esempio di un S. Pietro esposto all'Accademia di Brera di Milano, che ha in mano delle chiavi vere, e di altri santi con altri oggetti, senza contare le aureole fatte con vere pietre preziose e vere perle.

Fu così che mi venne l'idea di fare un ritratto di Paul Fort con le copertine di 'Vers et Prose' e di altri suoi libri di poesie, e di costruire una ballerina con delle forme in rilievo sulle quali incollai dei veri lustrini di ballerina." *Tutta la vita di un pittore,* 174–75.

25. "Il contrasto tra un elemento realistico (di un realismo trascendentale, s'intende) ed altri elementi portati in un piano di assoluta astrazione, genera, come tutti i contrasti, dinamismo e vita." Ibid., 89.

26. "In fotografia, queste applicazioni risultavano poco, ma la pittura originale guadagnava molto in intensità espressiva." Ibid.

27. "Creando cioè delle zone per i lustrini, che così non erano messi per descrivere una realtà, ma per esprimerla in modo trascendentale." Ibid., 175.

28. A second *Portrait of Paul Fort,* which includes the poet's calling card, other publications associated with him, a pair of eyeglasses, a cummerbund, a fake moustache, and a wooden snuff box, was executed sometime after 1915.

29. "Suppongo che questa sia la ragione per cui Picasso in alcuni quadri mise addirittura dei numeri e delle lettere fatte con lo stampino. Ma più tardi abbandonò questo mezzo meccanico e dipinse anche lui degli elementi realistici, abbastanza evidenti per contrastare con l'astrazione con cui il resto del quadro era fatto." *Tutta la vita di un pittore,* 89.

30. In Apollonio, *Futurist Manifestos,* 123.

31. "La teoria dei contrasti poteva anche svilupparsi, soprattutto come inspirazione poetica, dal lato delle analogie. Un complementarismo di immagini, usato non per rendere più evidente una immagine con la guist'apposizione della sua analoga, ma crearne una nuova, tale era il mio scopo. In conclusione, io volevo, restando nello spirito della pittura, portare le immagini oltre la metafora nel più elevato piano poetico." *Tutta la vita di un pittore,* 207–08.

32. See chap. 1, n. 24.

33. "Marinetti dice che io sono portato ad esagerare il valore degli altri . . . Ma io non posso negare a me stesso il piacere di considerare l'opera di alcuni giovani francesi come eccellente e dichiarare a me stesso che Picasso è un talento straordinario, ma che mancano di tutto quello che io vedo e sento e per il quale credo e spero di superarli fra non molto." *Archivi,* 1:240.

34. ". . . mostrando, durante questo tempo, un grandissimo interesse per la scultura. Ogni giorno, e ad ogni momento, erano discussioni o conversazioni su questo argomento." *Tutta la vita di un pittore,* 163.

35. Braque returned to Paris on 6 June and remained there until late July or early August. It is not known exactly when Boccioni's visit to Paris took place since Severini's dates are not always precise.

36. "Prendi tutte le informazioni possibili sui cubisti e Picasso e Braque. Va da Kannailere [*sic*] se ci sono fotografie *ultimissime* di lavori (fatti dopo la mia partenza) comprane una o due." In *Archivi,* 1:246.

37. Published as a leaflet by *Poesia,* dated 11 April 1912, this manifesto did not appear in the newspaper *L'Italia* until 30 September 1912. The French version was published in *Je Dis Tout* on 6 October 1912.

38. Severini was dismayed by the publication of this manifesto, which claimed precedence for many of the ideas discussed in the studios of his friends, since it made it look as if he had been Boccioni's accomplice. *Tutta la vita di un pittore,* 164–65.

39. "Futurist Painting: Technical Manifesto," in Apollonio, *Futurist Manifestos,* 62. "In scultura come in pittura non si può rinnovare se non cercando LO STILE DEL MOVIMENTO." Ibid., 100.

40. Ibid., 64. "Non v'è né pittura, né scultura, né musica, né poesia, non v'è che creazione!" "La Scultura Futurista," in Apollonio, *Futurismo,* 103.

41. Ibid., 65. "Distruggere la nobiltà tutta letteraria e tradizionale del marmo e del bronzo. Negare l'esclusività di una materia per la intera costruzione d'un insieme scultorio. Affermare che anche venti materie diverse possono concorrere in una sola opera allo scopo dell'emozione plastica. Ne enumeriamo alcune: vetro, legno, cartone, ferro, cemento, crine, cuoio, stoffa, specchi, luce elettrica, ecc. ecc." In Apollonio, *Futurismo,* 104.

42. Ibid., 64–65.

43. "Io lavoro molto ma non concludo, me sembra. Cioè spero che quello che faccio significhi qualche cosa perché non capisco cosa faccio. È strano ed è terribile ma sono calmo. Oggi ho lavorato sei ore consecutive alla scultura e non capisco il risultato . . .

Piani su piani, sezioni di muscoli, di faccia e poi? E l'effetto totale? Vive ciò che creo? dove vado a finire? Posso chiedere ad altri entusiasmo e comprensione quando io stesso mi domando qual'è l'emozione che scaturisce da ciò che faccio? Basta ci sarà sempre un revolver . . . e pure sono calmissimo." [July or August 1912] *Archivi,* 1:248.

44. "La tua cara cartolina mi coglie in un momento terribile. Quello che dobbiamo fare è enorme; l'impegno preso è terribile e i mezzi plastici appaiono e scompaiono al momento della realizzazione. È terribile!

Non so cosa dire, non so cosa fare. Non capisco più nulla! . . .

È il caos dell'arbitrio? Quale la legge?

È terribile!

Io lotto poi con la scultura! lavoro lavoro lavoro e non sò cosa dò . . .

I cubisti han torto . . . Picasso ha torto." "Letter from Boccioni to Severini [August 1912], reproduced in Severini, "Lettere e documenti," *Critica d'arte,* 12; also partially reproduced in *Archivi,* 1:249.

45. "Io quindi pensai che scomponendo questa unità di materia in parecchie materie, ognuna delle quali servisse a caratterizzare, con la sua diversità naturale, una diversità di peso e di espansione dei volumi molecolari, si sarebbe già potuto ottenere un elemento dinamico." "Prefazione al Catalogo della 1ª Esposizione di scultura futurista," *Archivi,* 1:118.

46. "Technical Manifesto of Futurist Literature," in Flint, *Marinetti, Selected Writings,* 88.

47. "Si les reflets ont une vie composée et interpénétrable, en est-il de même des formes? Je ne le pense point. La science qu'on peut évoquer pour dire leur pénétrabilité ne dit pas que cette pénétration s'exerce par masses solides." Kahn, "Iᵉʳᵉ Exposition de sculpture futuriste de M. Umberto Boccioni (Galerie la Boétie)," 420.

48. "De plus il est fâcheux qu'un artiste tel que M. Boccioni condescende à ces petits jeux de juxtaposition de matière d'art et de matériaux vulgaires qu'ont pratiquée et bien à tort, hors l'exemple des mieux doués, quelques enfants perdus du Cubisme. Il ne sera jamais artiste de mêler à la glaise ou de coller sur la toile du verre, des cheveux, du bois découpeé." Ibid.

49. Ibid., 421.

50. See Longhi, *Scultura futurista Boccioni.* In his interpretation of Boccioni's sculpture, Longhi was very much influenced by the ideas of Soffici and Papini. This can be seen in his emphasis on the importance of Impressionism to the Futurists, his belief that art is a matter of expressive deformation, and his view that the juxtaposition of different elements in a single sculpture resulted in "realism" rather than in lyrical transformation.

51. "Deformazione organica di leggera astrazione raggiata e imposta architettura statica di blocchi d'atmosfera, di ambiente, di luce; massa squadrata e profilo lineare di volumi tortili, s'incontrano e sensa potersi fondere, si stanno allato. . . . *Testa + casa + luce* non potrà mai divenire *Testacasaluce.*" Ibid., 15.

52. Ibid., 17.

53. "Non siamo dunque ancor giunti a una vera concezione di organismo isolato e situato." Ibid., 15.

54. See Wescher, "Collages futuristes," 21–22.

55. This phrase can be found in many Futurist manifestos beginning with the "Technical Manifesto of Futurist Painting." See Apollonio, *Futurist Manifestos,* 27.

56. Bergson discusses the difference between relative and absolute motion in his essay "Introduction à la métaphysique" of 1903, which Giovanni Papini had published in Italian translation in 1909 with the title "La filosofia dell'intuizione."

57. In *Lacerba* (15 March 1914), repr. in Apollonio, *Futurist Manifestos,* 150–54.

58. "The Exhibitors to the Public," in Apollonio, *Futurist Manifestos,* 48

59. In *Passages in Modern Sculpture,* Rosalind Krauss offers an extremely lucid analysis of the role of the structural core in Boccioni's sculpture *Development of a Bottle in Space* of 1912 (see esp. 41–51). The revealed hollow center of this work provides the viewer with a stable, unified object of knowledge, while the overlapping and displaced profiles of the bottle and dish suggest a multiplicity of views synthesized so that they may be taken in from a single, frontal vantage point. The sculpture thus becomes a demonstration of the power of consciousness to achieve total knowledge of an object. In contrast, Picasso's Cubist constructions have no central core, and as Krauss argues, "fail to deliver that 'sign' of unity through which the essence of the object can be grasped." (47)

60. "La creazione che si rifà semplice azione; l'arte che torna natura greggia." "Il Cerchio si chiude," 189.

61. Papini evidently knew Severini's 1913 *Portrait of Marinetti* only in reproduction, since the moustache in question was a fake.

62. "Si tratta di sostituire alla trasformazione lirica o razionale delle cose le cose medesime." Ibid., 190.

63. "Ma appena questa realtà entra a far parte della materia elaborata dell'opera d'arte, l'ufficio lirico a cui essa viene chiamata, la sua posizione, le sue dimensioni, il contrasto che suscita, ne trasformano l'anonimo oggettivo e l'incamminano a divenire elemento elaborato." "Il Cerchio non si chiude," 192.

64. "Nelle nostre opere ultime gli elementi di realtà greggia, come tu dici, vanno diminuendo *assorbiti, sintetizzati e deformati nell'astrazione dinamica.*" Ibid.

65. "In Picasso invece, logicamente, gli elementi di realtà greggia vanno aumentando proprio nella produzione più recente." Ibid.

66. "Picasso mi ha fatto vedere le fotografie di pareti del suo studio dove erano (accomodati da lui) diversi oggetti e mi ha detto che secondo qualcuno quegli aggruppamenti di oggetti veri eran già dei quadri." "Cerchi aperti," 195. That someone was undoubtedly Gertrude Stein.

67. "La materia impiegata dall'artista resta tutta e sempre inerte, morta, inespressiva, se non è condotta dal genio a *spiritualizzarsi*; a divenire cioè puro elemento di raffigurazione lirica simbolica. Il che equivale a sparire in quanto materia." *Primi principi di una estetica futurista,* 92.

68. "Vero è che un'obbiezione si presenta subito alla mente, in tale materia: ed è che un oggetto, un brano di giornale, di affisso, di stoffa, o qualunque altra cosa, applicati in un quadro o in una scultura per evitare la fatica di rappresentarli non possono se non restarvi come qualcosa di estrinseco e di morto, oltre che come un segno di grossezza spirituale o d'impotenza. E non ci sarebbe da ripetere, se questa fosse davvero la loro assurda funzione. Ma se invece, e precisamente, tali cose non hanno nessuna funzione *rappresentativa* in un'opera dove, nemmeno, si tratta di rappresentar checchessia; ma l'oggetto, il pezzo di carta, o di stoffa, ecc. hanno soltanto una funzione cromatica, o di tono, o di forma plastica, o comunque di elemento armonico, di materia tecnica, proprio come i colori, le crete, le pietre, i metalli, eccetera, in luogo dei quali sono impiegati?" Ibid., 91–92.

69. Soffici's closest ties in Paris were to the Baroness Oettingen, her brother Serge Ferat, and Apollinaire, who were jointly engaged in publishing *Les Soirées de Paris* at this time.

70. Tatlin was also taken by the "open" cut-out diagonal pattern of this bottle and included a similar form in one of his earliest constructions titled *The Bottle*.

71. "Il pittore impressionista . . . veniva a provare come tutto potesse esser materia di bellezza e di poesia se contemplato da un occhio di creatore . . . la figura umana, l'animale, il più insignificante cantuccio della natura, la stessa cosa inanimata—l'utensile, un bicchiere vuoto, che so io? un cencio sgualcito—ebbero uno stesso valore in quanto *puri elementi artistici*, non differenziati da altro che dal loro colore e dalla loro forma." Soffici, *Cubismo e Futurismo,* 8–9. This paragraph had also appeared in Soffici's article "Picasso e Braque" (1911).

72. Soffici, like Papini and Carrà, considered art to be a deformation from the everyday appearance of things, intended to reveal the personality of the artist. He was clearly indebted to Maurice Denis for this attitude, as his many references to Denis reveal. See, for example, "Arte Francese moderna," (January 1913), repr. in *Opere,* 1:303–08.

73. "Medardo Rosso, simile in questo agl'impressionisti francesi . . . , non concepisce le cose se non come una successione rapida di movimenti in un mutuo continuo rapporto di colori e di luci. Secondo lui, come secondo i suoi colleghi pittori, il colore e l'aspetto di un oggetto variano senza posa, a seconda dell'ambiente in cui questo si trova, o la vicinanza di uno o di un altro oggetto che col suo riflesso o col suo contrasto influisca su esso." "Medardo Rosso a Firenze," *La Voce* (May 1910), repr. in *Medardo Rosso (1858–1928),* 38–39.

74. "Secondo lui il movimento di una figura non deve arrestarsi alle linee di contorno, come il suono alle pareti di una campana di cristallo, ma per un'impulsione prodotta dall'intensità dei giuochi dei valori, dei sobbalzi e delle linee dell'opera, propagarsi nello spazio, spandersi all'infinito, a guisa di un'onda elettrica che sprigionandosi da una macchina ben costrutta, vola a reintegrarsi con la forza eterna dei mondi." "Per Medardo Rosso" *La Voce* (4 March 1909), repr. in *Medardo Rosso,* 19.

75. All of these fragments were excerpted from the 15 March 1913 issue of *Lacerba.*

76. Carrà's introduction of a bit of trompe l'oeil wood grain in the lower right part of his collage is unusual in a Futurist work and further suggests this collage is a response to Cubist constructions. In an essay of 1 June 1914, "Vita moderna e arte populare," published in *Lacerba,* Carrà advocated the use of oilcloth and tin in constructed works. In the spring of 1914 Picasso had executed a series of constructions made with milk tins, including the example in the present comparison.

Chapter 7. Collage Poems

1. *Reality,* of course is a problematic term here, since for the most part the collage elements in Picasso's works were already cultural signifiers in their own right. One could make a similar argument for the conventionalized or "coded" character of Marinetti's onomatopoeias, but the poet considered these disruptive sounds to be elements of untransformed reality.

2. " . . . fondere il dinamismo plastico con le parole in libertà." Cited in Giovanni Lista, *Le Livre futuriste de la libération du mot au poème tactile,* 43. In a letter to Soffici dated 21 July 1914 regarding the publication of Carrà's *Festa Patriottica* in *Lacerba,* Marinetti urged him, "Do not forget, I beg of you, to put under the picture by Carrà this caption, exactly: CARRÀ—FREE WORD PICTURE (*Patriotic Festival*)

Severini has also agreed always to designate in this manner these fusions of Futurist painting and of *parole in libertà,* to avoid confusions and to establish the lineage."

[Non dimenticare, ti prego, di far mettere sotto la fotografia del quadro di Carrà questa dicitura, esattamente: CARRÀ—dipinto parolibero (*Festa patriottica*)

Siamo d'accordo anche con Severini di chiamare sempre cosi queste fusioni di pittura futurista e di parole in libertà, per evitare confusioni e determinare la corrente.] Cited in *Soffici: Immagini e documenti (1879–1964)*, 231.

3. Marinetti, *Grande esposizione nazionale futurista,"* 23. I am grateful to Giovanni Lista for bringing this citation to my attention.

4. For a detailed analysis of Apollinaire's borrowings from texts by Marinetti, Paolo Buzzi, Blaise Cendrars, and others in "Zone" and subsequent poems, see Francis J. Carmody, *The Evolution of Apollinaire's Poetics, 1901–1914*, 71–120.

5. See Billy, *Apollinaire Vivant*, 54–55. This poem was published in the catalogue of a one-man exhibition of the works of Robert Delaunay in Berlin in January 1913.

6. Guillaume Apollinaire, *Calligrammes: Poems of Peace and War (1913–1916)*, 26–27.

7. Ibid., 54–55.

8. Oliver Shell made this observation in an unpublished paper, University of Pennsylvania, 1988.

9. The manuscripts for some of Apollinaire's calligrammes are preserved in the Bibliothèque National in Paris ("Oeuvres Poètiques" NAF 16280). They show that mock-ups for several poems included in *Etendards* and other poems such as "Visée" involved the use of collage as a compositional technique.

10. My reading of "Visée" is indebted to that of Anne Hyde Greet and S. I. Lockerbie. See Apollinaire, *Calligrammes: Poems of Peace and War*, 420.

11. "Quel che mi fece più piacere, furono due righe di Apollinaire in una cartolina, con cui mi diceva che tale mia intuizione riportava alla sua memoria dei poemetti del 17° secolo, nei quali le parole erano disposte in modo da suggerir la forma. Ed infatti poco dopo vennero fuori i "calligrammi" che ognuno conosce, e ai quali, suppongo, deve aver contribuito anche il ricordo di Mallarmé; come contribuì ai miei primi quadri con applicazione di pagine stampate ecc." See Severini, *Tutta la vita di un pittore*, 210–11.

12. Ibid., 210.

13. Ibid., 102.

14. For a discussion of Picasso's attitude toward Mallarmé, see chap. 5.

15. In a letter to Soffici, for example, Marinetti insisted on maintaining a distinction between the Futurists' parole in libertà and the "ideograms" of Apollinaire. He criticized the latter for being "passatisti, puramente decorativi e quasi *mallarméens*" [passatisti, purely decorative, and almost *Mallarméan*]. Letter from Marinetti to Soffici [between 15 August and 1 December 1914], *Archivi*, 1:344.

16. The "Enquête" was sponsored by the Symbolist paper *L'Ermitage*. Cited in Olga Ragusa, *Mallarmé in Italy: Literary Influence and Critical Response*, 46.

17. For an analysis of the rhetoric of crisis in Mallarmé's essay, see Paul de Man, "Criticism and Crisis," in *Blindness and Insight: Essays in the Rhetoric of Contemporary Criticism*, 3–19.

18. "J'apporte en effet des nouvelles. Les plus surprenantes. Même cas ne se vit encore. On a touché au vers." "La Musique et les lettres," *Oeuvres*, 643.

19. " . . . vers rompu, jouant avec ses timbres et encore les rimes dissimulées: selon un thyrse plus complexe." Ibid., 644.

20. The full passage reads, "Nous assistons, en ce moment, [m'a-t-il dit], à un spectacle vraiment extraordinaire, unique, dans toute l'histoire de la poésie: chaque poëte allant, dans son coin, jouer sur une flûte, bien à lui, les airs qu'il lui plaît; pour la première fois, depuis le commencement, les poëtes ne chantent plus au lutrin. Jusqu'ici, n'est-ce pas, il fallait, pour s'accompagner, les grandes orgues du mètre officiel." "Sur l'évolution littéraire," *Oeuvres*, 866.

21. " . . . donné le signal et l'orientation de ce mouvement poétique." Kahn, "Préface," *Premiers Poèmes*, 3.

22. For Kahn, the category Romanticism included the Parnassian School. Ibid., 5.

23. "Le Vers est la parole humaine rythmée de façon à pouvoir être chantée, et, à proprement parler, il n'y a pas de poésie en dehors du chant." Cited in ibid., 6.

24. [The law of rhyming] "est une LOI absolue, commes les lois physiques." Théodore Faullain de Banville, *Petit traité de la poésie française*, 65.

25. "Il n'y en a pas." Ibid., 68.

26. Ibid., 11.

27. "L'unité vraie n'est pas le *nombre* conventionnel du vers, mais un arrêt simultané du sens et du rythme sur toute fraction organique du vers et de la pensée. Cette unité consiste en un nombre ou rythme de voyelles et de consonnes qui sont cellule organique et indépendante. . . . L'unité du vers peut se définir encore: un fragment le plus court possible figurant un arrêt de voix et un arrêt de sens." Kahn, "Préface," *Premiers Poèmes*, 26.

28. Ibid., 33.

29. "Mallarmé attracted me because of his talent and because of his formidable lack of success. I take pride in having paid my first respects to the most unrecognized man of world literature." [Mallarmé m'attirait et par son talent et par son formidable insuccès. Je me targue d'avoir porté mes premiers respects à l'homme le plus méconnu de la littérature mondiale.] Gustave Kahn, *Symbolistes et Décadents*, 22.

30. "D'abord, je m'étais rendu compte de la parfaite imperméabilité des masses populaires vis-à-vis de la littérature de nos ainés, et leur art m'apparaissait bâtard, incapable de satisfaire le populaire, incapable de charmer l'élite . . ."

Ibid., 32. Given the context of this statement, Kahn's reference to the elite seems to imply the bourgeois intelligentsia, since he had already observed that a new generation of poets had begun to appreciate Mallarmé.

31. "M. Stéphane Mallarmé, qui pensait que le vers manquait d'euphémisme et de fluidité, ne cherchait point à le libérer, bien au contraire; pour ainsi dire, il l'essentiellisait; c'était affaire de fonds et de choix de syllabes." Kahn, "Préface," *Premiers Poèmes,* 14–15.

32. Kahn, "Symbolistes et Décadents," 32.

33. Kahn recalled, with some irony, Mallarmé's advice to young poets: "Il enhardit à ne point craindre toute complication d'idées, sous prétexte d'obscurité, à renoncer à la carrure vulgaire dans la mise en page d'une idée." "Préface," *Premiers Poèmes,* 20. Thus for Kahn, typographical experimentation was associated with obscurity, and he wished to reject both.

34. "Le vers et la strophe sont tout ou partie de phrase chantée et sont de la parole avant d'être une ligne écrite. En vertu de notre définition, tous les artifices typographiques utilisés pour l'homologation de deux vers (rime pour l'oeil) sont d'un coup écartés. Le poète parle et écrit pour l'oreille et non pour les yeux." Ibid., 31.

35. For Kahn's criticism of Gris's inclusion of fragments of mirror and printed letters and numbers in his paintings, see chap. 4, n. 59.

36. This manifesto was probably published as a leaflet in late June or early July. Reviews of the French version appeared on 8 July 1912 in *L'Intransigeant* and *Le Figaro.* An Italian version was published by *La Gazzetta di Biella* on 12 October 1912.

37. The manifesto was later reprinted in *Zang Tumb Tumb* (1914) and in *Les mots en liberté futuristes* (1919).

38. See Marinetti, *I poeti futuristi,* 11

39. The Marinetti Archive at Yale University contains at least seventy-four pieces of correspondence from Kahn to Marinetti, most of which are dated 1899 to 1909. Significantly, Kahn did not endorse Marinetti's "Founding Manifesto" in 1909 and seems to have withdrawn his support for Marinetti's endeavors from this time.

40. Marinetti wrote a series of articles titled "Une Bataille moderne" for the French newspaper *L'Intransigeant.*

41. For a fascinating discussion of the relation of aerial perspectives to Marinetti's literary theories and Futurist art, see Linda Landis, "Futurists at War," in *The Futurist Imagination: Word + Image in Italian Futurist Painting, Drawing, Collage and Free-Word Poetry,* ex. cat., ed. Anne Coffin Hanson, 60–75.

42. "Technical Manifesto of Futurist Literature," in Flint, *Marinetti, Selected Writings,* 84.
 "In aeroplano, seduto sul cilindro della benzina, scaldato il ventre dalla testa dell'aviatore, io sentii l'inanità ridicola

della vecchia sintassi ereditata da Omero. Bisogno furioso di liberare le parole, traendole fuori dalla prigione del periodo latino! Questo ha naturalmente, come ogni imbecille, una testa previdente, un ventre, due gambe e due piedi piatti, ma non avrà mai due ali. Appena il necessario per camminare, per correre un momento e fermarsi quasi subito sbuffando! Ecco che cosa me disse l'elica turbinante." "Manifesto tecnico della Letteratura Futurista," in Apollonio, *Futurismo,* 105.

43. "Destruction of Syntax—Imagination without Strings—Words-in-Freedom," in Apollonio, *Futurist Manifestos,* 98 "Manate di parole essenziali. . . ." "Distruzione della sintassi—Immaginazione senza fili—PAROLE IN LIBERTÀ—La sensibilità futurista," in Apollonio, *Futurismo,* 146.

44. Ibid., 98.

45. "L'écrit, envol tacite d'abstraction, reprend ses droits en face de la chute des sons nus." Mallarmé, "Le Mystère dans les lettres," *Oeuvres,* 385.

46. " . . . une préalable disjonction, celle de la parole, certainement par effroi de fournir au bavardage." Ibid., 385.

47. See n. 16 above.

48. "Destruction of Syntax," in Apollonio, *Futurist Manifestos,* 105 (translation amended). "Combatto l'estetica decorativa e preziosa di Mallarmé e le sue ricerche sulla parola rara, dell'aggettivo unico insostituibile, elegante, suggestivo, squisito [il suo] ideale statico." "Distruzione della sintassi," in Apollonio, *Futurismo,* 152. Mallarmé, of course, never described his poetic ideal as static. He frequently referred to the mobility of words, as did Kahn and other Symbolist poets.

49. "Quel pivot, j'entends, dans ces contrastes, à l'intelligibilité? il faut une garantie— La Syntaxe—." Mallarmé, "Le Mystère dans les lettres," *Oeuvres,* 385.

50. "Un parler, le français, retient une élégance à paraître en négligé et le passé témoigne de cette qualité . . . mais notre littérature dépasse le 'genre', correspondance ou mémoires. Les abrupts, hauts jeux d'ail, se mireront, aussi: qui les mène, perçoit une extraordinaire appropriation de la structure, limpide, aux primitives foudres de la logique. Un balbutiement, que semble la phrase, ici refoulé dans l'emploi d'incidentes multiplie, se compose et s'enlève en quelque équilibre supérieur, à balancement prévu d'inversions." Ibid., 386.

51. In Flint, *Marinetti, Selected Writings,* 84–85. "OGNI SOSTANTIVO DEVE AVERE IL SUO DOPPIO, cioè il sostantivo deve essere seguito, senza congiunzione, dal sostantivo a cui è legato per analogia. Esempio: uomo-torpediniera, donna-golfo, folla-risacca, piazza-imbuto, porta-rubinetto.
 Siccome la velocità aerea ha moltiplicato la nostra conoscenza del mondo, la percezione per analogia diventa sempre più naturale per l'uomo. Bisogna dunque sopprimere il come, il quale, il così, il simile a. Meglio ancora,

bisogna fondere direttamente l'oggetto coll'immagine che esso evoca, dando l'immagine in iscorcio mediante una sola parola essenziale." "Manifesto Tecnico della Letteratura Futurista," in Apollonio, *Futurismo,* 106.

52. Paul de Man, *The Rhetoric of Romanticism,* 248.

53. In Flint, *Marinetti, Selected Writings,* 85. "L'analogia non è altro che l'amore profondo che collega le cose distanti, apparentemente diverse ed ostili." "Manifesto Tecnico della Letteratura Futurista," in Apollonio, *Futurismo,* 106.

54. Ibid., 89. " . . . oseremo sopprimere tutti i primi termini delle nostre analogie per non dare più altro che il seguito ininterrotto dei secondi termini." In Apollonio, *Futurismo,* 111.

55. Ibid., 86. "Per avviluppare e cogliere tutto ciò che vi è di più fuggevole e di più inafferrabile nella materia, bisogna formare delle STRETTE RETI D'IMMAGINI O ANALOGIE, che verranno lanciate nel mare misterioso dei fenomeni." In Apollonio, *Futurismo,* 108.

56. Ibid., 87. " . . . L'OSSESSIONE LIRICA DELLA MATERIA." In Apollonio, *Futurismo,* 109.

57. This poem was appended to the "Supplement to the Technical Manifesto of Futurist Literature" dated 11 August 1912. The French version of the "Supplement" was reviewed on 20 August 1912 by *L'Instransigeant* and *Paris-Journal.* The Italian version was included in the volume *I poeti futuristi.*

58. "Bataglia Peso + Odore," in *I poeti futuristi,* 12. The French version of this poem makes the typographic advance of the "avant-gardes" more clear than the Italian version. In translating this parole in libertà, I have consulted the French as well as the Italian version and noted that there are considerable differences between the two.

59. Marinetti had declaimed parts of this parole in libertà during Futurist evenings in 1913 and 1914, before its publication in March 1914. The first performance took place in Berlin on 16 February 1913.

60. In this free-word poem, as in "Battle of Weight + Smell," Marinetti wrote of his experiences while serving as a war correspondent in Turkey from 11 October to 15 November 1912.

61. In Apollonio, *Futurist Manifestos,* 104. [Onomatopoeia serves to] "vivificare il lirismo con elementi crudi e brutali di realtà . . ." In Apollonio, *Futurismo,* 151.

62. René Ghil, *Traité du verbe, Avec avant-dire de Stéphane Mallarmé,* 28.

63. " . . . un vrai morceau de musique, suggestive infiniment et 's'instrumentant' seule: musique de mots évocateurs d'Images-colorées, sans qu'en souffrent en rien, que l'on s'en souvienne! les Idées." Ibid., 30.

64. For an account of Ghil's theories and of his association with the Abbaye de Créteil, which Marinetti also fre-
quented, see Daniel J. Robbins, "Sources of Cubism and Futurism," 324–27. Apollinaire regarded Ghil as a precursor of contemporary literature, admiring him especially for his celebration of life and work, but rejected Ghil's traditional syntax and theory of "instrumentation." For a discussion of Apollinaire's views on Ghil, see P. A. Jannini, *Le Avanguardie letterarie nell'idea critica di Guillaume Apollinaire,* 30.

65. Marinetti, "Destruction of Syntax," in Apollonio, *Futurist Manifestos,* 104. " . . . un lirismo telegrafico che non abbia assolutamente alcun sapore di libro, e, il più possibile, sapore di vita. Da ciò l'introduzione coraggiosa di accordi onomatopeici per rendere tutti i suoni e i rumori anche i più cacofonici della vita moderna." "Distruzione della sintasi," in Apollonio, *Futurismo,* 151.

66. "Geometric and Mechanical Splendor," in Apollonio, *Futurist Manifestos,* 158.

67. Ibid.

68. In Apollonio, *Futurist Manifestos,* 30. This English version is from the catalogue of the "Exhibition of Works by the Italian Futurist Painters," (Sackville Gallery, London, 1912).

69. "Geometric and Mechanical Splendor," in Apollonio, *Futurist Manifestos,* 157.

70. "Destruction of Syntax," in Apollonio, *Futurist Manifestos,* 106. "Poco importa se la parola deformata, diventa equivoca." "Distruzione della sintassi," in Apollonio, *Futurismo,* 153.

71. "Geometric and Mechanical Splendor," in Apollonio, *Futurist Manifestos,* 157. "Queste tavole sinottiche non devono essere uno scopo, ma un mezzo per aumentare la forza espressiva del lirismo. Bisogna dunque evitare ogni preoccupazione pittorica, non compiacendosi in giochi di linee, né in curiose sproporzioni tipografiche." "Lo splendore geometrico e meccanico," in Apollonio, *Futurismo,* 214.

72. Marjorie Perloff, *The Futurist Moment: Avant-Garde, Avant Guerre, and the Language of Rupture,* 60.

73. In Apollonio, *Futurist Manifestos,* 157. "Le parole in libertà, in questo sforzo continuo di esprimere colla massima forza e la massima profondità, si trasformano naturalmente in *auto-illustrazioni,* mediante l'ortografia e tipografia libere espressive, le tavole sinottiche di valori lirici e le analogie disegnate." In Apollonio, *Futurismo,* 214–15.

74. John J. White, "The Argument for a Semiotic Approach to Shaped Writing: The Case of Italian Futurist Typography," 53–86.

75. "Geometric and Mechanical Splendor," in Apollonio, *Futurist Manifestos,* 157.

76. Ferdinand de Saussure, *Course in General Linguistics,* 70, 73.

77. David Cundy has pointed out that Futurist typographic practice did not make use of modern printing technology. Ironically, the demand for a variety of typefaces and inks led to multiple handset pressings and the use of outdated equipment. See "Marinetti and Italian Futurist Typography," 349–52.

78. Benedikt Livshits, *The One-and-a-Half-Eyed Archer,* 191.

79. Giovanni Lista published this interpretation, given to him by Luce and Elica Balla, in *Le Livre futuriste,* 44.

80. Numerous connections between Futurist poetry and Dada experiments with "bruitisme," sound compositions, and simultaneous poetry, etc. could be traced. Tristan Tzara clearly admired Marinetti, and many of his Dada manifestos refer to Futurism, a movement he hoped to rival. Fritz Glauser recalled a conversation with Tzara in which the latter expressed his desire to found a new movement in art: "The fame of Marinetti, the leader of the Italian Futurists, would not let him sleep. Excitedly he told me about a visit by this esthetic sect in Bucharest. . . . Tzara dreamed of fame; 'Dada sounds much better than Futurism and the public is so dumb.'" "So war das damals," in *Das war Dada: Dichtungen und Dokumente,* ed. Peter Schifferli (Berlin: Deutsches Taschenbuch, 1963), 127; cited in Gordon Frederick Browning, *Tristan Tzara: The Genesis of the Dada Poem or from Dada to Aa,* 33, n. 7. On 31 March 1916, Tzara, Janco, and Huelsenbeck presented their poem "L'amiral cherche une maison a louer," a simultaneous reading of nonsense verse in French, German, and English, at the Cabaret Voltaire. The poem was published, with parallel lines of text extending across two pages, in the single issue of the review *Cabaret Voltaire,* dated 25 May 1916, along with an explanatory "Note pour les bourgeois." In this note, Tzara justified his interest in simultaneity by invoking the work of Mallarmé, Marinetti, Apollinaire, Henri Barzun, Fernand Divoire, and others. Interestingly, he also suggested a parallel with the Cubist "transmutation of objects and colors." See Tristan Tzara, *Oeuvres complètes. Tome 1 (1912–1924),* 492–93. In the February 1916 entry of Tzara's "Chronique Zurichoise," we also find a reference to "cartes-poèmes géographiques futuristes: Marinetti, Cangiullo, Buzzi" hanging on the walls of the Cabaret Voltaire. Ibid., 561. Hugo Ball notes in his diary on 9 July 1915 that "Marinetti sends me *Parole in Libertà* by himself, Cangiullo, Buzzi, and Govoni. They are just letters of the alphabet on a page; you can roll up such a poem like a map. The syntax has come apart. The letters are scattered and assembled again in a rough-and-ready way. There is no language any more, the literary astrologers and leaders proclaim; it has to be invented all over again. Disintegration right in the innermost process of creation." See *Flight Out of Time: A Dada Diary,* 25. In the entry for 18 June 1916 Ball interpreted the Dada desire to expand the expressive force of "isolated vocables" as a means of going beyond Marinetti's parole in libertà. (68)

81. This newspaper is actually a fragment of Soffici's simultaneous poem "Treno-Aurora," which records with considerable irony the various disconnected snatches of conversation overheard at a train station. The text has to do with the thoughts and emotions of an eloping couple.

82. ". . . un flusso, un tessuto di sensazioni diffuse." Soffici, *Primi principi di una estetica futurista,* 85.

83. "La scatola di cerini che ho davanti a me si lega, come immagine, a un mio pensiero sul mondo, a una memoria amorosa, e questa alla campagna serale che vedo dalla finestra, strettamente complementare del titolo nero del *Corriere della Sera.*" Ibid.

84. For a discussion of the relation between Apollinaire's calligrammes and Soffici's free-word poetry, which differs somewhat from my own, see Willard Bohn, "Free-Word Poetry and Painting in 1914: Ardengo Soffici and Guillaume Apollinaire," 209–26.

85. *Primi principi,* 87.

86. "Animata poi di colori e luci, in combinazioni sorprendenti, posta in movimento nei più vivi gurgiti della nostra esistenza, la sua efficacia diviene ancora più evidente. Efficacia di suggestione e di complemento figurativo. Non più muto segno di convenzione, ma forma viva fra forme vive, la lettera può far corpo con la materia della rappresentazione." Ibid., 88.

87. "Ho incominciato subito il quadro Poema—pittorico—forse viene interessante. Ho visto le parole in libertà di Apollinaire mi piacciono." Letter from Carrà to Soffici dated 23 June 1914. Repr. in *Carlo Carrà, Ardengo Soffici: Lettere 1913 / 1929,* 58–59. On 4 July 1914 Carrà wrote to Soffici again to tell him that he had finished the "first pictorial poem," "La Festa patriottica." Ibid., 60. For a discussion of this work and its relation to Apollinaire's "Lettre-Océan," see Bohn, "Circular Poem-Paintings by Apollinaire and Carrà," 246–71.

88. Bohn, "Circular Poem-Paintings," 256.

89. As Bohn points out, "Lettre-Océan" may have been inspired by Marinetti's "Captive Turkish Balloon," which was published in *Zang Tumb Tumb* in March 1914. In this work, Marinetti had inscribed the center of the balloon with the notation "hauteur 400 m." In fact, Apollinaire cites the Futurists' innovations in an essay titled "Simultanisme-Librettisme," which was published in the same June 1914 issue of *Les Soirées de Paris* as "Lettre-Océan." Other precedents for a circular, simultaneous composition existed in the contemporary painting of the Delaunays. See Bohn, "Circular Poem-Paintings," 264.

90. "Il est impossible de les lire sans concevoir immédiatement la simultanéité de ce qu'ils expriment, poèmes-conversation où le poète au centre de la vie enregistre en quelque sorte le lyrisme ambiant." Apollinaire, "Simultanisme-Librettisme," 323.

91. Willard Bohn, *The Aesthetics of Visual Poetry, 1914–1928,* 35.

92. See Severini, *Tutta la vita di un pittore,* 210.

93. "La sensazione di penetrazione luminosa di due reflettori elettrici—alla quale si riattaccava, per analogia, quella di una pallottola mauser che strappi lo spazio sibilando,—è resa dal contrasto di due angoli acuti, che si incontrano nelle due punte." Severini, "Ideografia Futurista," repr. in *Mostra Antologica di Gino Severini,* 24.

94. Ibid.

95. "Le opere del nuovo lirismo non potranno certo esser lette, ma possiamo forse noi leggere le nostre tele, e può il musicista leggere la sua sinfonia? Si legge il canto degli uccelli?" Ibid., 24–25.

96. "Ho visto su l'ultimo n° di Lacerba un tuo disegno che da un certo punto di vista mi ha interessato moltissimo, perché anch'io in questi ultimi tempi ho fatto un lavoro, che ho chiamato "festa patriottica—poema pittorico" e che col tuo ha molti punti di contatto. . . . 2 giorni fa l'ho portato dal fotografo per riprodurlo in fotografia . . . " Letter from Carrà to Severini, dated 11 July 1914, in *Archivi,* 1:341.

97. "Futurist Painting: Technical Manifesto 1910," in Apollonio, *Futurist Manifestos,* 28. "Noi porremo lo spettatore nel centro del quadro." "La Pittura Futurista—Manifesto Tecnico," in Apollonio, *Futurismo,* 56.

98. See Landis, "Futurists at War," 63.

99. Within a few months Futurists like Carrà would no longer cry, "Long Live the King" but would instead menace him with revolution if he did not take up the interventionist cause.

100. "Simultanisme-Librettisme," 324. In this passage Apollinaire is describing the first attempt at simultaneity undertaken by Blaise Cendrars and Sonia Delaunay, *La Prose du Transsibérien et de la Petite Jehanne de France,* but their work is cited as exemplary of a contemporary tendency that includes his own work.

101. Ballerini, *Italian Visual Poetry, 1912–1972,* 6.

102. "Una scrittura dunque non più mezzo della funzione espressiva-comunicativa della lingua, . . . ma una scrittura finalmente avviata alla liberazione da ogni problema di denotazione d'oggetti fuori di essa esistenti, liberazione cioè dal suo platonismo tipico, finalmente oggetto essa stessa e luogo d'invenzione e d'immaginazione, passo ulteriore sulla strada della liberazione della realtà." *Tavole Parolibere Futuriste (1912–1944),* ed. Luciano Caruso and Stelio M. Martini, 4.

103. For Marinetti's remarks, see Giacomo Balla and Fortunato Depero, "Futurist Reconstruction of the Universe," in Apollonio, *Futurist Manifestos,* 198. Marinetti's interpretation of Balla's "plastic complexes" as new "objects" is also discussed in chapter 8 below.

104. "Dynamic and Synoptic Declamation," in Flint, *Marinetti, Selected Writings,* 143. "Col nuovo lirismo futurista, espressione dello splendore geometrico, il nostro *io* letterario brucia e si distrugge nella grande vibrazione cosmica, così che il declamatore deve anch'esso sparire, in qualche modo, nella manifestazione dinamica e sinottica delle parole in libertà." "La declamazione dinamica e sinottica" (11 March 1916), *Per conoscere Marinetti e il Futurismo,* ed. Luciano De Maria, 177.

105. Ibid., 145.

Chapter 8. Futurist Collage and Parole in Libertà in the Service of War

1. "Le mouvement futuriste exerça tout d'abord une action artistique, tout en influençant indirectement la vie politique italienne par une propagande de patriotisme révolutionaire, anticlérical, directement lancé contre la Triple Alliance et qui préparait notre guerre contre l'Autriche." Marinetti, *Les mots en liberté futuristes,* 9.

2. See, for example, "Merveille de la guerre," in Apollinaire, *Calligrammes: Poèmes de la paix et de la guerre (1913–1916)* (Paris: Gallimard, [1925] 1966), 137–39. As the war progressed, Apollinaire grew increasingly less optimistic about it. Even the early poems demonstrate some ambivalence and are never a celebration of militarism for its own sake. For an intelligent, well-informed interpretation of Apollinaire's poetry in the light of his wartime experiences, see Claude Debon, *Guillaume Apollinaire après Alcools: Calligrammes, Le poète et la guerre.*

3. For Cendrars's view of the war as "a painful delivery, needed to give birth to liberty," see Perloff, *The Futurist Moment,* 6.

4. "Bisogna dunque che il Futurismo non solo collabori direttamente allo splendore di questa conflagrazione (e parecchi di noi sono decisi a giocarvi la pelle energicamente) ma anche diventi l'espressione plastica di quest'ora futurista. Voglio parlare di una espressione ampia, non limitata a un piccolo cerchio di intenditori; di una espressione tâlmente forte e sintetica da colpire l'immaginazione e l'occhio di tutti o di quasi tutti i lettori intelligenti. . . . Cerca di vivere pittoricamente la guerra, studiandola in tutte le sue meravigliose forme meccaniche (treni militari, fortificazioni, feriti, ambulanze, ospedali, cortei ecc.)." Letter from F. T. Marinetti to Severini, dated 20 November 1914. In *Archivi,* 1:349–50.

5. "Italia sovrana assoluta. —La parola ITALIA deve dominare sulla parola LIBERTÀ.

Tutte le libertà, tranne quella di essere vigliacchi, pacifisti, anti-italiani.

Una più grande flotta e un più grande esercito; un populo orgoglioso di essere italiano, per la Guerra, sola igiene del mondo e per la grandezza di un' Italia intensamente agricola, industriale e commerciale.

Difesa economica ed educazione patriottica del proletario.

Politica estera cinica, astuta e aggressiva.— Espansionismo coloniale.—Liberismo.

Irredentismo.—Panitalianismo.—Primato dell'Italia." Marinetti, "Programma Politico Futurista," *Lacerba* (15 October 1913), 221.

6. "Technical Manifesto of Futurist Literature," in Flint, *Marinetti, Selected Writings,* 85.

7. The fragments have been cut from page 122 of the section titled "Hadirlik quartier generale turco" in *Zang Tumb Tumb,* 1914.

8. "Bombe, infatti, o meglio siluri sono i loro versi liberi. L'immagine può sembrare eccessiva soltanto ai miopi cervelli incapaci d'intuizione profonda." Marinetti, *I poeti futuristi,* 11.

9. This title has been given to this mock-up to distinguish it from the two published versions of this free-word picture.

10. Marinetti, "Geometric and Mechanical Splendor," 158. "L'amore della precisione e della brevità essenziale. . . " "Lo splendore geometrico e meccanico," in Apollonio, *Futurismo,* 218.

11. "Libri quadrati = cella / Le idee schiacciate = farfalle tra le pagine quadrate." Cited in Francesco Cangiullo, *Le serate futuriste,* 149.

12. For an analysis of the role played by military maps in Futurist art, see Landis, "Futurists at War."

13. This parole in libertà was first published on 9 September 1917 in *L'Italia Futurista* 2, no. 28 with the title "Morbidezze in agguato + bombarde italiane" [Softnesses in ambush + Italian bombings].

14. The "Arditi" (daredevils) were a group of volunteer shock troops who later in 1919 became the *Fasci Futuristi.* They were renowned for rushing into battle stripped to the waist with a dagger between their teeth and a grenade in each hand. For a discussion of the role they played in the war and in the transition to a Fascist state after the war, see Tisdall and Bozzolla, *Futurism,* 204–05, and Enrico Crispolti, *Storia e critica del futurismo,* 202–04.

15. Charles Baudelaire, "The Painter of Modern Life," in *Selected Writings on Art and Artists,* trans. P. E. Charvet (Harmondsworth: Penguin Books, 1972), 402.

16. For an illuminating discussion of the temporal unfolding of narrative and of the necessary "dissymmetry" between the time of the telling in relation to the told, see Peter Brooks, *Reading for the Plot,* 20–22.

17. "Siccome ogni specie di ordine è fatalmente un prodotto dell'intelligenza cauta e guardinga bisogna orchestrare le immagini disponendole secondo un MAXIMUM DI DISORDINE." "Manifesto tecnico della Letteratura Futurista," in Apollonio, *Futurismo,* 108. Inexplicably, this sentence (number 10 in the manifesto) was omitted from Flint's standard translation.

18. "Futurist Painting: Technical Manifesto," in Apollonio, *Futurist Manifestos,* 27.

19. "Technical Manifesto of Futurist Literature," in Flint, *Marinetti, Selected Writings,* 84.

20. Marinetti, "Geometric and Mechanical Splendor," 158. One can also note that Saussure had drawn attention to the fact that onomatopoeias are largely conventional in character: "As for authentic onomatopoeic words (e.g. *glug-glug, tick-tock,* etc.), not only are they limited in number, but also they are chosen somewhat arbitrarily, for they are only approximate and more or less conventional imitations of certain sounds (cf. English *bow-wow* and French *ouaoua*). In addition, once these words have been introduced into language, they are to a certain extent subjected to the same evolution—phonetic, morphological, etc.,—that other words undergo . . . obvious proof that they lose something of their original character in order to assume that of the linguistic sign in general, which is unmotivated." *Course in General Linguistics,* 69

21. Cited in Tisdall and Bozzolla, *Futurism,* 104.

22. "Non vedo in ciò una prostituzione del dinamismo plastico; ma credo che la grandissima guerra, vissuta intensamente dai pittori futuristi, possa produrre nella loro sensibilità delle vere convulsioni, spingendoli a una semplificazione brutale di linee chiarissime, spingendoli insomma a colpire e ad incitare i lettori, come essa colpisce e incita i combattenti." Letter from F. T. Marinetti to Severini, dated 20 November 1914, in *Archivi,* 1:349.

23. "Probabilmente si avranno dei quadri o degli schizzi meno astratti, un po' troppo realistici e in certo modo una specie di post-impressionismo avanzato." Ibid., 350.

24. This collage was published in January 1915 in *Grande Illustrazione* and must have seemed, with the inclusion of a January 4 text, as hot off the press as the newspaper fragment itself.

25. See Landis, "Futurists at War," 64.

26. Ibid., 64–65.

27. "L'angolo retto, per esempio, serve a dare espressione di calma austera e di serenità, quando la composizione esige un ritmo semplice, appassionale, neutro. Con questo stesso intento di neutralità, si utilizzano, in altri casi, la linea orizzontale e la verticale pura. . . . L'angolo acuto, invece, è passionale e dinamico, esprime volontà e forza penetrativa." Carrà, "Il Dinamismo plastico: Piani plastici come espansione sferica nello spazio," *Guerrapittura,* 66. This is a revised and expanded version of Carrà's manifesto "Piani plastici come espansione sferica nello spazio" published in *Lacerba* (15 March 1913).

28. "Il modo di esprimere con nuovi mezzi di lirismo sintetico l'intenso realismo delle nostre emozioni mi vien suggerito dal mio disegno parolibero nel quale accordai *volontariamente* forma [*sic*] ed angoli acuti con speciali parole, e forme rotonde o angoli aperti con altre." Severini, "Ideografia Futurista," 24.

29. "Noi siamo agili, multiformi, e voi siete duri, uniformi, grigi.

Noi siamo *caldi, passionali,* e voi freddi, apassionali.

Voi siete per l'erudizione, per l'intellettuale, il professorume e l'accademia, e noi siamo per l'intuizione, la rapida esperienza e adoriamo l'ignoranza, la geniale ignoranza che giudichiamo essenziale virtù e forza igienica del cervello.

Noi siamo la sensibilità resa anatomia, e voi siete l'insensibilità fatta cervello.

Come si vede, si tratta di un vero rovesciamento di valori—e l'accordo non sarà mai possibile." Carrà, "I tedeschi questuanti d'amore," *Guerrapittura,* 14.

30. Giovanni Lista has pointed out that the bellicose tone of this manifesto can be attributed largely to Marinetti. In a manifesto of December 1913 titled "Futurist Manifesto of Men's Clothing," Balla had described his ideas for an "antipassatista" suit without, however, mentioning war or the colors of the Italian flag. See Lista, *Balla,* 57. According to Cangiullo, Balla initially resisted Marinetti's idea that he turn his antipassatista suit into an antineutralista tricolor suit. Marinetti eventually prevailed, and the suit was first worn by Cangiullo in a prowar demonstration at the University of Rome on 11 December 1914. The manifesto, although written after this event and largely by Marinetti, was dated September 1914. See Cangiullo, *Le serate futuriste,* 199–219. Nonetheless, Balla did participate in many of the Futurist interventionist *serate* and did sign the manifesto.

31. "The Anti-Neutral Suit," repr. in Virginia Dorch Dorazio, *Giacomo Balla, An Album of His Life and Work*, n.p. "Noi futuristi vogliamo liberare la nostra razza da ogni neutralità, dall'indecisione paurosa e quietista, dal pessimismo negatore e dall'inerzia nostalgica, romantica e rammollente. Noi vogliamo colorare l'Italia di audacia e di rischio futurista, dare finalmente agl'italiani degli abiti bellicosi e giocondi." Also in ibid., n.p.

32. "Si pensa e si agisce come si veste." Ibid., n.p.

33. "Se il Governo non deporrà il suo vestito passatista di paura e d'indecisione, noi *raddoppieremo,* CENTUPLICHEREMO IL ROSSO *del tricolore che vestiamo.*" Ibid., n.p.

34. In Apollonio, *Futurist Manifestos,* 22.

35. Benjamin, "The Work of Art in the Age of Mechanical Reproduction," 241–42. Benedikt Livshits, who met Marinetti on his visit to St. Petersburg in 1914, came to a similar conclusion about the ideological basis of Marinetti's program: "He made no mention of what really lay at the basis of his slogans, but he couldn't have done that without removing the last romantic covering from reality. Marinetti's ecstatic screaming was nothing more than the passionate inclination, the frenzied thirst of the propertied classes of a semi-agricultural country to possess, at whatever cost, their own industry, their own export markets and their own colonial policy. The Tripoli War, which Marinetti eulogized, and the rejection of nature ('Death to moonlight: we glorify the tropics bathed in electric moons!') were but varying forms of the manifestation of the same force which pushed Italy along this path." *The One and a Half-Eyed Archer,* 186.

36. "Noi gridiano [*sic*] oggi:—O la Guerra o la Rivoluzione! Ascolti chi deve ascoltare." Carrà, "Guerra o Rivoluzione purificatrici, ringiovanitrici," *Guerrapittura,* 18.

37. Severini, *Tutta la vita di un pittore,* 13–16.

38. There are numerous references to anarchist events and workers' strikes in Carrà's autobiography. See *La mia vita,* 23–26, 37–42. Carrà recalled having been influenced by his reading of Marx, Plato, Thomas More, Max Stirner, Nietzsche, Kropotkin, Fourier, Owen, Saint-Simon, Bakunin, and the Italian theorists Carlo Pisacane and Antonio Labriola, an impressive list.

39. "Dobbiamo avere fiducia e coraggio in noi stessi e come artisti e come italiani. Rinnegare il nazionalismo vuol dire assoggettarci al nazionalismo d'altri.

Se non opereremo con audacia contro i francesi, credilo amico, noi supporteremo ancora per un pezzo il loro stupido giogo. Il futurismo, nato da noi, vuole che l'Italia abbia di nuovo una grande Arte—vuole che gli stranieri, barbari o smidollati che essi siano dovranno d'ora in avanti, guardare L'Italia e non più la Francia." Cited in Cavallo, *Soffici: Immagini e documenti (1879–1964),* 170. The purpose of this letter was to convince Soffici to change the title of his book *Cubismo e oltre* to *Cubismo e Futurismo* for the second edition.

40. Carrà, "Nazionalità," *Guerrapittura,* 5–6.

41. See Soffici's remarks in *Primi Principi di una estetica futurista,* 64.

42. "Così, ora mi appariva chiaramente, come quel borghese capitalista e quel proletario non fossero che figure drammatiche, e i loro rapporti economici non altro che gli elementi poetici del loro contrasto, contrasto sociale; tutto insieme: un'armonia immaginata e posta come legge di quella creazione di un mondo sui generis, inesistente nella realtà, ma vero nella infinita sfera dello Spirito." Ibid., 65–66.

43. Ibid., 69.

44. Ibid., 15.

45. See Soffici, "Per la Guerra," *Lacerba* (1 September 1914), 253–56.

46. In Apollonio, *Futurist Manifestos,* 197. "Balla cominciò collo studiare la velocità delle automobili, ne scoprì le leggi e le linee-forze essenziali. Dopo più di venti quadri sulla medesima ricerca, comprese che il piano unico della tela non permetteva di dare in profondità il volume dinamico della velocità. Balla sentì la necessità di costruire con fili di ferro, piani di cartone, stoffe e carte veline, ecc., il primo complesso plastico-dinamico." "Ricostruzione futurista dell'universo," in Apollonio, *Futurismo,* 254.

47. Ibid. "Daremo scheletro e carne all'invisibile, all'impalpabile, all'imponderabile, all'impercettibile. Troveremo degli equivalenti astratti di tutte le forme e di tutti gli elementi dell'universo, poi li combineremo insieme, secondi i capricci della nostra ispirazione, per formare dei complessi plastici che metteremo in moto." "Ricostruzione futurista dell'universo," in Apollonio, *Futurismo,* 254.

48. Ibid. "TRASPARENTISSIMO. Per la velocità e per la volatilità del complesso plastico, che deve apparire e scomparire, leggerissimo e impalpabile." "Ricostruzione futurista dell'universo," in Apollonio, *Futurismo,* 254.

49. Cited in Lista, *Balla,* 49.

50. In the "Futurist Reconstruction of the Universe," Balla and Depero declared that the new "plastic-dynamic complex" should be "AUTONOMOUS, that is, resembling itself alone." In Apollonio, *Futurist Manifestos,* 197. "AUTONOMO, cioè somigliante solo a sé stesso." "Ricostruzione futurista dell'universo," in Apollonio, *Futurismo,* 254.

51. Lista discusses the importance of Fuller's dances, which Balla would have had the opportunity to see in Paris in 1900 and in Rome in 1902 and 1906: see *Balla,* 77. Fuller performed a series of abstract "Synaesthetic symphonies" in Paris in 1914, and Balla would undoubtedly have heard or read reports of this event.

52. "Futurist Reconstruction of the Universe," Apollonio, *Futurist Manifestos,* 198, translation modified by the author. (Apollonio mistakenly translated "Presenza" as "Present" rather than "Presence," an important distinction in this context.) "L'arte, prima di noi, fu ricordo, rievocazione angosciosa di un Oggetto perduto (felicità, amore, paesaggio) perciò nostalgia, statica, dolore, lontananza. Col Futurismo invece, l'arte diventa arte-azione, cioè volontà, aggressione, possesso, penetrazione, gioia, realtà brutale nell'arte. (Es.: onomatopee.—Es.: intonarumori = motori), splendore geometrico delle forze, proiezione in avanti. Dunque l'arte diventa Presenza, nuovo Oggetto, nuova realtà creata cogli elementi astratti dell'universo. Le mani dell'artista passatista soffrivano per l'Oggetto perduto; le nostre mani spasimavano per un nuovo oggetto da creare. Ecco perché il nuovo oggetto (complesso plastico) appare miracolosamente fra le vostre." "Ricostruzione futurista dell'universo," in Apollonio, *Futurismo,* 255.

53. Ibid., 199. "Ricostruzione futurista dell'universo," in Apollonio, *Futurismo,* 258.

54. Benjamin, "The Work of Art in the Age of Mechanical Reproduction," 223.

Chapter 9. Collage and the Modernist Tradition

1. Crow, "Modernism and Mass Culture in the Visual Arts." Crow bases his analysis on the criticism of Stéphane Mallarmé and the early writings of Clement Greenberg, especially "Avant-Garde and Kitsch" of 1939.

2. "Les pointillistes ne scandalisaient plus; le Salon des Artistes Français devenait le refuge de l'impressionnisme toléré, chez ces modérés, comme un radicalisme inoffensif; Bonnard et Vuillard ne pouvaient indigner que quelques amateurs de banlieue, les autres, lecteurs anciens de la *Revue Blanche,* trouvant infiniment de charme à leurs "villégiatures" intellectuelles. On se montrait généralement pacifique; on industrialisait Cézanne et Gauguin. . . . Les révolutionnaires s'embourgeoisaient-ils?" Salmon, *La jeune peinture française,* 9.

3. Metzinger, "Note on Painting," in Fry, *Cubism,* 59. Metzinger mentions Picasso, Braque, Delaunay, and Le Fauconnier, but none of the latter three would have denounced the "theoreticians of emotion" in 1910. Moreover, a section referring to Picasso alone follows the passage quoted here.

4. "Picasso les yeux brûlés par des déformations criardes de plus en plus insupportables, car malgré tout, si déformations il y a, ne déforme pas qui veut, Picasso, dis-je, ne vit bientôt plus en elles qu'improvisations laborieuses, brutalités trop voulues, travaux pénibles semblant faits de 'chic', à tel point que ces tentatives finissaient par rendre fatigantes, nous ne craignons pas de le dire, même l'oeuvre responsable de Cézanne." Raynal, *Picasso,* 68.

5. Cited in Antonina Vallentin, *Pablo Picasso,* 130.

6. Perloff, "The Invention of Collage," in *Collage,* ed. Jeanine Parisier Plottel, 6. This essay is reprinted in Perloff's recent book, *The Futurist Moment.*

7. Greenberg, "Modernist Painting," 103.

8. See Greenberg, "The Pasted-Paper Revolution," and "Collage."

9. Greenberg, "Collage," 71.

10. Ibid., 76.

11. Ibid., 77.

12. Ibid., 80.

13. Ibid.

14. See Krauss, "Re-Presenting Picasso."

15. Letter from Picasso to Braque, dated 9 October 1912, repr. in Isabelle Monod-Fontaine, "Braque, la lenteur de la peinture," 41.

16. See, for example, Ardengo Soffici, *Cubismo e Futurismo,* and Umberto Boccioni, "Per l'ignoranza italiana; Sillabario pittorico," *Lacerba* (1 August 1913), 179–81.

Selected Bibliography

Cubism

Adams, Brooks. "Picasso's Absinthe Glasses: Six Drinks to the End of an Era." *Artforum* 18, no. 8 (April 1980): 30–33.

Allard, Roger. "Au Salon d'Automne de Paris." *L'Art Libre* (Lyons: November 1910): 441–43.

———. "Sur Quelques peintres." *Les Marches du Sud-Ouest,* no. 2 (June 1911): 57–64.

———. "Les Beaux-Arts." *Revue Indépendante,* no. 3 (August 1911): 127–40.

———. "Le Salon des Artistes Indépendants. Coup d'oeil d'ensemble." *La Côte* (19, 20 March 1912).

———. "Le Salon des Indépendants." *La Revue de France et des pays françaises* (March 1912): 67–74.

———. "Le Salon d'Automne." *Les Écrits Français,* advance no. (14 November 1913): 3–14.

———. "Le Salon d'Automne." *Les Écrits Français* 1, no. 1 (5 December 1913): 62–68.

Altieri, Charles. "Picasso's Collages and the Force of Cubism." *The Kenyon Review,* n.s. 6, no. 2 (Spring 1984): 8–33.

Apollinaire, Guillaume. "La vie artistique [Exposition Pablo Picasso-Vollard]." *L'Intransigeant* (25 October 1910).

———. "L'Art et ses représentants. Georges Braque." *Revue Indépendante,* no. 3 (August 1911): 166–69.

———. *Chroniques d'art, 1902–1918.* With preface and notes by L.-C. Breunig. Paris: Éditions Gallimard, 1960.

———. *Méditations esthétiques, les peintres cubistes.* Paris: Eugène Figuière et Cⁱᵉ Éditeurs, 17 March 1913.

Apollinaire e l'avanguardia. Ex. cat. Rome: Galleria Nazionale d'Arte Moderna, 1980.

Aragon, Louis. *La peinture au défi. Exposition de Collages.* Galerie Goemans. Paris: Librairie José Corti, March 1930.

———. *Les Collages.* Paris: Hermann, [1965] 1980.

Argan, Giulio Carlo. *Scultura di Picasso.* Venice: Alfieri, 1953.

Ashton, Dore, ed. *Picasso on Art: A Selection of His Views.* New York: Viking Press, 1972.

Barr, Alfred H., Jr. *Cubism and Abstract Art.* Cambridge: Belknap Press of Harvard University Press, [1936] 1986.

———. *Matisse, His Art and His Public.* New York: Museum of Modern Art, 1951.

———. *Picasso, Fifty Years of His Art.* New York: Museum of Modern Art, [1946] 1974.

Basel. Kunstmuseum Basel. *Picasso.* Ex. cat. (15 June–12 September 1976).

Baxandall, Michael. *Patterns of Intention: On the Historical Explanation of Pictures.* New Haven and London: Yale University Press, 1985.

Bern. Kunstmuseum Bern. *Sammlung Justin K. Thannhauser.* Ex. cat. (8 June–16 September 1978).

Bielefeld. Kunsthalle Bielefeld. *Zeichnungen und Collagen des Kubismus: Picasso, Braque, Gris.* Ex. cat. (1979).

Billy, André. *Apollinaire Vivant.* Paris: Éditions de La Siréne, 1923.

———. *L'Époque 1900.* Paris: Tallandier, 1954.

———. *Apollinaire.* Paris: Seghers, 1956.

Blum, René. "Préface." *Salon de "La Section d'Or."* Ex. cat. Paris: Galerie la Boétie (10–30 October 1912).

Blunt, Anthony, and Phoebe Pool. *Picasso, the Formative Years: A Study of His Sources.* Greenwich, Conn.: New York Graphics Society, 1962.

Bois, Yve-Alain. "Kahnweiler's Lesson." *Representations* 18 (Spring 1987): 33–68. Reprinted in *Painting as Model,* 65–97. Cambridge: MIT Press, 1990.

———. "The Semiology of Cubism." In *Picasso and Braque: Pioneering Cubism,* 2, edited by William Rubin. New York: Museum of Modern Art, 1992.

Braque, Georges. "Pensées et Réflexions sur la peinture." *Nord-Sud,* no. 10 (December 1917).

———. *Le jour et la nuit. Cahiers de Georges Braque 1917–1952.* Paris: Gallimard, 1952.

"Georges Braque." [Text established by Christian Zervos after conversations in response to a questionnaire.] *Cahiers d'Art,* nos. 1–4 (1935): 21–24.

Brassai. *Conversations avec Picasso.* Paris: Gallimard, 1964.

Breunig, L.-C. "Apollinaire et le cubisme." *La Revue des lettres modernes,* nos. 69–70 (Spring 1962): 7–24.

Brion-Guerry, Liliane, ed. *L'année 1913.* Paris: Éditions Klincksieck, 1971.

Brunet, Christian. *Braque et l'espace. Langage et peinture.* Paris: Éditions Klincksieck, 1971.

Buchloh, Benjamin H. D. "Figures of Authority, Ciphers of Regression. Notes on the Return of Representation in European Painting." In *Modernism and Modernity, The Vancouver Conference Papers,* 81–119, edited by Benjamin H. D. Buchloh. Halifax: Press of the Nova Scotia College of Art and Design, 1983.

Bürger, Peter. *Theory of the Avant-Garde.* Translated by Michael Shaw. Theory and History of Literature, vol. 4. Minneapolis: University of Minnesota Press, 1984.

Burgess, Gelett. "The Wild Men of Paris." *The Architectural Record* 27 (May 1910): 400–14.

Cabanne, Pierre. *Pablo Picasso, His Life and Times.* Translated by Harold J. Salemson. New York: Morrow, 1977. [Translation of *Le Siècle de Picasso.*]

Camfield, William A. "Juan Gris and the Golden Section." *The Art Bulletin* 47, no. 1 (March 1965): 128–14.

Carco, Francis. *De Montmartre au Quartier Latin.* Paris: Albin Michel Éditeur, 1927.

Carmean, E. A., Jr. "Juan Gris' 'Fantômas.'" *Arts Magazine* 51 (January 1977): 116–19.

Cendrars, Blaise. "Le 'Cube' s'effrite." *La Rose Rouge,* no. 3 (15 May 1919): 33–34.

Chevalier, J.-C., and L. C. Breunig. "Apollinaire et 'Les Peintres Cubistes.'" In *Apollinaire et les Surréalistes, La Revue des Lettres Modernes,* nos. 104–07 (1964): 88–112.

Clouzot, Henri. *Le papier peint en France du XVIIe au XIXe siècle.* Paris: Les Éditions G. van Oest, 1931.

———, and Charles Follot. *Histoire du papier peint en France.* Paris: Éditions d'art Charles Moreau, 1935.

Cocteau, Jean. "Picasso." *Les Feuilles Libres* (November-December 1913): 217–32.

Cooper, Douglas. *Letters of Juan Gris, 1913–1927.* London: [privately printed] 1956.

———. *The Cubist Epoch.* New York: Phaidon Publishers, 1971.

———. *Juan Gris.* 2 vols. Catalogue raisonné, prepared with the collaboration of Margaret Potter. Paris: Berggruen Éditeur, 1977.

———, and Gary Tinterow. *The Essential Cubism. Braque, Picasso & Their Friends, 1907–1920.* Ex. cat. London: The Tate Gallery, 1983.

Coquiot, Gustave. *Cubistes, futuristes, passéistes; Essai sur la jeune peinture et la jeune sculpture.* Paris: Librairie Ollendorff, 1914.

Cottington, David. "Cubism, Law and Order: The Criticism of Jacques Rivière." *The Burlington Magazine* 126, no. 981 (December 1984): 744–49.

———. "What the Papers Say: Politics and Ideology in Picasso's Collages of 1912." *Art Journal* 47, no. 4 (Winter 1988): 350–59.

Cranshaw, Roger. "Cubism 1910–12: The Limits of Discourse." *Art History* 8, no. 4 (December 1985): 467–83.

Crespelle, Jean-Paul. *Les maîtres de la belle époque.* Paris: Hachette, 1966.

———. *La vie quotidienne à Montmartre au temps de Picasso, 1900–1910.* Paris: Hachette, 1978.

Crow, Thomas. "Modernism and Mass Culture in the Visual Arts." In *Modernism and Modernity. The Vancouver Conference Papers,* 215–64, edited by Benjamin H. D. Buchloh. Halifax: Press of the Nova Scotia College of Art and Design, 1983.

Daix, Pierre. *Picasso.* New York: Praeger, 1965.

———. "Des Bouleversements chronologiques dans la révolution des papiers collés (1912–1914)." *Gazette des Beaux Arts,* ser. 6, 82, no. 1257 (October 1973): 217–27.

———. "Les trois séjours 'cubistes' de Picasso à Céret (1911–1912–1913)." In *Picasso et la paix.* Ex. cat. Brest: Palais des Arts et de la Culture (15 November 1973–15 February 1974).

———. *La vie de peintre de Pablo Picasso.* Paris: Éditions du Seuil, 1977.

———, and Joan Rosselet. *Le Cubisme de Picasso, catalogue raisonné de l'oeuvre peint 1907–1916.* Neuchâtel, Switzerland: Éditions Ides et Calendes, 1979. English version published as *Picasso: The Cubist Years—A Catalogue Raisonné of the Paintings and Related Works.* Translated by Dorothy S. Blair. London: Thames and Hudson, 1979.

———. *Journal du Cubisme.* Geneva: Skira, 1982. English version published as *Cubists and Cubism.* Translated by R. F. M. Dexter. New York: Rizzoli International Publications, 1982.

———. *Picasso créateur: la vie intime et l'oeuvre.* Paris: Éditions du Seuil, 1987.

Descargues, Pierre. *G. Braque.* Paris: Draeger, 1971.

Dufour, Pierre. "Actualité du cubisme." *Critique* 25, nos. 267–68 (August-September 1969): 809–25.

Einstein, Carl. *Negerplastik.* In *Werke 1908–1918,* 1:245–377. Berlin: Medusa Verlag, [1915] 1980. French translation by Jacques Matthey-Doret, "La sculpture nègre," *Médiations* 3 (Autumn 1961): 93–114.

———. "Notes sur le Cubisme." *Documents* 3 (1929): 146–55.

———. *Georges Braque.* Paris: Éditions des Chroniques du Jour, 1934.

Elgar, Frank. "Une Conquête du Cubisme: Le Papier Collé." *XXe Siècle,* n.s., no. 6 (January 1956): 3–18.

Fels, Florent. "D'hier à aujourd'hui; Le Cubisme: P.P.C." *Les Feuilles Libres* (July 1921): 205–10.

———. *Propos d'artistes.* Paris: La Renaissance du Livre, 1925.

———. *L'Art vivant de 1900 à nos jours*. Geneva: Pierre Cailler, Éditeur, 1950.

Flam, Jack D., ed. *Matisse on Art*. New York: E. P. Dutton, [1973] 1978.

Fourcade, Dominique. "Rêver à trois aubergines . . ." *Critique* 30, no. 324 (May 1974): 467–89.

Fry, Edward F., ed. *Cubism*. New York: McGraw Hill, 1966.

———. "Review of Daix and Rosselet, *Le Cubisme de Picasso*." *Art Journal* 41, no. 1 (Spring 1981): 91–99.

———. "Picasso, Cubism, and Reflexivity." *Art Journal* 47, no. 4 (Winter 1988): 296–310.

Gamwell, Lynn. *Cubist Criticism*. Ann Arbor: UMI Research Press, 1980.

Gee, Malcolm. *Dealers, Critics, and Collectors of Modern Painting: Aspects of the Parisian Art Market between 1910 and 1930*. New York and London: Garland, 1981.

———. "The Avant-Garde, Order and the Art Market, 1916–23." *Art History* 2, no. 1 (March 1979): 95–106.

Giry, Marcel. "Le fauvisme source du cubisme." *Le Cubisme. Travaux IV*. Université de Saint-Étienne: CIEREC, 1971.

Gleizes, Albert. "L'Art et ses représentants, Jean Metzinger." *La Revue Indépendante,* no. 4 (September 1911): 164.

———. "Les Beaux-Arts. A propos du Salon d'Automne." *Les Bandeaux d'or* (November 1911): 42–51.

———, and Jean Metzinger. *Du Cubisme*. Paris: Eugène Figuière et Cⁱᵉ· Éditeurs, [October 20] 1912.

———. "Le Cubisme et la Tradition." *Montjoie!* no. 1 (10 February 1913): 4; no. 2 (25 February 1913): 2–3.

———. [Opinions] *Montjoie!* nos. 11–12 (November-December 1913): 14.

———. *Tradition et cubisme*. Paris: Pavolovzky, 1927. [First published in *La Vie des Lettres et des Arts,* 1921.]

———. *Souvenirs, Le Cubisme 1908–1914*. Cahiers A. Gleizes. Vol. 1. Lyons: L'Association des Amis d'Albert Gleizes, 1957.

Golding, John. *Cubism. A History and an Analysis 1907–1914*. New York: Harper and Row, [1959] 1968.

Goldwater, Robert. *Primitivism in Modern Art*. Revised edition. New York: Random House, 1967.

Granié, J. "Au Salon d'Automne." *Revue d'Europe et d'Amérique* (15 November 1911): 984–86.

Gray, Christopher. *Cubist Aesthetic Theories*. Baltimore: Johns Hopkins University Press, 1953.

Green, Christopher. "Synthesis and the 'Synthetic Process' in the Painting of Juan Gris 1915–1919." *Art History* 5, no. 1 (March 1982): 87–105.

———. "Purity, Poetry and the Painting of Juan Gris." *Art History* 5, no. 2 (June 1982): 180–204.

———. *Cubism and Its Enemies: Modern Movements and Reaction in French Art, 1916–1928*. New Haven and London: Yale University Press, 1987.

Greenberg, Clement. "The Pasted-Paper Revolution." *Art News* 57, no. 5 (September 1958): 46–49ff. A revised version was published as "Collage," in *Art and Culture*. Boston: Beacon Press, [1959] 1961.

Guilbeaux, Henri. "Le Salon d'Automne." *Les Hommes du Jour* (8 October 1910 and 22 October 1910).

———. "Le Salon d'Automne." *Les Hommes du Jour* (30 September 1911).

———. "Le Cubisme et M. M. Urbain Gohier et Apollinaire." *Les Hommes du Jour* (11 November 1911).

Hoog, Michel. "Le cubisme et les problèmes de la couleur." *Le Cubisme. Travaux IV*. Université de Saint-Étienne: CIEREC, 1973.

Jacob, Max. "Souvenirs sur Picasso." *Cahiers d'Art* 2, no. 6 (June 1927): 199–202.

Johnson, Ronald. "Picasso's 'Old Guitarist' and the Symbolist Sensibility." *Artforum* 13 (December 1974): 56–62.

———. "Primitivism in the Early Sculpture of Picasso." *Arts Magazine* 49, no. 10 (June 1975): 64–68.

———. *The Early Sculpture of Picasso, 1901–1914*. New York: Garland, 1976.

———. "Picasso's Musical and Mallarméan Constructions." *Arts Magazine* 51, no. 7 (March 1977): 122–27.

Judkins, Winthrop. "Toward a Reinterpretation of Cubism." *The Art Bulletin* 30, no. 4 (Winter 1948): 270–81.

———. *Fluctuant Representation in Synthetic Cubism: Picasso, Braque, Gris, 1910–1920*. New York and London: Garland, 1976.

Kachur, Lewis. "Juan Gris" [exhibition review]. *The Burlington Magazine* 126 (June 1984): 381–82.

———. "Gris, cubismo y collage." In *Juan Gris [1887–1927]*, 33–44, edited by Gary Tinterow. Ex. cat. Madrid: Ministerio de Cultura, Salas Pablo Ruiz Picasso (20 September–24 November 1985).

Kahn, Gustave. "L'Exposition des Indépendants." *Mercure de France,* s.m. 96, no. 355 (1 April 1912): 634–43.

———. "Le Salon d'Automne." *Mercure de France,* s.m. 99, no. 368 (16 October 1912): 879–84.

———. "La Section d'Or (Galerie la Boétie)." *Mercure de France,* s.m. 100, no. 369 (1 November 1912): 181–82.

Kahnweiler, D.-H. "Der Kubismus." *Die Weissen Blätter* 3, no. 9 (Zurich-Leipzig: September 1916): 212–14.

———. *Der Weg zum Kubismus*. Munich: Delphin Verlag, 1920. Republished in 1958: Stuttgart, Verlag Gerd Hatje. English version published as *The Rise of Cubism*. Translated by Henry Aronson. The Documents of Modern Art. New York: Wittenborn, Schultz, 1949.

———. *Juan Gris, sa vie, son oeuvre, ses écrits*. Paris: Gallimard, 1946. English version published as *Juan Gris, His Life and Work*. Translated by Douglas Cooper. New York: Curt Valentin, 1947. Expanded versions of *Juan Gris, His Life and Work* were published in 1968–69 and 1977: New York: Harry N. Abrams.

———. *Les Sculptures de Picasso*. Photographs by Brassai. Paris: Éditions du Chêne, 1948.

———. "Negro Art and Cubism." *Horizon* 18, no. 108 (December 1948): 412–20.

———. "Huit Entretiens avec Picasso." *Le Point* 7, no. 42 (October 1952): 22–30.

———. "Du temps que les cubistes étaient jeunes." *L'oeil*, no. 1 (15 January 1955): 27–31.

———. "Entretiens avec Picasso." *Quadrum,* no. 2 (November 1956): 73–76.

———. *Mes Galeries et mes peintres: Entretiens avec Francis Crémieux*. Preface by André Fermigier. Paris: Éditions Gallimards, 1961. English version published as *My Galleries and Painters*. Translated by Helen Weaver. New York: Viking, 1971.

———. *Confessions esthétiques*. Paris: Éditions Gallimard, 1963.

Kozloff, Max. *Cubism / Futurism*. New York: Icon Editions, 1974.

Kramer, Hilton. "Pablo Picasso's Audacious Guitar." *New York Times* (March 21, 1971): section D, 21.

Krauss, Rosalind. "The Cubist Epoch." *Artforum* 9, no. 6 (February 1971): 32–38.

———. *Passages in Modern Sculpture*. Cambridge: MIT Press, 1981.

———. "Re-presenting Picasso." *Art in America* 68, no. 10 (December 1980): 90–96.

———. "In the Name of Picasso." *October* 16 (Spring 1981): 5–22. Reprinted in *The Originality of the Avant-Garde and Other Modernist Myths,* 23–40. Cambridge: MIT Press, 1985.

———. "The Originality of the Avant-Garde. A Postmodernist Repetition." *October* 18 (Fall 1981): 47–66. Reprinted in *The Originality of the Avant-Garde and Other Modernist Myths,* 151–70. Cambridge: MIT Press, 1985.

———. "The Motivation of the Sign." In *Picasso and Braque: Pioneering Cubism,* 2, edited by William Rubin. New York: Museum of Modern Art, 1992.

Lagrange, Gaston. "Exposition d'Industrie d'Art (Au Musée Galliéra)." *Gil Blas* (2 July 1909).

Lanchner, Carolyn, and William Rubin. "Henri Rousseau and Modernism." In *Henri Rousseau*. Ex. cat. New York: Museum of Modern Art, 1985.

Lassaigne, Jacques. "Un Entretien avec Georges Braque." *XXᵉ Siècle,* n.s., no. 41 (December 1973): 3–9.

Laude, Jean. *La peinture française (1905–1914) et l'art nègre*. Paris: Klincksieck, 1968.

———. "Picasso et Braque, 1910–1914: La transformation des signes." In *Le Cubisme. Travaux IV,* 7–28. Université de Saint-Étienne: CIEREC, 1971.

Leighten, Patricia. "Picasso's Collages and the Threat of War, 1912–13." *The Art Bulletin* 67, no. 4 (December 1985): 653–72. Reprinted in *Collage: Critical Views,* 121–70, edited by Katherine Hoffman. Ann Arbour / London: UMI Research Press, 1989.

———. "*La propagande par le rire*: Satire and Subversion in Apollinaire, Jarry and Picasso's Collages." *Gazette des Beaux-Arts,* ser. 6, 112 (October 1988): 163–70.

———. *Re-Ordering the Universe: Picasso and Anarchism, 1897–1914*. Princeton: Princeton University Press, 1989.

Level, André. *Picasso*. Paris: Crès, 1928.

Leymarie, Jean. *Braque*. Translated by James Emmons. Paris: Éditions d'Art Albert Skira, 1961.

Lipton, Eunice. *Picasso Criticism, 1901–1939. The Making of an Artist-Hero*. New York: Garland, 1976.

London. The Tate Gallery. *G. Braque*. Ex. cat. Essay by Douglas Cooper. Arranged by the Arts Council of Great Britain, in association with the Edinburgh Festival Society (28 September–11 November 1956).

Madrid. Ministerio de Cultura, Salas Pablo Ruiz Picasso. *Juan Gris [1887–1927]*. Ex. cat. Edited by Gary Tinterow. Essays in Spanish by G. Tinterow, M. McCully, P. Daix, L. Kachur, K. Silver, M. Rosenthal, J. Gállego, R. de Costa, C. Green (20 September–24 November 1985).

Malraux, André. *La Tête d'obsidienne*. Paris: Gallimard, 1974. English version published as *Picasso's Mask*. Translated by June Guicharnaud with Jacques Guicharnaud. New York: Holt, Rinehart and Winston, 1976.

Mare, André. "Le Papier Peint." *Montjoie!* nos. 4, 5, 6 (April, May, June 1914): 13.

Markov, Vladimir. "L'art des nègres." *Cahiers du Musée national d'art moderne* 2 (1979): 319–27. Translation by Louis Paudrat and Jacqueline Paudrat of *Iskusstvo negrov,* written in 1913–14 and posthumously published in 1919.

Martin, Alvin Randolph. "Georges Braque: Stylistic Formation and Transition, 1900–1909." Ph.D. diss., Harvard University, 1979.

Matisse, Henri. *Écrits et propos sur l'art*. Text, notes, and index established by Dominique Fourcade. Paris: Herman, Collection Savoir, 1972.

Miller, Michael B. *The Bon Marché. Bourgeois Culture and the Department Store, 1869–1920*. Princeton: Princeton University Press, 1981.

Minneapolis. Walker Art Center. *Picasso from the Musée Picasso, Paris*. Ex. cat. (10 February–30 March 1980).

Morice, Charles. "Salon des Indépendants." *Paris Journal* (18 March 1910): 4.

———. "Le 26ᵉ Salon des Indépendants." *Mercure de France,* s.m. 84, no. 308 (16 April 1910): 724–31.

Nash, John M. "The Nature of Cubism: A Study of Conflicting Explanations." *Art History* 3, no. 4 (December 1980): 435–47.

New York. Metropolitan Museum of Art. *Manet 1832–1883.* Ex. cat. Curated by Françoise Cachin and Charles S. Moffett, in collaboration with Michel Melot. New York: Abrams, 1983.

Nochlin, Linda. "Picasso's Color: Schemes and Gambits." *Art in America* 68, no. 10 (December 1980): 105–23, 177ff.

Olivier, Fernande. *Picasso et ses amis.* Paris: Librairie Stock, 1933. English version published as *Picasso and His Friends.* Translated by Jane Miller. New York: Appleton-Century-Crofts, 1965.

Olivier-Hourcade. "La Tendance de la peinture contemporaine." *La Revue de France et des pays français* 1, no. 1 (February 1912): 35–41.

———. "Enquête sur le Cubisme." *L'Action* (25 February 1912, 17 March 1912, 24 March 1912).

———. "Le mouvement pictural: Vers une école française de peinture." *La Revue de France et des pays français* (June 1912): 254–58.

Oppler, Ellen C. *Fauvism Reexamined.* New York: Garland, 1976.

Padrta, Jiri. *Picasso, The Early Years.* Preface by Jean Cocteau. New York: Tudor, [1964].

Palau i Fabre, Josep. *Picasso, Cubism 1907–1917.* Translated from the Catalan by Susan Branyas, Richard Lewis Rees, and Patrick Zabalbeascoa. New York: Rizzoli, 1990.

Parigoris, Alexandra. "Les constructions cubistes dans 'Les Soirées de Paris': Apollinaire, Picasso et les clichés Kahnweiler." *Revue de l'Art,* no. 82 (1988): 61–74.

Paris. Grand Palais. *Picasso: oeuvres reçues en paiement des droits de succession.* Ex. cat. (11 October 1979–7 January 1980). Éditions de la Réunion des musées nationaux, 1979.

Paris. Musée national d'art moderne, Centre Georges Pompidou. *Georges Braque: Les papiers collés.* Catalogue prepared by Isabelle Monod-Fontaine with E. A. Carmean, Jr., and contributions by Trinkett Clark, Douglas Cooper, Pierre Daix, Edward F. Fry, and Alvin Martin. Ex. cat. (17 June–27 September 1982). English version published as *Braque: The Papiers Collés.* Washington: National Gallery of Art, 1982.

Paris. Musée national d'art moderne, Centre Georges Pompidou. *Donation Louise et Michel Leiris. Collection Kahnweiler-Leiris.* Ex. cat. (22 November 1984–28 January 1985).

Paris. Musée national d'art moderne, Centre Georges Pompidou. *Daniel-Henry Kahnweiler, marchand, éditeur, écrivain.* Ex. cat. (22 November 1984–28 January 1985).

Parmelin, Hélène. *Picasso dit . . .* Paris: Denoël / Gonthier, 1966.

Paulhan, Jean. *Braque le patron.* Paris: Gallimard, 1952.

———. *La peinture cubiste. Les sources de l'art moderne.* Paris: Éditions Gonthier, 1970.

Penrose, Roland. *Picasso, His Life and Work.* New York: Harper and Row, [1958] 1971.

"Picasso." *Le Point* 42 (October 1952). Special issue. Includes articles by M. Raynal, D.-H. Kahnweiler, P. Reverdy, G. Besson, T. Tzara, P. Gay, E. Pignon, and C. Roy. Photographs by Robert Doisneau.

"Picasso Speaks." *The Arts* 3, no. 5 (May 1923): 315–26.

Poggi, Christine. "Mallarmé, Picasso, and the Newspaper as Commodity." *Yale Journal of Criticism* 1, no. 1 (Fall 1987): 133–51. Reprinted in *Collage: Critical Views,* 171–92, edited by Katherine Hoffman. Ann Arbor / London: UMI Research Press, 1989.

———. "Frames of Reference: 'Table' and 'Tableau' in Picasso's Collages and Constructions." *Art Journal* 47, no. 4 (Winter 1988): 311–22.

———. "Braque's Early *Papiers Collés:* The Certainties of *Faux-Bois.*" In *Picasso and Braque: Pioneering Cubism,* 2, edited by William Rubin. New York: Museum of Modern Art, 1992.

———. "La structure allegorique du collage de Picasso." *Actes du Colloque, Langage et modernité,* June 1990, 21-48, edited by Benjamin H. D. Buchloh. Villeurbanne: Le Nouveau Musée hors les murs, 1991.

Pool, Phoebe, and Anthony Blunt. *Picasso, the Formative Years: A Study of His Sources.* Greenwich, Conn.: New York Graphics Society, 1962.

Puy, Michel. "Le dernier état de la peinture." *Mercure de France,* s.m. 86, no. 314 (16 July 1910): 243–66.

———. "Les Indépendants." *Les Marges* 8, no. 28 (July 1911): 26–30.

———. "Les paradis du Salon d'Automne." *Les Marges* 8, no. 30 (December 1911): 164–68.

Raynal, Maurice. "Conception et Vision." *Gil Blas* (29 August 1912).

———. "Qu'est-ce que . . . le 'Cubisme'?" *Comoedia Illustré,* no. 6 (20 December 1913): n.p.

———. *Quelques intentions du Cubisme.* Paris: Éditions de "L'Effort Moderne," Leonce Rosenberg, 1919. Text of a lecture delivered on 11 May 1919.

———. "Les Arts." *Action* 1, no. 1 (February 1920): 76–78.

———. "Picasso et l'Impressionnisme." *L'Amour de l'art* (1921): 213 16.

———. *Georges Braque.* Rome: Éditions de "Valori Plastici," 1921.

———. "Juan Gris." *L'Esprit Nouveau,* no. 5 (February 1921): 534–54.

———. "Exposition Picasso." *L'Esprit Nouveau,* no. 9 (1921): 1020–22.

———. *Picasso.* Paris: G. Crès et Cⁱᵉ 1922.

———. "Juan Gris et la métaphore plastique (A propos de son Exposition à la Galerie Simon)." *Les Feuilles Libres* 5 (March–April 1923): 63–65.

————. "Picasso." *Bulletin de l'Effort Moderne,* no. 10 (December 1924): 8–11; (January 1925): 5–7; (February 1925): 6–7.

————. "Juan Gris." *Bulletin de l'Effort Moderne,* no. 16 (June 1925): 1–6.

————. *Anthologie de la peinture en France de 1906 à nos jours.* Paris: Éditions Montaigne, 1927.

————. Preface to "Le Cubisme." In Raymond Cogniat, *Les Créateurs du Cubisme.* Les Étapes de l'art contemporain V. Ex. cat. no. 13 (March–April 1935).

————. "Les Papiers Collés de Picasso." *Arts et Métiers Graphiques,* no. 46 (15 April 1935): 29–33.

————. "Panorama de l'oeuvre de Picasso." *Le Point* 42 (October 1952): 4–21.

Reff, Theodore. "Harlequins, Saltimbanques, Clowns and Fools." *Artforum* 10, no. 2 (October 1971): 30–43.

Reverdy, Pierre. "Sur le cubisme." *Nord-Sud,* no. 1 (15 March 1917).

————. "L'Essai d'esthétique littéraire." *Nord-Sud,* nos. 4–5 (June–July 1917).

————. "Certains avantages d'être seul." *SIC,* no. 32 (October 1918): 242–43.

————. *Pablo Picasso et son oeuvre.* Les Peintres Français Nouveaux, no. 16. Paris: Éditions de la Nouvelle Revue Française, Librairie Gallimard, 1924.

Richardson, John. *Georges Braque.* Harmondsworth and Baltimore: Penguin Books, 1959.

Rivière, Jacques. "Sur les tendances actuelles de la peinture." *Revue d'Europe et d'Amérique* (1 March 1912): 383–406.

Robbins, Daniel. "From Symbolism to Cubism: The Abbaye of Créteil." *Art Journal* 23, no. 2 (Winter 1963–64): 111–16.

————. "Sources of Cubism and Futurism." *Art Journal* 41, no. 4 (Winter 1981): 324–27.

Rosenberg, Léonce. "Introduzione." *Valori Plastici.* Special number on Cubism. (February-March 1919): 1–3.

————. "Séquestres 'Uhde et Kahnweiller [sic].'" *Bulletin de L'Effort Moderne,* no. 1 (January 1924): 13–16.

Rosenblum, Robert. *Cubism and Twentieth-Century Art.* New York: Abrams, [1959] 1976.

————. "Picasso and the Coronation of Alexander III: A Note on the Dating of Some *Papiers Collés.*" *The Burlington Magazine* 113 (October 1971): 604–08.

————. "Picasso and the Typography of Cubism." In *Picasso in Retrospect,* edited by Sir Roland Penrose and John Golding. New York: Icon Editions, 1980. Reprinted in *Collage: Critical Views,* 91–120, edited by Katherine Hoffman. Ann Arbor / London: UMI Research Press, 1989.

————. "Cubism as Pop Art." In *Modern Art and Popular Culture: Readings in High & Low,* 116–32, edited by Kirk Varnedoe and Adam Gopnik. New York: Museum of Modern Art, Abrams, 1990.

Rosenthal, Mark. "The Nietzschean Character of Picasso's Early Development." *Arts Magazine* 55, no. 2 (October 1980): 87–91.

————. *Juan Gris.* Ex. cat. University Art Museum, University of California, Berkeley, and New York: Abbeville Press, 1983.

Roskill, Mark. *The Interpretation of Cubism.* London and Toronto: Associated University Presses, 1985.

Rubin, William. *Picasso in the Collection of the Museum of Modern Art.* With additional texts by Elaine L. Johnson and Riva Castelman. New York: Museum of Modern Art, 1972.

————. "Visits with Picasso at Mougins: Interview with Milton Esterow." *Art News* 72, no. 6 (Summer 1973): 42–46.

————. "Cézannisme and the Beginnings of Cubism." In *Cézanne, The Late Work.* Ex. cat. Edited by William Rubin. New York: Museum of Modern Art, 1977.

————. "Pablo and Georges and Leo and Bill." *Art in America* 67, no. 2 (March-April 1979): 128–47.

————. "Fom Narrative to 'Iconic' in Picasso: The Buried Allegory in *Bread and Fruitdish on a Table* and the Role of *Les Demoiselles d'Avignon.*" *The Art Bulletin* 65, no. 4 (December 1983): 615–49.

————. "Modernist Primitivism: An Introduction" and "Picasso." In *"Primitivism" in 20th Century Art: Affinity of the Tribal and the Modern,* 1:1–81 and 240–343. Ex. cat. New York: Museum of Modern Art, 1984.

————. *Picasso and Braque: Pioneering Cubism.* Ex. cat. 2 vols. New York: Museum of Modern Art, 1989, 1992.

Russell, John. *Georges Braque.* London: Phaidon Press, 1959.

Sabartés, Jaime. *Picasso: portraits et souvenirs.* Paris: Louis Carré & Maximilien Vox, 1946.

Salmon, André. "Salon des Indépendants." *Paris Journal* (18 March 1910): 4–5.

————. "Courrier des Ateliers." *Paris Journal* (10 May 1910): 4.

————. *La jeune peinture française.* Paris: Société des Trente, Albert Messein, 1912.

————. "Le Salon [d'Automne]." *Montjoie!* 1, nos. 11–12 (November-December 1913): 1–9.

————. "Le Salon [des Artistes Indépendants]." *Montjoie!* 2, no. 3 (March 1914): 21–28.

————. *La jeune sculpture française.* Paris: Société des Trente, Albert Messein, 1919.

————. "Peindre." *Valori Plastici* (February-March 1919): 4–9.

————. "Picasso et le cubisme." *Les feuillets d'art* (1919): 45–46.

————. "Picasso." *L'Esprit Nouveau,* no. 1 (1920): 59–81.

————. "Georges Braque. L'Artiste et L'Artisan [Galerie de l'Effort Moderne]." *L'Europe Nouvelle* (1921): 625–26.

———. *L'Air de la Butte*. Paris: Éditions de la Nouvelle France, 1945.

———. *Souvenirs sans fin*. 2 vols. Paris: Gallimard, 1955, 1956.

Schiff, Gert, ed. *Picasso in Perspective*. Englewood Cliffs: Prentice-Hall, 1976.

Schneider, Pierre. *Matisse*. Translated by Michael Taylor and Bridget Stevens Romes. New York: Rizzoli, 1984.

Shiff, Richard. "On Criticism Handling History." *History of the Human Sciences* 2, no. 1 (February 1989): 63–87.

———. "Picasso's Touch: Collage, *Papier collé, Ace of Clubs*." *Yale University Art Gallery Bulletin* (1990): 38–47.

Silver, Kenneth E. "Purism: Straightening Up After the Great War." *Artforum* 15, no. 7 (March 1977): 56–63.

———. *Esprit de Corps: The Art of the Parisian Avant-Garde and the First World War, 1914–1925*. Princeton: Princeton University Press, 1989.

Soby, James Thrall. *Juan Gris*. Ex. cat. New York: Museum of Modern Art, 1958.

Soffici, Ardengo. "Picasso e Braque." *La Voce* 3, no. 34 (Florence: 24 August 1911): 635–37. Reprinted in *La Voce 1908–1916*, 237–48, edited by Giansiro Ferrata. Rome: Luciano Landi, 1961.

———. *Cubismo e oltre*. Florence: Libreria della Voce, 1913. Second revised edition published as *Cubismo e Futurismo*. Florence: Libreria della Voce, 1914.

Spies, Werner. "La guitare anthropomorphe." *Revue de l'art*, no. 12 (1971): 89–92.

———. *Picasso: Das plastische Werk*. Stuttgart: Verlag Gerd Hatje, 1971. English version published as *Sculpture by Picasso, with a Catalogue of the Works*. Translated by J. Maxwell Brownjohn. New York: Abrams, 1971.

———, and Christine Piot. *Picasso: Das plastische Werk*. Ex. cat. Berlin: Nationalgalerie (October 7–November 27, 1983), and Kunsthalle Düsseldorf (December 11, 1983–January 29, 1984).

Staller, Natasha. "Early Picasso and the Origins of Cubism." *Arts Magazine* 61, no. 1 (September 1986): 80–91.

———. "Melies' 'Fantastic' Cinema and the Origins of Cubism." *Art History* 12, no. 2 (June 1989): 202–32.

Steegmuller, Francis. *Apollinaire, Poet among the Painters*. New York: Farrar, Strauss, 1963.

Stein, Gertrude. *The Autobiography of Alice B. Toklas*. New York: Random House, 1933.

———. *Picasso*. Boston: Beacon Press, [1938] 1959.

Steinberg, Leo. "The Philosophical Brothel [Part 1]." *Art News* 71, no. 5 (September 1972): 20–29; [Part 2], 71, no. 6 (October 1972): 38–47. Reprinted in *October*, no. 44 (Spring 1988): 7–74.

———. *Other Criteria*. New York: Oxford University Press, [1972] 1975.

———. "Resisting Cézanne: Picasso's *Three Women* [Part 1]," *Art in America* 66, no. 6 (November-December 1978); and "The Polemical Part [Part 2]," 67, no. 2 (March-April 1979): 115–27.

Sweeney, James Johnson. "Picasso and Iberian Sculpture." *The Art Bulletin* 23, no. 3 (September 1941): 190–99.

Tabarant. "Au Salon d'Automne." *Paris-Midi* (30 September 1912, 2 October 1912).

Tucker, William. "Picasso's Cubist Constructions." *Studio International*, no. 179 (May 1970): 201–05.

Tzara, Tristan. "Le papier collé ou le proverbe en peinture." *Cahiers d'Art* 6, no. 2 (1931): 61–74.

Uhde, Wilhelm. *Picasso et la tradition française*. Paris: Éditions des quatre-chemins, [1928].

Vallentin, Antonina. *Pablo Picasso*. Paris: Albin Michel, 1956.

Vallier, Dora. "Braque, la peinture et nous. [Propos de l'artiste]." *Cahiers d'Art* 29, no. 1 (October 1954): 13–24.

Valsecchi, Marco, and Massimo Carrà. *L'Opera completa di Braque, dalla scomposizione cubista al recupero dell'oggetto, 1908–1929*. Milan: Rizzoli, 1971.

Vanderpyl, Fritz-R., and Guy-Charles Cros. "Réflexions sur les dernières tendances picturales." *Mercure de France*, s.m. 100, no. 371 (1 December 1912): 527–41.

Verdet, André. *Entretiens, notes, et écrits sur la peinture: Braque, Léger, Matisse, Picasso*. Paris: Éditions Galilée, 1978.

Waldo-Schwartz, Paul. *Cubism*. New York: Praeger, 1971.

Warnod, André. "La Section d'Or." *Comoedia* (13 October 1912).

———. "Le Salon des Indépendants: 1. Fauves et Cubistes." *Comoedia* (18 March 1913): 1–2, (19 March 1913).

———. *Le Vieux Montmartre*. Paris: Figuière et Cⁱᵉ· Éditeurs, 1913.

———. "'En peinture tout n'est que signe,' nous dit Picasso." *Arts* (Paris: 29 June 1945).

Werth, Léon. "Exposition Picasso [Galerie Notre-Dame des Champs, May 1910]." *La Phalange* 4 (20 June 1910): 728–30.

Wescher, Herta. *Picasso, papiers collés*. Paris: Fernand Hazan, Petite Encyclopédie de l'art, 1960.

Will-Levaillant, Françoise. "La lettre dans la peinture cubiste." In *Le Cubisme. Travaux IV*. Université de Saint-Étienne: CIEREC, 1971.

Worms de Romilly, Nicole, and Jean Laude. *Braque, le Cubisme fin 1907–1914*. Paris: Maeght, [1982].

Zervos, Christian. "Georges Braque et le développement du cubisme." *Cahiers d'Art* 7, nos. 1–2 (1932): 13–23.

———. "Conversation avec Picasso." *Cahiers d'Art* 10, nos. 7–10 (1935): 173–78.

————. "Oeuvres et images inédites de la jeunesse de Picasso." *Cahiers d'Art* 25 (1950): 277–333.

————. *Pablo Picasso. Catalogue général illustré.* Vols. 1–33. Paris: Cahiers d'Art, 1932–78.

Zurcher, Bernard. *Georges Braque: Vie et oeuvres.* Fribourg, Switzerland: Office du Livres S.A., 1988. English version published as *Georges Braque: Life and Work.* Translated by Simon Nye. New York: Rizzoli, 1988.

Futurism

Allard, Roger. "Futurisme, Simultanéisme et autres métachories." *Les Écrits Français,* no. 3 (5 February 1914): 254–59.

Andreoli-de-Villers, Jean Pierre. *Le premier manifeste du futurisme: édition critique avec, en fac-similé, le manuscrit original de F. T. Marinetti.* Ottawa: Éditions de l'Université d'Ottawa, 1986.

Apollinaire, Guillaume. *Chroniques d'art, 1902–1918.* With preface and notes by L.-C. Breunig. Paris: Éditions Gallimard, 1960.

Apollonio, Umbro, ed. *Futurismo.* Milan: Gabriele Mazzotta, [1970] 1976. English version published as *Futurist Manifestos.* Translations by Robert Brain, R. W. Flint, J. C. Higgitt, and Caroline Tisdall. London: Thames and Hudson, 1973.

Archivi del Divisionismo. 2 vols. Edited by Teresa Fiori. Rome: Officina, 1968.

Archivi del Futurismo. 2 vols. Edited by Maria Drudi Gambillo and Teresa Fiori. Rome: De Luca Editore, 1958, 1962.

Ballerini, Luigi, ed. *Italian Visual Poetry, 1912–1972.* Ex. cat. New York: Finch College Museum of Art and Istituto Italiano di Cultura, 1973.

Ballo, Guido. *Boccioni, la vita e l'opera.* Milan: Casa editrice Il Saggiatore, 1964.

Bergman, Pär. *Modernolatria et Simultaneità.* Uppsala: Appelbergs Boktryckeri AB, 1962.

Bergson, Henri. *The Creative Mind.* Translated by Mabelle L. Andison. New York: Philosophical Library, 1946. Includes essays from 1903–23.

————. *An Introduction to Metaphysics.* Authorized translation by T. E. Hulme, and with an introduction by Thomas A. Goudge. New York: The Liberal Arts Press, [1903] 1955.

Boccioni, Umberto. *Pittura Scultura Futuriste.* Florence: Vallecchi Editore, [1914] 1977.

————. *Gli scritti editi e inediti.* Edited by Zeno Birolli. Milan: Giangiacomo Feltrinelli Editore, 1971.

L'Opera completa di Boccioni. With an introduction by Aldo Palazzeschi and a collection of critical statements. Milan: Rizzoli Editore, 1969.

Cachin, Françoise. "Futurism in Paris 1909–1913." *Art in America* 62, no. 2 (March 1974): 38–44.

Calvesi, Maurizio. "Dinamismo e simultaneità nella poetica Futurista." *L'Arte Moderna* 5, nos. 37–45. Milan: Fratelli Fabbri Editori, 1967.

Cangiullo, Francesco. *Le serate futuriste: romanzo storico vissuto.* Milan: Casa Editrice Ceschina, 1961.

Carrà, Carlo. *Guerrapittura.* Milan: Edizioni Futuriste di "Poesia," 1915.

————. "Picasso." *Valori Plastici* 2, nos. 9–12 (1920): 101–07.

————. *Tutti gli scritti.* Edited by Massimo Carrà. Milan: Feltrinelli Editore, 1978.

————. *La mia vita.* Milan: Feltrinelli Editore, 1981.

————. *Carlo Carrà, Ardengo Soffici: Lettere 1913 / 1929.* Edited by Massimo Carrà and Vittorio Fagone. Milan: Feltrinelli Editore, 1983.

L'opera completa di Carrà, dal Futurismo alla metafisica e al realismo mitico 1910–1930. Introduction by Piero Bongiari. Critical notes by Massimo Carrà. Milan: Rizzoli, 1970.

100 Opere di Carlo Carrà. With essays by Mario de Micheli and Mario Luzi. Prato: Edizioni Galleria Fratelli Falsetti, 1971.

Carrà Futurista. Florence: Stampa della Eurografica, S.p.A., 1978.

Carrieri, Raffaele. *Futurism.* Translated by Leslie van Rensselaer White. Milan: Edizioni del Milione, 1961.

Cavallo, Luigi, ed. *Soffici: Immagini e documenti (1879–1964).* Milan: Vallecchi Editore, 1986.

Clough, Rosa Trillo. *Futurism. The Story of a Modern Art Movement. A New Appraisal.* New York: Greenwood Press, 1969.

Coen, Ester. *Umberto Boccioni.* Ex. cat. New York: Metropolitan Museum of Art, 1988.

Coquiot, Gustave. *Cubistes, futuristes, passéistes; essai sur la jeune peinture et la jeune sculpture.* Paris: Librairie Ollendorff, 1914.

Crispolti, Enrico. *Storia e critica del futurismo.* Rome-Bari: Editori Laterza, 1986.

Cundy, David. "Marinetti and Italian Futurist Typography." *Art Journal* 41, no. 4 (Winter 1981): 349–52.

Damigella, Anna Maria. *Il Futurismo. Storia e Analisi (1909–1916).* Catania: ITES, 1971.

De Marchis, Giorgio. *Giacomo Balla: L'aura futurista.* Turin: Giulio Einaudi Editore, 1977.

De Maria, Luciano, ed. *Per Conoscere Marinetti e il Futurismo.* Arnoldo Mondadori Editore, 1973.

Dorazio, Virginia Dorch. *Giacomo Balla, An Album of His Life and Work.* New York: Wittenborn and Co., [1969].

Easton, Elizabeth W. "Marinetti before the First Manifesto." *Art Journal* 41, no. 4 (Winter 1981): 313–16.

Fanelli, Giovanni, and Ezio Godoli. *Il futurismo e la grafica.* Milan: Edizioni Communità, 1988.

Fonti, Daniela. *Gino Severini: Catalogo ragionato.* Texts by Maurizio Fagiolo dall'Arco et al. Milan: Mondadori-Phillippe Daveria, 1988.

Golding, John. *Boccioni's Unique Forms of Contintuity in Space.* Charleton Lectures on Art. Newcastle upon Tyne: University of Newcastle upon Tyne, 1972.

Hanson, Anne Coffin, ed. *The Futurist Imagination.* Ex. cat. New Haven: Yale University Art Gallery, 1983.

———. "*Portrait of Soffici* and *Conclusion*: Two Drawings by Carlo Carrà." *Yale University Art Gallery Bulletin* 40 (1987): 70–77.

Henderson, Linda Dalrymple. "Italian Futurism and 'The Fourth Dimension.'" *Art Journal* 41, no. 4 (Winter 1981): 317–23.

Hulten, Pontus, ed. *Futurismo e Futurismi.* Ex. cat. Venice: Palazzo Grassi, Gruppo Editoriale Fabbri, Bompiani, Sonzogno, Etas S.p.A., 1986. English version published as *Futurism & Futurisms.* New York: Abbeville Press, 1986.

Jannini, P. A. *Le Avanguardie letterarie nell'idea critica di Guillaume Apollinaire.* Rome: Bulzoni Editore, 1971.

Kahn, Gustave. "I^ère Exposition de sculpture futuriste de M. Umberto Boccioni (Galerie la Boétie)." *Mercure de France,* s.m. 104, no. 386 (16 July 1913): 420–21.

Kozloff, Max. *Cubism / Futurism.* New York: Icon Editions, 1973.

Lacerba. Florence: 1913–15.

Lista, Giovanni. *Futurisme. Manifestes, Documents, Proclamations.* Lausanne: L'Age d'Homme, 1973.

———. *Marinetti et le Futurisme.* Lausanne: L'Age d'Homme, 1977.

———. "Futurisme et Cubo-Futurisme." *Cahiers du Musée national d'art moderne,* no. 5 (1980): 456–95.

———. "Préface" to F. T. Marinetti, *Le Futurisme.* Lausanne: L'Age d'Homme, 1980.

———. *Balla.* Modena: Edizioni Galleria Fonte d'Abisso, 1982.

———. *Le Livre futuriste de la libération du mot au poème tactile.* Modena-Paris: Éditions Panini, 1984.

———. "Préface" to F. T. Marinetti, *Les mots en liberté futuristes.* Lausanne: L'Age d'Homme, 1987.

Livshits, Benedikt. *The One-and-a-Half-Eyed Archer.* Edited and translated by John E. Bowlt. Newtonville, Mass.: Oriental Research Partners, 1977.

London. Royal Academy of Arts. *Post-Impressionism: Cross-Currents in European Painting.* Ex. cat. Edited by John House and Mary Anne Stevens. (1979).

Longhi, Roberto. *Scultura Futurista Boccioni.* Florence: Libreria della Voce, 1914.

Lukach, Joan M. "Severini's 1917 Exhibition at Stieglitz's '291.'" *The Burlington Magazine* 113, no. 817 (April 1971): 196–207.

Marcadé, Jean-Claude, ed. *Présence de F. T. Marinetti.* Lausanne: L'Age d'Homme, 1982.

Marinetti, F. T. *Le Futurisme.* Paris: Sansot, 1911.

———. *Grande esposizione nazionale futurista: Quadri, complessi plastici, architettura, tavole parolibere, teatro plastico futurista e moda futurista.* Ex. cat. Milan: Galleria Centrale d'Arte, March 1919.

———. *Teoria e invenzione futurista.* Preface by Aldo Palazzeschi. Introduction, text, and notes by Luciano De Maria. Milan: A. Mondadori, 1968.

Marinetti, Selected Writings. Edited and with an introduction by R. W. Flint. Translated by R. W. Flint and Arthur A. Coppotelli. New York: Farrar, Straus and Giroux, 1971.

Martin, Marianne W. *Futurist Art and Theory, 1909–1915.* Oxford: Clarendon Press, 1968.

———. "Carissimo Marinetti: Letters from Severini to the Futurist Chief." *Art Journal* 41, no. 4 (Winter 1981): 305–12.

———, and Anne Coffin Hanson, eds. "Futurism" *Art Journal* 41, no. 4 (Winter 1981).

Milan. Civico Museo d'Arte Contemporanea, Palazzo Reale. *Boccioni à Milano.* Ex. cat. Gabriele Mazzotta editore (December 1982–March 1983).

Olivier-Hourcade. "Les Futuristes." *La Revue de France et des pays français,* no. 3 (April 1912): 135–36.

Petrie, Brian. "Boccioni and Bergson." *The Burlington Magazine* 116 (March 1974): 140–47.

Philadelphia. Philadelphia Museum of Art. *Futurism and the International Avant-Garde.* Ex. cat. With essays by Anne d'Harnoncourt and Germano Celant (1980).

Poggi, Christine. "Marinetti's *Parole in Libertà* and the Futurist Collage Aesthetic." In *The Futurist Imagination,* 2–15, edited by Anne Coffin Hanson. Ex. cat. New Haven: Yale University Art Gallery, 1983.

Previati, Gaetano. *La tecnica della pittura.* Turin: Fratelli Bocca, 1905.

———. *I Principii Scientifici del Divisionismo: (La tecnica della pittura).* Turin: Fratelli Bocca, 1906.

Raynal, Maurice. "Gino Severini." *SIC,* nos. 45, 46 (15 May, 31 May 1919): 368.

Richter, Mario. *La formazione francese di Ardengo Soffici, 1900–1914.* Milan: Società Editrice Vita e Pensiero, 1969.

Robbins, Daniel. "Sources of Cubism and Futurism." *Art Journal* 41, no. 4 (Winter 1981): 324–27.

Robinson, Susan Barnes. *Giacomo Balla: Divisionism and Futurism, 1871–1912.* Ann Arbor: UMI Research Press, 1981.

Roche-Pézard, Fanette. *L'Aventure futuriste, 1909–1916.* Rome: École Française de Rome, 1983.

Rodriguez, Jean-François. "Picasso à la Biennale de Venise (1905–1948): Sur deux lettres de Picasso à Ardengo Soffici." *Atti dell'Istituto Veneto di Scienze, Lettere ed Arti* 143 (1984–85): 27–63.

Romani, Bruno. *Dal Simbolismo al Futurismo.* Florence: Edizioni Remo Sandron, 1969.

Rosenblum, Robert. *Cubism and Twentieth-Century Art.* New York: Abrams, [1959] 1976.

———. "Picasso and the Typography of Cubism." In *Picasso in Retrospect,* edited by Sir Roland Penrose and John Golding. New York: Icon Editions, 1980. Reprinted in *Collage: Critical Views,* 91–120, edited by Katherine Hoffman. Ann Arbor / London: UMI Research Press, 1989.

Schiavo, Alberto, ed. *Futurismo e Fascismo.* Rome: Giovanni Volpe Editore, 1981.

Severini, Gino. "Symbolisme plastique et symbolisme littéraire." *Mercure de France,* s.m. 113, no. 423 (1 February 1916): 466–76.

———. "Cézanne et le Cézannisme." *L'Esprit Nouveau* (1921): 1257–66.

———. "Vers une synthèse esthétique." *Bulletin de l'Effort Moderne,* no. 7 (July 1924): 14–16; no. 8 (October 1924): 13–15.

———. *Tutta la vita di un pittore.* Vol. 1. Rome-Paris-Milan: Garzanti, 1946. Vol. 2. Florence: Vallecchi, 1968. An integrated edition was published as *La Vita di un pittore.* Milan: Feltrinelli Editore, 1983.

———. "Apollinaire et le Futurisme." *XXᵉ Siècle,* n.s., no. 3 (June 1952): 13–17.

———. "L'intuition futuriste du 'dynamisme plastique.'" *XXᵉ Siècle,* n.s., no. 5 (June 1955): 49–52.

———. "Lettere e documenti." *Critica d'art* 3 (May-June 1970): 8–48.

———. *Dal cubismo al classicismo e altri saggi sulla divina proporzione e sul numero d'oro.* Florence: Marchi & Bertolli Editori, 1972.

———. *Écrits sur l'art.* Preface by Serge Fauchereau. Paris: Éditions Cercle d'Art, 1987.

Mostra Antologica di Gino Severini. Ex. cat. Rome: Palazzo Venezia, 1961.

Gino Severini (1883–1966). Ex. cat. Curated by Renato Barili with collaboration of Silvia Evangelisti and Paola Marescalchi. Florence: Palazzo Pitti, 1983. Milan: Electa Editrice, 1983.

Silk, Gerald D. "Fu Balla e Balla Futurista." *Art Journal* 41, no. 4 (Winter 1981): 328–36.

Smith, Denis Mack. *Italy, a Modern History.* Revised edition. Ann Arbor: University of Michigan Press, [1969].

Soffici, Ardengo. *Cubismo e oltre.* Florence: Libreria della Voce, 1913. Second revised edition published as *Cubismo e Futurismo.* Florence: Libreria della Voce, 1914.

———, and Giovanni Papini, eds. *Almanacco Purgativo.* Florence: Lacerba, 1914.

———. *BïF § ZF + 18 Simultaneità e Chimismi Lirici.* Florence: Vallecchi Editore, 1915, 1919.

———. *Primi principi di una estetica futurista.* Florence: Vallecchi Editore, 1920.

———. *Medardo Rosso (1858–1928).* Florence: Vallecchi Editore, 1929.

———. *Ricordi di vita artistica e letteraria.* Florence: Vallecchi Editore, 1931.

———. *Opere.* 2 vols. Florence: Vallecchi Editore, 1959.

Ardengo Soffici e il Cubofuturismo 1911–1915. With essays by L. Cavallo, G. Raimondi, F. Russoli. Florence: Galleria Michaud, 1967.

100 Opere di Ardengo Soffici. Ex. cat. With essays by Piero Bargellini and Fortunato Bellonzi. Prato: Edizioni Galleria Fratelli Falsetti, 1969.

Ardengo Soffici. L'artista e lo scrittore nella cultura del 900. Edited by Geno Pampaloni. Ex. cat Florence: Centro Di, 1975.

Taylor, Joshua C. *Futurism.* New York: Museum of Modern Art, 1961.

Tisdall, Caroline, and Angelo Bozzolla. *Futurism.* New York: Oxford University Press, 1978.

Wescher, Herta. "Collages futuristes," *XXᵉ Siècle,* n.s., no. 6 (January 1956): 21–23ff.

Poetry, Literary History, and Theory

Aarsleff, Hans. *From Locke to Saussure. Essays on the Study of Language and Intellectual History.* Minneapolis: University of Minnesota Press, 1982.

Adema, P. M. *Guillaume Apollinaire.* Paris: La Table Ronde, 1968.

Admussen, Richard. "Nord-Sud and Cubist Poetry." *Journal of Aesthetics and Art Criticism* 27, no. 1 (Fall 1968): 21–24.

Apollinaire, Guillaume. *Alcools, poèmes 1898–1913.* Paris: Mercure de France, 1913. This book was republished by Éditions Gallimard in 1920.

———. *Alcools.* [Followed by reproductions of the first proofs corrected by the hand of Apollinaire.] Paris. Le Club du Meilleur livre, 1953.

———. "Simultanisme—Librettisme," *Les Soirées de Paris,* no. 25 (June 1914): 322–25.

———. *Calligrammes, poèmes de la paix et de la guerre, 1913–1916.* Paris: Mercure de France, 1918. This book was republished by Éditions Gallimard in 1925.

———. *Calligrammes. Poems of Peace and War (1913–1916).* Translated by Anne Hyde Greet, with an introduction by S. I. Lockerbie, and with commentary by Greet and Lockerbie. Berkeley: University of California Press, 1980.

———. *Selected Writings of Guillaume Apollinaire.* Edited and translated by Roger Shattuck. New York: New Directions Books, 1971.

Apollonio, Umbro, ed. *Futurismo.* Milan: Gabriele Mazzotta, [1970], 1976. English version published as *Futurist Manifestos.* Translations by Robert Brain, R. W. Flint, J. C. Higgitt, and Caroline Tisdall. London: Thames and Hudson, 1973.

Aragon, Louis. "Calligrammes." *L'Esprit Nouveaux* (1921): 103–07.

Balakian, Anna. *The Symbolist Movement, A Critical Appraisal.* New York: New York University Press, 1977.

Ball, Hugo. *Flight Out of Time: A Dada Diary.* Edited with an introduction, notes, and bibliography by John Elderfield. Translated by Ann Raimes. New York: Viking, 1974.

Ballerini, Luigi, ed. *Italian Visual Poetry, 1912–1972.* Ex. cat. New York: Finch College Museum of Art and Istituto Italiano di Cultura, 1973.

Banville, Théodore Faullain de. *Petit traité de poésie française.* Paris: A. Lemerre, [1871] 1891.

Batault, Georges. "Les Tendances de la poésie contemporaine." *Mercure de France,* s.m. 99, no. 366 (16 September 1912): 298–325.

Bergman, Pär. *Modernolatria et Simultaneità.* Uppsala: Appelbergs Boktryckeri AB, 1962.

Billy, André. *Apollinaire vivant.* Paris: Éditions de la Sirène, 1923.

——. *Max Jacob.* Paris: Seghers, 1945.

——. *L'Époque 1900.* Paris: Tallandier, 1954.

——. *Apollinaire.* Paris: Seghers, 1956.

Bohn, Willard. "Free-Word Poetry and Painting in 1914: Ardengo Soffici and Guillaume Apollinaire." In *Ardengo Soffici: L'Artista e lo scrittore nella cultura del 900,* 209–26, edited by Geno Pampaloni. Ex. cat. Florence: Centro Di, 1976.

——. "Circular Poem-Paintings by Apollinaire and Carrà." *Comparative Literature* 31, no. 3 (Summer 1979): 246–71.

——. *The Aesthetics of Visual Poetry 1914–1928.* Cambridge: Cambridge University Press, 1986.

Brooks, Peter. *Reading for the Plot. Design and Intention in Narrative.* New York: Vintage Books, [1984], 1985.

Browning, Gordon Frederick. *Tristan Tzara: The Genesis of the Dada Poem or from Dada to Aa.* Stuttgart: Akademischer Verlag Hans-Dieter Heinz, 1979.

Bruns, Gerald L. "Mallarmé: The Transcendence of Language and the Aesthetics of the Book." *The Journal of Typographic Research* 3, no. 3 (July 1969): 219–40.

Calvesi, Maurizio. "Dinamismo e simultaneità nella poetica Futurista." *L'Arte Moderna* 5, nos. 37–45. Milan: Fratelli Fabbri Editori, 1967.

Carmody, Francis James. *The Evolution of Apollinaire's Poetics, 1901–1914.* Berkeley: University of California Press, 1963.

Carrà, Carlo. *Guerrapittura.* Milan: Edizioni Futuriste di "Poesia," 1915.

—— *Tutti gli scritti.* Edited by Massimo Carrà. Milan: Feltrinelli Editore, 1978.

——. *La mia vita.* Milan: Feltrinelli Editore, 1981.

Caruso, Luciano, and Stelio M. Martini, eds. *Tavole parolibere futuriste (1912–1944).* 2 vols. Naples: Liguori Editore, 1974.

Caruso, Luciano, and Stelio M. Martini. *Scrittura visuale e poesia sonora futurista.* Ex. cat. Florence: Palazzo Medici Riccardi, 1977.

Cendrars, Blaise. *Oeuvres complètes.* Paris: Denoël, 1960.

Cohn, Robert Greer. *Mallarmé's 'Un Coup de Dés': An Exegesis.* New Haven: Yale French Studies, 1949.

Cornell, Kenneth William. *The Post-Symbolist Movement: French Poetic Currents 1900 to 1925.* New Haven: Yale University Press, 1951.

Culler, Jonathan. *Ferdinand de Saussure.* Revised edition. Ithaca and New York: Cornell University Press, 1986.

Cundy, David. "Marinetti and Italian Futurist Typography." *Art Journal* 41, no. 4 (Winter 1981): 349–52.

Damigella, Anna Maria. *Il Futurismo: storia e analisi (1909–1916).* Catania: ITES, 1971.

Debon, Claude. *Guillaume Apollinaire après Alcools: Calligrammes: le poète et la guerre.* Bibliothèque des Lettres Modernes 31. Paris: Librairie Minard, 1981.

Décaudin, Michel. *La crise des valeurs symbolistes. Vingt ans de poésie française, 1895–1914.* Toulouse: Éditions Privat, 1960.

——. *Le Dossier d' "Alcools".* Paris: Librairie Minard, 1965.

De Man, Paul. *Allegories of Reading. Figural Language in Rousseau, Nietzsche, Rilke, and Proust.* New Haven and London: Yale University Press, 1979.

——. *Blindness and Insight. Essays in the Rhetoric of Contemporary Criticism.* 2nd edition, revised. Theory and History of Literature, 7. Minneapolis: University of Minnesota Press, 1983.

——. *The Rhetoric of Romanticism.* New York: Columbia University Press, 1984.

De Maria, Luciano, ed. *Per Conoscere Marinetti e il Futurismo.* Milan: Arnoldo Mondadori Editore, 1973.

Derrida, Jacques. "Structure, Sign, and Play in the Discourse of the Human Sciences." In *The Structuralist Controversy: The Languages of Criticism and the Sciences of Man,* 247–72, edited by Richard Macksey and Eugenio Donato. Baltimore: Johns Hopkins University Press, 1972.

——. *Of Grammatology.* Translated by Gayatari Chakravorty Spivak. Baltimore and London: Johns Hopkins University Press, [1967] 1976.

——. "The Double Session." In *Dissemination,* 173–285, translated and with an introduction by Barbara Johnson. Chicago: University of Chicago Press, 1981.

Fort, Paul, and Louis Mandin. *Histoire de la poésie française depuis 1850.* Paris-Toulouse: Flammarion, 1926.

Foucault, Michel. *The Order of Things.* New York: Random House, Vintage Books, [1966] 1973.

Frank, Joseph. "Spatial Form in Modern Literature." *Sewanee Review* 53 (1945): part 1, 221–40; part 2, 433–56; part 3, 643–53.

Ghil, René. *Traité du verbe*. With a preface by Stéphane Mallarmé. Paris: Chez Giraud, 1886.

———. *Méthode Évolutive-Instrumentiste d'une poésie rationnelle*. Paris: Albert Savine, Éditeur, 1889.

———. *Les Dates et les oeuvres*. Symbolisme et poésie scientifique. Paris: Les Éditions G. Crès et Cⁱᵉ., 1923.

Gide, André. "Verlaine et Mallarmé." [Lecture at the Théatre du Vieux-Colombier, 22 November 1913.] *La Vie des Lettres* (April 1914): 1–23.

Hanson, Anne Coffin, ed. *The Futurist Imagination*. Ex. cat. New Haven: Yale University Art Gallery, 1983.

Huelsenbeck, Richard. *Memoirs of a Dada Drummer*. Edited, with an introduction, notes, and bibliography by Hans J. Kleinschmidt. Translated by Joachim Neugroschel. New York: The Viking Press, [1969] 1974.

Hulten, Pontus, ed. *Futurismo e Futurismi*. Ex. cat. Venice: Palazzo Grassi, Gruppo Editoriale Fabbri, Bompiani, Sonzogno, Etas S.p.A., 1986. English version published as *Futurism & Futurisms*. New York: Abbeville Press, 1986.

Jacobbi, Ruggero. *Poesia futurista italiana*. Parma: Guanda, 1968.

Jameson, Fredric. *The Prison-House of Language. A Critical Account of Structuralism and Russian Formalism*. Princeton: Princeton University Press, 1972.

Jannini, P. A. *Le Avanguardie letterarie nell'idea critica di Guillaume Apollinaire*. Rome: Bulzoni Editore, 1971.

Johnson, Barbara. *The Critical Difference. Essays in the Contemporary Rhetoric of Reading*. Baltimore and London: Johns Hopkins University Press, [1980] 1985.

Kahn, Gustave. *Premiers Poèmes. Avec une Préface sur le vers libres*. Paris: Société du Mercure de France, 1897.

———. *Symbolistes et Décadents*. Paris: Librairie Léon Vanier, Éditeur, 1902.

———. "Le Vers libre." *Vers et Prose* 28 (January-March 1912): 40–50.

Krauss, Rosalind. "The Motivation of the Sign." In *Picasso and Braque: Pioneering Cubism*, 2, edited by William Rubin. New York: Museum of Modern Art, 1992.

Lacerba. Florence: 1913–15.

Lehmann, A. G. *The Symbolist Aesthetic in France, 1885–1895*. 2d ed. Oxford: Basil Blackwell, 1968.

Lemaitre, Georges. *From Cubism to Surrealism in French Literature*. Westport, Ct.: Greenwood Press, [1941] 1978.

Lista, Giovanni. *Futurisme. Manifestes, Documents, Proclamations*. Lausanne: L'Age d'Homme, 1973.

———. *Marinetti et le Futurisme*. Lausanne: L'Age d'Homme, 1977.

———. *Le Livre futuriste de la libération du mot au poème tactile*. Modena-Paris: Éditions Panini, 1984.

———. "Préface." F. T. Marinetti, *Les mots en liberté futuristes*. Lausanne: L'Age d'Homme, 1987.

Livshits, Benedikt. *The One-and-a-Half Eyed Archer*. Edited and translated by John E. Bowlt. Newtonville, Ma.: Oriental Research Partners, 1977.

Mallarmé, Stéphane. "Un Coup de dés jamais n'abolira le hasard." *Cosmopolis* 6 (May 1897): 419–27.

———. *Oeuvres complètes*. Edition established and annotated by Henri Mondor and G. Jean-Aubry. Paris: Éditions Gallimard, Bibliothèque de la Pléiade, 1945.

———. *Selected Prose Poems, Essays, and Letters*. Translated and with an introduction by Bradford Cook. Baltimore: Johns Hopkins University Press, 1956.

Marcus, Susan. "The Typographic Element in Cubism, 1911–1915: Its Formal and Semantic Implications." *Art International* 17, no. 5 (May 1973): 24–29ff.

Marinetti, F. T. *Le Futurisme*. With an introduction by Giovanni Lista. Lausanne: L'Age d'Homme, [1911] 1980.

———. *I poeti futuristi*. Milan: Edizioni futuriste di "Poesia," 1912.

———. *Zang Tumb Tumb*. Milan: Edizioni futuriste di "Poesia," 1914. French version published as *Zang Toumb Toumb*.

———. *Les mots en liberté futuristes*. Milan: Edizioni futuriste di "Poesia," 1919.

———. *Teoria e invenzione futurista*. Preface by Aldo Palazzeschi. Introduction, text, and notes by Luciano De Maria. Milan: A. Mondadori, 1968.

———. *Marinetti, Selected Writings*. Edited and with an introduction by R. W. Flint. Translated by R. W. Flint and Arthur A. Coppotelli. New York: Farrar, Straus and Giroux, 1971.

Morice, Charles. *La littérature de tout à l'heure*. Paris: Perrin et Cⁱᵉ. 1889.

Perloff, Marjorie. *The Futurist Moment: Avant-Garde, Avant-Guerre, and the Language of Rupture*. Chicago and London: University of Chicago Press, 1986.

Poggi, Christine. "Marinetti's *Parole in Libertà* and the Futurist Collage Aesthetic." In *The Futurist Imagination*, 2–15, edited by Anne Coffin Hanson. Ex. cat. New Haven: Yale University Art Gallery, 1983.

Poggioli, Renato. *The Theory of the Avant-Garde*. Translated by Gerald Fitzgerald. New York: Icon Editions, [1962] 1971.

Ragusa, Olga. *Mallarmé in Italy. Literary Influence and Critical Response*. New York: S. F. Vanni, 1957.

Richter, Mario. *La formazione francese di Ardengo Soffici, 1900–1914*. Milan: Società Editrice Vita e Pensiero, 1969.

Rivaroli, Edmondo. *La poétique parnassienne d'après Théodore de Banville. Théorie, applications, conséquences*. Paris: A. Maloine et fils, Éditeurs, 1915.

Romains, Jules [Louis Farigoule]. *La vie unanime, Poème 1904–1907*. Paris: Éditions Gallimard, [1926] 1983.

Romani, Bruno. *Dal Simbolismo al Futurismo*. Florence: Edizioni Remo Sandron, n.d.

Sacks-Galey, Pénélope. *Calligramme ou écriture figurée: Apollinaire inventeur de formes*. Paris: Lettres Modernes, Minard, 1988.

Sartre, Jean-Paul. *Mallarmé, or the Poet of Nothingness*. Translated and introduced by Ernest Sturm. University Park and London: Pennsylvania State University Press, 1988.

Saussure, Ferdinand de. *Cours de linguistique générale*. Paris: Presses universitaires de France, [1916] 1965. English version published as *Course in General Linguistics*. Translated by Wade Baskin. New York: McGraw-Hill, 1966.

Seaman, David W. *Concrete Poetry in France*. Ann Arbor: UMI Research Press, 1981.

Severini, Gino. *Tutta la vita di un pittore*. Vol. 1. Rome-Paris: Garzanti, 1946.

———. "Apollinaire et le Futurisme." *XXᵉ Siècle*, n.s., no. 3 (June 1952): 13–17.

Shattuck, Roger. *The Banquet Years, The Origins of the Avant-Garde in France, 1885 to World War I*. Revised edition. New York: Vintage Books, 1968.

Soffici, Ardengo. *BïF § ZF + 18 Simultaneità e Chimismi Lirici*. Florence: Vallecchi Editore, 1915, 1919.

———. *Ricordi di vita artistica e letteraria*. Florence: Vallecchi Editore, 1931.

———. *Opere*. 2 vols. Florence: Vallecchi Editore, 1959.

Ardengo Soffici e il Cubofuturismo 1911–1915. With essays by Cavallo, Raimondi, Russoli. Florence: Galleria Michaud, 1967.

Ardengo Soffici. L'artista e lo scrittore nella cultura del 900. Ex. cat. Florence: Centro Di, 1975.

Steegmuller, Francis. *Apollinaire, Poet among the Painters*. New York: Farrar, Strauss, 1963.

Steiner, Wendy. "*Res Poetica*: The Problematics of the Concrete Program." *New Literary History* 12, no. 3 (Spring 1981): 529–45.

———. *The Colors of Rhetoric. Problems in the Relation between Modern Literature and Painting*. Chicago and London: University of Chicago Press, 1982.

Thibaudet, Albert. *La poésie de Stéphane Mallarmé: Étude littéraire*. Paris: Éditions de la Nouvelle Revue Française, 1912.

Tisdall, Caroline, and Angelo Bozzolla. *Futurism*. New York: Oxford University Press, 1978.

Todorov, Tzvetan. *Theories of the Symbol*. Translated by Catherine Porter. Ithaca: Cornell University Press, [1977] 1982.

Tzara, Tristan. *Oeuvres complètes. Tome 1 (1912–1924)*. Edited by Henri Béhar. Paris: Flammarion, 1975.

Vanor, Georges. *L'Art Symboliste*. Preface by Paul Adam, with notes by Gustave Kahn. Paris: Vanier, 1889.

Venice. La Biennale di Venezia. Archivio storico delle arti contemporanee. *Tavole parolibere e tipografia futurista*. Ex. cat. With an essay by Luciano Caruso. 1977.

White, John J. "The Argument for a Semiotic Approach to Shaped Writing: The Case of Italian Futurist Typography," *Visible Language* 11 (Winter 1976): 53–86.

Will-Levaillant, Françoise. "La lettre dans la peinture cubiste." In *Le Cubisme. Travaux IV*. Université de Saint-Étienne: CIEREC, 1971.

Windsor, Alan. "Apollinaire, Marinetti and Carrà's 'Dipinto Parolibero.'" *Gazette des Beaux-Arts* 89 (April 1977): 145–52.

General Works

Abdy, Jane. *The French Poster: Chéret to Cappiello*. London: Studio Vista Ltd., 1969.

Ades, Dawn. *Photomontage*. New York: Phaidon, 1976.

Adorno, Theodor W. *Aesthetic Theory*. Edited by Gretel Adorno and Rolf Tiedemann. Translated by C. Lenhardt. London and New York: Routledge and Kegan Paul, 1986.

Alberti, Leon Battista. *On Painting*. Translated with introduction and notes by John R. Spencer. New Haven and London: Yale University Press, 1966.

Aurier, Albert. "Le Symbolisme en peinture, Paul Gauguin." *Mercure de France* 2, no. 15 (March 1891): 155–65.

Avenel, Henri. *Histoire de la presse française depuis 1789 jusqu'à nos jours*. Paris: Flammarion, 1900.

Balakian, Anna. *The Symbolist Movement, A Critical Appraisal*. New York: New York University Press, 1977.

Barthes, Roland. *Mythologies*. Translated by Jonathan Cape Ltd. New York: Farrar, Strauss and Giroux, [1957] 1984.

———. L'Effet de réel." *Communications* 2 (1968): 84–89.

Benjamin, Walter. "The Work of Art in the Age of Mechanical Reproduction." In *Illuminations*, translated by Harry Zohn. New York: Schocken Books, 1977.

———. *The Origin of German Tragic Drama*. With an introduction by George Steiner. Translated by John Osborne. London: Verso, 1977.

———. *Charles Baudelaire: A Lyric Poet in the Era of High Capitalism*. Translated by Harry Zohn. London: Verso Editions, 1983.

Blanc, Charles. *Grammaire des arts du dessin: architecture, sculpture, peinture*. Paris: Librairie J. Renouard, 1867.

———. *Grammaire des arts décoratifs*. Paris: Librairie J. Renouard, 1867.

Buchloh, Benjamin H. D. "Allegorical Procedures: Appropriation and Montage in Contemporary Art." *Artforum* 21, no. 1 (September 1982): 43–56.

———. "From Faktura to Factography." *October* 30 (Fall 1984): 83–119.

Bürger, Peter. *Theory of the Avant-Garde.* Translated by Michael Shaw. Theory and History of Literature, 4. Minneapolis: University of Minnesota Press, 1984.

Collage. Edited by Jeanine Parisier Plottel. *New York Literary Forum* 10–11. New York: 1983.

Da Vinci, Leonardo. *A Treatise on Painting.* Translated by John Francis Rigaud. London: J. B. Nichols and Son, 1835.

Denis, Maurice. *Théories, 1890–1910. Du Symbolisme et de Gauguin vers un nouvel ordre classique.* Paris: L. Rouart et J. Watelin Éditeurs, 1920.

Donato, Eugenio. "The Museum's Furnace: Notes Toward a Contextual Reading of Bouvard and Pecuchet." In *Textual Strategies. Perspectives in Post-Structuralist Criticism,* edited by Josue V. Harari. Ithaca: Cornell University Press, 1979.

Eagleton, Terry. *Literary Theory.* Minneapolis: University of Minnesota Press, 1983.

———. *The Function of Criticism. From the Spectator to Post-Structuralism.* London: Verso Editions and NLB, 1984.

———. *Walter Benjamin or Towards a Revolutionary Criticism.* London: Verso, 1981.

Eco, Umberto. *La struttura assente.* Milan: Bompiani, 1968.

Farwell, Beatrice, ed. *The Cult of Images: Baudelaire and the 19th-Century Media Explosion.* Ex. cat. Santa Barbara: University of California at Santa Barbara Art Museum (April 6–May 8, 1977).

Faucher, J. André. *Le Quatrième Pouvoir: La presse, de 1830 à 1930.* Paris: Les Éditions Jacquemart, 1957.

Fragments: Incompletion & Discontinuity. Guest editor, Lawrence D. Kritzman. *New York Literary Forum* 8–9 (1981).

Fried, Michael. *Absorption and Theatricality. Painting and Beholder in the Age of Diderot.* Berkeley: University of California Press, 1980.

Fussell, Paul. *The Great War and Modern Memory.* New York and London: Oxford University Press, 1975.

Goodman, Nelson. *Languages of Art; An Approach to a Theory of Symbols.* Indianapolis: Hackett, [1968] 1976.

Greenberg, Clement. "Avant-Garde and Kitsch." In *Art and Culture.* Boston: Beacon Press, 1961.

———. "Towards a Newer Laocoon." *Partisan Review* 7, no. 4 (July-August 1940): 296–310.

———. "Modernist Painting." *Arts Yearbook* 4 (1961): 101–08.

Hildebrand, Adolf. *The Problem of Form in Painting and Sculpture.* Translated and revised with the author's cooperation by Max Meyer and Robert Morris Ogden. New York: G. E. Stechert, [1893] 1907.

Hoffman, Katherine, ed. *Collage: Critical Views.* Ann Arbor / London: UMI Research Press, 1989.

Janis, Harriet, and Rudi Blesh. *Collage. Personalities, Concepts, Techniques.* Philadelphia: Chilton, 1967.

Joll, James. *The Origins of the First World War.* London and New York: Longman Group Ltd., 1984.

Lévi-Strauss, Claude. *The Savage Mind.* Chicago: University of Chicago Press, 1966.

Maindron, Ernest. *Les affiches illustrées.* Paris: H. Launette, 1886.

Motherwell, Robert, ed. *The Dada Painters and Poets: An Anthology.* The Documents of Twentieth-Century Art. Boston: G. K. Hall, [1971] 1981.

Procaccini, Alfonso. "Alberti and the 'Framing' of Perspective." *The Journal of Aesthetics and Art Criticism* 40, no. 1 (Fall 1981): 29–39.

Rearick, Charles. *Pleasures of the Belle Epoque. Entertainment and Festivity in Turn-of-the-Century France.* New Haven and London: Yale University Press, 1985.

Rodari, Florian. *Collage: Pasted, Cut, and Torn Papers.* New York: Skira / Rizzoli, 1988.

Schapiro, Meyer. "On Some Problems in the Semiotics of Visual Art: Field and Vehicle in Image-Signs." *Semiotica* 1, no. 3 (1969): 222–42.

Seitz, William C. *The Art of Assemblage.* Ex. cat. New York: Museum of Modern Art, Doubleday, 1961.

Shapiro, Theda. *Painters and Politics. The European Avant-Garde and Society, 1900–1925.* New York and Amsterdam: Elsevier, 1976.

Shiff, Richard. "Representation, Copying, and the Technique of Originality." *New Literary History* 15, no. 2 (Winter 1984): 333–63.

———. "The Original, the Copy, and the Spontaneous Classic: Theory and Painting in Nineteenth-Century France." *Yale French Studies,* no. 66 (Spring 1984): 27–54.

Shklovsky, Victor. "Art as Technique," 3–24. In *Russian Formalism: Four Essays,* translated and with an introduction by Lee T. Lemon and Marion J. Reis. Lincoln and London: University of Nebraska Press, 1965.

Signac, Paul. *D'Eugène Delacroix au néo-impressionnisme.* Paris: Revue Blanche, 1899.

Stone, Norman. *Europe Transformed, 1878–1919.* Cambridge: Harvard University Press, 1984.

Weber, Eugen. *Peasants into Frenchmen: The Modernization of Rural France, 1870–1914.* Stanford: Stanford University Press, 1976.

Wescher, Herta. *Die Collage.* Cologne: M. Dumont Schauberg, 1968. English version published as *Collage.* Translated by Robert E. Wolf. New York: Harry N. Abrams, [1968].

Wolfram, Eddie. *History of Collage.* New York: Macmillan, 1975.

Index